A LOVE FOR THE BEAUTIFUL

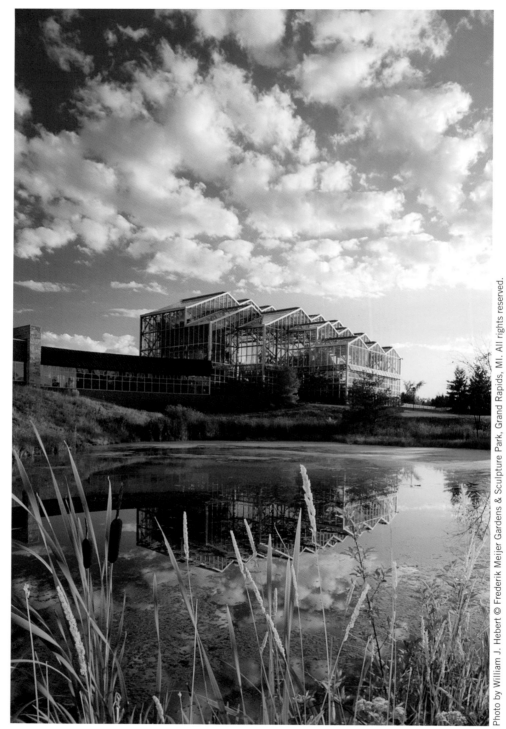

A view of the Tropical Conservatory, Frederik Meijer Gardens & Sculpture Park

A LOVE FOR THE BEAUTIFUL

DISCOVERING AMERICA'S HIDDEN ART MUSEUMS

SUSAN JAQUES

Guilford, Connecticut

Editor: Amy Lyons
Project Editor: Tracee Williams
Cover Design: Diana Nuhn
Text Design: Sheryl P. Kober
Layout Artist: Melissa Evarts

Library of Congress Cataloging-in-Publication Data

Jaques, Susan.
A love for the beautiful : discovering America's hidden art museums / Susan Jaques. — First [edition].
pages cm
Summary: "Some of the country's best art is hidden in plain sight, in museums largely unknown outside their regions. How works by masters like Rembrandt, Rodin, Picasso, van Gogh, Monet, Hokusai, and O'Keeffe wound up where they did is a colorful tale of American art collecting. The fifty museums in A Love for the Beautiful offer uniquely personal art-viewing experiences for both business and pleasure travelers." — Provided by publisher.
ISBN 978-0-7627-7950-5 (pbk.)
1. Art museums—United States. I. Title.
N510.J37 2012
708.13—dc23
2012025860

Printed in the United States of America
10 9 8 7 6 5 4 3 2 1

FOR JACK & GRACE

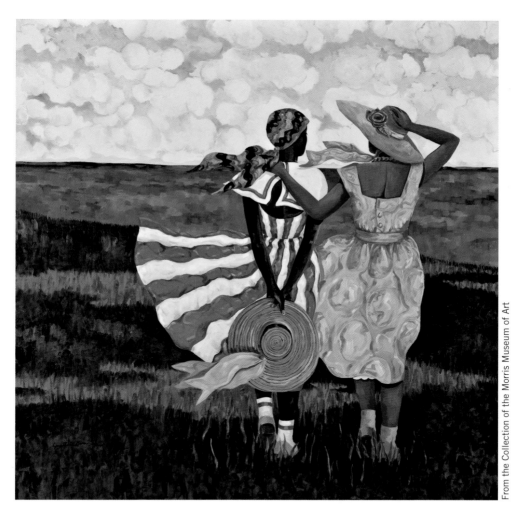

Daughters of the South, © Jonathan Green, 1993, Oil on Canvas, 69 1/4 x 70 inches, Morris Museum of Art

From the Collection of the Morris Museum of Art

Indiana University Art Museum Atrium designed by I. M. Pei

CONTENTS

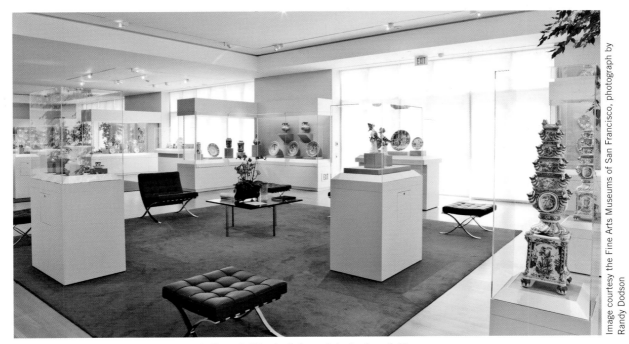

Image courtesy the Fine Arts Museums of San Francisco, photograph by Randy Dodson

Constance and Henry Bowles Porcelain Gallery, California Palace of the Legion of Honor

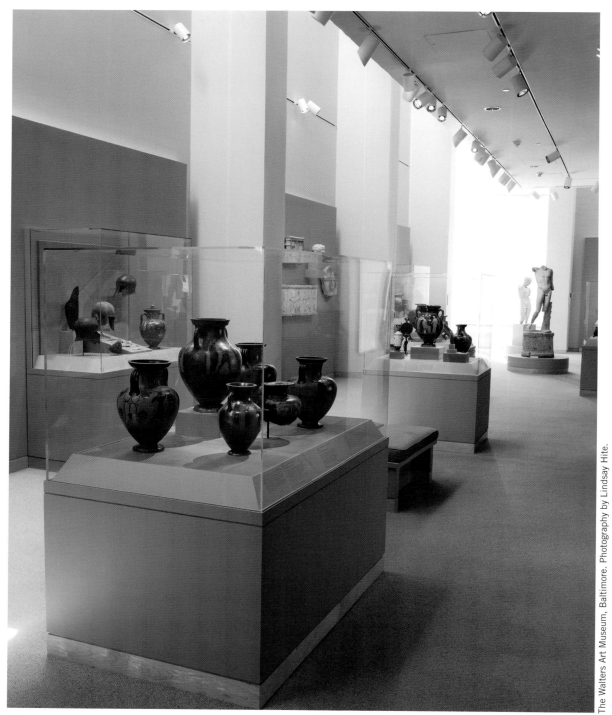

The Walters Art Museum, Greek Gallery

The Walters Art Museum, Baltimore. Photography by Lindsay Hite.

ACKNOWLEDGMENTS

There are many people who helped me realize this book. I want to thank Maria Di Pasquale for her eloquent lectures and encouragement. I also have Maria to thank for introducing me to Brian Allen, director of the Addison Gallery of American Art at Phillips Academy, who shared his knowledge so generously in the book's early stage.

For the book title, I am indebted to Addison founder Thomas Cochran. In 1930 Cochran set out to foster "a love of the beautiful" among students at his alma mater, commissioning an elegant brick building for his hand-picked paintings by Winslow Homer, George Bellows, and Edward Hopper.

I also wish to express my thanks to the Corcoran Gallery of Art in Washington, DC for the book's cover image, Willard Metcalf's moonlit *May Night*. The painting depicts one of the featured museums—the Florence Griswold House in Old Lyme, Connecticut, where Metcalf and his fellow American impressionists found inspiration and camaraderie.

The joy of writing this book was discovering so many remarkable art museums across the country— far more than can be presented here. A very special thank you to all the artists who have been so gracious and supportive. I wish to extend my sincerest appreciation to the museum staffs, directors, curators, registrars, and public relations people—who have helped me with tours, interviews, and images.

Among this group are a number of individuals who deserve special thanks: Daniela Oliver-Portillo (McNay Art Museum), Barbara O'Brien (the Kemper Museum of Contemporary Art), Beth Moore (Telfair Museums), Amy Sawade (Frederik Meijer Gardens & Sculpture Park), Bernard Barryte (the Cantor Arts Center), Scott Gardiner (the John and Mable Ringling Museum of Art), Joan Kropf (the Dali Museum), Patrick Sears (the Rubin Museum of Art), Carmelo Quinto (Millicent Rogers Museum), Mindy Besaw (Whitney Gallery of Western Art), and Virginia O'Hara (the Brandywine River Museum).

I also want to express my gratitude to a precious resource—the Getty Research Institute and its dedicated staff, including Ross Garcia, Jane Mandel, Sally McKay, Nancy Perloff, and Lois White. The library's titles on museums, genres, and artists proved invaluable throughout this project. Thanks also to the Dali Foundation and the Yale University Art Gallery and Beinecke Rare Book and Manuscript Library.

Thanks to Marie-Therese Brincard, African art consultant at the Neuberger Museum of Art at Purchase College, New York, for introducing me to this remarkable genre. Thanks to Karen Wada for her friendship and advice; to computer whiz Eric Schlissel for helping organize the book's many images; and to Kathy Hart and Bruce Vinokour for their generosity.

I also wish to thank my agent, Alice Martell, along with the talented team at Globe Pequot Press, including editors Amy Lyons and Tracee Williams, designers Diana Nuhn and Sheryl P. Kober, and layout artist Melissa Evarts.

Finally, thanks to my beloved family, especially my stalwart husband, Doug, whose support made this book possible. To our son and daughter, Jon and Clara, who cheered me on from start to finish. And to amazing role models—my dear mother-in-law, Carlene, and my parents, Jack and Grace Feld.

INTRODUCTION

The idea for a book about America's under-the-radar art museums came in the middle of a club soccer tournament in St. Petersburg, Florida. Between games, I dragged my teenage daughter and her teammate to the Salvador Dali Museum, then located in a former warehouse. Within minutes I realized we'd stumbled upon an exceptional place—one of the largest collections of the surrealist's work outside of Spain.

The story became even more compelling when I learned that during the 1970s, husband and wife collectors Reynolds and Eleanor Morse couldn't give away their Dalis. Several decades later the art world rediscovered Dali, and in 2011, the now-coveted collection moved to a striking new building nearby designed by Yann Weymouth.

Intrigued, I began searching for other unsung museums with extraordinary art collections. After months of research and travel, I made a startling discovery. Some of the country's best art resides in museums largely unknown outside their regions. How these galleries ended up where they did is a fascinating tale of American art collecting.

I discovered that America's under-the-radar art museums are as diverse as their holdings. They aren't necessarily small, though this book has its share of intimate galleries. They aren't always off the beaten path; some are hiding in plain sight. Another group is located on college campuses and even a secondary school. What each of the museums offers is a unique art-viewing experience that's genuine, intimate, and uncrowded.

Choosing from hundreds of outstanding art museums is a personal, subjective process, one that reflects this author's taste. Collections of so-called "minor arts" like glass, textiles, and decorative arts get equal billing with painting and sculpture. This book focuses on museums that display art from permanent collections; much-loved noncollecting museums fall outside its scope.

Geography played another factor in the selection process—the museums cut a wide swath across the country, with a balance of big cities and small towns.

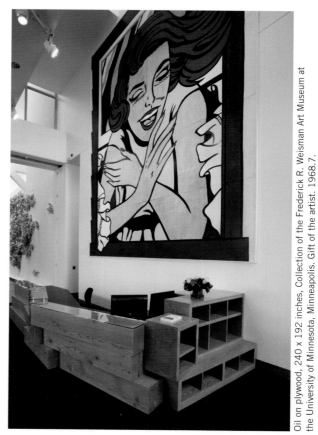

Oil on plywood, 240 x 192 inches, Collection of the Frederick R. Weisman Art Museum at the University of Minnesota, Minneapolis. Gift of the artist. 1968.7.

Roy Lichtenstein, World's Fair Mural, *1964, Weisman Art Museum*

Populated, art-rich states like New York, Florida, Texas, and California are represented by multiple museums. In an effort to strike a geographic balance and avoid repetition, I know I may disappoint some readers by not including their favorite museums.

Rather than owning encyclopedic collections, lesser-known museums tend to be exceptional in specific areas. For this reason the book is organized by genre. Each museum falls into an outstanding category—from ancient to contemporary art. In some cases the chosen category represents a less known area at that institution, like African art at the Menil Collection. Because of their focus on the Wyeth family and Louis Comfort Tiffany, respectively, the Brandywine River Museum and Charles Hosmer Morse Museum are listed in the single-artists category; both museums also display other wonderful collections.

The "Not to Miss" works are meant to give readers a flavor for each museum's permanent collection. Due to a number of factors, including loans to other museums and limitations on gallery space, these objects aren't guaranteed to be on display. This is almost always true at the photography museums, which regularly rotate their fragile works.

At the 2010 opening of the Mint Museum Uptown in Charlotte, North Carolina, glass artist Danny Lane said: "I think the purpose in making art is to make something beautiful—that's going to give you a liftoff, a feeling, that elevates the soul." That's the feeling I hope readers experience when they visit the featured museums.

—Susan Jaques
Los Angeles, April 2012

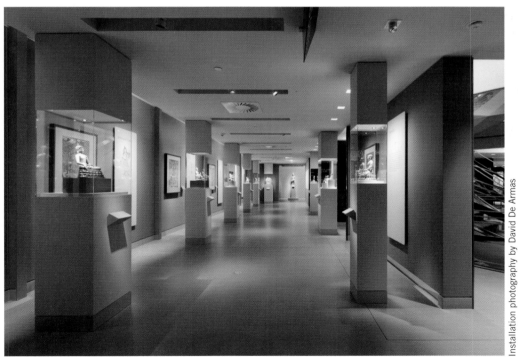

Gateway to Himalayan Art, Rubin Museum of Art

Installation photography by David De Armas

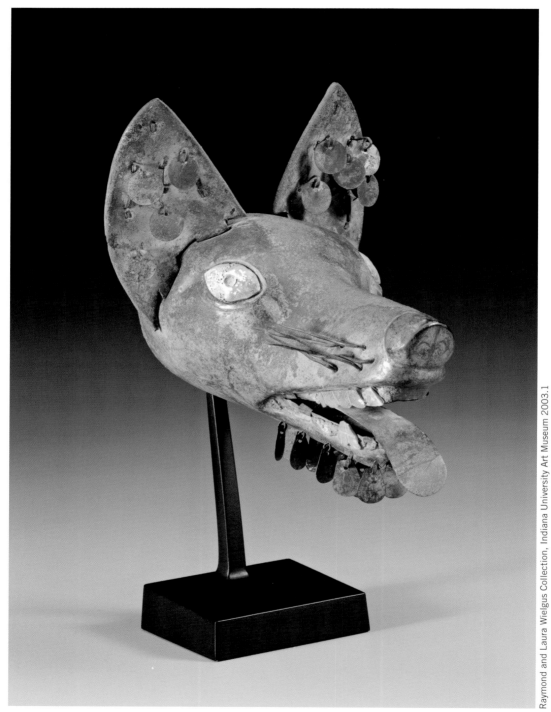

Headdress Element in the Form of a Fox Head, Moche Culture, Peru, 400–800 CE, Indiana University Art Museum

CHAPTER I

AFRICAN, PRE-COLUMBIAN & OCEANIC ART

Pre-Columbian Treasures

DUMBARTON OAKS
Washington, DC

"I know the ones that are the greatest triumphs, like the Dumbarton Oaks Museum . . . I had total freedom . . . and the owner and I worked together and it was pure delight from beginning to end and it came out very well."

—Philip Johnson, architect

❧ Today, objects from the ancient cultures of Latin America are part of the pantheon of world art, alongside ancient works from Egypt, the Near East, and the classical world. One of the pioneering collections that helped bring this about is tucked quietly away at Dumbarton Oaks, a wooded estate in Washington, DC's Georgetown neighborhood. Several hundred pre-Columbian objects are showcased in an elegant pavilion designed by Philip Johnson.

Dumbarton Oaks is the former home and gardens of Mildred and Robert Woods Bliss, collectors of pre-Columbian and Byzantine art. Mildred Bliss inherited a fortune from her family's investment in the patent medicine Fletcher's Castoria. Career diplomat Robert Bliss held numerous assignments, including ambassador to Argentina.

The couple's pre-Columbian collection began in 1914, when Robert Bliss bought a small polished

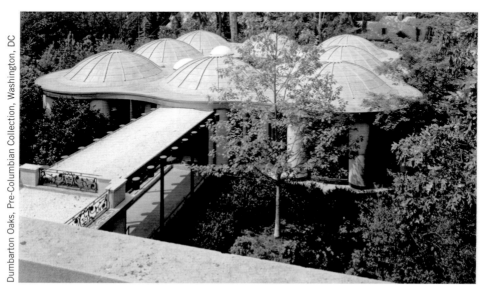

Dumbarton Oaks, Pre-Columbian Collection, Washington, DC

Exterior of the Pre-Columbian Gallery

jadeite figure at a Paris antique shop. Recent carbon-14 dating places the male figure with pierced earlobes and delicately carved teeth from the early Olmec civilization of Mexico. Many more beautiful examples would enter Bliss's collection.

After retiring, Bliss spent two months in 1935 exploring Maya sites like Chichen Itza, Copán, and Tikal. That's when he contracted what he called "an incurable malady" for pre-Columbian art. Bliss acquired ancient objects from European and American dealers like Earl Stendahl, who sold him 150 pieces. Though Bliss collected across a wide range of styles and media, he was especially interested in gold, jade, and polished stone.

In 1940 the couple donated their Georgian-style mansion, sixteen upper acres, Byzantine art collection, and library to Robert Bliss's alma mater, Harvard University. They gave another twenty-seven acres to the National Park Service, now Dumbarton Oaks Park.

For fifteen years the pre-Columbian collection was on view at the nearby National Gallery of Art. In 1963 the prized objects came home to a glass and travertine pavilion connected to the mansion. Architect Philip Johnson arranged eight domed circular galleries around a small fountain court open to the sky. Floor-to-ceiling glass walls surround visitors with garden views that change with each season. Sixteen years after the museum's opening, Johnson returned to Dumbarton Oaks to receive the Pritzker Architecture Prize.

Suspended in Plexiglas cases, ancient artworks appear to float in midair. The galleries are organized by culture and geography—starting with Central Mexico and the Aztecs, the last Mesoamerican empire that covered modern-day Mexico south to Honduras. From the mighty Aztecs come golden turtle and snail shell ornaments, lip plugs worn through a pierced lower lip, and gold-sheathed obsidian blades used for ritual bloodletting, a Mesoamerican tradition.

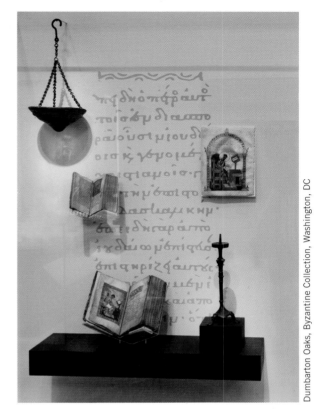

Detail of case, Byzantine Gallery

Dumbarton Oaks, Byzantine Collection, Washington, DC

In the Coastal Lowlands gallery, visitors are introduced to the Olmec and Veracruz, two of the most artistically expressive cultures. Stunning Olmec lapidary work includes a jadeite jaguar mask and serpentine pendant of a reclining male figure. A Veracruz hacha in white marble depicts an elderly male with an elaborate headdress, possibly marking the sacrifice of an elite person. A later sandstone Huastec death figure commemorates a woman of high status. Her expressive face emerges from a large monster-maw helmet.

The next two galleries are devoted to the artistry of the Maya. Powerful Maya kings were deified in art—like the limestone panel of a Palenque ruler performing a ceremonial dance and pictorial ceramic vessels with delicately painted scenes of Maya lords.

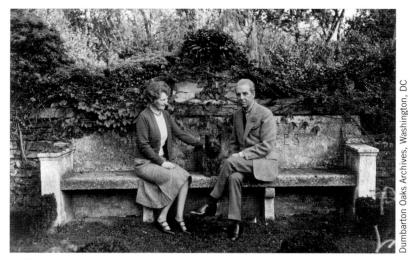

Mildred and Robert Woods Bliss in the Rose Garden

A flower-shaped jadeite ear spool worn by a lord or lady gives a glimpse into the Maya's elaborate court dress. From Teotihuacan, northeast of Mexico City, are a series of serene face masks and a mural depicting a jaguar in a net costume. Some seventeen centuries ago, this red and green fresco decorated an apartment in the cosmopolitan city.

In the Intermediate Area between today's eastern Honduras and the coasts of Columbia and Venezuela, chiefs wore ornaments to display their power and status. One such status symbol is a small jaguar pendant. Carved from light-blue jadeite with dark specks, the jaguar stands on its hind legs, holding its tail between its front paws. A finely polished translucent jadeite crocodile pendant features incised scales and teeth. Leaders also wore gold, like the dramatic double-headed eagle and double-figure pendants.

Andean artisans from South America's west coast produced sophisticated objects. A spectacular Wari mirror is covered in mosaic shell and stone inlays with mother-of-pearl on its handle and central panes. There are silver cups with elaborate repoussé decoration and roundels made with orange-colored spiny

oyster shell, sacred to many ancient peoples. A standing silver figure of a nobleman with his hands on his chest, possibly from an Inka shrine, is made of cut and folded sheet silver.

Each year Dumbarton Oaks organizes special exhibitions, like the one marking the pavilion's golden anniversary in 2013. In a separate low-lit gallery, the museum rotates its collection of Andean textiles. Among the Andean masterworks are a red embroidered funerary mantle found in Peru's Paracas necropolis and a woven Wari tunic decorated with musicians and dancers.

About one third of the Bliss's twelve hundred Byzantine objects are on view in a separate jewel-toned gallery with high ceilings and clerestory windows. Among the gems are a silver-gilded liturgical paten from Syria, tenth-century ivories and miniature mosaics from Constantinople. Nearby, the Renaissance-style Music Room is a charmed setting for chamber music concerts. Igor Stravinsky conducted his *Dumbarton Oaks Concerto* here to celebrate Robert and Mildred Bliss's fiftieth wedding anniversary.

Not to Miss

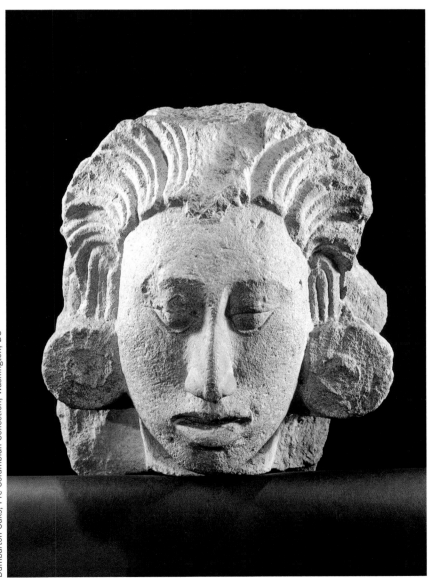

Dumbarton Oaks, Pre-Columbian Collection, Washington, DC

Head of the Maize God, Maya, Copan, eighth century CE

Maize was sacred for the Maya, whose economy depended on its cultivation. Artists often depicted maize in the form of a graceful young man, as in this trachyte sculpture that sits atop a tall clear column. Originally part of a larger figure, the youth sports large ear spools and a coveted corn cob–shaped forehead. This powerful work entered the collection in the 1950s in a trade between Robert Bliss and the Peabody Museum. The Peabody acquired it during expeditions in the 1890s under a permit from the Honduran government.

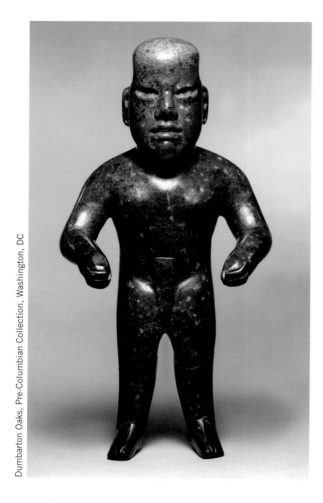

Dumbarton Oaks, Pre-Columbian Collection, Washington, DC

Standing Figure, Olmec, 900–300 BCE

This small but stunning jadeite figure is the first pre-Columbian object bought by Robert Woods Bliss and set a high bar for the rest of the collection. Standing at nine and a half inches tall, the figure's legs are slightly bent and his arms project forward, bent at the elbows. The elongated head is characteristic of Olmec art, with pierced earlobes and delicately carved teeth and nostrils. The hands, whose fingers are represented by fine incised lines, may have once grasped objects. Incisions also outline the figure's toes and buttocks. A celt-shaped object, carved in low relief, may represent a loincloth.

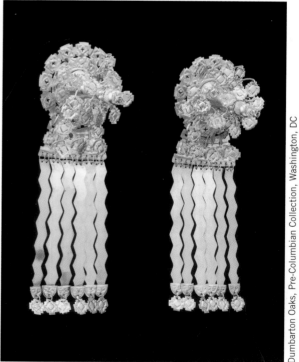

Dumbarton Oaks, Pre-Columbian Collection, Washington, DC

Pair of Ear Ornaments, Chimú, Late Intermediate Period, 1370–1470 CE

A myth describes the origin of the Chimú society of northern Peru from three eggs made of gold, silver, and copper. Noblemen emerged from the gold egg, noblewomen from the silver egg, and commoners from the copper egg. Because gold was considered a sacred metal, its use was reserved for the gods and those thought to be their descendants. In this dazzling jewelry, a tiny bird protrudes from the center of each earring. Six hanging snakes are capped by small human faces. According to Chimú belief, the noble who wore these earrings may have received the essence of birds and snakes.

A SPIRITED GATHERING

INDIANA UNIVERSITY ART MUSEUM
Bloomington, Indiana

"I have just visited the Indiana University Art Museum for the first time . . . the collection of African and Oceanic art is one of the best I've ever seen anywhere in the world. Every work is of the highest quality, and I do not think that anywhere, except perhaps in the great museum in Berlin, have I ever seen so many good pieces gathered together."

—Sir Anthony Caro, sculptor

An academic museum in a small Midwestern town isn't where you'd expect to find a coveted collection of African, Oceanic, and pre-Columbian art, the envy of many museums. Neither would you expect to find it housed in a stunning I.M. Pei–designed building with a glass-roofed atrium.

The remarkable collection at the Indiana University Art Museum in Bloomington spans three thousand years, three continents, and numerous islands. The ancient Americas are represented in stone, ceramics, and precious gold, silver, and jade. From Africa come delicately carved ivories, powerful wood reliquary figures, and brilliant textiles. South Pacific objects range from tiny figurines and exquisitely crafted tools to towering commemorative sculptures.

Roy Sieber, Laura and Raymond Wielgus at opening of gallery

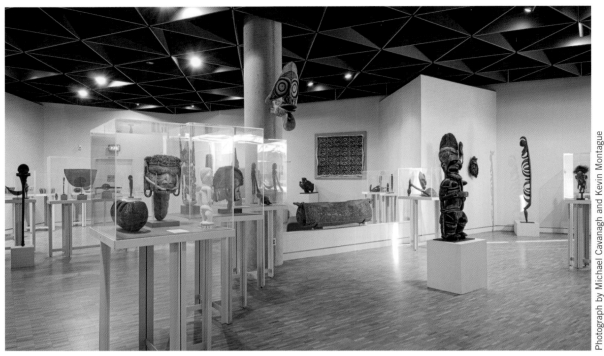

Photograph by Michael Cavanagh and Kevin Montague

IUAM South Pacific Gallery

Most of the choicest of the 450 objects on view once belonged to Midwesterners Raymond and Laura Wielgus, for whom the third-floor gallery is named. In the mid-1950s, the Chicagoans were looking for a hobby when they began collecting pre-Columbian, followed by African and Oceanic art. In twenty years the couple assembled one of the premier private collections in the United States, which they left to Indiana University in 2010.

Their remarkable gift is the result of a friendship between Raymond Wielgus and Indiana University African art history professor Roy Sieber. The two connoisseurs met in 1956 when Raymond Wielgus loaned several pieces for a sculpture exhibition Sieber was organizing in Iowa (where he received the first Ph.D. in African art history in the United States). Their friendship continued for the next three decades after Sieber moved to Indiana.

A gallery visit begins in the world of the ancient Americas, set against large photomurals of archeological sites in Mexico, Peru, and Guatemala. The artworks of ancient Mesoamerican peoples like the Olmec, Maya, and Aztec reflect the importance of spirits and mythological figures. Among the most compelling objects is a three-thousand-year-old Olmec clay vessel of an elderly woman whose gaping mouth forms the spout. Maya vases illustrate a rich ceramics tradition with delicately painted scenes and hieroglyphics. From Veracruz is a vessel with an animated spider monkey holding its tail and a vase in the form of the wrinkled, bearded fire god.

A remarkable group of Peruvian objects underscores the diversity of ancient Latin American cultures. Among these are a stylized double-spouted pot from Paracas and a dramatic Moche fox headdress made of copper, silver wash, and shell. An inlaid Huari

lime container—Laura Wielgus's favorite piece—was part of the paraphernalia for coca chewing, an ancient practice where small amounts of cocaine were released from coca leaves. A Lambayeque Valley ear spool with bird and water imagery is made of annealed gold sheets with repoussé decoration and incised motifs.

From the ancient Americas we move into a gallery space devoted to Africa, where art played an important role in religious and civic life. Working with modest materials like wood and clay, as well as precious ivory and metals, sculptors created evocative images of important ancestors. There's a compelling female figure with a raised head from the Montol peoples of eastern Nigeria, a mask used for masquerade performances by the Baule peoples of the Ivory Coast, and a striking cast brass head of a king created by an artist in the royal court of Benin.

Along the far wall hang a pair of long ceremonial dance skirts, part of the textile tradition of the Kuba kingdom in today's Democratic Republic of the Congo. The textiles were woven out of raffia fiber by men and embroidered and appliquéd by women. With over two hundred named patterns, the inventive abstract designs captivated European avant-garde artists like Henri Matisse, who lined his studio wall with the decorative fabrics. There is also brilliant beadwork jewelry from Maasai women, who began using European glass beads in the late nineteenth century, and an exquisite white beaded wedding train from South Africa.

On Raymond Wielgus's recommendation, the museum acquired six objects from the estate of Frederick Pleasants, a collector and curator at the Brooklyn Museum. Among Pleasants's masterworks are a Mukudj mask from Gabon and a nearly seven-foot-tall ancestor figure from Tomman Island in Vanuatu created to house the spirit of a high-ranking chief.

The museum's Oceania collection is rich in objects from Melanesia and Polynesia, a triangle of islands formed by Hawaii, Easter Island, and New Zealand. Objects like the powerful Biwat flute figure, with its boar-tusk nose ornament and cassowary feather headdress, were part of important Melanesian initiation ceremonies. Hosting feasts for initiates would have brought great status to the owner of this sacred flute.

Central to Polynesian culture were the concepts of mana, a supernatural energy all things possess, and *tapu*, a restriction that assures that a person or object maintains its mana. According to traditional belief, objects like the museum's fly whisks and bone ornaments possessed the mana of previous owners. To increase the mana of the intricately carved tall Austral Islands drum, a priest would have chanted and prayed while braiding the coconut fiber that holds the sharkskin drumhead in place. The museum's exquisite carved-wood canoe bailer illustrates how the Maori of New Zealand turned everyday tools into works of art.

The museum rotates its collection of contemporary works by African artists who blend native traditions with international styles. Among the artists represented are Nigerian Twins Seven- Seven, known for his sculpture paintings; Nigerian portrait photographer Tijani Sitou; Senegalese mixed-media painter Kalidou Sy; and ceramicists Magdalene Odundo of Kenya and Clive Sithole of South Africa.

GETTING THERE Address: 1133 E. 7th St., Bloomington, IN Phone: (812) 855-5445 Website: iub.edu/~iuam/iuam_home.php Hours: Tuesday to Saturday 10:00 a.m. to 5:00 p.m., Sunday noon to 5:00 p.m. Tours: Saturday 2:00. Admission: Free

Not to Miss

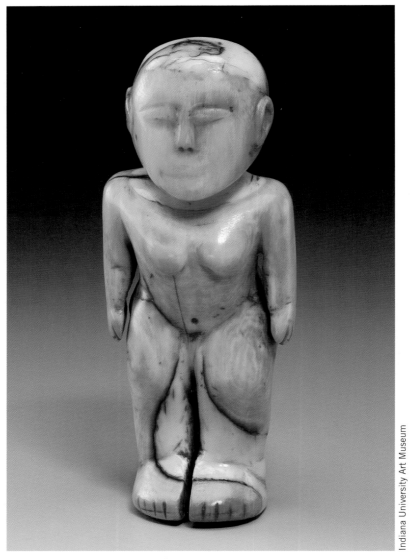

Indiana University Art Museum

Female Figure, Ha'apai island group, Tonga, eighteenth century

Before European trade made ivory more available in the nineteenth century, the only ivory in Polynesia came from the teeth of an occasional stranded sperm whale. This small female figure is one of just about a dozen whale-tooth sculptures that survived from the period. Five inches tall, the rare figure is thought to represent a deity associated with fertility and harvest. Her smooth surface and stocky proportions reflect Tongan ideas of female beauty. The figure may have been either worn by a female leader as a charm or displayed in a shrine dedicated to the deity.

Chief's Chair, Chokwe peoples, Democratic Republic of the Congo/Angola, 1885–1930

In many parts of Africa, special objects are associated with political leaders, like this exquisitely carved wood chair with an antelope-hide seat and brass tacks. Before the arrival of Europeans, Chokwe chiefs used stools. This example, with its leather seat and backrest, was inspired by a seventeenth-century Portuguese chair. Chokwe carvers distinguished this piece with carvings on the back and slats that depict a series of secular and religious scenes. The central seatback features a masquerader representing Cihongo, a symbol of masculine power and wealth, usually associated with the chief.

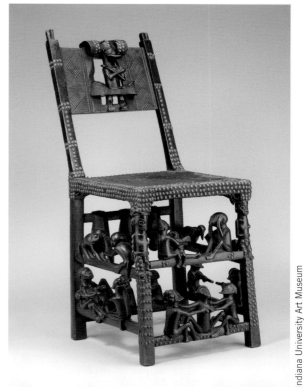

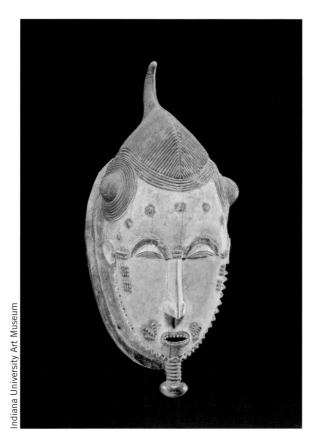

Mask, Goli Kpan, Baule peoples, Ivory Coast, early twentieth century

Among the first African objects to capture Western attention were Baule masks like this delicately carved example. Among the Baule peoples of the Ivory Coast, scarification (no longer widely practiced) and elaborate hairdos are signs of beauty. This beautiful wood piece with its human female face and crested coiffure was one of four types of masks made for *goli*, a masquerade performance held at funerals and other events. Wound around the rim of the mask were long strands of raffia, creating a long cape-like fringe. The wearer would also attach a leopard skin to the back of the mask as a symbol of royalty and power.

THE MENIL COLLECTION
Houston, Texas

"Paradoxically, the Menil Collection with its great serenity, its calm and its understatement is far more modern than Centre Pompidou."

—Renzo Piano, architect

Best known for its Cubist and Surrealist art, the Menil Collection in Houston, Texas, is also home to a striking collection of African and Oceanic art. Like many of the modern artists they collected, museum founders John and Dominique de Menil found spiritual meaning and aesthetic beauty in non-Western art.

Their collection is displayed at an elegant Renzo Piano–designed building that marked its twenty-fifth anniversary in 2012. In Piano's spacious galleries bathed in natural light, nineteenth- and twentieth-century objects from Africa and the Pacific Islands appear timeless. And without wall texts, tours, or audio guides, visitors are free to experience their own reactions to the works.

That was the intention of the museum's matriarch, Paris-born Dominique de Menil. Heiress to the Schlumberger oil fortune, she married John de Menil, a banker from an aristocratic French family. The couple spent their 1931 honeymoon in Morocco, where John de Menil had done his army service. Starting with their first acquisition, a Cézanne watercolor, the de Menils became avid collectors, acquiring works by artists like Max Ernst, Joan Miró, and Rene Magritte.

During World War II, the family left France and eventually settled in Houston, Schlumberger's American headquarters. To their passion for modern art they added "primitive" art, assembling an African collection of some one thousand pieces. For these objects, the de Menils found themselves competing with collectors like Nelson Rockefeller, Raymond Wielgus, and sculptor Jacques Lipchitz. "My, my goodness we did buy a lot of things," recalled Dominique de Menil.

The couple donated art to a number of museums, including MoMA in New York City and the Museum of Fine Arts in Houston. In a 1965 letter to the director of Musee de l'Homme about their gift of a Ghana vessel, the de Menils wrote, "When we are in Paris . . . we like to drift along quietly, visiting old friends in the glass cases and discovering new ones."

After her husband's death, Dominique de Menil decided the art belonged in their adopted home. She

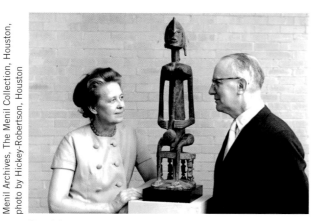

Menil Archives, The Menil Collection, Houston, photo by Hickey-Robertson, Houston

Dominique and John de Menil, 1967

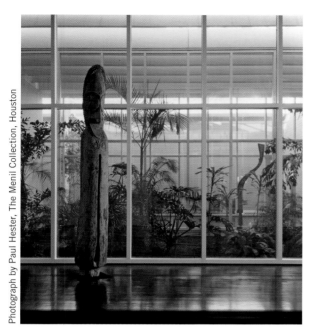

Oceanic Gallery

Photograph by Paul Hester, The Menil Collection, Houston

The first objects that greet visitors are an imposing life-size Sudanese grave effigy beside a tiny ivory figurine. Populating the space are expressive Dogon sculptures from Mali, ghostly Senoufo ancestor statues, and Baule masks from the Ivory Coast. In the glass-walled garden gallery resides a herd of antelope headdresses from the Bamana peoples of Cameroon.

From Benin, present-day Nigeria, are a pair of impressive bronze heads that once decorated altars. Powerful Benin kings, wealthy from trade with the Portuguese, maintained a guild for bronze casters who commemorated their past rulers with crowned heads. Over time these heads became increasingly stylized with exaggerated features.

The de Menils' bronze head from the late eighteenth century may have once supported an elaborately carved ivory elephant tusk like the one that is also on display. An uncrowned head was possibly a victory trophy depicting the defeated ruler of another kingdom.

A central garden connects African art with the Oceanic gallery, a small but exceptional collection of some two hundred objects from Australia, Polynesia, Micronesia, and Melanesia. From jewel box cases of small intimate amulets to a towering water drum and large Easter Island paddle, visitors feel the tremendous arc of the objects and of time. Artists imbued these ceremonial objects with spiritual power preserved by a strict set of rules.

Surrealist Max Ernst introduced the de Menils to adventurer Jacques Viot, who sold them decorative bark cloths and ancestral sculptures from Lake Sentani, today's Papau. The bark cloths, which feature elaborate black and tan geometric patterns, were traditionally worn by prominent men and exchanged ceremonially. Some of the objects on display are gifts from the de Menils' daughter, Adelaide de Menil, and the late Edmund Carpenter, who lived and worked in New Guinea.

hired Piano to design a museum in the quiet Houston neighborhood of Montrose. Unlike the flamboyant Pompidou Center that Piano codesigned, his low-key gray clapboard building sits modestly on a large lawn. Galleries with dark-stained pine floors occupy the main floor, and upstairs "treasure rooms" hold the rest of the collection. "The portrait of Dominique de Menil" is how Piano describes his first US museum.

About one hundred select pieces from the Menil's one-thousand-object African collection are arranged to show the breadth of the collection and give visitors a personal, one-on-one experience. In several spaces works from different cultures and mediums are displayed together, underscoring the diverse artistic traditions across the continent. About the African collection, Dominique de Menil wrote: "What could never have been written is there, all the dreams and anguishes of man. The hunger for food and sex and security, the terrors of night and death, the thirst for life and the hope for survival."

Cubists like Pablo Picasso were fascinated by African art, while the Surrealists turned to the lesser-known arts of the Pacific Islands and the Northwest Coast. This intersection is explored in a permanent exhibition, Witnesses. The octagonal floor-to-ceiling gallery is filled with objects owned by Surrealists.

The Menil campus also includes a Renzo Piano addition, a homage to the late abstract artist Cy Twombly. Down the street is the Rothko Chapel, an octagonal ecumenical sanctuary with fourteen purplish brown murals by Mark Rothko. One of Dominique de Menil's last projects was rescuing and restoring two medieval frescoes stolen from a Cyprus chapel and cut into some three dozen pieces. De Menil bought the works on behalf of the Greek Orthodox Church in Cyprus in exchange for the right to display them in Houston. In 2012 the Menil returned the seven-hundred-year-old wall paintings to Cyprus.

GETTING THERE Address: 1515 Sul Ross St., Houston, TX Phone: (713) 525-9400 Website: menil.org Hours: Wednesday to Sunday 11:00 a.m. to 7:00 p.m. Admission: Free

Not to Miss

Trophy Head, Bamileke region, Cameroon, late nineteenth to early twentieth century

Although this rare, ornately beaded head represents the skull of an enemy killed in battle, its core is made of wood, not bone. Among the luxury goods traded between Cameroon and the Arab world were coral and glass beads. In the late fifteenth century, European beads as well as brass, porcelain, and mother-of-pearl buttons were used to decorate objects for chiefs and high-ranking allies. The European glass beads and English brass buttons in this trophy head are attached to cotton fastened to a wood core. The beadwork patterns are rich in symbolism—the chevron motif on the face alludes to crocodiles, pythons, and the theme of rebirth; the circular forehead design refers to a wise spider; and the upside-down U in between represents a frog, a symbol of fertility.

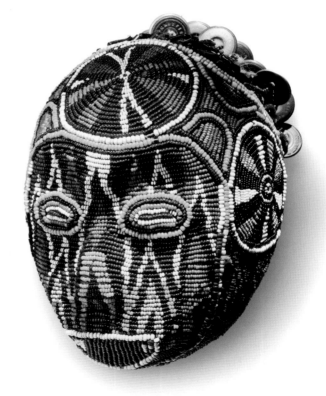

Photograph by Hickey-Robertson, The Menil Collection, Houston

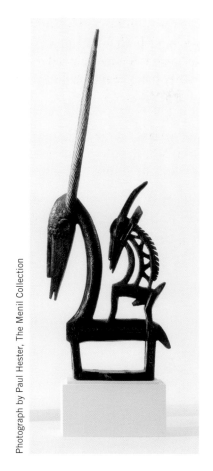

Photograph by Paul Hester, The Menil Collection

Antelope Headdress (Ciwara), Mali, Bamana peoples, twentieth century

This striking headdress nearly three feet tall is one of about half a dozen at the Menil. According to Bamana belief, Ciwara was the supernatural creature who taught the community how to farm. During agricultural festivals, performers attached wood Ciwara headdresses like this one to basketry hats. They also attached costumes made of natural plant fibers that hid the dancers' identities. The headdresses were carved in male and female pairs, with the female often carrying a baby antelope on her back, a symbol of fertility. Eastern and Western Bamana communities produced a wide variety of Ciwara, both vertical and horizontal.

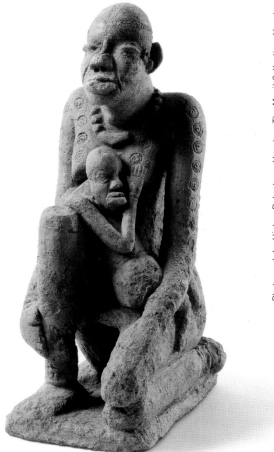

Photograph by Hickey-Robertson, Houston, The Menil Collection, Houston

Woman and Child, Mali, Jenne culture, eleventh to seventeenth century

The terra-cotta sculptures from the region near Jenne in Mali represent some of the oldest art from sub-Saharan Africa. Standing nearly nineteen inches tall, this figure is a good example of the complexity and abstraction of African sculpture. A figure of a mother kneels on one knee tenderly embracing a child. But closer inspection of its stooped posture and lined face reveals that the "child" is actually an adult. Most adult men among the nearby Senufo are considered children of the deity Ancient Mother, the supreme creator. The sculptor of this piece may have been metaphorically depicting the ancient mother who protects humankind.

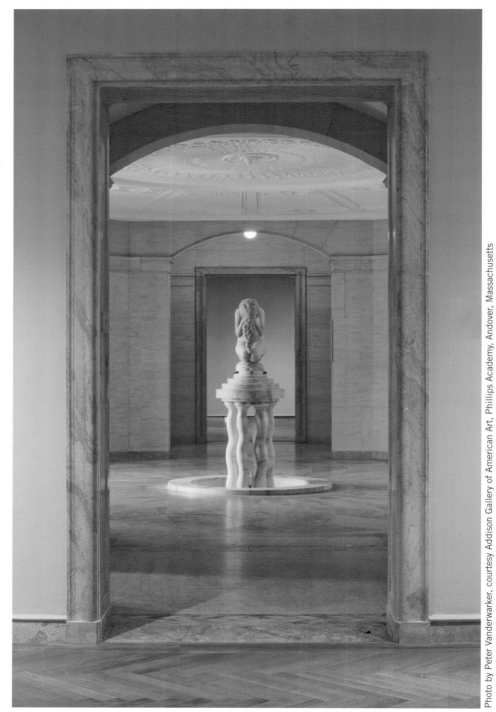

Addison Rotunda, Paul Manship's Venus Anadyomene, *1927, Addison Gallery of American Art*

CHAPTER 2

AMERICAN ART

THE ADDISON GALLERY OF AMERICAN ART
Andover, Massachusetts

"If you had to go to one place to experience American art, in some ways the Addison is the best place to go. It's almost like the Frick Collection (in New York) for Old Masters: It's very small, it's very select, with great paintings."

—Henry Adams,
Professor of American Art,
Case Western Reserve University

❧ One of the country's great collections of American art also happens to be the only full-scale art museum at a high school. The Addison Gallery of American Art at Phillips Academy is the brainchild of New York banker Thomas Cochran. Inspired in the 1920s by a new appreciation for American art, Cochran set out to create a museum for students at his alma mater.

Cochran hired architect Charles Platt to design the campus museum, which he named Addison after the mother of a close friend. With the help of Platt, as well as art dealer Robert McIntyre and patrons Lizzie Bliss and her sister-in-law, Mrs. Cornelius Bliss, Cochran filled the galleries with several hundred American artworks. From that modest start, alumni and friends have helped the collection grow to nearly seventeen thousand objects dating from the eighteenth century to the present, including some seven thousand photographs.

In 2010 the red brick museum was restored to its former glory, starting with the elegant octagonal rotunda and art deco sculpture of Venus by Paul Manship. Interior vistas, like the long view from the rotunda to a far gallery, give the museum a sense of spaciousness. At the same time, Platt's galleries have an intimate, domestic feel that makes the museum welcoming and the art accessible. The main gallery, home to many iconic paintings, features a ceiling cove decorated with a Sol LeWitt wall drawing.

One of the joys of visiting the Addison is the unexpected. Curators regularly reinstall the entire museum, mixing works from various media and time periods to encourage fresh dialogues. On one visit objects may be installed thematically; on a return visit, visitors are likely to find a monograph show or exhibition inspired by a historical event. By popular demand, greatest hits by artists Winslow Homer, James McNeill Whistler, and Edward Hopper are almost always on view, juxtaposed with rotating works from the collection.

The Addison has benefited by Phillips Academy's unusually large number of alumni–artists, among them Joseph Cornell, Walker Evans, Carl Andre, and Frank Stella, the museum's second- largest benefactor after Thomas Cochran. Since 1946 the Addison has also added works by artists in residence like Sol LeWitt

Addison Gallery at twilight

and William Wegman. The museum has a long tradition of hosting in-depth shows of living artists like Stella, LeWitt, Josef Albers, and Robert Frank.

Modernism, abstraction, and contemporary artworks have entered the collection thanks to a number of key patrons. Lizzie Bliss, cofounder of the Museum of Modern Art in New York, left the fledgling museum works by Arthur B. Davies, Charles Prendergast, and Walter Kuhn. Collectors Candace Stimson and Edward Root added important pictures by Charles Burchfield, Homer, and Hopper. In 1950 Peggy Guggenheim gave the museum its Jackson Pollock.

Starting with the early purchase of four Margaret Bourke-White prints at five dollars each, the Addison has built an impressive photography collection. In 1953 Georgia O'Keeffe donated photogravures by her husband Alfred Stieglitz and his fellow Photo-Secessionists. Among the many contemporary photographers represented at the Addison are Dawoud Bey, Joel Shapiro, Lorna Simpson, and Laurie Simmons.

A large and beautiful part of the collection dates from pre–Civil War to World War I, a period when American artists were developing their own distinct voices. There are sublime Hudson River School landscapes like Asher B. Durand's mossy *Study of a Wood Interior*, as well as works by George Inness and Homer. Among the showstoppers is Frederic Remington's lyrical *Moonlight, Wolf*.

American expatriate artists Mary Cassatt, John Singer Sargent, and James McNeill Whistler are all represented. Cassatt, the only American to exhibit with the French impressionists, often depicted mothers and children, as in the Addison's *Mother and Child in a Boat*. After a successful career as a portraitist, Sargent shifted to the plein air painting we see in the Addison's colorful *Val d'Aosta: A Man Fishing* and *Cypress Trees at San Vigilio*. Whistler spent much of his adult life in London, where his first commission was the Addison painting, *Brown and Silver: Old Battersea Bridge*.

The Addison is also rich in works by Thomas Eakins and members of The Eight (also known as the Ashcan School), a group of urban realists working during the early decades of the twentieth century. The same year Eakins resigned as director of the Pennsylvania Academy over a nude modeling scandal, Robert Henri enrolled. In 1908 the charismatic painter and teacher organized an exhibit in

New York of eight artists including George Bellows, George Luks, and John Sloan.

The Addison continues to add art to its collection. One recent addition, Dale Chihuly's *Black Niijimi Floats*, is permanently installed on the roof of its learning center. Ten black glass spheres in various sizes flecked with gold, purple, blue, and green bob on a sea of ground cover. The work evokes the glass floats that once buoyed the nets of Japanese fishermen.

GETTING THERE Address: 180 Main St., Andover, MA (on the campus of Phillips Academy) Phone: (978) 749-4015 Website: addisongallery.org Hours: Tuesday to Saturday 10:00 a.m. to 5:00 p.m., Sunday 1:00 to 5:00 p.m. Admission: Free

Not to Miss

Oil on canvas, 38 9/16 x 64 1/8 inches (97.95 x 162.88 cm), 1956.6. Gift of Stephen C. Clark in recognition of the 25th Anniversary of the Addison Gallery of American Art, Phillips Academy, Andover, Massachusetts

The Monk, George Inness (1825–1894), 1873

In an interview five years after he created this painting, George Inness said, "A work of art does not appeal to the intellect . . . Its aim is not to instruct, not to edify, but to awaken an emotion." Inness developed his lyrical style after trips to Europe, including France's Barbizon art colony. His atmospheric landscapes reflect a belief in the divinity of nature, espoused by Swedish mystic Emanuel Swedenborg. This picture is possibly set in the gardens at Villa Barberini, a papal summer residence south of Rome. Against a glowing yellow sky, a grove of Italian pines take on a mysterious abstract quality. Into this other-worldly landscape, Inness adds a solitary monk dwarfed by the garden.

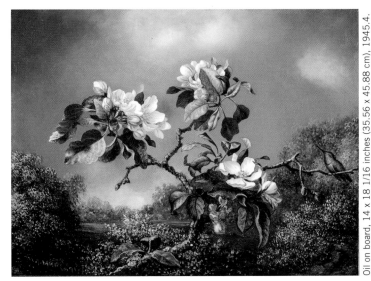

Oil on board, 14 x 18 1/16 inches (35.56 x 45.88 cm), 1945.4. Museum purchase; Addison Gallery of American Art, Phillips Academy, Andover, Massachusetts

Apple Blossoms and Hummingbird, Martin Johnson Heade (1819–1904), 1871

In 1871 the *New York Evening Post* reported that "M.J. Heade is painting . . . a study of apple blossoms, with hummingbirds perched upon the branches among them . . . devoting the most careful attention to its elaboration and finish." In this exquisite painting, a tiny green hummingbird rests on a twig, camouflaged by the blossom's matching leaves and petals. Heade's lifelong obsession with hummingbirds led him to travel several times to South America. The outspoken artist eventually settled in St. Augustine, Florida, where he continued to paint the gemlike hummers into his early eighties.

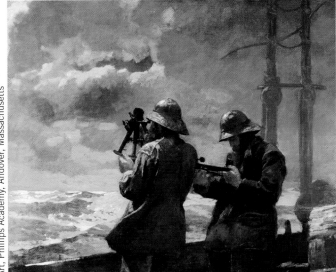

Oil on canvas, 25 3/16 x 30 3/16 inches (63.94 x 76.68 cm), 1930.379. Gift of anonymous donor; Addison Gallery of American Art, Phillips Academy, Andover, Massachusetts

Eight Bells, Winslow Homer (1836–1910), 1886

This classic men against the sea canvas is the last in a marine series executed by Winslow Homer in the 1880s. The close-cropped composition puts us on deck alongside two bearded sailors charting a course after a violent storm. Largely self-taught, Boston-born Homer began his career as a magazine illustrator before shifting to painting the outdoors. In 1883, Homer settled in Maine's Prout's Neck, where he painted in his studio home on the cliffs overlooking the Atlantic. Homer also created marine scenes in watercolor, many during his winters in the Bahamas, Florida, and the West Indies. In the century since his death at Prout's Neck, Homer has come to embody the quintessential American painter.

COLBY COLLEGE MUSEUM OF ART
Waterville, Maine

"This collection could have gone to the Met, the Smithsonian. Anyone would have leapt at it. It's an amazing gift for a liberal arts college."

—Mark Bessire, Director
Portland Museum of Art

In 2007, Colby College launched into the upper strata of college art museums when alumnus Peter Lunder and his wife, Paula, promised five hundred paintings, sculptures, and prints. With an estimated value of one hundred million dollars, the couple's trove of nineteenth- and twentieth-century works is considered one of the most valuable private American art collections.

The Lunder collection will enjoy a sparkling new home, scheduled to open in 2013 for the bicentennial

Photo by Peter Siegel

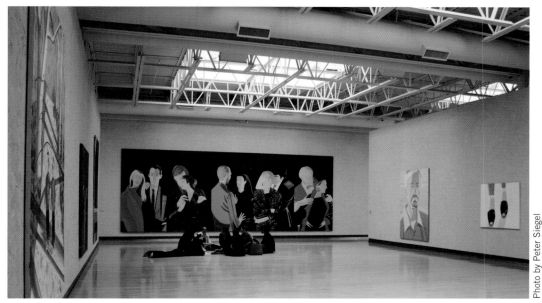

Students in the Schupf Wing with art by Alex Katz

Photo by Peter Siegel

of the liberal arts college. The airy glass pavilion promises to be a dramatic addition to the museum's existing cluster of red brick buildings. Paintings by American masters like John Singer Sargent, Georgia O'Keeffe, and Edward Hopper will be showcased in ten thousand square feet of new gallery space, along with rotating exhibits of prints by James McNeill Whistler.

Colby is also poised to become an exciting venue for American sculpture. Joining Richard Serra's massive *4-5-6* and Sol LeWitt's monumental *Seven Walls* are works in a new sculpture terrace adjacent to the pavilion. In addition the museum plans to present sculpture from its permanent collection inside its expanded lobby. Among the artists represented in the sculpture collection are Augustus Saint Gaudens, Alexander Calder, Louise Nevelson, Elie Nadelman, and Maya Lin.

Although Colby's holdings include European works on paper and Asian art, the focus has been American art since it first opened in a small campus gallery in 1959. One of the museum's cornerstone

paintings is Winslow Homer's *The Trapper*, painted during the first of many trips the artist made to the Adirondacks. With paddle in hand, a man stands on a fallen tree trunk beside his canoe. Another beloved early painting is George Caleb Bingham's serene *Landscape with Fisherman*, in which the trees seem to protect the lone fisherman sitting by the riverbank.

Colby's collection has reached some six thousand works, the result of a number of key patrons. In the early 1950s, Bangor sisters and lumber heirs Adeline and Caroline Wing began anonymously donating works by Homer as well as William Merritt Chase, Childe Hassam, and Andrew Wyeth. Two decades later the family of John Marin strengthened Colby's collection of Maine-connected artists with their gift of some two dozen paintings, watercolors, and works on paper. Highlights are pictures of coastal Maine and New York City that reveal Marin's experimentation with abstraction.

Marsden Hartley returned to his native state in the late 1930s, where he painted the expressionistic

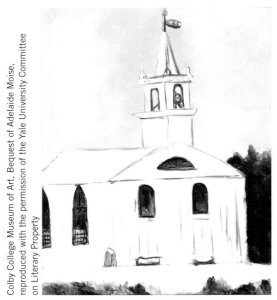

Church at Head Tide, Maine, Marsden Hartley, 1938, oil on panel

Church at Head Tide, Maine. Like much of the ship-building village of Head Tide, the church was already abandoned when Hartley arrived. Dark windows and a scattering of tombstone-like stones and benches give the white impastoed church an eerie quality. Hartley's charcoal sketch of another church he used as a studio is also in the collection.

Maine's Monhegan Island is represented by Rockwell Kent and his former classmate, George Bellows. Invited to Monhegan by Robert Henri, Bellows painted over one hundred paintings during one productive season. Among these is Colby's *Hill and Valley,* in which Bellows captures the island's dramatic rocks and dense forests in sumptuous blues and greens. Maurice Prendergast spent a summer at Penobscot Bay after exhibiting at the Armory Show. The stay inspired his impressionistic *Barn, Brooksville, Maine.*

In 1995 Alex Katz donated over four hundred of his works to Colby, a collection that's now approaching seven hundred. Maine became the New York artist's annual summer retreat after he'd studied at the Skowhegan School of Painting and Sculpture and had his work exhibited in Colby's library. Today his art—from cut-paper collages to monumental oils—hangs in its own loft-style wing named for Colby patron and art collector Paul Schupf.

Colby has also received gifts from the Alex Katz Foundation, including works by Hartley, Jane Freilicher, Chuck Close, and Jennifer Bartlett. Colby's photography collection got a boost in 2011 when John Marin's daughter-in-law, Norma Marin, pledged her collection with images by Berenice Abbott, Alfred Stieglitz, Charles Sheeler, and Harry Callahan.

But it's Peter and Paula Lunder's prized possessions that's put Waterville on the map. The unassuming philanthropists live near Colby in a modest ranch-style home. Until his uncle Harold Alfond sold Dexter Shoe Company to Warren Buffett's Berkshire Hathaway in 1993, Peter Lunder worked in the family business. Longtime Colby College supporters, the Lunders began collecting art in the 1980s, seeking advice from experts and other collectors.

The couple's trove of two hundred Whistler prints represents one of the largest collections of the artist's work. Although best known for his oils, watercolors, and pastels (including the famous portrait of his mother at the Musee d'Orsay, Paris), Whistler executed some 450 etchings and dry points and 180 lithographs.

The Lunders' print collection, along with rich archival material, has turned Colby into a study center for the influential American expatriate. Along with the Hunterian at the University of Glasgow and Freer and Sackler Galleries at the Smithsonian, Colby plans to host Whistler symposia and other scholarly projects. The new role fits neatly with Colby's primary mission as a teaching museum.

GETTING THERE Address: 5600 Mayflower Hill, Waterville, ME Phone: (207) 859-5600 Website: colby.edu/museum Hours: Tuesday to Saturday, 10:00 a.m. to 5:00 p.m.; Sunday noon to 5:00 p.m. Admission: Free

Not to Miss

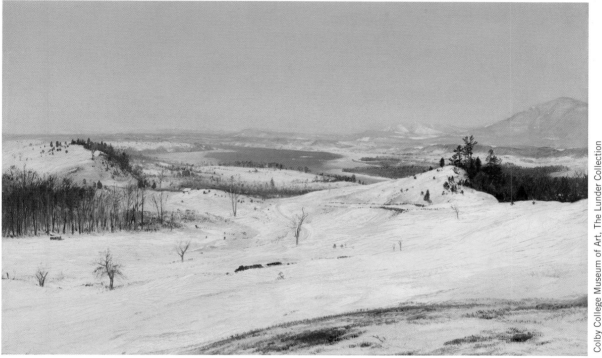

Colby College Museum of Art, The Lunder Collection

View from Olana in the Snow, Frederic Edwin Church, circa 1871

Landscape painter Thomas Cole, founder of the Hudson River School, inspired a number of followers. One of his star pupils was Hartford native Frederic Church, who achieved early fame depicting natural wonders like Niagara Falls, the South American Andes, and Arctic icebergs. The avid traveler settled in New York's Hudson River Valley, where he built his hilltop masterpiece, Olana, an exotic Persian-style villa he called the "Center of the World" (today a state historic site). Church transformed his farm into a giant canvas—turning a bog into a lake, creating winding paths and pastures, and planting trees to frame views of the river and Catskill Mountains. These became favorite subjects for Church's landscapes, like this winter scene.

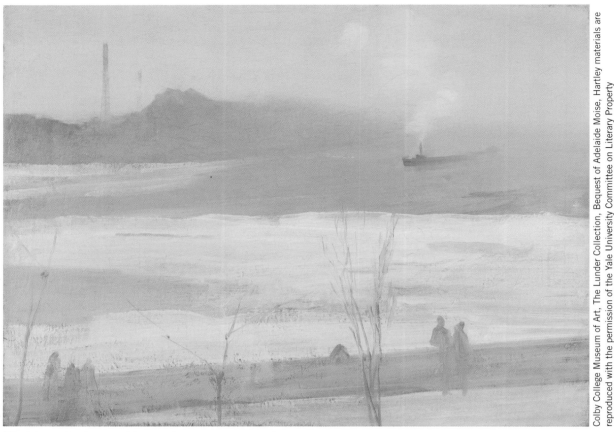

Harmony in Grey—Chelsea in Ice, James McNeill Whistler, 1864

"As music is the poetry of sound, so is painting the poetry of sight . . .," said James McNeill Whistler, who gave his canvases musical titles like harmony, nocturne, and arrangement. After growing up in St. Petersburg, Russia, and being discharged from the US Military Academy at West Point, Whistler left for Europe in 1855 and never returned. Whistler painted this work soon after moving to Chelsea on the Thames River, a view he painted often. With broad sweeping brushstrokes and subtle changes in color and texture, Whistler transforms the industrial Thames into a poetic seascape of floating ice and fog. Whistler's lyrical canvases contrast with his combative personality that led him to file a lawsuit against John Ruskin over an attack on *Nocturne in Black and Gold: the Falling Rocket.* After a court victory that left him bankrupt, Whistler focused on works on paper in Venice before returning to London in 1888.

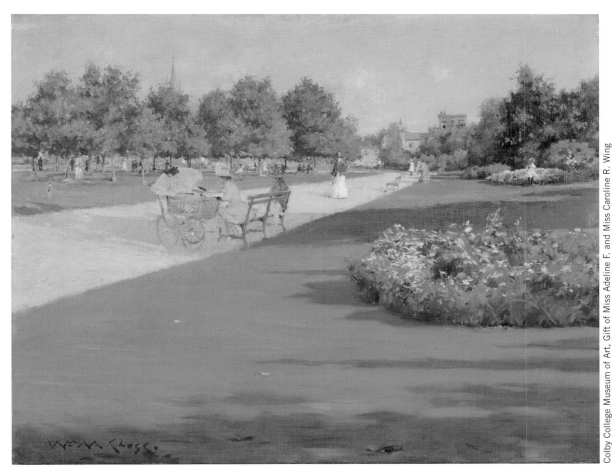

Tompkins Park, Brooklyn, William Merritt Chase, 1887

"Do not try to paint the grandiose thing," William Merritt Chase told his students. "Paint the commonplace so that it will be distinguished." From the end of the Civil War to the start of World War I, Chase painted parks and gardens as well as his summer home in Shinnecock Hills, designed by Stanford White. In 1886, the same year Paul Durand-Rùel introduced French impressionism to New York, Chase's parents and sister moved from the Midwest to Brooklyn. With a brightened impressionist palette, the newly married Chase painted his wife in a rowboat, *Mrs. Chase in Prospect Park* (Metropolitan Museum of Art). The following year Chase, a new father, dotted his angled scene of Tompkins Park with people, including a young woman sitting on a bench with a baby carriage.

THE FLORENCE GRISWOLD MUSEUM
Old Lyme, Connecticut

"No lover of American art can afford to miss a visit to Old Lyme."
—William H. Gerdts, art historian, Professor Emeritus CUNY Graduate Center

At the turn of the nineteenth century, the graceful New England town of Old Lyme became one of the nation's largest, longest-running art colonies. Its heart and soul was a stately yellow boarding house, where for seven dollars a week artists from cities like Boston and New York received room, board, and camaraderie. Today Florence Griswold's house and eleven-acre property is an unforgettable art museum starring American impressionist paintings in the charmed setting that inspired them.

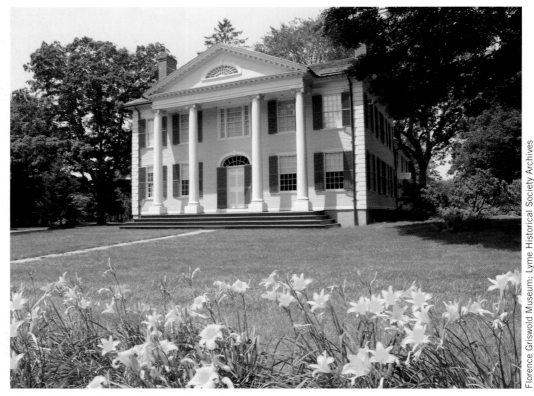

Florence Griswold Museum; Lyme Historical Society Archives

Florence Griswold House, Old Lyme, Connecticut

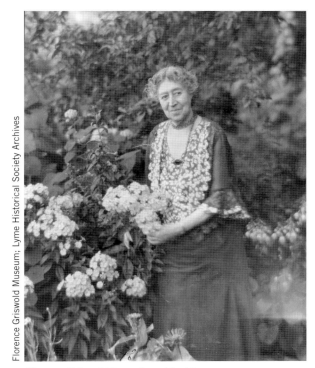

Florence Griswold in garden with phlox

Old Lyme started as an art colony for the Tonalists, known for their harmonious colors and soft light. In 1899 the gregarious, cigar-smoking leader of the group, Henry Ward Ranger, discovered Old Lyme. For a few years Miss Florence's became the center for Ranger and his peers, many fresh from painting in France. "It looks like Barbizon, the land of Millet," Ranger wrote. "See the knarled [sic] oaks, the low rolling country. . . It is only waiting to be painted."

But Old Lyme quickly went from America's Barbizon to America's Giverny with the arrival of impressionists like Hassam, Metcalf, and William Chadwick. For the next three decades, the artists painted the town's laurel groves, wooded uplands and estuaries, and river, as well as its weathered houses,

In 2002 the Florence Griswold Museum opened an airy white riverfront annex with an unexpected treasure. The Hartford Steam Boiler Company gave the museum its landmark art collection: 188 paintings and 2 sculptures by artists who worked in Connecticut between the late eighteenth and early twentieth centuries. The strength of the collection is works by these artists, including Frederick Childe Hassam, Willard Metcalf, Theodore Robinson, and J. Alden Weir.

With this distinguished gift, the Florence Griswold Museum became the largest public repository for Metcalf's work. The holdings include nearly two dozen Metcalf paintings, along with pastels, silverpoints, sketchbooks, and a diary. The artist's wooden cabinet of "curiosities" filled with butterflies and birds' eggs attests to his lifelong interest in the natural world.

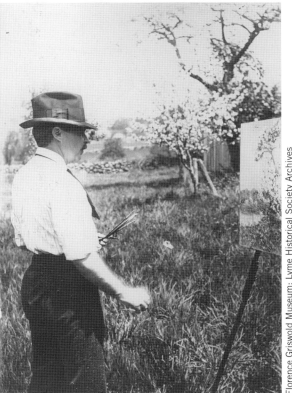

Childe Hassam painting en plein air

gristmills, and white spired church. At its heyday some two hundred artists passed through the rural coastal town each summer.

The Old Lyme artists were as colorful as their palettes—dressing up in sun bonnets and Miss Florence's mother's old clothes and taking out leaky rowboats they dubbed *Prickly Heat, Scarlet Fever,* and *Small Pox.* Hassam called Miss Florence's just the place for "high thinking and low living." The artists nicknamed themselves the "Hot Air Club," after the weather and their spirited conversations on the outside porch. An exception to the artists-only rule was made for Woodrow Wilson, who accompanied his artist wife, Ellen Axson Wilson, to Miss Florence's.

Florence Griswold turned her family's late-Georgian–style home into a boardinghouse by necessity. The youngest child of a sea captain, Griswold was famous for her generosity, taking in stray cats and starving artists who couldn't pay their rent. She subdivided rooms and converted barns into art studios, including one for Hassam. To help sell her boarders' works, she turned her central hall into an art gallery.

Today visitors enter Miss Florence's stately house through the same side-porch door artists used when they arrived by carriage with their trunks and painting supplies. Period rooms include Henry Ward Ranger's bedroom, with his easel and old phonograph and records, and the parlor where artists listened to Miss Florence play the harp (still standing by the window). The orientation gallery plays a home movie with artist Edward Volkert trying to line up a group of uncooperative cows for his painting. Volkert throws down his hat in frustration when the cows decide to chew cud rather than pose.

As a token of affection for Miss Florence, boarders decorated her walls and doors with colorful scenes. In 1905 Matilda Browne, the only female artist invited to contribute, painted a landscape on the hall door near Miss Florence's bedroom. The dining room is magical, with thirty-eight painted seascapes, landscapes, and still lifes. In his mantelpiece frieze, Henry Rankin Poore caricatures two dozen Old Lyme artists abandoning their easels to chase a fox.

Upstairs, former guest rooms have been converted into intimate galleries with paintings by tonalists and impressionists. There are also works by earlier artists such as Ralph Earl, who helped found the "Connecticut school" of portrait painters and Hudson River School painters Frederic Church and John Frederick Kensett.

Outside, the meadowlike lawn sweeps down to the river, dotted by willows and apple and pear trees. Miss Florence's original gardens have been replanted with delphinium, hollyhocks, and irises using historic photographs, paintings, and her seed catalogs. Daffodils and scilla blanket the north side of the house, along with native mountain laurel, Connecticut's state flower.

From the museum a path leads over a wooden footbridge to the nearby Lyme Art Association, built on land bought from Miss Florence in 1917. Charles Platt, architect of the Addison Gallery of American Art, designed the gallery that still sells and exhibits art. Between 1902 and the gallery's 1921 opening, the impressionists' summer exhibition took place in the town library.

Just as movements like Fauvism and Cubism eventually replaced French impressionism, American impressionism faded by the mid-1920s, eclipsed by the realism of the Ashcan painters and early modernism. But one thing didn't change: Connecticut continued to inspire artists, from abstract art pioneer Arthur Dove and regionalist John Steuart Curry to photographer Walker Evans. Today, artists still set up their easels in the meadows and marshy riverbank by Miss Florence's.

GETTING THERE Address: 96 Lyme Street, Old Lyme, CT Phone: (860) 434-5542 Website: FlorenceGriswoldMuseum.org Hours: Tuesday to Saturday 10:00 a.m. to 5:00 p.m., Sunday 1:00 to 5:00 p.m. Admission: adults $9, seniors $8, students $7, children 12 and under free

Not to Miss

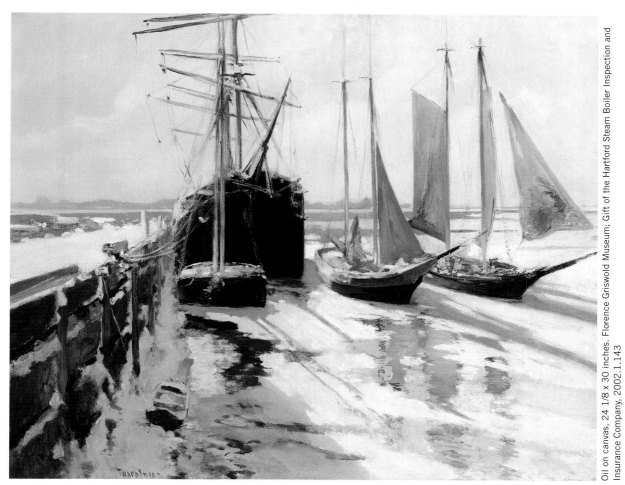

Oil on canvas, 24 1/8 x 30 inches. Florence Griswold Museum; Gift of the Hartford Steam Boiler Inspection and Insurance Company, 2002.1.143

Connecticut Shore—Winter, John Henry Twachtman (1853–1902), circa 1893

Of the seasons, John Henry Twachtman found the deepest emotional power in winter, as in this early painting of an icy New England harbor. "Never is nature more lovely than when it is snowing. Everything is so quiet and the whole earth seems wrapped in a mantle," he wrote his friend J. Alden Weir. Twachtman's poetic style was influenced by French impressionism, Japanese woodblock prints, and James McNeill Whistler. The Greenwich farm Twachtman shared with his artist wife, Martha Scudder, inspired many landscapes. For a decade before his premature death from a brain aneurysm, Twachtman taught and summered at the Cos Cob art colony near his farm.

Oil on canvas, 18 x 18 inches, Florence Griswold Museum; Gift of the Hartford Steam Boiler Inspection and Insurance Company, 2002.1.66

The Ledges, October in Old Lyme, Connecticut, Frederick Childe Hassam (1859–1935), 1907

A reviewer who saw this painting of young trees growing out of granite boulders thought there might be "no contemporary artist who can render with greater distinction the sharp joyousness of the Autumn color and the Autumn air." Like his friends J. Alden Weir and John Henry Twachtman, Childe Hassam discovered a wealth of subjects in rural settings. The prolific artist also famously painted a patriotic series of Allied flags flying over New York's Fifth Avenue. In 1897 Hassam and nine colleagues formed an exhibiting society called the "The Ten." He didn't miss a single one of the group's twenty annual shows.

Oil on canvas, 29 x 26 inches. Florence Griswold Museum; Gift of the Hartford Steam Boiler Inspection and Insurance Company, 2002.1.92

Dogwood Blossoms, Willard L. Metcalf (1858–1925), 1906

Willard Metcalf probably painted this backlit dogwood grove with two female figures in Old Lyme. Though he spent just three summers at the art colony, it's here he produced the first works to receive critical acclaim. Smitten by his surroundings, Metcalf spent his days at Miss Florence's painting outdoors. He'd arrived here after studying in Paris and working at French painters' colonies like Grez-sur-Loing and Giverny, where he helped set up an American colony. The same year Metcalf painted *Dogwood Blossoms,* he immortalized the Griswold House in his moonlit *May Night* (Corcoran Gallery of Art, Washington, DC) gracing this book's cover.

THE PORTRAIT GALLERY OF THE SECOND BANK OF THE UNITED STATES

Philadelphia, Pennsylvania

"The portico of this glorious edifice, the sight of which always repays me for coming to Philadelphia, appeared more beautiful to me this evening than usual . . . Each of the fluted columns had a jet of light from the inner side . . . casting a strong light upon the front of the building, the softness of which, with its flickering from the wind, produced an effect strikingly beautiful."

—Philip Hone, Mayor of New York, 1838

On Philadelphia's tree-lined Chestnut Street, a block from the crowds at Independence Hall, stands an imposing marble building commonly mistaken for a private building or passport office. Curious passersby who climb the stairs and step through monumental doors into the Greek Revival–style building are richly rewarded with a splendid collection of portraits, a who's who of eighteenth- and early nineteenth–century America.

A museum devoted to the young nation's early leaders, war heroes, explorers, and scientists may seem like an anachronism. That's until one considers the reemergence of portraiture by contemporary artists like Andy Warhol, Lucien Freud, Chuck Close, and Shepard Fairey.

It's this tradition that's in glorious display at the Portrait Gallery in Independence National Historical Park. What makes this Gallery unique is its historic setting—the Second Bank of the United States, created by President James Madison after the War of 1812 left the country reeling with inflation.

To symbolize the integrity of the US economy, twenty-eight-year-old architect William Strickland created a Greek Revival mini-Parthenon, complete with Pennsylvania blue marble columns inside and out. After opening in 1824, the Second Bank became a popular tourist attraction, wowing visitors with its dramatic banking room painted salmon pink after the ancient city of Pompeii, barrel vaulted ceiling, and Palladian windows. Soon, however, the Second Bank became embroiled in a bitter battle over US monetary policy.

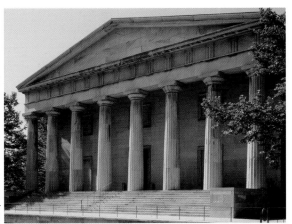

Independence National Historical Park

34

Incumbent President Andrew Jackson, an ardent foe of central banking, handily defeated Henry Clay on an anti-Bank platform. In 1836, twenty years after its creation, Jackson vetoed the bill to renew the Bank's charter, calling it "the death blow to our liberty." The Civil War would eventually lead to a central banking system and creation of the Federal Reserve in 1913. Fortunately the Second Bank found new life as Philadelphia's Customs House for nearly a century.

Since the opening of Independence National Historic Park in 1974, the Second Bank's restored interiors have housed two thirds of the museum's 320-work permanent collection. Viewing portraits of a young nation within a historic architectural gem is powerful and affecting. The galleries transport us back two centuries, when Philadelphia was the country's political and financial center.

Visitors enter the elegantly proportioned banking room, where tall transparent scrims printed with street scenes of eighteenth-century Philadelphia are an evocative backdrop for the portraits. In addition to the familiar faces of William Penn, John Paul Jones, and Thomas Jefferson, there are portraits of lesser-known scientists, merchants, and bankers.

The heart of the collection is a re-creation of Charles Willson Peale's gallery of "noted worthies." The son of a convicted felon, Peale founded the first US museum. His portraits of the country's "worthies" shared space with natural history specimens—including a mastodon skeleton he excavated in upstate New York and Benjamin Franklin's badly preserved pet angora cat. Peale proposed to an unenthusiastic group of founding fathers that their own remains be preserved in his museum for posterity.

With ninety-four Peale paintings, there is no comparable collection in existence. The Portrait Gallery's collection spans Peale's forty-year career, including a late self-portrait from 1795 with balding head and rumpled clothes. At eighty-one, Peale

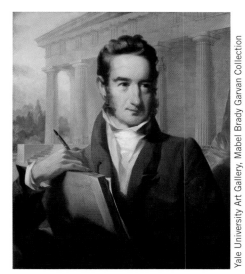

Portrait of William Strickland (1787–1854), John Neagle, 1829

Yale University Art Gallery, Mabel Brady Garvan Collection

painted his iconic self-portrait *The Artist in His Museum*, where he lifts a crimson curtain to reveal his gallery (Pennsylvania Academy of the Fine Arts).

Peale, a three-time widower, named the majority of his sixteen children after favorite artists and scientists. Recognizing the demand for images of the nation's leaders, his son Rembrandt Peale started a cottage industry of everything George Washington—not unlike Shepard Fairey's Obama bumper stickers, T-shirts, and mugs.

Incredibly, Peale's staggering output of one thousand paintings was doubled by Thomas Sully, who averaged thirty-five to forty portraits a year, and whose work is on display here. Dubbed the "Sir Thomas Lawrence of America" for his idealized, romantic style, the British-born artist studied with Gilbert Stuart and expatriate Benjamin West in London. After the deaths of Peale and Stuart, Sully became Philadelphia's most popular portraitist. His coronation portrait of Queen Victoria created the vogue for full-length portraiture in America. In a gesture of thanks, the eighteen-year-old queen gave the

artist a 61¼-inch pink ribbon, a precise record of her height.

Another notable artist in the collection is Ralph Earl, whose short but vivid life included treason, two overlapping marriages, and debtors prison. Before being expelled in 1776 for spying for the British, Earl painted hundreds of portraits of Connecticut's aristocracy. A decade in England under the influence of Benjamin West and George Romney lightened Earl's palette and softened his brushwork. After the Revolutionary War, Earl returned to America, where he worked until his early death at age fifty. He's best remembered for individualizing his portraits with landscapes and interior settings.

There's a separate gallery devoted to pastel portraits by British artist James Sharples Sr., his wife, Ellen, and their two sons. With forty-two works, it's the largest single collection of Sharples's portraits outside of England. Although pastel portraiture was an affordable alternative to oils, the technique took a deft hand. Colors could not be mixed and required finely nuanced application. Sharples's depictions of James and Dolley Madison are highlights, expertly executed and in superb condition.

For a museum devoted to early American portraiture, Dolley Madison is a fitting finale. We know her best as a fashionable hostess who established the public role of the First Lady. But in August 1814, in the hours before the burning of Washington by the British, she refused to leave the White House until Gilbert Stuart's full-length portrait of George Washington had been safely removed. James Madison helped rebuild the capital. Dolley Madison saved its cherished symbol.

GETTING THERE Address: 420 Chestnut St., Philadelphia, PA (near Independence Hall) Phone: (800) 537-7676 Website: nps.gov/inde/second-bank.htm Hours: Wednesday to Sunday, 11:00 a.m. to 5:00 p.m. Admission: Free

Not to Miss

Timothy Matlack, Charles Willson Peale, from life, 1826

This tour de force in character study is outstanding in its immediacy and details of the elderly sitter's vital appearance, including a bushy beard and Indian-print handkerchief. As secretary of the Continental Congress, Timothy Matlack wrote out the Declaration of Independence so it could be signed. What makes this painting even more impressive is that it's one of Peale's last, painted at age eighty-six, a year before his death. Peale and Matlack were friends for over fifty years, a fact that comes across in the warmth of the portrait.

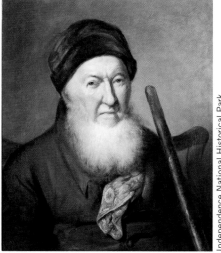

Independence National Historical Park

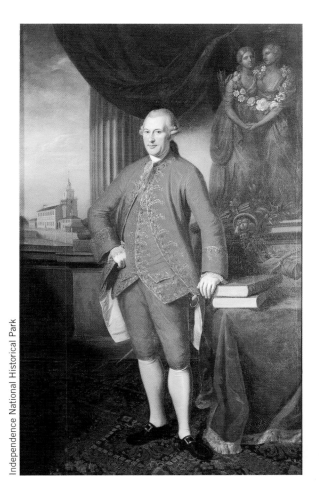

Independence National Historical Park

Conrad Alexandre Gerard, Charles Willson Peale, from life, 1779

Congress commissioned this opulent full-length portrait of the first French ambassador to America to mark the nation's gratitude to France. The ambassador stands in a luxuriously detailed room with his right hand on his hip and his left on a table with books. The background includes the earliest painted portrait of Philadelphia's Independence Hall. Two allegorical figures are joined by a garland of flowers—shy young America with a quiver of arrows at her shoulder, protected by a taller, older France.

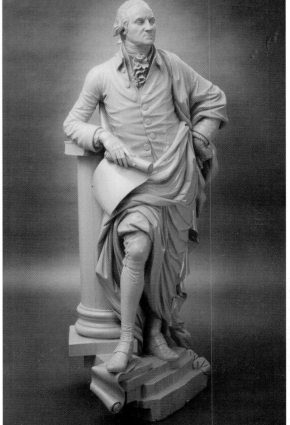

Independence National Historical Park

George Washington, William Rush, 1815

During the mid-nineteenth century, this heroic full-length sculpture carved from eastern white pine was displayed with the Liberty Bell. William Rush poses George Washington in eighteenth-century attire with a toga cascading over his shoulder, a reference to the political ideals of classical Rome. He also adds symbolic attributes—a book signifying wisdom and a Doric column representing fortitude. Although Rush never studied abroad like most of his colleagues, the self-taught artist made a career of carving wood busts of statesmen. By painting his sculptures white, Rush achieved a faux marble look, popular with Neoclassicists.

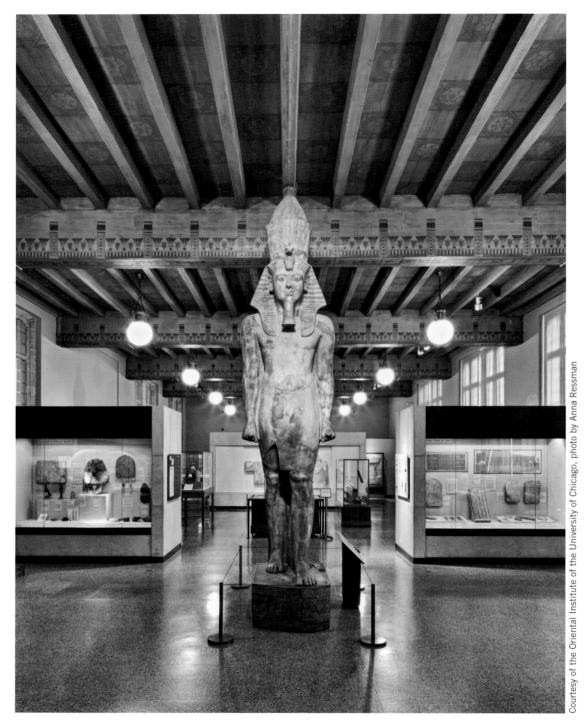

Statue of Tutankhamun, *Oriental Institute Museum*

ANCIENT ART

THE MICHAEL C. CARLOS MUSEUM
Atlanta, Georgia

"As we walked over the sands of this ancient place, we were conscious of a feeling of awe in the presence of a civilization so much older than recorded history."
—William A. Shelton, Emory professor, on visiting Abydos in Egypt

With its distinguished collection of ancient art and compelling galleries, the Michael C. Carlos Museum offers a captivating journey back to the long-vanished worlds of ancient Egypt, the Near East, Greece, and Rome. The marble and brick museum is located in Atlanta, Georgia, in the heart of Emory University's leafy campus quadrangle.

Emory's antiquities collection got its start in 1920 when theology professor William Arthur Shelton traveled to Egypt with his former teacher, Oriental Institute founder James Henry Breasted. After searching for artifacts, Shelton returned to Atlanta with 250 Egyptian, Babylonian, and other Near Eastern antiquities. In the following decades the collection continued to grow through Emory's involvement in excavations at Jericho, Jerusalem, and the Levant, bordering the eastern Mediterranean. The museum was first located in the basement of the theology school, followed by the old Law School building.

In 1983 Emory hired Michael Graves to remodel the interior of architect Henry Hornbostel's 1916 law school. Two decades later Graves returned for an extensive expansion of the gallery, renamed for Atlanta businessman and philanthropist Michael C. Carlos. A first generation American, Carlos's father immigrated to Atlanta in 1900 where he founded a liquor wholesale company. As a tribute to his Greek heritage, Carlos donated twenty million dollars over two decades for the acquisition of Greek and Roman works and construction of the new galleries.

To harmonize with the Beaux-Arts architecture of Emory's quadrangle, Graves chose a symmetrical

Courtesy of the Michael C. Carlos Museum, Emory University

Michael C. Carlos Museum

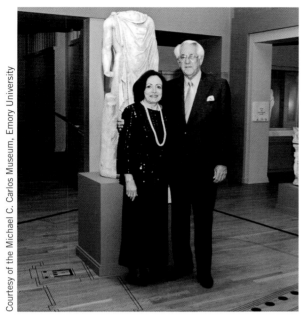

Thalia and Michael Carlos

design with a red tile roof and marble walls. Columns over the new marble façade were cut from the same Georgia quarries that supplied the original material. The spacious new wing provides space for 75 percent of the permanent collection. To add context, ancient sites like the Acropolis are stenciled on the wood floors of the galleries. An upstairs gallery is used for special exhibits, which often tie in to fieldwork by Emory archeologists. A ramp connects the new wing to the historic building with the museum's Ancient Americas collection.

The odyssey begins in the cream-colored rotunda, where key objects from the collection are displayed in niches. A loop of galleries forms an ancient timeline, starting with the Egyptian galleries and many of the museum's oldest objects. In the funerary court, mummies lie in glass cases by their ornately decorated coffins. Egyptian beliefs about the afterlife are illustrated through small animal mummies, canopic chests, and amulets wrapped within mummies. Other objects

buried with the dead include a palette for grinding pigment into eye makeup and an elegant calcite headrest.

The most poignant of the mummies is an extremely rare fellow from the Old Kingdom, wrapped in layers of linen and lying on his right side with his head cradled by a modern wood headrest. The mummy was acquired by Shelton from excavations at the sacred site of Abydos, a cult center of the Egyptian god Osiris. A year-long conservation project re-created missing bones and repaired the decomposed and torn linens. Conservators also discovered a fragment of a fringed sleeve that may have been part of his childhood garment. Only the bottom of his rectangular wooden coffin remains.

The next stop is the ancient Near East gallery, where most of the objects come from Shelton's visits to the Mesopotamian sites of Ur, Lagash, and Babylon. Another notable holding is a group of some two hundred clay tablets with cuneiforms, one of the earliest-known written language. There are several hundred objects from Jericho as well as objects from an underwater archeological expedition at Caesarea, an ancient seaport north of Tel Aviv, Israel.

The Greek Gallery holds other riches, often with imagery borrowed from Egypt and the Near East. From the early Geometric period, a small, beautifully patinated bronze horse appears modern in its simplicity. A century later a Minoan artist decorated a bathtub with whimsical painted fish. The graceful marble statue of the muse of dance, Terpsichore, stands near a carved garnet head of Berenike II, the Ptolemaic queen and art patron. She dedicated a lock of hair in a temple to ensure her husband's safe return from war. It worked, but her lock was missing, taken to the heavens and turned into the Coma Berenikes, a group of stars that still bears her name. Garnet came to Greece from India thanks to Alexander the Great.

With its conquests Rome assimilated Greek arts into its own aesthetic tradition. Alexander remained a popular subject for centuries after his death, and visitors can see him in the Roman Gallery, depicted in bronze with his trademark twisting neck, silver inlaid eyes, copper inlaid mouth, and lionlike mane of hair. Another idealized marble bust portrays Tiberius, Rome's second emperor and son of the ruthless Livia. The historian Suetonius gives us the following description of the ruler: "He had a handsome, fresh complexioned face, though subject to occasional rashes of pimples."

In 1999 the Carlos Museum bought a cache of Egyptian mummies and coffins in a liquidation sale by a defunct Niagara Falls Museum. One of the mummies had been given the royal treatment—arms crossed, skull and chest cavity filled with tree resin, organs removed, and linen placed under his ribs. Consensus among Egyptologists was that the mummy was likely that of Ramses I, the short lived ruler and grandfather of Ramses the Great. The celebrated grandson built more temples (and sired more children) than any other Egyptian king. In 2003 Emory University returned the mummy to Egypt.

GETTING THERE Address: 571 S. Kilgo St., Atlanta, GA Phone: (404) 727-4282 Website: carlos.emory.edu Hours: Tuesday to Friday 10:00 a.m. to 4:00 p.m., Saturday 10:00 a.m. to 5:00 p.m., Sunday noon to 5:00 p.m. Admission: $7 Tours: Sundays at 2:30 p.m., September through June

Not to Miss

Calyx-Krater Depicting the Death of Aktaion,
Greek, Attic, attributed to the Dinos Painter, circa 430 BCE, ceramic. 2000.6.1

This stunning krater used to mix wine and water is attributed to the Dinos Painter, named for a famous dinos or round mixing bowl he also decorated. Just over a foot and a half tall, the krater's red clay–colored figures pop against the dramatic black background. The decorations tell the story of Artemis, goddess of the hunt, and her great nephew Aktaion. Angry at Aktaion for boasting about his superior hunting prowess, Artemis turns him into a stag to be eaten by his own hounds. Young Aktaion is shown with antlers sprouting from his forehead, his dogs sniffing menacingly, and Artemis looking on with bow and quiver. On the reverse, an older bearded man with a scepter is possibly Aktaion's father, Aristaios. One of the women may be Aktaion's mother, Autonoe, daughter of the king of Thebes, the city where the story takes place.

Carlos Collection of Ancient Art. Michael C. Carlos Museum, Emory University. Photo by Bruce M. White, 2009

Statue of Aphrodite (Venus), Roman, first century AD, after a Greek original of the 4th century BC, marble. 2006.41.1

The Greek writer Pliny describes how Kos commissioned a marble statue of Aphrodite, goddess of love, from Praxiteles of Athens during the fourth century BCE. The islanders opted for the famous sculptor's draped version of the goddess, while his nude version became a sensation on mainland Greece. During the Roman period the goddess continued to symbolize female physical beauty, grace, and charm. Copies of Praxiteles's original sculpture adorned Roman villas and bath complexes. In the Carlos's version Aphrodite covers herself demurely, originally concealing her right breast with a missing arm. At Aphrodite's side, Eros (Cupid), in the form of an infant boy, rides a dolphin, an allusion to her birth from the sea. In 2006 the museum reunited the separated head and body.

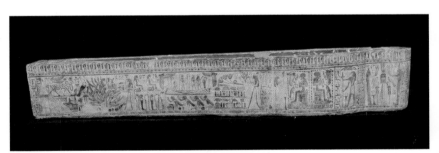

Coffin and Coffin Board of Tanakhtnettahat/Ta-Aset, Egypt, Dynasty 21, 1075–945 BCE, wood, pigment. 1999.1.17

This brightly painted wood coffin belongs to Lady Tahat, a musician in the temple of the god Amun at Karnak. Women served as singers, playing instruments and reciting hymns to the gods. Tahat is depicted wearing a full wig and jewels and is surrounded by protective gods and symbols. Elaborate imagery from the *Book of the Dead* depicts Tahat's judgment in the underworld and mythological scenes. Below the lid her coffin board features amuletic symbols for further protection. Both would have been placed inside an outer coffin. Nearby is a well-preserved funerary papyrus belonging to one of Tahat's fellow singers, inscribed with sections of the Litany of Re and the Amudat. Funerary books like this helped the deceased navigate the perilous journey through the underworld, with the demons and divine beings they'd likely run into.

THE ORIENTAL INSTITUTE MUSEUM
Chicago, Illinois

"Whole periods of man's activity can be so presented through original objects . . . as to make them much more vivid, real and understandable . . . To see them . . . arranged is like looking down a visa of milestones marking the long road over which we have passed . . ."

—James Henry Breasted, 1933

On the leafy campus of the University of Chicago is a gem that's part think tank, part museum. The Oriental Institute is dedicated to the art, languages, and history of the ancient Near East, antiquity's earliest civilizations. The Institute's name goes back to its founding nearly a century ago, when ancient Egypt, Nubia, Persia, Mesopotamia, Syria, and Anatolia were collectively known as the Orient.

Unlike most US museum collections built through donations and acquisitions, the majority of the Institute's holdings have come from its own archeological expeditions. Back in the old days, archeologists split their finds with their host countries. In today's politically charged environment concerning

museum antiquities, additions to the Institute's collection are generally restricted to gifts.

In relief carvings and monumental sculptures, we meet the peoples of these states and empires, along with their rulers and gods. Clay tablets, papyrus scrolls, and stone inscriptions reveal secrets of humankind's earliest writing systems, and decorated objects attest to the talents of ancient artisans and sculptors working in mediums like ivory, gold, limestone, and clay.

In addition to its eight permanent collection galleries, the Institute organizes special exhibits around its rich holdings. Recent shows explored subjects like the role of birds in ancient Egypt and little-known

Human Headed Winged Bull, *Khorsabad courtyard*

predynastic Egyptian art one thousand years before the pyramids. Another groundbreaking show traced the independent invention of writing by the Sumerians, Egyptians, Chinese, and Mayans.

The Oriental Institute was founded in 1919 by James Henry Breasted, whose ultimate goal was "recovering the lost chapters in the career of man." In 1894 the charismatic, Indiana Jones–like scholar spent his Egyptian honeymoon copying hieroglyphic inscriptions and acquiring antiquities for the university's fledgling collection. After camels carted four mummies to the couple's Nile houseboat, they were loaded "right into our bedrooms and [we] did not lose any sleep," wrote the newlywed.

In 1906 Breasted and a crew spent forty days photographing and copying inscriptions at Abu Simbel, often working by candlelight in sweltering, bat-infested tombs. As a preeminent Egyptologist, Breasted was invited to examine Tutankhamun's tomb shortly after its discovery. Breasted found a key supporter in philanthropist John D. Rockefeller Jr., who traveled with him to the Near East in 1929. The only child of Standard Oil's cofounder, Rockefeller financed the Oriental Institute as well as its campus headquarters with galleries, libraries, and offices. Rockefeller's wife, Abby, who helped found the Museum of Modern Art in New York, used to read Breasted's best-selling *Ancient Times* to her children, including the future vice president, Nelson Rockefeller.

In the large Egyptian Gallery, barely clearing the stenciled ceiling, is a colossal seventeen-foot quartzite statue of King Tut, excavated by the Institute at Luxor in 1930. Hieroglyphics on the back of the rose-colored pillar read: "Beloved of him—possessor of diadems— ruler of happiness . . ." Another favorite is the mummy and painted coffin of Meresamun, a singer at the Temple of Amun. A collection of relief sculptures, portrait statues, and *ushebti* servant figures further illustrates the ancient Egyptians' belief in the afterlife.

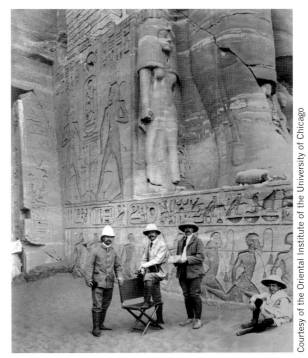

James Henry Breasted, middle, Abu Simbel, February 1906 (his son Charles Breasted at far right)

Courtesy of the Oriental Institute of the University of Chicago

The ancient world of the Canaanites and Israelites is revealed with objects from the Institute's excavations at Megiddo, biblical Armageddon, in today's Israel. Among the highlights from this ancient cultural crossroads are ivories carved from elephant tusks discovered in a subterranean palace treasury. Other beautiful pieces are a Canaanite bronze statuette and a four-horned limestone incense altar used for offerings. The stratum in which this altar was found is thought to have been built by King Solomon.

The Syro-Anatolian Gallery features pottery, clay tablets, and the world's earliest cast bronze figurines that record the Hittites and their neighbors in ancient Anatolia, the Asiatic part of modern Turkey. On display is a tall, graceful, red lustrous ware bottle found beside a skeleton at an ancient Anatolian burial site. Widely used throughout the ancient Middle East to

store perfume and honey, this type of pottery was part of trade routes that included Syria, Israel, and Anatolia.

From 1928 to 1935 the Institute excavated at Khorsabad, an ancient capital city in northern Iraq. Curators have re-created a courtyard from the palace of Assyrian King Sargon II starring one of the museum's prized possessions—a forty-ton, sixteen-foot-long sculptural relief of a human-headed winged bull, one of a pair that guarded Sargon's throne room. The sculptor's addition of a fifth leg gives the illusion that the creature is walking when seen from the side and standing when viewed from the front. In another massive gypsum relief found outside the throne room, two court officials sport ankle-length fringed robes.

Nearby are more remarkable objects from the Sumerian, Babylonian, and Assyrian cultures, known collectively as Mesopotamia. A colorful roaring lion in molded brick and polychrome glaze was one of an estimated 120 felines lining the "Processional Way" leading out of Babylon through the massive Ishtar Gate. Ishtar, whose symbol was the lion, was the Mesopotamian goddess of love and war. Another treasure is a horde of Sumerian statues, circa 2700 BCE, depicting men and women praying.

Breasted called the recording of inscriptions of ancient monuments "one of the great and sacred obligations." Today the Institute continues that work at the Epigraphic Survey in Luxor, Egypt, founded in 1924. Breasted would be pleased by a recent milestone. After ninety years deciphering clay and stone tablets in Iraq, Iran, Syria, and Turkey, the Institute published his pet project—a twenty-one-volume dictionary dedicated to Akkadian, a language out of use for two millennia.

GETTING THERE Address: 1155 East 58th St., Chicago, IL (on the campus of the University of Chicago) Phone: (773) 702-9514 Website: oi.chicago.edu/museum Hours: Tuesday, Thursday to Saturday 10:00 a.m. to 6:00 p.m., Wednesday 10:00 a.m. to 8:30 p.m., Sunday noon to 6:00 p.m. Admission: Free

Not to Miss

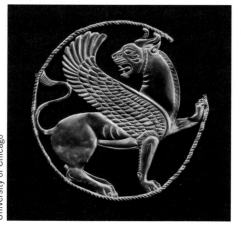

Persian Roundel, Achaemenid period, circa 404–359 BCE

This snarling winged lion within a twisted circular gold cord is the work of an exceptionally skilled goldsmith. One of the largest known examples of a gold roundel from the Archaemenid period, the roundel is part of a collection of ornaments acquired by the Oriental Institute to mark its thirtieth birthday. The owner would have attached the piece to his garment using sixteen tiny loops on the back. Greek writers often described the tremendous wealth of the Persians. According to Herodotus, troops "were adorned with the greatest magnificence . . . they glittered all over with gold, vast quantities of which they wore about their persons."

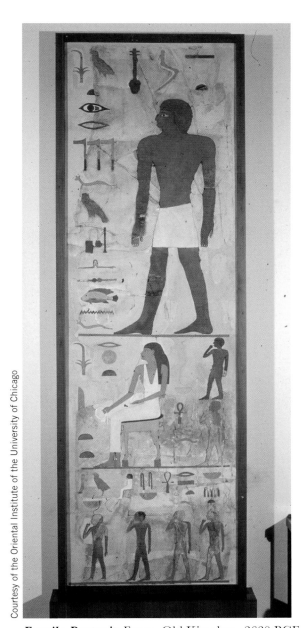

Family Portrait, Egypt, Old Kingdom, 2630 BCE

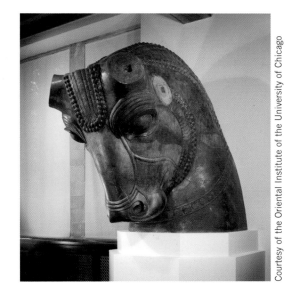

Colossal Bull Head, Achaemenid period, circa 465 BCE

Among the Institute's early excavations was the palace complex of Persepolis, founded by Persian King Darius the Great, father of Xerxes. Persepolis thrived for nearly two centuries until Alexander the Great's troops destroyed it. This magnificent, highly polished bull head carved from dark-gray limestone was part of a pair of stone bulls that guarded the northern portico of the Hundred-Columns Palace, also known as Throne Hall. The Hall was initially used for military and diplomatic receptions and later for displaying riches from the royal treasury. The bull's ears and horns were made separately; the horns were likely overlaid with gold. Also on view is a marble slab, a cornerstone of the palace, with a forty-eight-line inscription in old Persian left by Xerxes over twenty-four hundred years ago.

This large family portrait comes from a tomb near Cairo. Egyptian artists carved the limestone in sunk relief and filled the recesses with bright-colored paste. Hieroglyphs identify the family as that of Nefermaat, probably the brother of Khufu, the pharaoh who built the Great Pyramid at Giza. Below Nefermaat is his wife, Itet, who sits in profile on a decorated chair with their two sons. The lower panel depicts four more children, possibly grandchildren. The youths hold their fingers to their mouths, a frequent way of depicting children in Egyptian art.

AN EPIC COLLECTION

THE WALTERS ART MUSEUM
Baltimore, Maryland

"In my opinion, piece for piece, the Walters is the best museum in the United States."
—Thomas Hovering, former director, Metropolitan Museum of Art

From exquisite Thai Buddhas and Ethiopian icons to medieval ivories and illuminated manuscripts, the Walters Art Museum in Baltimore offers a comprehensive tour of art history. Among the museum's vast eclectic holdings is a collection of antiquities ranked among the finest in the country. The remarkable objects offer a rare look at the civilizations of the ancient Near East and Mediterranean as well as their connections to one another.

The ancient treasures are the result of a lifetime of collecting by museum founder Henry Walters. He inherited the collecting gene from his father, railroad magnate William Thompson Walters, who began acquiring European art when the family lived in Paris during the Civil War. Henry Walters enlarged both his father's railroad interests and the scope of his art collection. Because of the early provenance of Walters's antiquities, his eponymous gallery is unique in avoiding repatriation claims by Greece, Italy, and Egypt.

In 1902 Henry Walters made his grandest acquisition, paying one million dollars for the collection of Don Marcello Massarenti, a ninety-year-old Vatican official. Walters had to charter a steamship to bring the seventeen-hundred-piece collection to New York. Although many of the paintings' attributions turned out to be overstated, including self-portraits by Michelangelo and Raphael, the antiquities shined. They include exquisite Roman sarcophagi and Greek black and red figure vases.

With a museum in mind for his growing collection, Walters bought several properties near his Charles Street home. At its 1909 opening the gallery was hailed as America's "Great Temple of Art," with a lofty columned court modeled after a Genoese

The Walters Art Museum, Baltimore

Portrait of Henry Walters, Frank O. Salisbury, 1947

48

Baroque palazzo. When Walters died in 1931, he left the museum, a multimillion-dollar endowment, and twenty-two thousand objects to his native Baltimore. It would take decades for the museum's staff to sort through over 240 crates and 700 paintings stashed in the basement.

Today, the Walters's evocative ancient art galleries are organized into three main areas: Greece and Rome, Egypt, and the Near East. At every turn visitors see how empire building and trade routes connected these cultures—from early monumental Greek kouros sculpture introduced after contact with Egypt and Greek-influenced Etruscan objects, to Roman copies of prized Hellenistic sculptures.

The colorful Egyptian gallery reflects Henry Walters's taste for bronze statuary and the small precious objects he began collecting on a Mediterranean cruise in 1889. Other key acquisitions are statues from the Temple of Amun at Karnak bought from the Egyptian Museum and a life-size limestone statue of the elegantly coiffed chantress, Nehy. In a 1941 object exchange with the Metropolitan Museum of Art, the Walters acquired its petite female mummy and her decorated cartonnage.

The Near East Gallery is populated with wonders large and small. A monumental alabaster relief, *Assyrian Winged Genius,* once decorated the palace at Nimrud (today's Iraq) with a cuneiform inscription describing the king's triumphs. Wearing the horned crown of a divinity and fringed cloak of a courtier, the winged spirit sprinkles a magic potion from a cone-shaped object. Nearby is an adorable, palm-size rock-crystal figurine of a young Hittite boy. Also on view is the Walters's version of the Rosetta Stone—a small silver seal with a bilingual inscription that helped linguists decipher Hittite hieroglyphs.

The ancient Greek galleries introduce visitors to the art of the early Minoan, Mycenaean, and Cycladic cultures—including a pottery cup with a

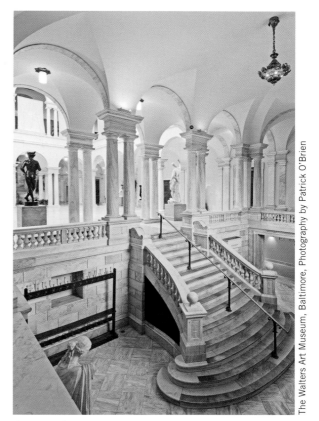

Sculpture Court

The Walters Art Museum, Baltimore, Photography by Patrick O'Brien

painted octopus on each side and a strikingly modern female idol believed to be from Naxos in the Cyclades. In the sixth century BCE, the enormous wealth of the Greek empire fostered a golden age for potters and painters. This artistic flowering is evident in a dramatic group of Attic black and red figure vases.

Rome's conquest of Greece in the first century BCE had a strong impact on its art. Roman sculptors copied famous Greek works like the Walters's *Aphrodite Torso* and *Pouring Satyr* by Praxiteles and Polykleitos's *Ephebe Westmacott.* Also on view are artworks from the provinces of the Roman Empire—like floor mosaics from Syria and wall paintings from southern Italy. Portrait sculpture, one of the great legacies of Roman art, is represented by marble busts of Rome's first

emperor Augustus and the bearded Marcus Aurelius. Another gallery evokes a dining room from a Roman villa, complete with a banqueting couch, pitchers, and figures of household gods.

Before being subsumed into Roman culture, the Etruscans flourished in central Italy for half a millennium. Much of what we know about this ancient people comes from their art, including sarcophagi and paintings of life, death, and myth. Among the Walters's Etruscan objects is a tiny, gold heart-shaped protective pendant depicting Dedalus and his winged son, Icarus. More ancient bling from Henry Walters's seven-hundred-piece jewelry collection is found in the alcove-like Ancient Treasury.

In 2011 the Walters announced a partnership with Roemer and Pelizaeus, a museum in Hildesheim, Germany, dedicated to ancient Egyptian art. The two museums are planning loans and shared exhibitions starting with *The Book of the Faiyum*, a Ptolemaic papyrus manuscript describing the mythical center of creation. In addition to the Walters's fragment, two other sections of the ancient manuscript are owned by the Morgan Library in New York and the Egyptian Museum in Cairo.

Research by the Walters's conservators continues to shed new light on antiquity. In 1998 an anonymous private collector deposited a Byzantine prayer book at the museum. The parchment turned out to hold erased text by Archimedes of Syracuse, one of the greatest minds of the ancient world. New imaging techniques helped resurrect these treatises, known as the *Archimedes Palimpsest*. Recently, thermoluminescence testing of the museum's Tanagra figurines helped confirm the authenticity of the charming ancient Greek terra cottas, popular with collectors and forgers since the nineteenth century.

GETTING THERE Address: 600 N. Charles St., Baltimore, MD Phone: (410) 547-900 Website: thewalters.org Hours: Wednesday to Sunday 10:00 a.m. to 5:00 p.m. Admission: Free, except for special ticketed exhibitions

Not to Miss

Olbia Bracelet, Hellenistic, Greek, late second century BCE

In 1891, peasants discovered a female burial tomb with lavish jewelry and silver objects near Olbia, a Crimean town on the Black Sea in today's Ukraine. Between 1921 and 1931, jewelry aficionado Henry Walters purchased spectacular pieces from what's believed to be the Olbia Treasure, including a stunning pair of bracelets. Alexander the Great's conquests brought opulent Persian-style gold and precious stones to Greece. Each three-piece hinged bracelet is encrusted with garnet, amethyst, emerald, and pearl. The lavish embellishment features intricate gold work with filigree, cloisonné, and multicolored enamel.

The Walters Art Museum, Baltimore, Photography by Lindsay Hite

Head of King Amasis, Egypt, Twenty-sixth dynasty, circa 560 BCE

Under the Saite kings, named for the capital city of Sais in the Nile Delta, Egypt enjoyed a long period of political stability and economic prosperity. King Amasis ruled during the height of this period, which saw a flourishing of the arts. Measuring twelve inches in height, this subtly modeled royal sculpture is thought to have come from a temple statue in Memphis. Amasis's small almond-shaped eyes are set high on his face, close to his thin brows and the lower rim of his traditional royal head cloth. The brown red quartzite stone speckled with sparkling crystals is a rare material for royal portraits.

The Walters Art Museum, Baltimore, Photography by Lindsay Hite

The Walters Art Museum, Baltimore, Photography by Lindsay Hite

Sarcophagus with the Triumph of Dionysus, Roman, circa 130–220 CE

Among the museum's most treasured antiquities are seven marble sarcophagi discovered together in 1885 in a triple burial chamber under the Via Salaria in Rome. They are thought to belong to multiple generations of the Calpurnii Pisones, one of Rome's most illustrious families. Displayed in an atmospheric darkened gallery, the intricate marble carvings depict mythological scenes centered around Dionysus, god of wine. The most magnificent and largest of these, ninety-one inches in length, features multiple planes of figures, many worked almost in the round. The subject is the triumphant procession of Dionysus and his retinue through India, which the Romans equated to their triumph over death.

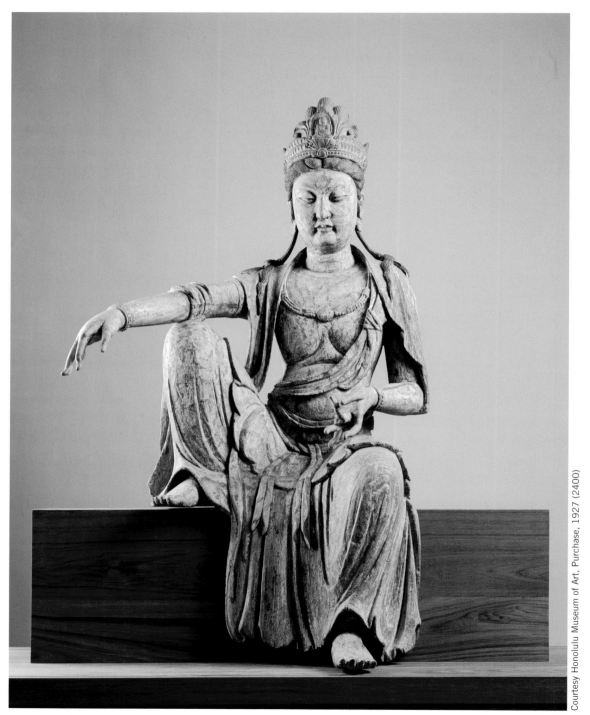

Guanyin (Bodhisattva), China, eleventh century, Honolulu Museum of Art

CHAPTER 4

ASIAN ART

THE HONOLULU MUSEUM OF ART
Honolulu, Hawaii

". . . the finest small museum in America."

—J. Carter Brown, former director, National Gallery of Art

At the dedication of the Honolulu Academy of Arts in 1927, missionary-turned-art-patron Anne Rice Cooke expressed her hope that art would help bring Hawaii's diverse cultures together. That remains the goal at the newly renamed Honolulu Museum of Art, with a collection numbering over fifty-three thousand Asian and Western artworks. Among the museum's many fine holdings are world-class Japanese prints and Chinese paintings.

In 2011 the museum merged with the Contemporary Museum, strengthening its modern and contemporary collection and adding a stunning ocean-view venue in residential Makiki Heights. A former Cooke residence built around the same time as the Honolulu Academy, the traditional Japanese-style home known as Spalding House has been transformed into fifty-five hundred square feet of contemporary gallery space.

The newly combined collection offers viewers a chance to look at the art in fresh, innovative ways. At both venues visitors can experience traditional Asian art alongside dynamic contemporary works. A recent collaborative exhibition featured rare thirteenth- and fourteenth- century landscape paintings from the Palace Museum in Beijing. At the same time, curators prepared a show on tattoo art and a biennial exhibition for Hawaiian artists.

Cooke, who traveled widely, launched the Honolulu Academy of Arts with a core group of works representing the diverse people and cultures of Hawaii—from Buddhist art and paintings from China to Japanese wood-block prints, ceramics, and lacquers. When the collection outgrew Cooke's home, she tore it down and hired architect Bertram Goodhue to design the gracious red tile roof building in its place.

Today Goodhue's outdoor hallways open onto tranquil courtyards, visual respites from the art galleries. Later additions house traveling exhibitions and Hawaiian painting, sculpture, and decorative arts.

One of the museum's treasures is a world-class collection of ten thousand–plus wood-block prints. Known as *ukiyo-e*, "images of the floating world," these Edo period prints reflect the tastes of Japan's

Chinese Courtyard

Courtesy Honolulu Museum of Art

new class of urban merchants. *Ukiyo-e* masters such as Kitagawa Utamaro, Katsushika Hokusai, and Utagawa Hiroshige developed contemporary styles using bold clear color, novel vantage points, and dramatic cropping. Because of the light sensitivity of the works, the museum frequently draws from its print vault, presenting changing thematic exhibitions.

About half of the *ukiyo-e* prints were a gift to the museum from Mari and James Michener. The award-winning novelist and avid collector wrote several books on the subject, including *The Floating World*, one of the first studies of Japanese prints in English. Michener's fascination with *ukiyo-e* prints grew after a friend left her small collection to him. Among the stars are more than five hundred Hokusai prints, including a complete set of his masterpiece, *Thirty-six Views of Mount Fuji*. To mark the 250th anniversary of the artist's birth, 170 of the museum's Hokusai works toured Japan in 2011 and 2012.

The daring perspectives and flat, decorative patterns of Japanese wood-block prints were popular in France and inspired painters like Claude Monet, Vincent van Gogh, and Paul Gauguin, represented at the museum by *Water Lilies*, *Wheat Field*, and *Two Nudes on a Tahitian Beach*. The year before he produced *Wheat Field*, van Gogh created paintings based directly on Hiroshige's wood-block prints.

Through the museum's modern art collection, visitors can also make connections between Eastern and American art. Abstract expressionist Robert Motherwell was inspired by Asian ink painting and calligraphy when he painted the museum's *Untitled* in 1963, as was Robert Rauschenberg in his part sculpture, part painting *Trophy V (for Jasper Johns)* from 1962. Japanese-American sculptor Isamu Noguchi, whose abstract work is represented in the collection by the red Persian travertine *Red Untitled*, was strongly influenced by traditional Japanese aesthetics and returned to Japan throughout his life.

Courtesy Honolulu Museum of Art

Japan Gallery

The second Japan gallery is devoted to paintings, ceramics, and decorative arts. The Kano School is especially strong—including Kano Motohide whose signature fan paintings depict scenes of Kyoto. Kano Eitoku, grandson of the founder of the Kano School, produced the museum's beautiful pine and cherry tree screen. A favorite of the nobility, Eitoku became famous for his sliding panels and folding-screen paintings.

In the China gallery curators rotate fragile works from a collection rich in Ming and Qing dynasty paintings. Shen Zhou's *Boating on an Autumn River* is an example of the early Ming painter's compositional innovations. In *The Seven Junipers,* a nine-inch-tall hand scroll, Zhou's student, Wen Zhenming, masterfully renders the twisted upper branches of an ancient stand of trees from Suzhou. Zhenming established a family dynasty of scholar-painters. Among the other artists represented are leading figure painter Chen Hongshou and Zhu Da, an Individualist painter of the Qing period.

Separate galleries explore the artistic traditions of other regions, including India, Southeast Asia, the Philippines, Indonesia, and Korea. The Buddhist gallery traces the wide variety of artistic expression that developed as the religion spread from India throughout

Asia. The stars here come from sixth- and eleventh-century China—a serene limestone Buddha from an imperial cave site and the riveting *Guanyin*, a larger-than-life wood Bodhisattva of Compassion. Japanese Buddhist art is represented with rare early Shinto sculpture, Japan's indigenous religion. Among the paintings are a beautiful gilded thirteenth-century Taima Mandala depicting the paradise of Amida Buddha.

The museum organizes popular tours of Shangri La, Doris Duke's nearby estate. Inspired by her honeymoon in 1935, the tobacco heiress filled her fourteen-thousand-square-foot home with several thousand objects of Islamic art, including commissions like her elegant Mughal bedroom and bathroom suite. The landscaped five-acre property offers sweeping views of the Pacific and Diamond Head.

GETTING THERE Address: 900 South Beretania St., and 2411 Makiki Heights Dr., Honolulu, HI Phone: (808) 532-8700 Website: honolulumuseum.org Hours: Tuesday to Saturday 10:00 a.m. to 4:30 p.m., Sunday 1:00 to 5:00 p.m. Admission: $10 adults, $5 children age 4 to17, free for children 3 and under Tours: Tuesday to Saturday 10:15 a.m., 11:30 a.m., and 1:30 p.m.; Sunday 1:15 p.m. To reserve and buy tickets for Shangri La, call (866) 385-3849.

Not to Miss

Gift of Mrs. Charles M. Cooke, 1927 (2121), Courtesy Honolulu Museum of Art

The Hundred Geese, China, traditionally attributed to Ma Fen, twelfth century

During the Song and Yuan Dynasties, wild geese took on many meanings—from autumn and reclusion to the four correct demeanors of Zen Buddhism. This lyrical hand scroll, over fifteen feet long, was kept rolled up in a box and enjoyed on special occasions. In a free-flowing calligraphic style in black to pale gray ink, the artist depicts one hundred geese against a soft misty landscape of reeds and marshes. The birds move through the landscape, resting, flying, diving, swimming, and preening. In one remarkable passage reminiscent of stop-motion photography, a single goose is shown in ten stages of flight. The signature of artist Ma Fen may have been added by one of the scroll's owners.

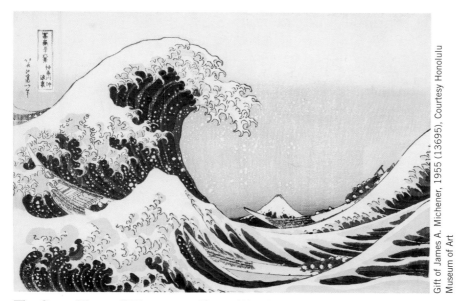

The Great Wave off Kanagawa, Katsushika Hokusai, circa 1830–1834

This famous image was one of the first in Hokusai's series *Thirty-Six Views of Mount Fuji.* Mainly in blue ink with touches of gray and yellow, the print depicts a great wave crashing in the sea with Mount Fuji in the distance, echoing the shape of the waves. It's easy to miss two boats caught in the maelstrom. The iconic print inspired many works, including French composer Debussy's *La Mer* in 1905. Around the time he finished the series, Hokusai wrote: ". . . all the works I did before my 70th birthday were insignificant. It was only when I was 73 that I understood a little of the anatomy of animals and the life of plants . . ." The artist lived to be eighty-nine. By the end of his prolific career, his signature translated to "Old Man Mad with Painting."

Dragon Jar, Korea, Joseon period, eighteenth century

This elegant blue and white porcelain jar stands just over eighteen inches and features a boldly painted dragon, a symbol of royalty and prosperity. Luxe porcelains with underglaze designs painted in cobalt blue were first made in Korea during the fifteenth century with minerals imported through China from Iran. By the eighteenth century, Korea entered an era of prosperity and blue and white ceramics like this jar became more widely available. The museum acquired the jar in honor of the 2003 centennial of Korean immigration to the United States.

THE PACIFIC ASIA MUSEUM
Pasadena, California

" . . . like a dream, and dreams are usually indescribable, but even grossly exaggerated praise would do the place scant justice."

—*House Beautiful*, 1927

Call it karma—the Pacific Asia Museum (PAM) is housed in a mini-Imperial palace with a serene Chinese garden courtyard. This little-known Pasadena, California, gem is particularly rich in Japanese paintings and drawings and Chinese ceramics and textiles. From classical to contemporary, an array of impressive exhibitions is drawn from the museum's wide-ranging holdings.

The atmospheric setting dates back to 1924, when art dealer Grace Nicholson tore down a Greene & Greene Arts and Crafts house to build a new residence and gallery modeled after architecture in the Forbidden City. From China, her architects imported green roof tiles, stone carvings, and bronze and copper work.

In her "Treasure House of Oriental and Western Art," Nicholson sold Navajo rugs and Native American baskets along with Chinese embroideries, porcelain, and jade. In 1943 Nicholson donated her treasure house to the city of Pasadena for art and cultural purposes. The Pasadena Art Museum occupied the building until 1970, when it relocated nearby and became the Norton Simon Museum.

Since moving in the following year, PAM quietly assembled an impressive collection of Asian art under the leadership of its retired director, David Kamansky. During his tenure Kamansky brought back artwork from his frequent travels. He also forged relationships

with Asian art collectors such as US Ambassador Jack Lydman, Nancy King, Hans and Margot Ries, and Robert Bentley, whose gifts help form the core of the fifteen-thousand-work collection.

An arched stone entrance leads to the museum's focal point—a tranquil courtyard inspired by the

Grace Nicholson

© Pacific Asia Museum

© Pacific Asia Museum

classic gardens of China. Dragons perch on the ends of the roof and carved lotus buds adorn the balustrades. A pair of stone lions, or "Foo Dogs," protects the premises against evil. As added insurance a zigzag bridge over the charming lotus pond throws off evil spirits that can only travel in straight lines. Although legend has it that a carp who leaps past the rapids of the Yangtze River will transform into a dragon, PAM's chubby koi won't be doing any leaping real soon.

In the orientation gallery, visitors are introduced to the region's geography as well as its artistic techniques and materials. Alongside ivory tusks, jade, and lacquer are exquisite examples from the museum

collection. Themed presentations explore topics like religion, celebrations, and the art of eating and drinking.

From ritual implements and traveling shrines to decoration for public places of worship, many of PAM's objects were created for religious expression. The small Southeast Asian gallery is populated with Buddhist and Hindu deities from Indonesia, Thailand, and Vietnam. Highly decorative Hindu wood carvings from Indonesia contrast with smooth Thai Buddhist bronzes and colorful lacquered wood Buddhist sculpture from Vietnam.

More Buddhist and Hindu works from India, China, Afghanistan, and Pakistan are found in the wood-paneled Himalayan gallery. Among the most striking objects here is a stucco head of the Buddha from Gandhara, modern Pakistan. The Buddha's hair is tied in a princely bun, possibly a forerunner of the *ushnisha*, the bump that's come to symbolize Buddha's spiritual power. *Bodhisattva in Yab-yum Embrace*, an early fifteenth-century Chinese carved wood sculpture of a male bodhisattva and his consort, represents the union between compassion and wisdom.

Topping the Japan gallery is a five-hundred-year-old ceiling salvaged from a Buddhist temple near Kyoto destroyed by fire. The gallery is used to explore various themes and traditions from Japanese art—like elaborate court culture and contemporary kimonos. The museum's Japan collection is especially rich in paintings and drawings from the Edo period, including works by master artists Utagawa Hiroshige, Katsushika Hokusai, and Kitagawa Utamaro. It also boasts an important collection of Japanese folk paintings, called *Otsu-e*.

A small grouping of celadon ceramics ranging from ethereal bluish green to soft dove gray is found in the new Korean gallery. Other Korean artworks include folk paintings from the golden age of the long-ruling Joseon dynasty, featuring subjects like birds, flowers, and mythical animals. Among PAM's recent acquisitions is a colorful eight-panel silk *Screen of Flowers and Rocks* that may have been part of a wedding dowry.

Highlights of the museum's rich porcelain collection are on view in the nearby Chinese ceramics gallery. The installation features vases, incense burners, chargers, and bowls from the Ming and Qing dynasties, when virtuoso craftspeople used the highest-quality porcelain and pigments. Jade is also on display, including an exquisite Qing dynasty marriage bowl and jaw-dropping apple green earrings thought to have belonged to Ci Xi, China's last Dowager Empress. Harder than all other minerals except diamond and quartz, jade was traditionally "carved" by highly trained artisans.

The museum's rich costume and textile collection ranges from Tibetan rugs and tapa bark cloth from the Pacific Islands to embroidered Chinese robes and Japanese kimonos. Among the most prized possessions are fifty Imperial Chinese silk robes and an embroidered hand scroll signed and dated 1627. Strict dress codes distinguished the Imperial family, royal court, and civic officials from the rest of society. Royals wore dragons and phoenixes; civil officials and military officers donned bird and animal motifs. Until 1868 most well-heeled Japanese men and women wore kimonos. Layering, length, textile design, and the obi sash conveyed specific occasions, seasons, formality, and personal style.

Another strength of the collection is the graphic work of Western artists inspired by Asian traditions—like Marilyn Korn, Paul Jacoulet, and Lilian Miller, known for her lyrical ink paintings of Japan and Korea. "Sometimes it is difficult to be a messenger between east and west," wrote Miller. ". . . If in my own work I may . . . help to widen and enrich our American outlook on the whole world of art, the bridge will have been built, however humbly."

Not to Miss

Gift of Robert Bentley, 1990.52.3

Guru Puja Mandala Tray, China, Ming dynasty, Wanli period, 1572–1620

Cloisonné enameling originated in western Asia and was introduced to China during the fourteenth century. Artisans achieved brilliant designs by filling copper or bronze strips known as cloisons with colored glass pastes, fixed to the metal by firing. Over the centuries this richly decorated copper Mandala tray has lost its original glossy surface, developing a beautiful patina. Around a central lotus are the Eight Auspicious Symbols of the Faith—fish, canopy, mystical knot, wheel, conch shell, umbrella, jar, and lotus. The rest of the tray is decorated with scrolling floral and vegetal patterns. Like many Buddhist cloisonné enamels, this Mandala tray once held religious offerings.

Monkey Performing the Sanbaso Dance, Mori Sosen, 1800

Macaques, or snow monkeys, that live in Japan's mountainous countryside are considered messengers of the Shinto gods. Their similarities to humans have made macaques a favorite subject of artists, especially Mori Sosen, who changed the first character of his name to one meaning "monkey." In this delightful work on paper, made for the Year of the Monkey in 1800, a dancing monkey in kimono and black cap holds a fan and bells. Sosen achieves the soft ruffled texture of fur using a dry brush and captures the fixed stare and the tightly pursed mouth with fine lines of dark ink. People born in the Year of the Monkey are believed to be clever, vain, and high-spirited.

Sake Bottle, Otagaki Rengetsu, Japan, nineteenth century

After her children died, Otagaki Rengetsu became a Buddhist nun in Kyoto's Chion'in Temple. In her late forties, Rengetsu started inscribing her poetry on her imperfect clay tea and sake wares using an elegant, rounded calligraphy. These intimate works became enormously popular in her lifetime. On this stoneware bottle with white slip and cobalt blue underglaze, Rengetsu inscribed her poem about a badger dressed as a Buddhist priest knocking on doors looking for a drink of sake. In addition to this poetry-inscribed bottle, PAM owns a hanging scroll by Rengetsu, along with her poetry cards and tea ceremony utensils.

Good Karma

THE RUBIN MUSEUM OF ART
New York, New York

The "art awakens in the mind a direct experience deeper than our ordinary selves and the material world."

—Matthieu Ricard, Buddhist monk

Collectors Donald and Shelley Rubin turned a Barney's department store in New York City into a serene gallery for Himalayan art. Since 2004 their eponymous museum has been showcasing the region's art and culture from a collection of over two thousand paintings, sculpture, textiles, and works on paper.

Most of the art here was created for religious use, both Buddhist and Hindu. Although the imagery is unfamiliar to most Westerners, the works delve into universal themes like devotion and life after death. To cast light on this complex iconography, the Rubin organizes thematic exhibitions drawn from its permanent collection along with traveling shows.

The museum got its start in 1979 when the Rubins bought their first scroll painting, an image of White Tara, from a Madison Avenue art gallery. From that initial purchase, the couple became hooked on the powerful imagery of Tibetan art, filling the large New York City office of their health care company with paintings. Over the next twenty years, they became avid collectors, broadening the scope of their holdings to include paintings and sculpture from neighboring countries.

The strength of the collection is the Tibetan *thangka*, literally meaning "something that unrolls." Created in India, this highly portable art form came to Tibet with monks who traveled and spread the teachings of Buddha. A variety of styles and techniques evolved, but most traditional *thangkas* are made from opaque, water-based pigments applied to primed cotton. Artists depicted iconic images of deities, narratives of the lives of religious figures, and portraits of teachers, or lamas.

The museum's six floors wrap around French designer Andrée Putnam's stunning elliptical staircase, a holdover from the building's retail days. On the second floor a digital map helps anchor visitors in the vast mountainous Himalayan region—some eighteen hundred miles that encompass western China, Tibet, northern India, Nepal, Bhutan, Pakistan, and Afghanistan. Photographs familiarize visitors with sacred Buddhist and Hindu sites.

The region's rich artistic traditions are introduced in the nearby Gateway to Himalayan Art. From colorful Tibetan Buddhist textiles and rich red and blue *thangka* paintings to Hindu sculptural deities from India and Nepal, visitors meet the pantheon of heavenly deities and bodhisattvas.

Like the Buddha, bodhisattvas are capable of achieving nirvana—eternal bliss—but choose to stay in this world to serve as examples for others. In addition there are humans with supporting roles like Arhats (legendary disciples of the Buddha), Mahasiddhas (great adepts of Tantric practices), and

teachers. Varied artistic materials and techniques are also described—from the labor-intensive Nepalese lost wax technique to the ground mineral pigments and iconometry (guidelines for proportions) used by *thangka* painters.

With this background visitors can enjoy Masterworks: Jewels of the Collection on the third level. Sculptural and painted treasures from the permanent collection are arranged geographically throughout the galleries, including the museum's newest acquisitions. Helping place the art in dramatic context are seven life-size photographic reproductions of murals from the Lukhang, the Dalai Lama's secret temple near the Portola Palace in Lhasa, Tibet. Set on an island in a pond, the temple was built around 1700 to appease the water spirits.

The exhibit presents a survey of Tibet's distinct aesthetic traditions as well as its relationships with neighbors in Nepal, India, China, and Mongolia. Although Tibetan art was oriented toward India, visitors learn that its culture both influenced and absorbed Chinese artistic traditions. Imperial work-shops in China adopted Tibetan Buddhist art, and Tibet became a repository of Chinese art, leading to the adoption of landscapes in painting. During their rule of China, the Mongols also became involved in Tibetan affairs. When Mongol tribes converted to Tibetan Buddhism, their art was also influenced by that of Tibet.

The Hindu trinity of male deities includes Shiva, god of destruction and transformation; Brahma, god of creation; and Vishnu, protector of the universe. Vishnu, who descended to Earth in various animal and human forms, including Rama and Krishna, is a popular subject in Nepalese art. A standout is a sculpture of the elephant-headed Ganesha, son of Shiva and Parvati, with a beautiful jade green patina. The rotund god of wealth and abundance, Ganesha holds a jewel and rides

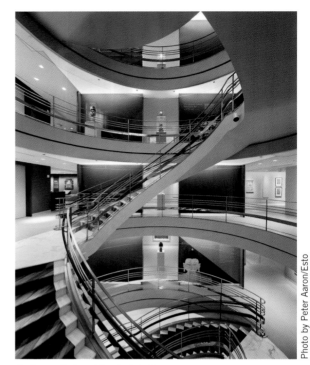

Photo by Peter Aaron/Esto

Staircase designed by Andrée Putman

on a *Mooshika*, a mouse-like creature that can gnaw through all barriers.

The museum hosts special exhibitions that delve into a variety of diverse themes. Recent shows include the sacred books of Buddhism, Hinduism, Jainism, Christianity, and Islam; the role of pilgrimage in Buddhism, Christianity, and Islam; Tibetan carpets; and the art of the Naxi, one of China's fifty-five ethnic minority nationalities. Past photography exhibitions include Thomas Kelly's striking photographs of sadhus, wandering ascetics of Hinduism who devote their lives to religious practice.

One of the museum's objects, a Tibetan bodhisattva riddled with bullet holes and missing an arm, is kept on view. Believed to have been used for target practice by the Communists, the work is a moving reminder of both the tragic history of the region and the enduring, transformative power of art.

Not to Miss

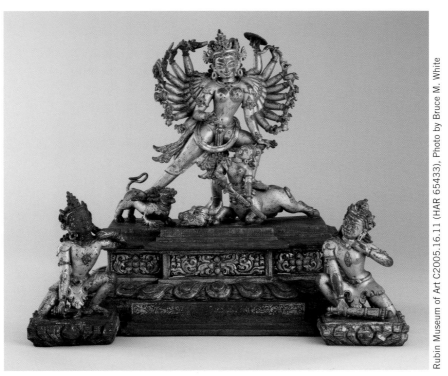

Rubin Museum of Art C2005.16.11 (HAR 65433), Photo by Bruce M. White

Goddess Durga Killing the Buffalo Demon, Nepal; thirteenth century

Virtuoso metal sculptors of the Kathmandu Valley between India and Tibet enjoyed the support of royals and wealthy Hindu and Buddhist patrons. This masterful gilt copper statue depicts the story of the Hindu goddess Durga. By assembling the weapons of all gods, Durga vanquished the demigod Mahisha, who endangered the order of the world. The sculptor captures the dramatic moment Durga takes control. Her sixteen arms fan out, revealing a serious arsenal of weapons. With her weight on the back of a beheaded buffalo, she stabs the emerging Mahisha before he can draw his sword. The demigod's two companions kneel before her. The lion under Durga's right leg is her vahana, the companion who transports her wherever she needs to go.

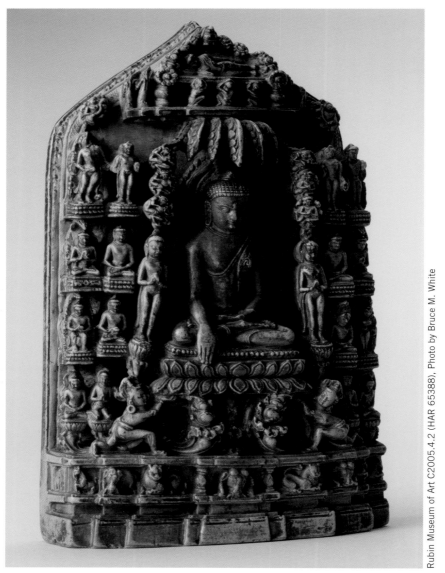

Major Events of the Buddha's Life, Northeastern India; twelfth century

For early Tibetan Buddhists, the northeastern Indian village of Bodhgaya, the place of the Buddha's enlightenment, was an important pilgrimage site. Some pilgrims returned to Tibet with small andagu stone steles dedicated to the Buddha's life—like this beautiful example. The Buddha's short, thick neck is a reference to the main image from the Bodhgaya temple from the eleventh to thirteenth centuries. At the center of the stele, the Buddha sits under a tree and touches the earth, a reference to the moment of his enlightenment. The figure, together with the six Buddhas to its sides, represents the seven weeks Buddha spent meditating in Bodhgaya. Around the figure are various scenes of the Buddha's life, culminating in his achieving nirvana at the top. Every year millions of pilgrims flock to this holy site trying to catch a falling leaf from the Bodhi tree.

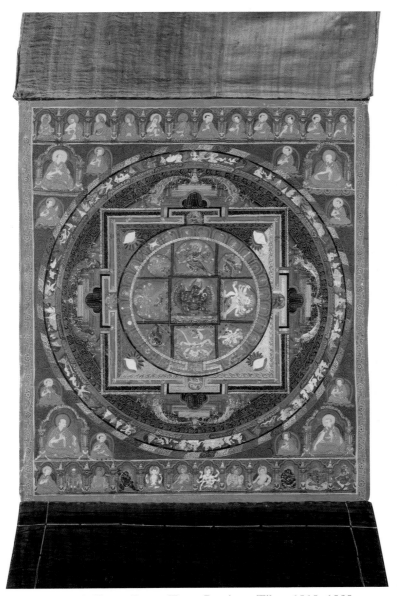

Mandala of Vajrabhairava in Solitary Form, Tsang Province, Tibet; 1515–1535

Buddhists in Tibet, Nepal, China, and Japan use mandalas as models of a perfected environment, most often symbolic depictions of the world of a particular deity. The gold inscription along the bottom red border of this intricately painted mandala indicates it was commissioned by Llachog Sengge, a distinguished abbot of Tibet's Ngor Monastery. The subject is the abode of Vajrabhairava, a wrathful manifestation of Manjushri, Bodhisattva of Wisdom. The Tantric Buddhist deity is depicted with a dark-blue buffalo face and jewelry that includes a necklace of freshly severed heads. In his first pair of hands, the deity holds a curved knife and skull cup to his heart. Other hands hold the hide of an elephant and other weapons.

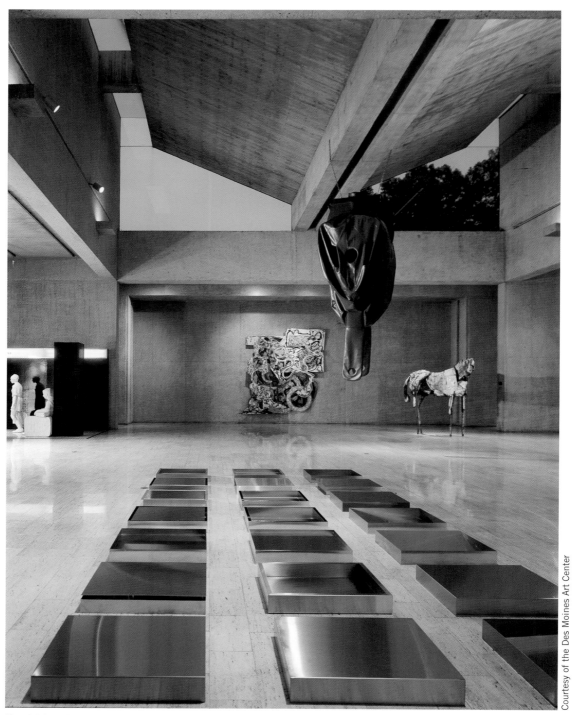

Des Moines Art Center, I.M. Pei Wing interior

CHAPTER 5

CONTEMPORARY ART

DES MOINES ART CENTER
Des Moines, Iowa

"These are big names in a small, focused collection."
—Michael Gormley, editorial director, American Artist magazine group

❦ Unlike university towns Ames and Iowa City, Des Moines is known more as a commercial center than a cultural one. So it's surprising to discover that the Des Moines Art Center is the creation of a world-renowned trio of architects—Eliel Saarinen, I.M. Pei, and Richard Meier. Just as remarkable as the architecture is the art itself. The majority of the collection is contemporary, featuring celebrated artists like Mark Rothko, Andy Warhol, and Jeff Koons.

This remarkable marriage of architecture and art is a far cry from the museum's start—a modest collection housed in a turn-of-the-twentieth-century library on the banks of the Des Moines River. In his 1933 bequest, James D. Edmundson left endowment funds of over half a million dollars. A decade later a small group of community leaders and art patrons began planning for a new museum, the first to be built in the United States after World War II. Among the early patrons was Nathan Emory Coffin, whose trust remains the Center's major source for acquisitions.

In 1948, Finnish architect Saarinen's flat-roofed stone gallery opened in wooded Greenwood Park. Light from a tall glass wall illuminates the foyer that leads to U-shaped galleries around a reflecting pool. Saarinen's warm, casual interior features rift grain oak on the walls, coved plaster ceilings, and wide-plank oak floors. Today the building is used to present works from the Center's collection of nineteenth- and early twentieth-century art. Masterworks include Edward Hopper's *Automat* (reproduced on a US postage stamp) and Iowa regionalist Grant Wood's *The Birthplace of Herbert Hoover* (co-owned with the Minneapolis Institute of Arts).

From the front of the museum, Pei's dramatic two-story wing is hardly visible. In respect for Saarinen's low-lying wing, Pei chose a site that drifts down from the south end of the original building. A large gallery on the main floor overlooks a soaring lower-level gallery. To soften the concrete slab walls, the surfaces were bush hammered to a rough finish. Pei's large spaces form a dramatic setting for mid-century minimalism and Pop Art by artists like Roy Lichtenstein, Claes Oldenburg, Richard Serra, Donald Judd, and Sol LeWitt. In 2004 the Saarinen and Pei wings were elected to the National Register of Historic Places.

A glassed-in walkway leads from the north end of the Saarinen building to Meier's pavilion for large-scale contemporary works. The highly sculptural, three-story building features the architect's trademarks—sweeping curves and white porcelain-coated metal panels with a central atrium running the height of the structure. A decade later Meier used similar ideas at the J. Paul Getty Museum in Los Angeles. The Saarinen courtyard is the only place to see all three wings at the same time.

The Center embarked on its current contemporary path in the 1970s under the leadership of director James T. Demetrion. It also decided to represent important artists through a seminal work, a philosophy that accounts for important works like Francis Bacon's *Study after Velazquez's Portrait of Pope Innocent X* and Jasper Johns's *Tennyson*, the first of the artist's paintings acquired by a museum outside New York. Other works added during Demetrion's tenure include a Dubuffet self-portrait, Lichtenstein's *The Great Pyramid*, two Frank Stellas, and Giacommeti's *Pointing Man*.

The Center continues to build its collection through gifts and purchases. Recent acquisitions include works by Felix Gonzalez-Torres, Anselm Reyle, Alison Elizabeth Taylor, and John Storrs. The Center's "greatest hits" remain on view most of the time, while other works are rotated frequently to create fresh, interesting dialogues between paintings, sculptures, and works on paper. Visitors can also

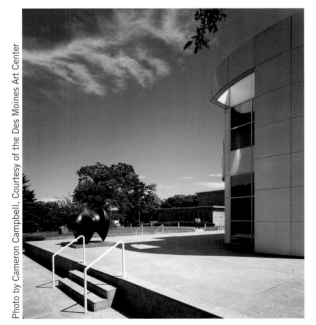

Photo by Cameron Campbell, Courtesy of the Des Moines Art Center

Richard Meier Pavilion with Henry Moore sculpture

expect extremely contemporary exhibitions—from Leslie Hewitt's photosculptural works to a survey of contemporary artists working with glass.

A gallery of the Meier wing is dedicated to video. Among the Center's compelling electronic works is *Ascension* by American video pioneer Bill Viola. For ten mesmerizing minutes, visitors watch as a man falls into a pool of water, rises up to the surface, and then slowly falls to the darkness of the water, air bubbles slowing rising to the surface. Although Viola uses sophisticated equipment in his video/sound installations, his themes are spiritual. "My work is about life and death," he explained, "not aesthetics or technology." The affecting video installations by William Kentridge reflect his background as a white South African of Jewish heritage. Incorporating the artist's charcoal drawings, the videos explore themes of class struggle, oppression, and social and political hierarchies.

A mile away stands the central part of *Three Cairns* by Andy Goldsworthy. Inspired by the Center's three wings, the Scottish artist created sister cairns at the Neuberger Museum of Art at the State University of New York in Purchase and the Museum of Contemporary Art in San Diego. Made with slabs of chalky white Iowa limestone like that used by Saarinen, the gigantic pinecone-shaped form stands eight feet tall with a twenty-one-foot circumference. Like ancient Stonehenge, this contemporary cairn is held together by the weight of the slabs. "I like its fullness, that swelling at the base, things you don't usually associate with stone," said Goldsworthy.

In 2009 the Center converted a swath of vacant land downtown into the Pappajohn Sculpture Park. Venture capitalist John Pappajohn and his wife, Mary, sold their Rothko painting for twelve million dollars to help finance their gift of twenty-six sculptures. The four-acre park is a who's who of contemporary sculpture, including Louise Bourgeois, Ellsworth Kelly, and Tony Smith.

Not to Miss

Oil, acrylic, emulsion, ash, lead objects, ballet shoes, and treated lead pieces on canvas, 153 1/2 x 220 1/2 x 10 inches (389.9 x 560.1 x 25.4 cm). Purchased with funds from the Coffin Fine Arts Trust; Nathan Emory Coffin Collection of the Des Moines Art Center, 1988.12.a-.b

Untitled, Anselm Kiefer (German, born 1945), 1987–1988

This two-paneled gray and brown canvas is typical of Anselm Kiefer's massive, mixed-media paintings that combine abstract form with realism and objects. The German artist uses lead, mud, and hay to evoke decay and destruction of the Holocaust. In the bottom panel two train tracks converge and then move, a reference to the trains that carried European Jews to their deaths in Nazi concentration camps. In the top panel Kiefer adds a contorted metal ladder and pair of ballet shoes, a possible reference to an escape from destruction.

Oil on canvas, 60 1/4 x 46 1/2 inches (153 x 118.1 cm). Purchased with funds from the Coffin Fine Arts Trust; Nathan Emory Coffin Collection of the Des Moines Art Center, 1980.1

Study after Velazquez's Portrait of Pope Innocent X, Francis Bacon (British, 1909–1992), 1953

This haunting painting is part of the Dublin-born artist's famous papal series of over forty-five works created between 1949 and 1971. Inspired by Diego Velazquez's mid-seventeenth century portrait commission, Francis Bacon depicts the tormented prelate behind a transparent veil or drape. Tied down to what looks like an electric chair, the pope emits a piercing scream. His white garment is spattered with red paint, possibly blood. Bacon produced this unsettling work not long after World War II, when the reigning pope did nothing to stop the Nazi genocide.

Oil on linen, 103 x 83 inches (261.6 x 210.8 cm). Purchased with funds from the Coffin Fine Arts Trust; Nathan Emory Coffin Collection of the Des Moines Art Center, 2006.13

Half-Blind, Cecily Brown (British, active United States, born 1969), 2005

Purples, greens, oranges, pinks, and flesh tones combine for a vibrant impact in this lush, painterly canvas. A nude female figure sits on a swing in the forest, while a figure at the lower left is either pushing the swing or spying on her. The British artist is known for her overtly sexual canvases painted in a variety of sizes, from the very intimate to large-scale works like this. Francis Bacon became Cecily Brown's favorite artist after her father, art critic David Sylvester, took her to see his paintings at the Tate. "The place between figuration and abstraction is very fertile ground, and I'm interested in that space," said Brown. ". . . I want my paintings to be ambiguous and open to lots of different readings . . . I want people to really look at paintings for a long time, and for the paintings to slowly reveal themselves . . ."

THE KEMPER MUSEUM OF CONTEMPORARY ART

Kansas City, Missouri

"People drive hundreds of miles to explore this gem of a museum because it truly does set itself apart from what we experience every day. It's a hidden treasure for sure and one not to be missed by anyone."

—Petah Coyne, artist

Kansas City's Kemper Museum is a rare breed—a contemporary art gallery that doesn't take itself too seriously. In an hour's time visitors can enjoy a rich survey of mid-twentieth to twenty-first century art without a hint of pretension. Even more unusual and delightful—women artists are well represented.

Sculptures on the museum's front lawn set the approachable tone, starting with Louise Bourgeois's enormous bronze *Spider* and baby version scaling the facade. The sculptor regarded arachnids as a protective feminine hero figure. At opposite grassy corners are Tom Otterness's *Crying Giant* and Claes Oldenburg's *Pocket Handkerchief,* a homage to the museum's dapper founder, R. Crosby Kemper Jr.

Over the years Kemper and his wife, Bebe Stripp Kemper, have forged friendships with some of the country's top contemporary artists. From the couple's initial gift of one hundred artworks, the permanent collection has grown to some fourteen hundred works, including photography, installations, and videos. The collection continues to grow through the acquisition of works by American and international talents.

The earliest work in the collection by American impressionist Childe Hassam dates to 1913, the year of the New York Armory Show, the first international exhibition of modern art. Three oil paintings created by Georgia O'Keeffe when she lived in New York show her early interest in the beauty of nature. Among the many notable artists in the collection are David Hockney, Andy Warhol, Wayne Thiebaud, Alice Neel, and Chuck Close.

Gunnar Birkerts designed the museum's sleek one-story concrete, steel, and glass building. A student of Eero Saarinen, the Riga-born architect's other art galleries include the Contemporary Arts Museum, Houston; Corning Museum of Glass; and the south wing of the Detroit Institute of Arts. Inside, Birkerts evokes a flying bird with two wings extending from either side of a light-filled atrium. The spacious main gallery is home to changing exhibitions drawn from the permanent collection. Traveling installations are rotated in the atrium, corridor, and smaller galleries.

With a few exceptions the works on view are always changing, grouped to explore contemporary culture and ideas. On the tenth anniversary of 9/11,

for example, the museum presented an exhibition of two sculptures by June Ahrens, who was near the Twin Towers that day. The artist processed the trauma through her art, including *Still Standing*, part of the Kemper's collection. The work features several dozen broken and reconfigured glass jars and vessels on a glass and aluminum support. Other past shows have featured Liza Lou, Christian Boltanski, Kojo Griffin, Alison Saar, and Fairfield Porter. The Kemper recently organized the first career retrospective of Maine plein-air painter Lois Dodd.

The centerpiece of the museum atrium is Frank Stella's large wall relief sculpture, *The Prophet*. In the 1970s Stella changed his style from minimalism to boldly colored three-dimensional canvases and sculptures. This mixed-media work is part of a series of wave pieces the Massachusetts-born artist named for chapters in Herman Melville's novel, *Moby Dick*. *The Prophet* refers to the chapter where the old sailor, Elijah, warns Ishmael and Queequeg about their voyage. Additional mixed-media works and prints by Stella are also in the collection.

American Abstraction is represented by the works of artists like Willem de Kooning, Cy Twombly, Franz Kline, Hans Hofmann, and Sam Francis. Among the stars is *Silver and Black Diptych* by Jackson Pollock, considered one of the great artists of the twentieth century. With his "poured" paintings created by dripping and flinging paint onto canvases, Pollock expanded the definition of a painting. Pollock was the most famous student of Missouri Regionalist Thomas Hart Benton, who taught at the Kansas City Art Institute, located across the street from the museum. The Kempers have donated works by Benton along with other American artists to the nearby Nelson-Atkins Museum of Art.

An important trio of second-generation female abstract expressionists are also represented in the collection—Joan Mitchell, Grace Hartigan, and

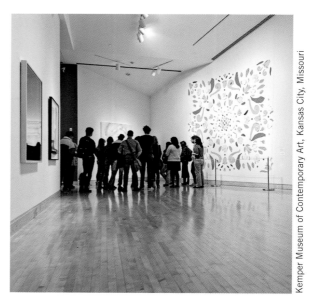

Kemper Museum of Contemporary Art, Kansas City, Missouri

Helen Frankenthaler. A protégé of de Kooning, Mitchell is known for her slashing strokes and colliding colored forms. Hartigan, a disciple of Pollock and de Kooning, produced intensely colored canvases that often include references to popular culture. The gestural strokes of *The Massacre* illustrate the physicality of this school of painting.

The Kemper also owns Frankenthaler's *Coral Wedge* and *Midnight Shore*. After experimenting with Pollock's "poured" method in the 1960s, Frankenthaler invented her own soak-staining technique, pouring washes of thinned paint directly onto raw canvas. The paint sank beneath the canvas surface, creating misty, floating fields of color that evoke the weather and seasons. In a six-decade career, the late Color Field pioneer also created prints, ceramics, sculpture, and tapestry.

Just down the street, Colombian sculptor Fernando Botero's rotund *La Pudeur* (French for "modesty") stands in front of Kemper East. Exhibitions drawn from the museum's permanent collection are on view on the ground-floor galleries. In 2008 the museum opened Kemper at the Crossroads, a

contemporary gallery in the Crossroads Arts District south of downtown, a lively enclave of studios, galleries, design stores, and restaurants. On the first Friday of each month, Kemper at the Crossroads and its fellow galleries stay open late. The newest addition to the neighborhood is Moshe Safdie's stunning Kauffman Center for the Performing Arts, home to the city's ballet, opera, and symphony.

GETTING THERE Address: The Kemper Museum of Contemporary Art, 4420 Warwick Blvd.; Kemper at the Crossroads, 33 W. 19th St.; Kemper East, 200 E. 44th St., Kansas City, MO Phone: (816) 753-5784 Website: kemperart.org Hours: Kemper Museum—Tuesday to Thursday 10:00 a.m. to 4:00 p.m., Friday and Saturday 10:00 a.m. to 9:00 p.m., Sunday 11:00 a.m. to 5:00 p.m.; Kemper East—Tuesday to Friday 10:00 a.m. to 4:00 p.m.; Kemper at the Crossroads—Friday noon to 8:00 p.m., First Friday until 10:00 p.m., Saturday noon to 6:00 p.m. Admission: Free

Not to Miss

Oil on canvas, 60 x 254 inches (152.4 x 645.10 cm). Collection of Kemper Museum of Contemporary Art, Kansas City, Missouri. Gift from the Kemper Foundations, 2010.19a-c

The Storm, David Bates, 2006–2007

This large panel is part of a moving triptych from *The Katrina Paintings*, David Bates's homage to the hurricane survivors. With lavish brushstrokes and a bold, forthright style reminiscent of African-American folk art, Bates personalizes the pain of the 2003 tragedy, one of the nation's deadliest natural disasters. A frequent visitor to New Orleans, Bates felt that "ethically and politically something went very wrong." The sculptor and painter was moved to create a visual record of the storm. "There were disasters up and down the coast," Bates said. "I focused on New Orleans because I knew it so well . . . Those people who got washed out of there came up with jazz and cooking and blues music and gumbo . . . New Orleans is the South—the king of the South—the showpiece."

Untitled #1336, (Scalapino Nu Shu), Petah Coyne, 2009–2010

In this visually arresting work, stuffed pheasants and peacocks occupy a fourteen-foot-tall apple tree covered in velvety black sand. Pheasants hang upside down from the branches, representing death. Above them on the gnarled branches stand the brilliantly plumed peacocks, symbols of beauty and spiritual renewal. Coyne's original inspiration for the tree was writer Flannery O'Connor, who raised and wrote about peacocks. The subtitle refers to the artist's friendship with Bay Area poet Leslie Scalapino and to Nu Shu, a secret, centuries-old Chinese writing technique women used to communicate with one another. Coyne and Scalapino corresponded until the poet's death.

Apple tree, taxidermy Black Melanistic Pheasants, taxidermy Blue India Peacocks, taxidermy Black-Shoulder Peacocks, taxidermy Splading Peacocks, black sand from pig-iron casting, Acrylex 234, black paint, cement, chicken-wire fencing, wood, gravel, sisal, staging rope, cotton rope, insulated-foam sealant, pipe, epoxy, threaded rod, wire, screws, jaw-to-jaw swivels, 158 x 264 x 288 inches (402.32 x 670.56 x 731.52 cm). Collection of Kemper Museum of Contemporary Art, Kansas City, Missouri. Museum Purchase made possible by a gift from the R.C. Kemper Trust, 2011.7

Crying Giant, Tom Otterness, 2002

Wichita, Kansas, native Tom Otterness is famous for his large-scale sculptures of whimsical, cartoonlike figures, often with messages about sex, class, and race. His oeuvre even includes a Humpty Dumpty balloon for a Macy's Thanksgiving Day Parade. The Kemper's colossal bronze weighs nearly three tons and stands eleven feet tall and over fourteen feet deep. Like Auguste Rodin's *The Thinker,* Otterness's crying giant sits with his head in his hands. "It's a simple language; it's a cartoon language; it's smiley, button faces," Otterness said. "[With my work] people aren't thrown off by a language they don't understand."

Bronze. 132 x 78 x 173 inches (335.28 x 198.12 x 439.42 cm). Collection of Kemper Museum of Contemporary Art, Kansas City, Missouri. Museum Purchase made possible by a gift from the Kearney Wornall Foundation and the Enid and Crosby Kemper Foundation, 2002.24a-b

TELFAIR MUSEUMS
Savannah, Georgia

"I want a building that 50 years hence people will still respect . . . vital, contemporary, appropriate to the expression of art yet to come . . . "

—Moshe Safdie, architect

When General James Oglethorpe mapped out the city of Savannah, he used an army grid of tree-lined squares. Today these squares form the heart of the historic district that includes the South's oldest art institution, the Telfair Museums. Long displaying art in two historic houses, the venerable Telfair has a contemporary look thanks to a dramatic addition— the Jepson Center for the Arts. The Center organizes innovative exhibitions ranging from light sculptures by Leo Villareal to photographs by Dan Winters.

Jepson Center Atrium

Photograph by David J. Kaminsky

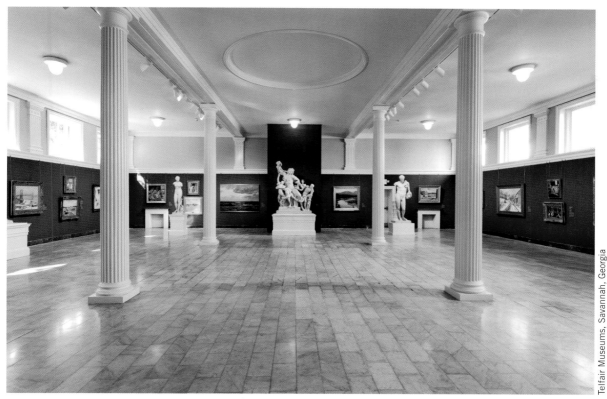

Telfair Academy Sculpture Gallery

Telfair Museums, Savannah, Georgia

Located diagonally across from the Telfair Academy on the corner of Telfair Square, the Jepson Center was named for its principal donors, Savannah philanthropists Alice and Robert Jepson. Israeli-born architect Moshe Safdie, whose portfolio includes museums around the world including the recent Crystal Bridges Museum of American Art in Bentonville, Arkansas, designed the sweeping new building.

After extended debate with the Savannah Historic District's Board of Review, the museum finally gained approval with revisions to its original plans. Safdie added modern columns to the transparent glass facade and preserved the city's historic street grid by splitting the structure into two parts connected by a narrow bridge. The Jepson Center opened in 2006, a three-story building made of white Portuguese limestone and glass.

Light streams into the multilevel atrium from all sides, with the glass facade facing the old oak trees of Telfair Square. A grand stone staircase leads to the third floor, where irregularly shaped galleries feature curved walls and light maple floors. Three large galleries are used for traveling shows; smaller spaces house rotating exhibitions of photography and works on paper.

The heart of the museum's contemporary holdings is the Kirk Varnedoe Collection, assembled in honor of the late Savannah native and art scholar. As chief curator of painting and sculpture at the Museum of Modern Art between 1988 and 2001,

Varnedoe forged close friendships with many leading artists. Twenty-two of these artists donated paintings, prints, and photographs in his memory, including Richard Avedon, Chuck Close, Jasper Johns, Ellsworth Kelly, Jeff Koons, Roy Lichtenstein, Robert Rauschenberg, and Frank Stella. These light-sensitive works are usually on view several months each year.

One of the Center's first exhibitions was the first full-career retrospective of Sam Gilliam. A member of the Washington Color School of painters, the Mississippi-born artist is best known for exploring the sculptural qualities of canvas with his innovative three-dimensional hanging paintings. The Telfair owns #8, *To Repin, To Repin*, Gilliam's homage to Russian portraitist and history painter Ilya Repin. Gritty impasto and a nine-sided polygonal shape give the large work its sculptural quality.

One of the museum's focuses is highlighting local talent. Recent solo exhibitions included Tuscaloosa, Alabama, native William Christenberry, who draws on the landscape of the rural South, and Savannah resident Marcus Kenney, whose mixed-media work is informed by his rural Louisiana childhood. Recently the museum co-organized the first monographic exhibition for Atlanta-born multimedia artist Anthony Goicolea. A first-generation Cuban-American artist, Goicolea is best known for powerful video works and unsettling manipulated photographs that blur the line between reality and fiction.

The Telfair also owns a growing collection of folk art, largely from the southeastern United States. Among the notable artists represented are Bessie Harvey, William O. Golding, Jimmie Lee Sudduth, Ned Cartledge, Eddie Mumma, and R. A. Miller. The museum owns an otherworldly sculpture by Ulysses Davis, who carved his eloquent pieces between haircuts at his Savannah barbershop. Vernon Edwards and Arthur Peter Dilbert have followed in Davis's footsteps; their emotionally powerful pieces are also represented in the collection.

Art is also on view across the Square in the original Telfair Academy. The former residence of Alexander Telfair, son of merchant-planter and three-term Georgia governor Edward Telfair, the Regency-style building was designed by English architect William Jay. In 1875 Alexander Telfair's well-educated, well-traveled sister, Mary Telfair, bequeathed the family mansion to the Georgia Historical Society for use as an art academy and museum.

On the front lawn, sculptures of great artists like Michelangelo, Raphael, and Peter Paul Rubens greet visitors. Inside the sculpture gallery, paintings by Ashcan School painters Robert Henri, George Bellows, and George Luks hang alongside a handful of original plasters casts of classical sculptures. Period furniture and decorative arts fill the ground floor dining room and octagon room. Upstairs bedrooms have been transformed into galleries for changing shows, including contemporary art.

In 1951 the Telfair inherited a second Jay design, the Owens-Thomas House, now a historic house museum open to the public for tours. Around the same time he built the Telfair mansion, Jay built the residence for his sister-in-law and her cotton merchant husband. Among its guests was the Marquis de Lafayette, who delivered two speeches from the cast-iron balcony in 1825.

Beyond the splendid architecture that includes a fabulous staircase, the house is historically important. In the course of renovating the Carriage House, conservators discovered slave quarters that housed nine to thirteen people. Today the space has been preserved and features furniture, textiles, and pottery made by slaves from the Acacia Collection of African Americans.

GETTING THERE Address: Jepson Center for the Arts, 207 W. York St.; Telfair Academy, 121 Barnard St.; Owens-Thomas House, 124 Abercorn St., Savannah, GA Phone: (912) 790-8800 Website: telfairmuseums.org Hours: Jepson Center hours are Tuesday, Wednesday, Friday, Saturday 10:00 a.m. to 5:00 p.m.; Sunday and Monday noon to 5:00 p.m.; Thursday 10:00 a.m. to 8:00 p.m.; Telfair Academy and Owens-Thomas House hours vary slightly; see website Tours: Owens-Thomas House, daily, 30-minute intervals, last tour 4:30 p.m. Admission: For the three venues, adults $20, seniors $18, student $5, children under 5 free

Not to Miss

Collection of Telfair Museums, Savannah, Georgia, Museum purchase with funds provided by the William Jay Society, © Marcus Kenney, photography: Nurnberg Photography, LLC

What Do You Have That Can't Be Replaced? Part 1 and 2, Marcus Kenney, 2003

Marcus Kenney is known for his provocative two- and three-dimensional mixed-media pieces composed largely of found materials. "What I like about my process is that my materials have been touched by many hands, not just my own," said the Savannah artist about the old photographs, news clippings, roofing paper, and vintage paint-by-numbers he uses. American consumer culture and the environment are frequent themes, as in this work where an American family picnics in a desert strewn with discarded appliances. The relatively unlittered Middle Eastern desert is patrolled by American military personnel, raising questions of cultural imperialism. The title suggests that, unlike disposable goods, the most valuable possessions are those that can't be replaced.

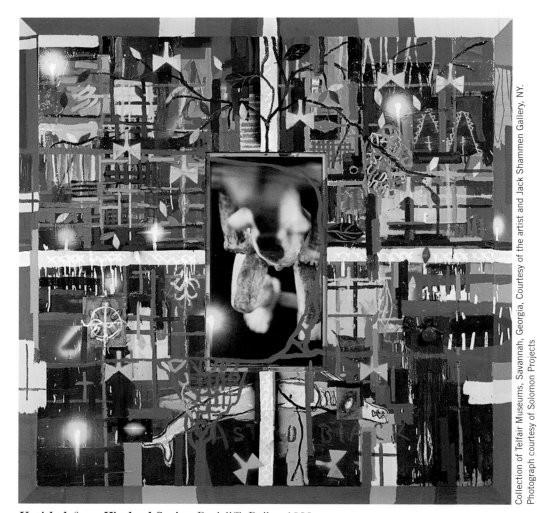

Untitled, from ***Kindred Series,*** Radcliffe Bailey, 1999

This large square canvas of layered acrylic, oil stick, resin, spray paint, and glitter is the final in a series of mixed-media paintings Radcliffe Bailey produced in anticipation of the birth of his daughter. Created during the ninth month of his wife's pregnancy, the colorful red painting is filled with symbols of life. In a central Plexiglas vitrine, Bailey placed a photo of a figurative African wood sculpture resembling a fetus. Jazz music is also an important part of Bailey's art. He creates visual riffs or repeated phrases by layering marks, symbols, language, and references to places, times, and images. A graduate of the Atlanta College of Art, Bailey is a member of the faculty at the University of Georgia.

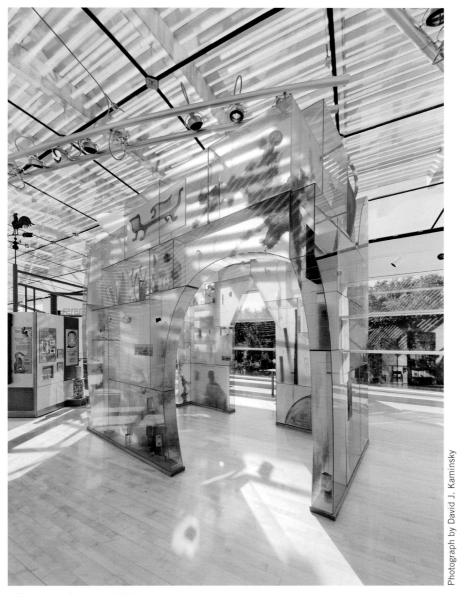

Photograph by David J. Kaminsky

Glass House, Therman Statom, 2005

Critic Matthew Kangas calls Therman Statom "one of the most significant and prolific American experimental glass artists." The sculptor, glass artist, and painter is best known for his life-size glass ladders, chairs, tables, and miniature houses, like the Telfair's site-specific installation in the ArtZeum interactive children's gallery. Statom creates his sculptures by cutting and assembling sheet glass that he paints in vibrant colors. He often adds found objects to the sculptures and his own blown- or cast-glass objects. Statom studied glass at Pilchuck Glass School and earned a BFA and MFA in sculpture from Rhode Island School of Design and Pratt Institute of Art and Design.

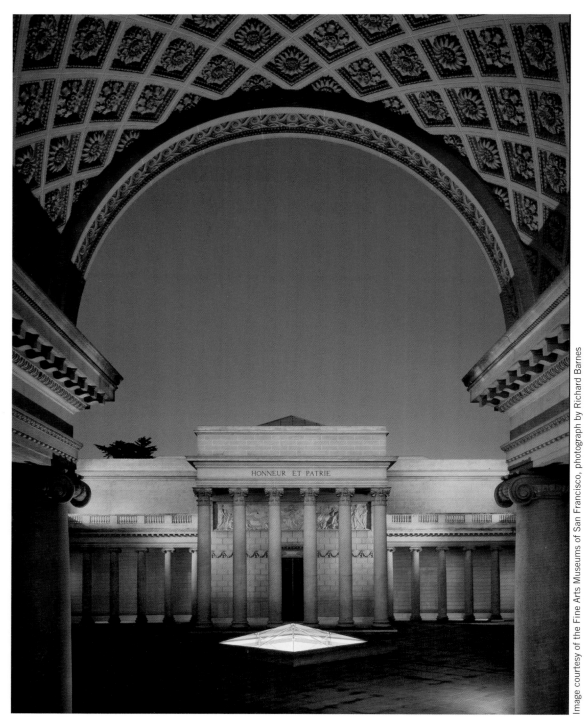

Court of Honor, California Palace of the Legion of Honor

Chapter 6

DECORATIVE ARTS

BAYOU BEND COLLECTION AND GARDENS
Houston, Texas

"Some persons create history. Some record it. Others restore and conserve it. She has done all three."

—Allan Shivers, former governor of Texas

From Philadelphia high chests to silver chocolate pots, Texas collector and philanthropist Ima Hogg sought out the finest in American antiques. Today her stately Houston home houses one of the country's finest collections of early American decorative arts. Yet this remarkable house museum, a branch of the Museum of Fine Arts, Houston (MFAH), remains one of the city's best-kept secrets.

Hogg and her brothers named their fourteen-acre property Bayou Bend after Buffalo Bayou Creek that *bends* around their wooded acreage. Thanks to a real estate fortune from their father, Texas's first

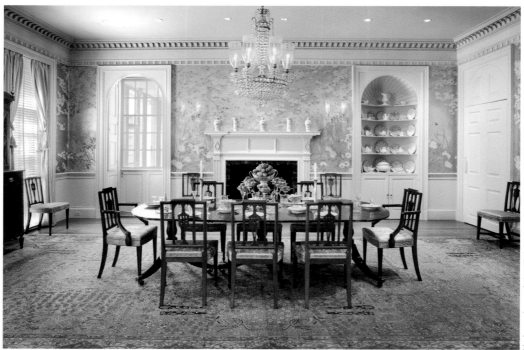

Dining room in the Hogg family home

Various views of the dining room in the Hogg family home, 4/5/2010, RG17-181 06-002: Photo by Rick Gardner, Houston, TX, Museum of Fine Arts, Houston Archives

native-born governor, and the discovery of oil on the family property, the siblings commissioned a house from John F. Staub adjacent to their new River Oaks suburb. "Latin Colonial" is how Hogg described the pink stucco and black ironwork mansion, completed in 1928.

Over the ensuing decades Miss Ima, as she was known, filled her mansion with the highest-quality antiques. In the process she became an expert on American historic furniture; First Lady Jacqueline Kennedy consulted her during the restoration of the White House in 1961. "From the time I acquired my first Queen Anne armchair in 1920," said Miss Ima, "I had an unaccountable compulsion to make an American collection for some Texas museum."

Fellow collector and Winterthur founder Henry Francis du Pont encouraged Hogg to create her own house museum. She followed his advice, donating her possessions and Bayou Bend to MFAH in 1957. In doing so she believed the collection would help connect Texas with the rest of the nation and "bring us closer to the heart of an American heritage which unites us."

Since Bayou Bend opened in 1966, the original forty-five hundred piece collection continues to grow through gifts and acquisitions. Some twenty rooms have been converted into galleries dedicated to the major stylistic periods of American decorative arts, from simple Jacobean to over-the-top rococo revival. Throughout the mansion, furnishings are presented alongside early American paintings.

At Bayou Bend's inviting Visitors Center, guests can learn how to tell a William and Mary side chair from a Queen Anne, a Federal-style table from a Grecian. The Center is also home to a library specializing in American decorative arts. A bouncy walk across the suspension bridge over a wooded creek leads to Bayou Bend's gracious gardens and mansion.

MS21-039: Museum of Fine Arts, Houston Archives

Ima Hogg formal portrait as Gibson girl, circa 1900

The earliest objects, colonial furnishings from 1620 to 1720, are found in the Murphy Room. Among the prized pieces are a carved great or wainscot white oak chair from Massachusetts and a handsome joined cupboard in red oak and red maple. In the early eighteenth century, artisans began producing furniture and metal works for two new pastimes—card playing and tea drinking. From Boston are a card table with a needlework top and tea table with a "turret" top (rounded corners) and semicircular scalloping to hold cups and saucers.

Also on view are American regional takes on the rococo or Chippendale style, named after London's Thomas Chippendale. The swollen bottom or bombe design of a tall desk and bookcase—a late-eighteenth-century home office—are trademarks of Boston. From the seaport town of Newport, Rhode Island comes another tall desk and bookcase with block and shell decoration. A third Philadelphia high

chest sports a scrolled pediment, carved shell, and ball-and-claw feet.

Upstairs in the Chippendale Bedroom, dozens of yards of deep red wool with a floral pattern drape a carved mahogany bed. Providing warmth and privacy, bed hangings like this were a high-end luxury made with fabric imported from England. Trellis wallpaper and green patterned bed and window fabrics decorate the nearby McIntire bedroom, named for Salem woodcarver Samuel McIntire. Schoolgirl embroideries and a ladies' worktable reflect the role of women in coastal New England.

Silversmiths were working in the colonies by the early seventeenth century, but because England limited silver exports, colonial silver is rare. Extraordinary examples are found in the cupboards of the Newport Room, including a sugar dish and slop bowl (for the dregs from a teapot) by Paul Revere. Early tableware, including seventy Revere teaspoons, dessert spoons, and tablespoons, is also on display in the metal study room. Drawers pull open to reveal two centuries of silver flatware—starting with a spoon by Jeremiah Dummer, the earliest-known American-born silversmith.

Bayou Bend's elegant gold wallpapered dining room is furnished in the Federal style, named for the federal government established after the Revolutionary War. Much of the furniture has references to the classical past, such as eagles, wheat sheaves, and urns. A handsome New York mahogany sideboard has drawers for storing silver and linen and a table to display serving pieces. Stylized chairs feature neoclassical urns and drapery details copied from a pattern by the English cabinetmaker, Thomas Sheraton.

Miss Ima's extensive ceramics collection is also on view, including her favorites—English delft, salt-glazed stoneware, mottled glazed wares, and agate wares. American pottery includes nineteenth-century works from H. Wilson & Co., an African-American pottery in Texas. A pair of painted mid-nineteenth-century doors adorns the folk art room, filled with furniture, wood sculpture, and weather vanes.

"Nothing but a dense thicket" is how Miss Ima described Bayou Bend's original grounds. Today woodland paths lead to a series of spectacular gardens. The showiest time to visit is March and April, when azaleas and dogwood trees blanket the property in pink, purple, and white. Over five dozen camellia varieties along with gardenias, roses, and Southern magnolias keep the grounds blooming year-round.

GETTING THERE Address: 6003 Memorial Dr., Houston, TX (10 minutes from MFAH's main campus); Rienzi, a house museum for European decorative arts, 1406 Kirby Dr., Houston, TX Phone: (713) 639-7750 Website: mfah.org/visit/bayou-bend-collection-and-gardens Hours: Tuesday to Saturday 10:00 a.m. to 5:00 p.m., Sunday 1:00 to 5:00 p.m. Tours: Docent led—Tuesday to Thursday 10:00 to 11:30 a.m.; 1:00 to 2:45 p.m.; Friday and Saturday 10:00 to 11:45 a.m. (reservations recommended for visitors over 10 years, not offered in August); self-guided—August, Tuesday to Saturday 10:00 a.m. to 4:00 p.m., Sunday 1:00 to 5:00 p.m.; other months, Friday, Saturday, Sunday 1:00 to 4:00 p.m. Admission: adults $10.00, seniors and students $8.50, children 10 to 17 $5.00, children 9 and under free

Not to Miss

Tankard, shop of John Coney, American, circa 1695–1711

One of the finest colonial silversmiths, Boston-born John Coney is credited as the first to design the New England teapot, along with the inkstand, fork, sugar box, chafing dish, and chocolate pot. Coney's shop made this richly decorated, early Baroque tankard for a prosperous merchant. It features a tiered and reeded lid, dolphin thumb piece, and deeply molded handle. A skilled engraver, Coney also designed the plates for paper money issued by the Massachusetts Bay Company. During his long career Coney trained many noted silversmiths, including French-born Appollos De Revoire, father of famed silversmith and midnight rider Paul Revere.

Pair of Side Chairs, Benjamin Henry Latrobe, American, died 1824; Thomas Wetherill; attributed to George Bridport, circa 1808

Between 1780 and 1810, excavations at Pompeii and Herculaneum inspired a passion for everything classical—from sofas to wallpaper. In the first decade of the nineteenth century, American furniture makers copied designs from classical relief sculptures, wall frescoes, and vase paintings. This graceful pair of gessoed, painted, and gilded chairs with cane backs is an example of this Grecian style, part of a suite of furniture by Benjamin Henry Latrobe for a Philadelphia house he designed. Latrobe created similar furniture for Dolley and President James Madison at the White House. Latrobe's friend Thomas Jefferson hired him for his most famous commission, the US Capitol.

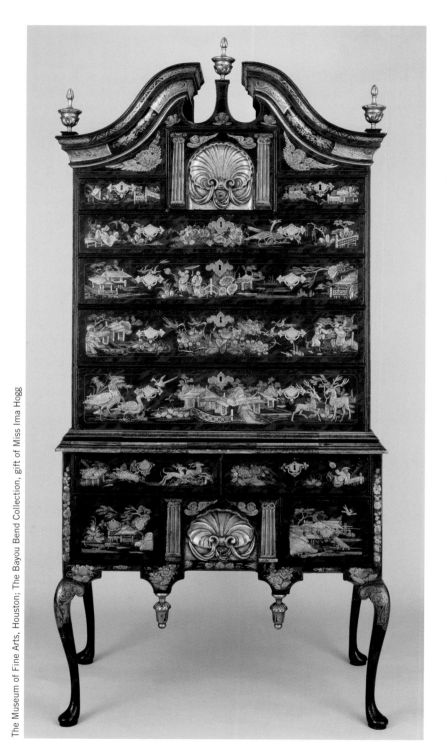

High Chest of Drawers,
Unknown, 1730–1760

Japanning, the decorative technique used to imitate luxury Asian lacquer, was the height of fashion in America during the first half of the eighteenth century. Standing over seven feet tall, this striking Queen Anne pedimented chest is the creation of skilled specialists, from a master cabinetmaker and carver to a gilder and japanner. Craftspeople applied the black background color directly onto the pine surface. Figures, teahouses, animals, and floral decoration were made with gesso (a mix of plaster and glue) and gold leaf. The graceful S-curve legs of the chest—outwardly curved knees and inwardly turned ankles—are a hallmark of Queen Anne furniture.

CALIFORNIA PALACE OF THE LEGION OF HONOR
San Francisco, California

"It may well be one of the most beautiful museum buildings in America."
—Michael Kimmelman, the *New York Times*

Atop a foggy bluff overlooking San Francisco's Golden Gate Bridge stands the California Palace of the Legion of Honor. A replica of Napoleon's Legion of Honor in Paris, the museum was a gift to the city from Adolph Spreckels and his wife, Alma de Bretteville Spreckels, one of San Francisco's most colorful personalities. In addition to antiquities, European fine arts, and works on paper, European decorative arts form a prized part of this memorable museum.

Artist's model Alma de Bretteville caught the eye of sugar magnate Adolph Spreckels after posing for the bronze figure that tops Union Square's Dewey Monument. After marrying her sugar daddy, Alma Spreckels became infatuated with everything French, including the work of a then-unknown sculptor, Auguste Rodin. Inspired by the French Pavilion at the 1915 Panama Pacific International Exposition in San Francisco modeled after the Parisian Legion of Honor, Alma Spreckels set out to build her own version.

Alma Spreckels hired architect George Applegarth, a graduate of the Ecole des Beaux-Arts in Paris, to design the three-quarter-scale re-creation of the Parisian building. In 1806 Napoleon commandeered the eighteenth-century Hotel de Salm (near the Musee d'Orsay), and turned it into the headquarters for his newly established Legion. After five years of construction, the California Legion of Honor opened on Armistice Day in 1924, dedicated to the thirty-six hundred Californians who died in World War I.

In 1970, two years after Alma Spreckels's death, the Legion of Honor merged with the M. H. de Young Memorial Museum in Golden Gate Park to form the

Alma de Bretteville Spreckels (Mrs. Adolph B. Spreckels), 1932, Sir John Lavery, English, 1856–1941

Oil on canvas, 46 x 36 inches. The Fine Arts Museums of San Francisco, gift of Alma de Bretteville Spreckels, 1951.40

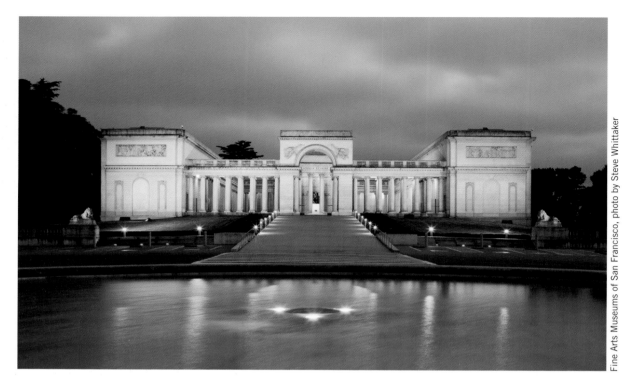

Fine Arts Museums of San Francisco. The overlapping holdings were reorganized to form two stronger collections—a move that would have been unimaginable a generation earlier due to long-standing animosity between the museums' founding families.

In 1884, angry over defamatory articles in the de Young-owned *San Francisco Chronicle*, Adolph Spreckels stormed the newspaper office, shooting and wounding editor Michael de Young. Spreckels was eventually acquitted, but Alma Spreckels was ostracized from San Francisco society. Undaunted, she gained acceptance in European social circles and persuaded friends like Archer Huntington and Mildred Anna and Henry K. S. Williams to donate art to her new museum.

Today visitors pass through the Legion's triumphal arch into a courtyard presided over by Rodin's *The Thinker*. The iconic sculpture is among some seventy Rodins Alma Spreckels acquired, many directly from the artist. Despite the grandeur of the building,

the original galleries are inviting, forming a U shape on the main level. Organized chronologically, the rooms start with medieval and Renaissance tapestries and enamels and finish with post-impressionist paintings.

French decorative arts, part of the museum's founding collection, are displayed in galleries with baroque and rococo paintings as well as in sumptuous gilded and paneled Parisian period rooms. Highlights include a sofa commissioned by Maria Antoinette from royal architect and furniture designer Jacques Gondoin, and a marquetry table by Andre-Charles Boulle, whose remarkable creations inspired the term *boulle work*.

To decorate the new furniture form known as the commode, French craftspeople used marquetry and veneers—including panels of Chinese and Japanese lacquer cut from imported chests. Among the museum's lavish holdings are an ebony commode with Japanese lacquer veneer by Martin Carlin (famous for his desks using Sèvres porcelain) and a Chinese

lacquer chest by Pierre Langlois (known for elaborate floral parquetry).

The elegance of French furniture was matched by finely crafted silver. The museum displays a number of pieces acquired by Alma Spreckels, including a hot-water urn in silver gilt and carnelian by Martin-Guillaume Biennais, Napoleon's official goldsmith. French style influenced silversmiths throughout Europe, and the Legion owns over two hundred English examples. Among the highlights is a rococo shell-shaped sauceboat with a serpent handle by Paul Storr, celebrated Regency period silversmith.

Demand for luxury goods extended to porcelain, which flourished in the eighteenth century. The Legion's porcelain gallery is on the terrace level, part of a thirty-five-thousand-square-foot subterranean addition opened in 1995. Named for porcelain collectors and patrons Henry Bowles and Constance Bowles Peabody, the airy lavender and green gallery is divided into two areas. The front section features English porcelain from makers like Bow, Chelsea, Longton Hall, and Worcester. The back part of the gallery showcases continental porcelain including Meissen, Chantilly, and Sèvres.

Germany's Meissen got an early lead in the European porcelain business thanks to Johann Friedrich Bottger, who arrived at a formula for hard-paste porcelain while under house arrest by Augustus II. Works by Meissen's chief modeler, Johann Joachim Kaendler, include a pair of large birds and a decorated plate from his two-thousand-piece swan service, designed for one hundred guests.

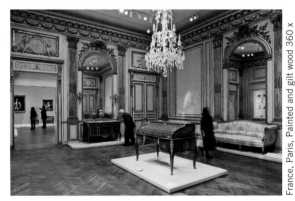

France, Paris, Painted and gilt wood 360 x 372 inches. The Fine Arts Museums of San Francisco, gift of Mr. and Mrs. Richard S. Rheem, 1959.123

Salon Doré from the Hôtel de la Trémoille, Paris, circa 1781

The impact of Asian porcelain-making techniques, shapes, and motifs can be seen throughout the gallery—including a striking pair of pagoda-inspired blue and white tulip vases from Delft in Holland. Another Chinese export, tea, created a new market for porcelain cups, saucers, and teapots. From Chantilly comes a Japanese-inspired tureen decorated with insects and topped with a strawberry cover knob. Sèvres highlights include a seventeen-piece tea service featuring scenes from Chinese life, bamboo handles, and delicate pierced work.

Adolph Spreckels died six months before the Legion of Honor opened, but his wish for music along with art is honored every weekend afternoon. Musicians give classical and popular music recitals on the 1924 Skinner pipe organ, a gift from Adolph's brother, John D. Spreckels. The mahogany, ivory, and ebony console is housed in the Rodin Gallery.

GETTING THERE Address: 100 34th Ave., San Francisco, CA (in Lincoln Park) Phone: (415) 750-3600 Website: legionofhonor.famsf.org Hours: Tuesday to Sunday, 9:30 a.m. to 5:15 p.m. Organ concerts: Saturday and Sunday 4:00 p.m. Admission: Adults $10, seniors $7, students and children 13 and over $6, children 12 and under free (includes same-day admission to the de Young in Golden Gate Park)

Not to Miss

Silver gilt; table veneered in Karelian birch. Height: 28 1/4 inches table; 13 1/2 inch kettle. The Fine Arts Museums of San Francisco, gift of Victoria Melita, Grand Duchess Kyril of Russia, through Alma de Bretteville Spreckels, 1945.355-366

Tea Service and Table, circa 1900, Peter Carl Fabergé (designer), Russian, 1846–1920; Julius Alexandrovitch Rappoport (workmaster), Russian, 1864–1918

This exquisite set was made by Fabergé's leading silversmith in St. Petersburg, the Jewish craftsman Julius Alexandrovich Rappoport. Grand Duchess Kyrill of Russia, sister of the queen of Romania (and granddaughter of Queen Victoria), gave Alma Spreckels the ten-piece silver tea service and silver-gilded table to thank her for raising money for Romanian medical supplies. Like Russian imperial goldsmith Peter Carl Fabergé, the duchess and many wealthy Fabergé patrons fled to Europe during the revolution, taking what treasures they could with them. In 1922 the exiled aristocrat wrote Spreckels: "As at this moment we cannot build anything in remembrance of our own millions of fallen brave . . . I am happy to offer a token of respect and regard to your 3,600 California sons whom you are immortalizing."

Rabbit Hunting with Ferrets,
1460–1470, Franco-Flemish, probably Tournai

This colorful wool and silk tapestry offers a rare look at secular life in the late Middle Ages. Measuring ten feet by eleven feet, eleven inches, the hunting scene is filled with ferreters and rabbits. In one section a woman with a basket stands beside a man who's carefully holding a white ferret, trying to avoid being bitten. Meanwhile, dogs wait to catch any errant rabbits. The source for the tapestry is thought to be *The Hunting Book,* written in the fourteenth century by Gaston Phoebus who dedicated the book to fellow hunter Philip the Bold, Duke of Burgundy. Under the Dukes of Burgundy, Tournai (Belgium) became an important tapestry-making center.

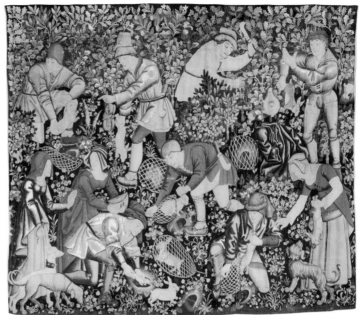

Wool, silk; tapestry weave 10 feet x 11 feet 11 inches. The Fine Arts Museums of San Francisco, museum purchase, M.H. de Young Endowment Fund, 39.4.1

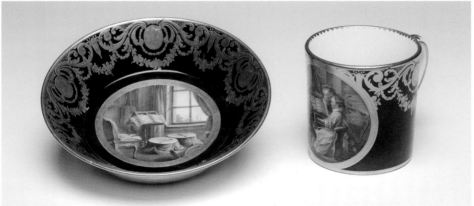

Soft-paste porcelain 2 7/8 x 3 7/8 x 2 7/8 inch cup; 1 1/4 x 5 3/4 x 5 3/4 inch saucer. The Fine Arts Museums of San Francisco, museum purchase, Bequest of the J.Lowell Groves 1984 Living Trust and European Art Trust Fund, 2009.28a-b

Cup and Saucer, 1778, Sèvres Factory (maker), French, established 1756 after Carle Vanloo, French, 1705–1765; Charles-Nicolas Dodin, French, active 1754–1803

Though many of Sèvres's wealthy clients lost their heads during the French Revolution, the factory continued producing its celebrated porcelain. Founded as a private enterprise at Vincennes, Sèvres eventually came to be owned by Louis XV, encouraged by his porcelain-loving mistress Madame de Pompadour. It was under royal patronage that Sèvres developed its trademark color palette, elaborate decoration, and intricate gilding. The scene on the front of this gilded dark-blue cup is based on a painting in the museum's collection, Carle Vanloo's *Allegory of Music* commissioned by Madame de Pompadour. Like Vanloo's painting, the cup features elegantly dressed children playing musical instruments.

THE SHELBURNE MUSEUM
Shelburne, Vermont

" . . . all around the Shelburne, we look in amazement at the results of her [Electra Webb's] evocative handiwork. Her museum is a tribute to collecting and its transformative powers. It is a museum about the origin of museums."

—Edward Rothstein, the *New York Times*

❧ Set on forty-five acres in northwestern Vermont, the Shelburne Museum offers a singular art experience. Over three dozen historic structures brim with the museum's vast, eclectic holdings—everything from duck decoys and moustache cups to quilts and weathervanes. Among the many groups of objects is a unique collection of eighteenth- and nineteenth-century decorative art from Europe and the United States.

This quirky museum opened in 1947, the creation of sugar heiress Electra Havemeyer Webb, the youngest child of impressionist art collectors Henry O. and Louisine Havemeyer. After her 1910 marriage

to James Watson Webb, great-grandson of Cornelius Vanderbilt, Webb began decorating their residences in Shelburne, Long Island, and New York City. "The rooms were over-furnished . . . then the closets and the attics were filled," she said. "I just couldn't let good pieces go by—china, porcelain, pottery, pewter, glass, dolls, quilts, cigar store Indians, eagles, folk art. They all seemed to appeal to me."

To solve her space shortage, Webb began relocating historic New England buildings to the Champlain Valley, including a lighthouse, jail, schoolhouse, and general store. For now, this assemblage of structures closes each November for the winter, a combined effort of curators, gardeners, and carpenters. *Ticonderoga* for example, a 900-ton steamboat hauled to the property from Lake Champlain, is wrapped in two thousand square feet of reinforced plastic sheeting. Starting in the fall of 2013, the Shelburne plans to stay open year-round for the first time. A handsome new glass, stone, and wood art and education center designed by Ann Beha will bring together what Webb called her "collection of collections." In addition to gallery space for changing special exhibitions, the building will house a lecture and performance space and classrooms for a variety of art programs geared to adults and children.

Photo courtesy Shelburne Museum

Stencil House

Photo courtesy Shelburne Museum

Quilts in the Hat and Fragrance Textile Gallery

Much of Webb's ceramics, pewter, and glass is on view in the rambling two-story, Federal-style brick house she named Variety Unit, after its eclectic contents. Built as a brick farmhouse around 1835, the house is the only structure original to the site. The rabbit warren of rooms includes a re-creation of Webb's Long Island dining room with hand-painted wallpaper, whimsical glass witches balls, and hundreds of charming dolls Webb collected during her lifetime, inspired by her grandmother's gifts.

The ceramics gallery is packed with English stoneware, with over two hundred pieces of colorful nineteenth-century mocha ware. In the pewter room, a large harvest table is set with ewers, plates and cutlery from American and European smiths. More handsome pewter from Vermont and Maine fills the surrounding cases. American artisans frequently copied costly silver designs into the more affordable pewter—a good example is a handsome wood-handled pewter teapot by Israel Trask, a Massachusetts silversmith. Trask added an engraved shield to the teapot, similar to those of the English silver company, Sheffield.

Furniture decorates several venues. Prentis House, a late eighteenth–century Massachusetts saltbox, displays William and Mary furnishings along with English delftware, embroideries, and crewel bed hangings, gifts from antiques dealer Katharine Prentis Murphy. American furniture, including chairs, case pieces, and tea tables, is housed in four rooms of the stone Vermont House. Painted furniture is on view in the Stencil House, named for the stenciled walls Electra Webb reinstalled from a home in upstate New York.

Rare furnishings by designer Louis Comfort Tiffany are installed in the Greek Revival–style Webb Memorial Building, which features six interiors from Electra Webb's New York City apartment. Among the pieces are an Oriental-style suite that belonged to Webb's parents and an art nouveau ash table and chair, part of a suite commissioned for her own Long Island estate. Ironically artist Mary Cassatt advised her friend Louisine Havemeyer against this: "Much as I admire Tiffany Glass, I confess I don't like his furniture, if I were Electra I would not have him make me any," wrote Cassatt.

Also at the Webb Memorial Building are the impressionist paintings by Cassatt, Claude Monet, Edouard Manet, and Degas that Electra Webb inherited from her parents (the Havemeyers donated most of their collection to the Metropolitan Museum of Art). Among the works is Cassatt's 1895 pastel double portrait *Louisine Havemeyer and Her Daughter Electra*. It was the expatriate Philadelphia artist who encouraged Louisine Havemeyer to buy some of America's first impressionist paintings.

Webb was one of the first collectors to display American quilts as works of art. From several hundred her prized collection has grown to over seven hundred textiles including contemporary works. The quilts are displayed in a former timber distillery known as the Hat and Fragrance Textile gallery, named for Webb's hatbox collection and the herbal sachets used to help preserve early textiles. From album and chintz to pieced and white work, the Shelburne's quilts represent the country's rich quilt-making traditions.

Along with special themed exhibitions, the museum regularly rotates some two dozen quilts.

While wandering among historic buildings, visitors are treated to the Shelburne's gardens. Among the colorful blooms are hundreds of lilacs and peonies each spring and several thousand summer daylilies. Electra Webb's nearby lakeside residence, Brick House, is also open to the public several times a year.

Webb transformed a modest mid-nineteenth century farmhouse, a gift from her in-laws, into a forty-room country estate. Over the years Webb redecorated Brick House several times, experimenting with vernacular furniture and folk art. One guest, Winterthur founder Henry Francis du Pont, credited his decision to collect American antiques to seeing her collection of pink Staffordshire.

GETTING THERE Address: 6000 Shelburne Rd., Shelburne, VT Phone: (802) 985-3346 Website: shelburnemuseum.org Hours: Reopens mid-May 2013, Monday to Saturday 10:00 a.m. to 5:00 p.m., Sunday noon to 5:00 p.m., open Thursday mid-June to mid-August until 7:30 p.m. Admission: Adults $20, children 5 to 18 $10, children under 5 free; includes a second consecutive day (for tickets bought before 4:00 p.m.) Tours: To visit Brick House, call (802) 985-3346, ext. 3349, or e-mail brickhouse@shelburnemuseum.org, $20.

Not to Miss

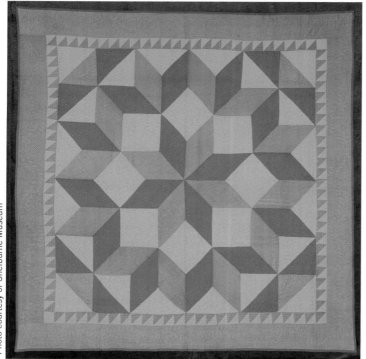

Quilt, unknown maker, late nineteenth century

This colorful pieced tumbling block quilt of square and diamonds was made between 1867 and 1900 in Pennsylvania by an unknown maker, thought to be Mennonite. Using a single diamond shape and careful placement of colors, quilt makers created the optical illusion of cubes, hexagons, stars, and diamonds. Achieving the look of stacked cubes required three fabrics in varying intensities of color—dark, medium, and light. The choice and combination of colors and the large size of the individual cotton blocks suggest this quilt was made by "English" women. "English" is how the Amish refer to non-Amish people. Pennsylvania Amish needlewomen are known for patterns like the center square, diamond in the square, bars, sunshine and shadow, and nine-patch variations.

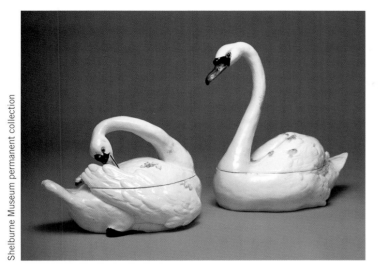

Swan Tureens, Chelsea, 1750

Despite Meissen's efforts to keep its early lead in porcelain making, England's Chelsea factory managed to copy an animal sculpture by the talented German modeler J. J. Kandler. The Shelburne's male and female swans are the only two of their kind, made with white feathers and tufts of grayish pink. Each is a two-piece tureen with a removable cover, used to serve swan, considered a delicacy. Until its acquisition by Derby in 1770, Chelsea produced some of England's most beautiful eighteenth-century porcelain. In a 1957 speech at Colonial Williamsburg, Electra Webb said, ". . . I bought them not knowing what they were; I bought them because I thought they were beautiful, and it was only about six years ago that I discovered they were the only pair known, and I loved them so and wanted to put them in the museum."

Chamber Table, Elizabeth Paine Lombard, Maine, 1816

Eighteen-year-old Elizabeth Paine Lombard was a student at the Misses Martin's School for Young Ladies in Portland, Maine, when she painted this charming ornamental chamber table. The Martins taught painting on wood—using maple, pine, and birch as canvases for images copied from English and American prints. Here, around a central fruit bowl, the young artist painted landscapes, seashells, seaweed, and birds. Lombard also inscribed a poem title "Hope" on the tabletop and her name and date in pencil on the drawer front. Winterthur in Delaware owns a painted table by the artist's sister, Rachel Lombard.

Inside the Racine Art Museum, Matt Eskuche, Agristocracy, *August 2010–July 2011*

CHAPTER 7

DESIGN & CRAFT

MINT MUSEUM
Charlotte, North Carolina

"... the final jewel is in place for uptown Charlotte's cultural crown, a complex that has come to life on South Tryon Street ..."

—Mark Washburn, *The Charlotte Observer*

In 2010, Charlotte, North Carolina's Mint Museum moved into a striking new home in the city's uptown arts district. Among its strengths is a connoisseur's collection of craft and design—from studio glass and ceramics to metalwork, wood, and textiles. Remarkable textiles of a very different sort—three centuries of costumes—are on view at the museum's sister museum, the Mint Randolph.

To celebrate its expansive new craft and design galleries, the Mint commissioned works from international artists working in a variety of mediums. Among the standouts is Danny Lane's *Threshold*, installed at the entrance to the galleries. Behind a curving screen of glass are hundreds of illuminated glass objects and wood forms. "... as always with glass it weighs as much as concrete, but appears visually lightweight," said Lane. "It floats away in your eyes."

Another commission, Icelandic artist Hildur Bjarnadóttir's *Urban Palette, Charlotte*, anchors the textile gallery. Charlotte residents participated in making this work, helping the artist dye Icelandic wool in hues of pale yellow, gold, gray blue, and lavender drawn from local chickweeds, dandelions, and camellia petals. Bjarnadóttir sewed some fifty individual rectangles crocheted in Iceland onto thin plexi. The artist started knitting as a child with her female relatives, including a beloved grandmother with whom she shared a love for crafts and textiles.

Another medium showcased here in stunning fashion is bamboo. For thousands of years Asian artisans have woven stems of the bamboo plant into practical and decorative objects. In the last few decades, Japanese artisans have transformed this age-old practice, creating dramatic, sophisticated sculptures. Two of the artists pushing the limits of bamboo are Torii Ippo and Morigami Jin, whose stunning works are on view in free-standing display cases. Working with several varieties of bamboo, the artists cut, bend, and mold to create expressive and intricate forms.

The remarkable tapestry work of textile pioneer Ritzi Jacobi is also represented. The Romanian-born

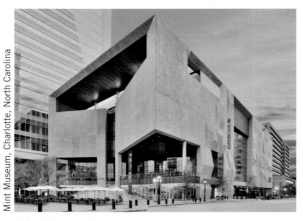

Photograph by Jeff Clare, Courtesy of The Mint Museum, Charlotte, North Carolina

Mint Museum Uptown

artist is known for large tapestry reliefs that she makes by binding and wrapping small lengths of fiber cables to each other using various materials like coconut fiber, cotton, and sisal. The Mint's *Relief*, created in white wool, is a good example of Jacobi's work. ". . . my approach . . . has always been defined by subordination of material in favor of expression and gesture," wrote Jacobi.

The slightest breeze or draft causes the threads in Ulla-Maija Vikman's *Coppery* to move, affecting the work's light and form. "Threads stretched like a warp form a surface on which I paint like a painter on canvas," wrote the Finnish artist of her harmonious pieces. To achieve the desired tones, Vikman repaints and washes her compositions two or three times.

Nearby in Charlotte's fashionable Eastover neighborhood, the Mint Museum Randolph presents a splendid costume collection with a rich history to match. The original building was designed a century earlier by William Strickland (architect of Philadelphia's Second Bank of the United States). From its opening in 1837 until the Civil War, the Mint turned out some five million dollars in gold coins.

After numerous incarnations, including a Confederate headquarters and federal courthouse, the building was headed for the wrecking ball. In 1932 a group of local citizens raised $950 to salvage and move the historic building to Eastover. Four years later the building became North Carolina's first art museum.

Today the Mint Randolph enjoys a parklike setting. Each year curators pull from the ten thousand–item closet of women's, men's, and children's fashions and accessories to assemble remarkable shows, ranging from Chinese silk court robes to platform shoes. Historical costumes are also occasionally presented alongside paintings to explore specific themes—like French fashions with Mary Cassatt's *Portrait of Madame X Dressed for the Matinee* and nineteenth-century children's outfits with depictions of children from the

Photograph by Sean Busher, Courtesy of The Mint Museum, Charlotte, North Carolina

Mint Museum Randolph

same period. Future shows include dresses and gowns embellished with beads, rhinestones, and gemstones.

Although the majority of the collection is women's garments, it contains a glamorous helping of historic menswear. Not to be outdone by women, fashionable European men frequently donned luxurious clothing—like nineteenth-century smoking jackets and white tie and tailcoat attire. The piece de la resistance of the collection is an eighteenth-century wool court suit. Gilt braid, foil-wrapped buttons, and lavish embroidery adorn the three-quarter-length coat and vest. A British major wore the suit to the wedding of Marie Antoinette and the future King Louis XVI.

Long before Kate Middleton wowed with her wedding dress, Alice Faye Otis impressed with a lavish gold silk velvet wedding gown with faux pearls and crochet buttons made by Boston's L. P. Hollander & Co. Otis's dress featured the classic bustle silhouette of the Gilded Age and eight-foot train lined with row after row of French lace. The beautiful creation is part of the Mint's holdings of bridal gowns and grooms wear from 1850 to the 1980s.

The collection also includes early one-of-a-kind haute couture Parisian fashions by Charles Frederick Worth and Jacques Doucet from a period when high-society women wore up to eight outfits a day. Among the many designers represented are Christian Dior, Cristobel Balenciaga, Gucci, Elsa Schiaparelli, Valentino, Versace, and Yves Saint Laurent.

The Mint Randolph recently organized a collection-based show devoted to legendary French designer Gabrielle "Coco" Chanel. Along with the designer's legendary suits, the museum displayed her glamorous accessories, evening wear, and quintessential little black dress. It was Chanel, one of *Time* magazine's most influential people of the twentieth century, who famously remarked, "Fashion passes; style remains."

GETTING THERE Address: Mint Museum Uptown, 500 S. Tryon St.; Mint Museum Randolph, 2730 Randolph Rd., Charlotte, NC Phone: (704) 337-2000 Website: mintmuseum.org Hours: Tuesday 10:00 a.m. to 9:00 p.m., Wednesday to Saturday 10:00 a.m. to 6:00 p.m., Sunday 1:00 to 5:00 p.m. Admission: Adults $10, college students and seniors $8, children 5 to 17 $5, 4 and under free

Not to Miss

Sculpture in linen and cork. Collection of The Mint Museum. Photograph by T. Ortega Gaines.

Mega Footprint Near the Hutch (May I Have This Dance), Sheila Hicks, 2011

This monumental vertical bas relief hangs some five stories in the Mint's light-filled atrium. Sheila Hicks (shown here) wrapped linen threads dipped in handcrafted dyes around cladding—the kind used to insulate plumbing. Hicks is renowned for combining the woven form with painting, sculpture, and drawing. "Textiles had been relegated to a secondary role in our society, to a material that was either functional or decorative," said Hicks. "I wanted to give it another status and show what an artist can do with these incredible materials."

Ball Gown, Jacques Doucet, circa 1890s

Jacques Doucet was one of the preeminent Parisian couturiers in the late nineteenth and early twentieth centuries. The grandson of lace dealers, Doucet's luxurious garments were frequently bought by American merchants. This two-piece gown is created from white satin woven with black silk velvet bands. Multiple pattern pieces create the chevron design of the skirt; the bodice is constructed of four dozen separate pattern pieces. The Mint recently acquired a green velvet beaded evening cape by Charles Frederick Worth, credited with inventing the fashion show.

Collection of The Mint Museum, Charlotte, North Carolina

Collection of The Mint Museum, Charlotte, North Carolina

Soundsuit, Nick Cave, 2007

Chicago-based artist Nick Cave constructs his extravagant soundsuits, named for the noise they make when worn, from a variety of materials including twigs and thrift store and flea market finds. Inspired by the Rodney King incident, Cave made his first suit as a way to explore issues of race, gender, and class distinctions. "When I was inside a suit, you couldn't tell if I was a woman or man; if I was black, red, green or orange; from Haiti or South Africa," said Cave. The Mint's lavish version features a beaded and sequined bodysuit with a metal armature covered by Victorian flowers.

107

MUSEUM OF GLASS

Tacoma, Washington

"There are more artists working with glass in the Northwest than any other place in the world. The Museum of Glass with its spectacular hotshop and galleries will become the premier showcase for new developments in the medium of glass."

—Dale Chihuly

Located on Tacoma, Washington's revitalized waterfront, the Museum of Glass (MOG) is a striking venue for studio glass. From monumental outdoor installations to contemporary European glass jewelry, the museum's collection features over 150 glassworks from the twentieth and twenty-first centuries.

One of the country's most renowned glass artists, Dale Chihuly, is a native of Tacoma. In a generous gesture to his hometown, Chihuly created three installations for the museum and the city's *Bridge of Glass*, a five-hundred-foot pedestrian overpass linking the museum with downtown Tacoma. "We wanted something unique in the world, something that is full of color and offers a joyous experience to passersby both night and day," Chihuly said about his collaboration with Texas architect Arthur Andersson.

Spanning the bridge is the magical Seaform Pavilion—twenty-three hundred–plus marine-inspired glass forms "floating" in a fifty-by-twenty-foot glass-plate ceiling. Illuminated from below are the two translucent *Crystal Towers* rising forty feet from the center of the bridge. *Venetian Wall*, an eighty-foot black grid by the approach to the museum, houses over one hundred of Chihuly's large blown-glass sculptures inspired by putti, Venetian art deco glass, and traditional Japanese floral arrangements.

The wow factor continues in MOG's main plaza with two evocative sculptures, Martin Blank's lyrical *Fluent Steps* and Howard Ben Tre's *Water Forest*. In the latter work water flows up and spills over the top of a series of clear acrylic vertical tubes. The cycles of water are meant to evoke the tidal cycles of the Thea Foss Waterway. The museum's concrete and glass building ascends from the banks of the Waterway with rimless reflecting pools on three stepped terraces.

Canadian architect Arthur Erickson's giant stainless steel–wrapped tilted cone has become a Tacoma landmark. Representing the wood burners of sawmills that were once part of the city's lumber industry, the cone contains a working hot shop for glassblowers. Large panels of curved glass form the exterior and most of the interior walls. The rooftop plaza offers access to the Bridge of Glass along with panoramic views of the waterfront and snowcapped Mt. Rainier.

Inside, fifteen-foot-high gallery ceilings create a spacious backdrop for the colorful glass pieces in MOG's permanent collection. Selections from the permanent collection are on view, including important pieces by celebrated artists like Chihuly, William Morris, Toots Zynsky, Tom Patti, Harvey Littleton, and Lino Tagliapietra. Exhibitions often showcase

Blown and hot sculpted glass with applied bits. Collection of the Museum of Glass, Tacoma, Washington. Photo by Duncan Price.

Snake on a Pole, 2010, designed by Zach Thomson (age eleven), made by James Mongrain (American, 1968) with Musum of Glass Hot Shop Team

Northwest art, like a recent midcareer survey for Seattle's Preston Singletary. The innovative artist uses a number of techniques including glassblowing, sand carving, and inlaying to create glass sculpture from traditional Native American forms like baskets, masks, and amulets. Also on view are homegrown works made in the museum's Hot Shop by visiting artists like Mary Shaffer, Mark Peiser, and Beth Lipman.

Kids Design Glass started as a temporary educational program and has developed into a popular art collection of eighty-plus works. Each month young museumgoers are invited to submit drawings for consideration by the Hot Shop Team. The creator of the most fantastical design is invited back to help glassblowers transform their idea into a three-dimensional sculpture. Two glass objects are made—one for the child to take home, the other for MOG's collection.

Among the visiting artists who've made the winning creatures are Venetian glassblowing maestro Tagliapietra, Singletary, Dante Marioni, and Nancy Callan. The whimsical pieces are rotated in the hallway at the front of the museum. "Going over the sketches and drawings by the children was a fresh and surprising experience for me," said Tagliapietra. "It was so different and exciting at the same time."

Exciting best describes the Hot Shop, contained within the stainless steel cone that's one hundred feet in diameter at its base and narrows to a fifteen-foot opening. From a comfortable perch in the large amphitheater, visitors watch as a team of professional glassblowers turn molten glass into objects of incredible beauty. Throughout the mesmerizing process, a guide shares information about the art and science of glassmaking, while a large video screen projects close-ups of the artists at work.

The molten glass is kept in two large furnaces that reach temperatures up to twenty-four hundred degrees Fahrenheit. In order to keep blown and shaped hot glass objects malleable, they must be continually reheated in a glory hole, where temperatures soar between twenty-one hundred and twenty-three hundred degrees. To prevent the glass from cracking and shattering, it is slowly cooled in annealing ovens, insulated boxes similar to electric kilns. In the adjacent Cold Shop, the cooled artwork is ground, polished, and cut to add surface details and remove imperfections.

Each year MOG invites both internationally known and emerging artists to Tacoma to create new works in glass. A piece created during each artist's residency is selected for the museum's permanent collection. In 2007 Maya Lin created her tranquil *Dew Point* installation, featuring clear glass forms that suggested water drops. In partnership with Pilchuk Glass School, MOG also presents the Visiting Artist Summer Series. A different artist is featured each

week from mid-June through Labor Day. Ceramicists like Richard Notkin, Magdalene Odundo, and Michael Sherrill have also explored the relationship between clay and glass.

Watching glassblowers in the Hot Shop leaves visitors with a deep appreciation for what contemporary artists are adding to this ancient art form. Perhaps the experience of a visit to MOG is best summarized by French artist Jean-Michel Othonial, a 2006 MOG resident: "The hand of the glassmaker is full of tenderness, the trace of his gentle stroke remains in the glass."

GETTING THERE Address: 1801 Dock St., Tacoma, WA Phone: (866) 468-7386 Website: museumofglass.org Hours: Memorial Day to Labor Day—Monday to Saturday 10:00 a.m. to 5:00 p.m., Sunday noon to 5:00 p.m.; fall, winter, and spring—Wednesday to Saturday 10:00 a.m. to 5:00 p.m., Sunday noon to 5:00 p.m., third Thursday of each month 10:00 a.m. to 8:00 p.m. Tours: Weekdays and Saturday 11:00 a.m., 1:00 p.m., and 3:00 p.m.; Sunday 11:00 a.m. and 2:00 p.m. Lectures: History of Glass and Demonstration Series, winter, select Sunday afternoons Admission: Adults $12, seniors and students $10, children 6 to 12 $5, 5 and under free

Not to Miss

Blown glass with canes, cut steel and glass base, 67 x 60 x 20 inches. Collection of the Museum of Glass, Tacoma, Washington. Photo by Russell Johnson.

Manhattan Sunset, 1997, Lino Tagilapietra (Italian, born 1934)

Today the two tallest of the eleven vessels in this work are a poignant reminder of the Twin Towers at the World Trade Center and the thousands of people killed on 9/11. Lino Tagliapietra assembled the various colored and sized vessels on a glass slab supported by multiple slim metal rods. One of the most influential glass artists, Tagliapietra remarkably designs in front of the furnace rather than on paper. His career began at age twelve as an apprentice on the island of Murano, Italy. He has shared Venetian glassblowing along with his own techniques with numerous students, helping develop the art form around the world.

Kiln-cast and sandcarved glass; water-jet cut, inlaid, and laminated medallion, 16 feet x 10 feet X 2 1/2 inches. Collection of the Museum of Glass, Tacoma, Washington. Photo by Duncan Price.

Clan House (Naakahidi), 2008, Preston Singletary (American, born 1963)

A member of the Tlingit tribe of southeast Alaska, Preston Singletary reinterprets traditional Native symbols and forms in glass. The results are beautifully executed, visually powerful works of art. This sixteen-by-ten-foot glass triptych recalls a Tlingit longhouse, a dwelling for the chief and his family. Two tall carved glass "house posts" flank eight yellow and black panels arranged to resemble the traditional cedar plank house screen. "The material of glass, I feel, brings a new dimension to Native art," said Singletary. "There is no other material that can hold the light and produce shadows in the same way."

Hot sculpted glass, stainless steel. Collection of the Museum of Glass, Tacoma, Washington. Photo by Duncan Price.

Fluent Steps, 2009, Martin Blank (American, born 1962)

It took a forty-one-person team to install the islands of glass in this monumental work that spans the length of the main plaza. Martin Blank created most of the 750-plus hand-sculpted pieces of glass in the museum's Hot Shop when he was a visiting artist here in 2008. "My intent with *Fluent Steps* is to awaken the viewer's eye to keenly observe, interact with, and respond to the emotive nature of water," explained Blank. "Water can be placid, sublime, and—in an instant—uncompromisingly raw and powerful. It's the vehicle for capturing light, motion, fluidity and transparency. It's the vehicle for life."

RACINE ART MUSEUM
Racine, Wisconsin

"With its sophisticated architecture, deep collection and experienced leadership, the new Racine Art Museum is a must-visit for anyone interested in the future of contemporary craft."
—Glenn Adamson, *American Craft*

Architecture fans know Racine, Wisconsin, from Frank Lloyd Wright's Wingspread and S. C. Johnson Building. There's another great reason to visit this town on the west shore of Lake Michigan, seventy miles north of Chicago. The Racine Art Museum (RAM) elegantly houses one of the country's most significant collections of contemporary crafts. On average, forty-five thousand visitors a year—over half of Racine's population—come to see the remarkable ceramics, glass, baskets, metalwork, and wood designs.

It's unlikely you'll see the same object twice. RAM's galleries are reinstalled three times a year with artworks from the nearly eight thousand–object permanent collection. A ninety-foot swathe of windows along Fifth Street, lit at night, is a dramatic space for changing glass, ceramics, and metalwork. Smaller objects are showcased in handsome blond wood display cases. Wood and fiber objects, sensitive to light, are presented in a large windowless gallery. Upstairs, a soaring sky-lit gallery is used to exhibit paintings, sculpture, and furniture.

Opened in 2003, RAM's building is a striking departure from its original location. In 1938 Jennie Wustum donated her thirteen-acre homestead and small trust fund to the city of Racine to found the Charles A. Wustum Museum of Fine Arts in memory of her husband. Six decades later the rapidly expanding collection had outgrown its house museum. RAM's dynamic director, Bruce Pepich, spearheaded a fundraising drive to renovate two downtown buildings—a turn-of-the-twentieth-century dry goods store and a bank robbed by gangster John Dillinger in the 1930s.

Photography by Christopher Barrett, Hedrich Blessing, Chicago, IL

Racine-born architect Bradley Lynch transformed the dark, gloomy structures into a serene, inviting space. To unite the buildings, Lynch wrapped the exterior with backlit frosted acrylic panels that create an ethereal glow at night. The eastern facade was replaced with glass, exposing Lake Michigan and flooding the thirty-foot atrium lobby with sunlight. Long rectilinear spaces and a palette of whites have created a quiet interior that lets the artwork shine. Over at the Wustum there are regional art exhibitions and studio art workshops.

RAM's approach is to collect artists in depth, tracing the development of their styles and ideas. Many of the artists in the collection are considered leaders in their categories, pushing the boundaries of their mediums. Visitors can expect to see mini–career surveys drawn from the collection along with exhibits featuring artworks from private collections. The collection has grown through generous gifts from a number of contemporary craft connoisseurs, most notably Karen Johnson Boyd.

Great-granddaughter of the founder of S. C. Johnson & Son, Boyd grew up in Racine and spent her teenage years at Wingspread, the hilltop house Frank Lloyd Wright built for her family (open to the public by reservation). Today the avid art collector and founder of the Perimeter Gallery lives in another Wright house in Racine. Her donations include an early gift of two hundred works that gave RAM a significant collection overnight.

RAM's largest collection is ceramics, representing a wide range of artists and styles. The Donna Moog Teapot Collection features over 250 remarkable pieces from the 1980s and 1990s. One of the highlights of the studio glass collection is Jon Kuhn's radiant glass *Pendulum Cluster* hanging from the ceiling of the two-story atrium. The prismlike pendants change color when seen from different angles, including the upstairs balcony. Other celebrated

Karen Johnson Boyd in RAM's gallery

Photography by Nicholsons' of Racine

glass artists include Philip Myers, Dale Chihuly, William Morris, Ginny Ruffner, William Carlson, and Mark Peiser.

In terms of size and scope, RAM's nearly five hundred–piece contemporary basket collection ranks at the top of US museums. Artists like Ed Rossbach, Kay Sekimachi, Ferne Jacobs, and Dorothy Gill Barnes laid the foundation for successors John McQueen, Jane Sauer, Gyongy Laky, and John Garrett. The baskets incorporate an astonishing array of materials—everything from zippers, beads, and feathers to horsehair and salmon skin. In addition to baskets from Karen Johnson Boyd, Lloyd Cotsen, the former CEO of Neutrogena, donated another 150 contemporary baskets, mostly by American women artists.

RAM's works of art in wood include both furniture and turned vessels. One of the museum's masterworks is a serpentine mahogany desk with a white laminate top by Wendell Castle, known for his highly sculptural, organic forms. Renowned wood turners like Mark Lindquist, Bob Stocksdale, and the Moulthrops highlight the natural characteristics of wood in varieties like Ashleaf Maple, Georgia Loblolly Pine, and Black Willow. In a testament to nature's role in their art, many wood turners sign the name of the wood alongside their own.

The museum's metal collection centers around American studio jewelry with works by artists like Arline Fisch, Lisa and Scott Cylinder, and Chunghi Choo. Also represented is jewelry by Earl Pardon, famous for combining rich colors in enameled metal surfaces and colored gemstones. Pardon is credited with helping to revive enameling and contributing to the popularity of American studio jewelry in the second half of the twentieth century.

A new addition to RAM's permanent collection is polymer—a synthetic modeling compound that's gaining recognition as an artistic medium. The museum owns a group of sophisticated polymer works, many of which combine the material with other contemporary craft disciplines. Among the highlights are a painterly polymer and wood credenza by J. M. Syron and Bonnie Bishoff and striking art jewelry by Elise Winters, Cynthia Toops, and Pier Voulkos.

GETTING THERE Address: The Racine Art Museum, 441 Main St.; the Wustum, 2519 Northwestern Ave., Racine, WI Phone: (262) 638-8300 Website: ramart.org Hours: Tuesday to Saturday 10:00 a.m. to 5:00 p.m., Sunday noon to 5:00 p.m. Admission: Adults $5, seniors, students, and young adults $3, children under 12 free

Not to Miss

Woven Feathers Bracelet, Arline Fisch, 1970

American jeweler Arlene Fisch is famous for the use of fiber techniques in metal. She weaves, pleats, knits, and crochets metal to create remarkable pieces of wearable jewelry. Early in her career Fisch found inspiration in ancient pre-Columbian and Egyptian art. Her stunning pieces range from collars and full-length body pieces to brooches and bracelets—like this work in sterling and fine silver, macaw feathers, and Egyptian faience beads.

Racine Art Museum, Gift of Jane R. Gittings in honor of Irene Purcell, photography by Michael Tropea, Chicago, IL

Star Series, Toshiko Takaezu, 1999–2000

The late Toshiko Takaezu donated this stunning installation of fourteen large-scale ceramic vessels to RAM. To create the masterwork, Hawaii-born Takaezu poured color on the top and sides of each piece, then brushed on dark color in a style reminiscent of Japanese painting. Each of the closed stoneware vessels contains a poem that can't be read unless the piece is shattered. With the individual elements ranging from forty-six to sixty-eight inches tall and twenty-five to forty inches in diameter, the installation is designed to walk through and around. The artist's favorite vessel in the series was *Unas,* named for an Egyptian pharaoh.

Vessel, David Ellsworth, 1987

Master technician David Ellsworth is a pioneer of freestyle turning—using the defects of wood like splits, rotten areas, and bark inclusions to create distinctive forms. Ellsworth also works with "green" or uncured wood, allowing the material to shrink and shape the surface as it dries. By using a blind turning technique and tools of his own design, Ellsworth's thin-walled pieces are surprisingly lightweight. This variegated Macassar ebony vessel is a good example of the artist's expressive works.

WOLFSONIAN–FIU
Miami Beach, Florida

"One of America's most remarkable museums."

—Herbert Muschamp, the *New York Times*

With the New World Symphony concert hall, new Pérez Art Museum Miami, and annual Art Basel Miami Beach is among the country's top cultural destinations. The city boasts another attraction that may very well change how you think about art. Located in Miami's Art Deco District, the Wolfsonian, part of Florida International University (FIU), is an applied-arts museum with a wholly unique approach.

Rather than highlighting individual artists or movements, the Wolfsonian–FIU uses its vast eclectic collection to explore how design reflects and shapes our politics, culture, and society. Exhibitions connect historical American and European holdings from 1885 to 1945 with what's happening today in areas like mass communication, technology, and transportation. In addition to furniture, ceramics, and glass, the museum brims with objects most museums don't collect—clocks and martini shakers, toys and games, political propaganda posters, and postcards.

Wolfsonian is a play on the name of museum founder, Miami native Mitchell (Micky) Wolfson Jr., and the Smithsonian. Wolfson's passion for collecting started as a teenager when he purchased a copy of Coleridge's *The Rime of the Ancient Mariner*. He came to see that objects were deeply imbued with ideas. "I think that objects made by men and women tell us things about human behavior better than any other form of human expression," said Wolfson. Funds for Wolfson's

acquisitions came from an inheritance from Wometco, the family's entertainment empire.

To house his growing collection, Wolfson bought the Washington Storage Company, whose celebrity clients included Al Capone and the Duchess of Windsor. The Mediterranean Revival–style building is considered part of the collection. The original cast stone facade features richly decorated entablatures and a decorative portal above the entrance.

The main entrance hall leads to an ornate Art Deco fountain and twenty-two-foot-tall glazed terra-cotta tile window grille. Originally part of an entrance to the Norris Theater in Norristown, Pennsylvania, the gold and green tile grille is an example of the stylized

Micky Wolfson Jr.

Wolfsonian–Florida International University

treatment that embellished American theater facades in the 1920s and 1930s. Salvaged from a Miami car dealer showroom are chandeliers and a coffered wood ceiling with stylized depictions of car parts.

The Wolfsonian's mascot resides by the downstairs elevator. *Wrestler,* Dudley Vaill Talcott's 6-foot-6, 475-pound aluminum sculpture was exhibited at the 1932 Olympics in Los Angeles, where an American wrestler won the gold medal. The futuristic sculpture became a symbol of America's emergence as an industrial power.

Three floors were added to the building, as well as a third-floor library, with a world-class collection of Dutch art nouveau material, World War II propaganda literature, and world's fair catalogs and books. Small objects and paintings are presented on the fourth floor. Once or twice a year curators cull several hundred works for special exhibitions. Text panels explore connections between the objects and the events surrounding their design, as well as their relevance to contemporary issues.

The museum owns a rich collection of objects from the period's aesthetic movements—from arts and crafts and art nouveau to neoclassicism, futurism, and art moderne. At the turn of the twentieth century, British Arts and Crafts leader William Morris

summed up the philosophy of the movement when he said, "Have nothing in your house that you do not know to be useful or believe to be beautiful." Many of Morris's handcrafted works are here, along with those by M. H. Baillie Scott and Charles Rennie Mackintosh.

By the turn of the twentieth century, the Arts and Crafts movement had spread to continental Europe, Asia, and the United States, where designers extolled truth to materials and hand craftsmanship. Gustav Stickley is among the American designers whose original, innovative furniture is in the Wolfsonian's collection. American art pottery also boomed at this time, both as a craft and a social reform.

From the Marblehead pottery in Massachusetts, which taught ceramics as therapy to sanatorium patients, comes a circular tile with incised clipper ships glazed in gray and blue. An unknown maker at the Rookwood pottery in Ohio created the museum's handsome dark-green matte-glazed vase with incised decoration. There are two earthenware "mud babies" by George E. Ohr, the self-proclaimed "mad potter of Biloxi," and a mossy green Teco vase by Fritz Albert that ends with a swirl of leaves at the base.

Another strength of the collection is Dutch and Italian art nouveau from 1890 to 1910, with many objects inspired by forms in nature. Among the highlights is Philippe Wolfer's silver centerpiece with openwork repoussé design of orchid blossoms, a gift to the prince and princess of Belgium. There's a double parlor from a Turin villa by furniture maker Agostino Lauro and an extensive collection of furniture by Dutch designer Michel de Klerk.

Other noted areas in the collection are Depression-era art, a result of Franklin Roosevelt's New Deal programs, and works on paper, including political propaganda posters from Germany, Italy, and the United States. As a member of the

foreign service, Mitchell Wolfson was posted to the US Consulate in Genoa, Italy. Today his second museum, Wolfsoniana, is housed in the renovated Castello Mackenzie overlooking the city of Genoa. The beautiful house museum showcases the bulk of Wolfson's Italian decorative arts collection.

GETTING THERE Address: 1001 Washington Ave., Miami Beach, FL Phone: (305) 531-1001 Website: wolfsonian.org Hours: Daily noon to 6:00 p.m., Friday noon to 9 p.m., closed Wednesday Tours: Friday 6:00 p.m. Admission: Adults $7, seniors, students, and children 6 to 12 years $5
The library is open to the public by appointment Monday to Friday 9:00 a.m. to 5:00 p.m., Saturday 11:00 a.m. to 5:30 p.m. For more information contact (305) 535-2641 or e-mail library@thewolf.fiu.edu. Bridge Tender House in front of the museum hosts temporary installations.

Not to Miss

Cabinet, Gustavo Pulitzer, 1927

Between the two World Wars, Italian designers searched for a style that would be both Italian and modern. Combining Greek mythology, the traditional intarsia woodworking technique, and abstract design, Gustavo Pulitzer produced this completely modern jewelry cabinet for a wealthy Trieste family. Made of walnut, maple, zebrawood, and rosewood, the cabinet features inlaid decoration of floating cherubs and a goddess emerging from a shell, à la Botticelli. The Trieste artist also designed and decorated stylish interiors for passenger ships like the *Victoria*.

Wolfsonian–Florida International University

Persian, Wallpaper Sample, Morris & Co, circa 1900

Of the many products created by William Morris's London firm, Morris & Co., it's wallpaper that's had the greatest impact. For the sophisticated handmade designs like this "Persian" pattern with leaves and a floral motif, Morris and his designers drew inspiration from Persian, Italian, and Turkish textiles along with flowers from the English countryside. The expensive, richly colored papers were initially popular with artists and aristocratic clients before catching on more widely. In addition to wallpaper, Morris & Co. produced textiles, tapestries, books, furniture, and stained glass.

Geneva Window Panel, Harry Clarke, 1930

Irish artist Harry Clarke created a lush, eight-panel, stained glass window for the League of Nations' International Labor Conference offices in Geneva. The window was to be a gift from Ireland to the League. But Clarke's depictions of literary scenes from modern Irish literature—including the censored author Liam O'Flaherty and a seminude dancer—were deemed offensive, and the government of Ireland decided against sending the work to Geneva. Clarke's widow bought the window, which stayed in the family until Mitchell Wolfson purchased it for the museum.

Wolfsonian–Florida International University

Girl with Blue Eyes, 1918, Amedeo Modigliani, McNay Art Museum

CHAPTER 8

EUROPEAN PAINTING, EIGHTEENTH TO TWENTIETH CENTURY

CHRYSLER MUSEUM OF ART
Norfolk, Virginia

". . . he managed to convert a sometimes uncontrollable obsession into an aesthetic enterprise of public importance. The result is the small-scale but utterly delightful Chrysler Museum . . ."
—Hilton Kramer, art critic

In addition to a world-class glass collection, the Chrysler Museum in Norfolk, Virginia, showcases a splendid group of European paintings. That's only fitting since the first work the museum founder bought at age fourteen was a watercolor by Pierre-Auguste Renoir. Auto heir Walter P. Chrysler Jr. would later count more Renoirs among his prized possessions, as well as paintings by Paul Gauguin, Henri Matisse, and Paul Cézanne.

After two years at Dartmouth, Chrysler traveled to Europe, where he met avant-garde artists Pablo Picasso, Georges Braque, Juan Gris, Matisse, and

Courtesy of the Chrysler Museum of Art, Norfolk, VA

View of the Joan P. Brock Gallery at the Chrysler Museum of Art

Fernand Léger. He returned home to stints in publishing, producing, and the family business, serving as president of the Art Deco Chrysler Building in New York City for two decades. In 1940, a multimillion dollar inheritance from his father allowed him to pursue his passion for art.

Chrysler's hands-on collecting approach resulted in both triumph and ignominy. In an episode out of *Antiques Road Show*, he loaded a dusty marble bust from a Canadian antiques dealer into the back of his Plymouth station wagon. A Renaissance scholar would identify the forgotten marble as *Bust of the Savior*, one of the last works by Italian sculptor Gian Lorenzo Bernini.

The biggest fiasco for Chrysler occurred in 1962 at an exhibition of his collection at the National Gallery of Canada in Ottawa, when dozens of pieces by Picasso and Vincent van Gogh turned out to be fakes. The Art Dealers Association of America cried foul; *Newsweek* called it "one of the art world's most notorious affairs." Chrysler weathered the scandal, weeded out the forgeries, and filled the resulting gaps.

By the early 1970s, Chrysler's art collection had outgrown an old Provincetown, Massachusetts, church. He moved to Norfolk, where he'd met his second wife as a World War II naval reserve. Soon he was donating art to the former Norfolk Museum of Arts and Sciences, renamed the Chrysler Museum.

Among Chrysler's gifts of Old Masters was *Madonna and Child*, the central panel of a triptych by Jan Gossart, who would influence later Flemish artists like Jan van Eyck and Peter Paul Rubens. Chrysler also donated important seventeenth- and eighteenth-century French art like *Saint Philip* by George de la Tour and *Vegetable Vendor* by François Boucher.

A year after Chrysler's death in 1989, a major renovation expanded the museum and reunited the galleries in a uniform Italianate style. Branching from the dramatic atrium with a peaked glass roof

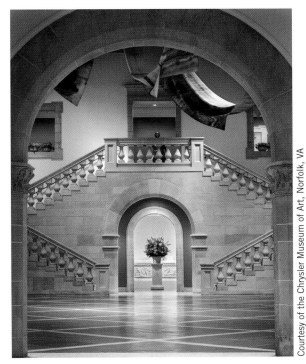

Huber Court

and checkerboard slate floor are galleries for glass, antiquities, and Asian art. European and American art is presented in spacious second-floor galleries, reached by two dramatic staircases that have turned the museum into a popular wedding venue.

Examples of Chrysler's idiosyncratic taste are found in the painting galleries. He purchased a painting with an enormous flock of sheep by Charles-Emile Jacque, hardly a household name. Rather than buy a landscape of Paul Cézanne's beloved Mont Sainte-Victoire, Chrysler bought a risky, life-size male nude from the artist's family home near Aix-en-Provence. Frequently on loan is Gauguin's *The Loss of Virginity*. Against bands of a Tahitian landscape, a young female nude lies in the foreground while a fox, a symbol of sexual power, rests its foot on her breast. The procession in the far distance may be a wedding party.

Exterior view of Chrysler Museum of Art with Hague Inlet

Downstairs, sparkling glass galleries flow chronologically with Roman, Venetian Murano, and baroque to art nouveau, art deco, and studio glass. French glass is a major area of strength, with stunning examples by glass virtuosos like Galle and Daum. Chrysler decorated his homes with glass objects by Louis Comfort Tiffany, a childhood neighbor on Long Island. The collection is sheer eye candy, with luminous stained glass windows and glorious lamps, including a jewel-toned wisteria, pond lily, and turquoise dragonfly. Among the treasures are Tiffany's desk and fireplace, along with a graceful flower-form vase, one of the masterpieces of American blown glass.

Another showstopper is John Northwood's *Milton Vase*, after Milton's *Paradise Lost*, considered the first original masterpiece in the English revival of Roman glass carving. Northwood's vase features white cameo images of the angel Raphael and Adam and Eve in the Garden of Eden against a brilliant blue background.

The museum has expanded its glass holdings through acquisitions of studio and contemporary glass by artists such as Harvey Littleton, William Morris, Stanislav Libensky and Jaroslava Brychtová, and Lino Tagliapietra. Visitors can gain a deeper appreciation for the art of glassblowing by watching artists at work at the glass studio across the street.

Also nearby is the Moses Myers House, a time capsule of late eighteenth century Virginia maintained by the museum. The elegant home belonged to the family of Moses Myers, one of the state's first Jewish citizens, who lived in the house for five generations. Most of the original contents are still in

place. Gilbert Stuart's portraits of Myers and his wife hang on the same nails they did two hundred years ago.

The majority of Chrysler visitors hail from a fifty-mile radius, making this seaside museum a local favorite. Most travelers to Colonial Williamsburg aren't aware that they're just thirty minutes from a world-class art collection. But it's an essential detour for art lovers who find themselves anywhere near Virginia. As *New York Times* critic John Russell wrote, "It would be difficult to spend time in the Chrysler Museum and not come away convinced that the most underrated American art collector of the past fifty years and more was the late Walter P. Chrysler Jr."

© Joseph Lust, Chrysler Museum of Art, Norfolk, VA

Walter P. Chrysler Jr.

GETTING THERE Address: 245 W. Olney Rd., Ghent, VA Phone: (757) 664-6200 Website: chrysler .org Hours: Wednesday 10:00 a.m. to 9:00 p.m., Thursday to Saturday 10:00 a.m. to 5:00 p.m., Sunday noon to 5:00 p.m. Tours: Weekdays 12:30 p.m., weekends 2:00 p.m. Admission: Free

Not to Miss

Oil on canvas, 12 3/4 x 16 1/2 inches. Gift of Walter P. Chrysler Jr., Chrysler Museum of Art, Norfolk, VA 71.506

Basket of Plums, Jean-Baptiste-Simeon Chardin (French, 1699–1779), circa 1765

"This magic is beyond comprehension," philosopher and art critic Denis Diderot declared when he saw this still life at the 1765 Salon in Paris. Walnuts, currants, and cherries rest on a stone ledge alongside a basket of plums. Using velvety brush strokes, a rich palette, and shadowy light, Chardin turns the modest arrangement into poetry. A member of the Academié Royale, Chardin enjoyed great success in mid-eighteenth-century Paris for his still life and genre paintings, counting King Louis XV among his patrons.

The Lagoon of Saint Mark, Venice, Paul Signac (French, 1863–1935), 1905

In this painting avid sailor Paul Signac creates a shimmering mosaic of Venice's fabled lagoon with gondolas and sailing ships. The city's famous landmarks fade softly into the background of the pastel sky. A full-size study in pastel and tempera hangs beside the finished painting, offering a rare look into Signac's working method and palette. Signac was a member of the Pointillists, also known as Divisionists, led by Georges Seurat. In a technique that combines impressionism with scientific theories about light and color, Signac applied thousands of dots of complementary colors side by side. Blended in the viewer's eye, the result is magical.

Daughters of Durand-Ruel, Pierre-Auguste Renoir (French, 1841–1919), 1882

A founding member of the impressionists, Pierre-Auguste Renoir is famous for his beguiling portraits of children, like the daughters of art dealer Paul Durand-Ruel. Soft, feathery brushwork and vibrant colors add to the charm of this double portrait. Marie-Therese and her younger sister Jeanne sit on a garden bench in their white and lavender summer frocks, sunlight streaming through the trees. Their father, Durand-Ruel, helped Renoir and other impressionist clients break into the American art market. Six years later, Renoir painted poet Catulle Mendès's three daughters around a piano (Metropolitan Museum of Art).

Oil on canvas, 32 x 24 3/4 inches. Gift of Walter P. Chrysler Jr. in memory of Thelma Chrysler Foy, Chrysler Museum of Art, Norfolk, VA 71.518

MAKING AN IMPRESSION

THE DIXON GALLERY AND GARDENS
Memphis, Tennessee

"An Englishman by birth, Hugo Dixon befriended another great English-born American collector, Montgomery Ritchie of Texas. The best works from the Impressionist collections of these friends are united in Dixon's superb house and garden, one of the most intimate and perfectly scaled environments for Impressionism in America."
—Richard Brettell, chair of Arts & Humanities, University of Texas at Dallas

❧ Hugo and Margaret Dixon didn't set out to create a museum. The successful businessman viewed art as an "investment in pleasure" to decorate the Georgian-style home he'd built with his Memphis-born wife. In fact throughout the 1950s, the couple gave the nearby Brooks Museum of Art over a dozen important works, including portraits by Joshua Reynolds and Henry Raeburn and paintings by Camille Pissarro and Pierre-Auguste Renoir.

Since the opening of the Dixons' stately red brick home to the public in 1976, the museum has expanded its founders' original bequest of twenty-six paintings to some two thousand works. In addition to paintings the collection includes works on paper,

Formal gardens in the spring

Hugo and Margaret Dixon

sculpture, European porcelain, and pewter. Through several additions the museum managed to retain its inviting, domestic ambience.

Its watershed moment came in 1996 with a six million dollar gift/purchase of the art collection of Montgomery H. W. Ritchie. Among the twenty-three works that entered the collection are a late Paul Cézanne, two early Claude Monets, and a rare Renoir seascape. In his roiling masterwork *The Wave*, Renoir experiments with light, color, and brush-strokes—innovations that we see in his later canvases of children and women.

Like Hugo Dixon, Montgomery Ritchie left England and made a fortune in the United States—as a cattleman on the vast Texas Panhandle ranch founded by his grandmother. But Ritchie, who died

in 1999 at age eighty-eight, was not your typical rancher. He was Cambridge educated, and flew for the US Navy in World War II. A painter himself, Ritchie began buying French impressionist and post-impressionist works in the 1940s.

Dixon's trajectory also took him from his native Southport, England, to the United States. But first Dixon had to survive a German internment camp during World War I. He made his fortune as a partner with McFadden, a major cotton company. In the early 1940s, Dixon hired John Staub to design a residence on his seventeen-acre property in Memphis. The native Tennessee architect had designed many of Houston's grand homes, including Bayou Bend and Rienzi.

Soon after moving in, the Dixons began collecting art, focusing initially on British works. During the remainder of their lives, they amassed a small but outstanding collection of French and American impressionism, post-impressionism, and related schools. Dixon relied on advisors like impressionist expert John Rewald, but he would only buy a painting on approval after seeing it in his living room.

Today visitors can enjoy the same ambience, including lovely views of the garden from the galleries. Though art is rotated regularly and reinstalled in different rooms, the museum's greatest hits by Monet, Edgar Degas, Henri Matisse, and Cézanne can usually be found in the living room, library, and dining room.

Impressionist Berthe Morisot painted *Peasant Girl among Tulips* during a summer stay in Mezy with her daughter and husband (the younger brother of painter Edouard Manet). In this loosely painted work, the young peasant girl is surrounded by tulips, whose pink petals match her complexion. The Dixon also owns a small color pencil sketch of the same scene by Morisot's daughter, Julie Manet. *The Jetty at La Havre, High Sea, Morning Sun* is part of a series of the famous pier Camille Pissarro painted during the last year of his life.

There are also works by lesser-known impressionists like Monet's teacher Eugene Bodin and friend Frederic Bazille. The museum is one of the biggest repositories for the works of Jean-Louis Forain, a protégé of Degas and mentor to Henri de Toulouse-Lautrec. Forain's colorful scenes of *fin-de-siecle* Paris led one critic to call him "the poet of corruption in evening clothes, of dandyism in the boudoirs, of high life masking empty hearts."

In addition to its impressionists, the Dixon shows work of Barbizon painters who influenced the movement like Camille Corot's *The Paver of the Chailly Road, Fountainebleau*. Among the art John Rewald advised the Dixons to acquire is Pierre Bonnard's *Woman Picking Flowers* painted during World War I. Along with Maurice

Denis and Edouard Vuillard, Bonnard was part of the Nabis, a group of artists influenced by Paul Gauguin. The artist spent the two years prior to his painting perfecting his form and composition. Abstracted planes of sky, woods, and fields are interrupted only by the small figure of a woman in black picking wildflowers.

It's easy to imagine Morisot or Claude Monet setting up their easels in the Dixon gardens surrounded by native woodlands, dogwoods, and brilliant sprays of azaleas and tulips. Music lovers with picnic baskets fill the garden for annual spring and fall concerts by the Memphis Symphony Orchestra. Each week volunteers from Margaret Dixon's association, the Memphis Garden Club, turn flowers from the cutting beds into fragrant bouquets for the galleries.

GETTING THERE Address: 4339 Park Ave., Memphis, TN (near Audubon Park) Phone: (901) 761-5250 Website: dixon.org Hours: Tuesday to Friday 10:00 a.m. to 4:00 p.m., Saturday 10:00 a.m. to 5:00 p.m., Sunday 1:00 p.m. to 5:00 p.m. Admission: Adults $7, seniors and students $5, children over 7 $3, children 6 and under free

Not to Miss

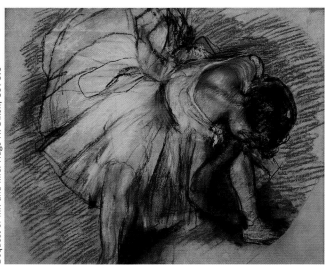

Charcoal and pastel on paper, 18 3/4 x 23 1/2 inches. Collection of the Dixon Gallery and Gardens, Memphis, Bequest of Mr. and Mrs. Hugo N. Dixon, 1975.6

Dancer Adjusting Her Shoe, Edgar Degas (French, 1834–1917), 1885

"People call me the painter of dancers," Edgar Degas told art dealer Abroise Vollard. "They fail to see that I regarded ballet dancers as a pretext for painting pretty fabric and rendering movement." While his fellow impressionists Camille Pissarro and Claude Monet found inspiration in landscapes, Degas is best known for his dance scenes. Pastel suited the artist's style well, allowing him to work quickly and retouch often. In this charcoal and pastel, Degas captures a young dancer as she bends down to adjust her ballet slipper and scratch her arm. Her billowing skirt creates a large circle topped with a blue satin bow.

The Visitor, Mary Cassatt (American, 1844–1926), 1880

Mary Cassatt left Pennsylvania for Europe at age twenty-one and spent most of her adult life in France. She played a key role in impressionism, both as an artist and an advisor to American art collectors. In Paris, Cassatt found an important ally in Edgar Degas, who invited her to exhibit with the impressionists. In this richly colored painting, Cassatt paints her subject seated in profile, waiting patiently, her face lit by the nearby window and her body silhouetted by the room's dark-brown walls. The woman may be Cassatt's sister Lydia, her frequent model and chaperone. In addition to her depictions of women, Cassatt frequently painted mothers and their young children.

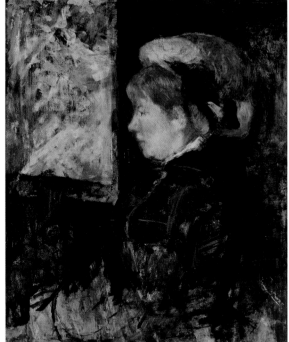

Oil on canvas with gouache, 28 7/8 x 23 3/4 inches. Collection of the Dixon Gallery and Gardens, Memphis, Bequest of Mr. and Mrs. Hugo N. Dixon, 1975.28

Oil on canvas, 24 3/8 x 20 1/4 inches. Collection of the Dixon Gallery and Gardens, Memphis, Museum purchase from Cornelia Ritchie and Ritchie Trust No. 4, 1996.2.20

Trees and Rocks, Near the Château Noir, Paul Cézanne (French, 1839–1906), circa 1900–1906

Three miles east of Aix stands the Château Noir, an eerie structure that captivated Paul Cézanne. The Château became the artist's base for landscapes, like this late work in which he uses an earthy palette of overlapping broad strokes. ". . . The direction of all his modulations was fixed in advance, in his reason," wrote Emile Bernard after observing Cézanne painting. Cézanne frequently painted trees and rocks, including the abandoned Bebemus quarries. After four decades of obscurity, Cézanne's genius was finally recognized by a generation of younger painters that included Henri Matisse and Pablo Picasso.

THE MCNAY ART MUSEUM
San Antonio, Texas

"I was impressed by the quality of the house, and so adding a piece of architecture next to this house was not easy. It was putting a new piece of architecture next to a beautiful building."

—Jean-Paul Viguier, architect

❧ Remember the Alamo? San Antonio has another required stop. Hidden inside the villa of oil heiress Marion Koogler McNay is a startling cache of French impressionist and post-impressionist paintings, including an important collection of works by Pablo Picasso.

Since its opening in 1954 as Texas's first museum of modern art, the McNay has built upon its founder's original bequest of seven hundred hand-picked works. In addition to the standout European paintings, the museum owns an impressive collection of sculpture, works on paper, theater arts, and American modern and contemporary art.

The Ohio-born, Kansas-raised art collector married five times, but she chose to use the name of her first husband, Don Denton McNay (he died of influenza during their first year of marriage). Overlooking twenty-three landscaped acres, McNay's Spanish Colonial mansion is designed around a central patio garden. There's beautiful tile work—from Talavera murals and Arts and Crafts geometric stair risers to the intricately patterned tiles adorning the front porch, patio fountain, and loggias.

Inside, a more subdued palette sets the tone for the elegant foyer with its stenciled wood-beam ceiling and wrought iron staircases. The former dining room, library, and sitting room are now intimate galleries for enjoying the museum's nineteenth- and early twentieth-century European paintings. A graceful staircase leads to upstairs galleries for Southwest, medieval, and Renaissance art.

The dining room, topped by a coffered ceiling stenciled with peacocks and cranes, houses Barbizon paintings by Jean-Baptiste-Camille Corot, Gustave Courbet, and Jean-Francois Millet. In the library visitors meet the next generation of French artists—impressionists Camille Pissarro, Pierre-Auguste Renoir, and Alfred Sisley and post-impressionist Paul Cézanne. Nearby in the sitting room are paintings from the early twentieth century, including *Woman with a Plumed Hat* by a budding nineteen-year-old talent named Pablo Picasso.

Corridors connect the original residence to 1970s additions, home to twentieth-century European and American art, prints, and drawings. In 2008 the McNay doubled its space with a striking two-story wing for sculpture and special exhibitions. Out of respect for the McNay mansion, French architect Jean-Paul Viguier set his two-story contemporary pavilion into a gently sloping berm, keeping its profile low. A system of louvers and shades diffuses the south Texas sunlight, bathing art in soft light.

The intrepid Marion Koogler McNay would likely approve of the new pavilion and outdoor sculpture garden. In 1913 the aspiring painter was studying

at the Art Institute of Chicago when it hosted the seminal New York Armory Show. The European avant-garde art offended many Midwesterners. Henri Matisse paintings with images of female nudes were burned in effigy by students, and the *Chicago Tribune* called the Armory Show nudes obscene and lewd. Matisse, Picasso, and other key artists would wind up in McNay's art collection.

McNay began collecting art in the 1920s. While exhibiting her own watercolors in New Mexico, she started acquiring Southwestern folk art and works by Taos colony artists. Back in San Antonio she made her first major purchase when Mexican artist Diego Rivera visited the city in 1927. With a fortune from oil finds on her father's Kansas properties, McNay commissioned a new home in northern San Antonio. At its formal opening in 1930, a local reporter raved about the romantic atmosphere and florid architecture.

McNay decorated the villa with outstanding art. She sought advice from Los Angeles art dealers Ruth and Dalzell Hatfield and New York City gallery owner Edith Gregor Halpert, an American art specialist. After McNay decided to found an art museum in the 1940s, she began focusing her collecting efforts on an important group of oils, including Vincent van Gogh's *Women Crossing the Fields*, Cézanne's *Portrait of Henri Gasquet*, and Matisse's *The Red Blouse*.

McNay also bought Amedeo Modigliani's *Girl with Blue Eyes*, painted in 1918 Nice during the German occupation of Paris. "We may discern in the thoughtful subtlety of Modigliani's faces something peculiar that the art of Botticelli had brought into Italian painting," wrote French critic Christian Zervos of the Sephardic Jewish artist who died prematurely at age thirty-five. The warm tones of the sitter's red hair, rosy cheeks, and red lips contrast with the cool blue of her almond-shaped, eyes.

In 1954 the new museum received a gift of 130 works from collectors Dr. and Mrs. Frederic G.

Courtesy McNay Art Museum

Oppenheimer. Among the gems are an early work by Pierre Bonnard, *Children Playing*, and two serene landscapes by impressionist Sisley, known for village scenes outside his native Paris. The earlier 1872 work, *The Route from Saint-Germain to Marly* appeared in the first impressionism show of 1874, where Sisley escaped the criticism directed at Cézanne and Monet.

Other gifts followed—including sixty artworks from Sylvan and Mary Lang. The Lang collection includes important American art and bronzes by Picasso, Degas, Matisse, and Albert Giacometti. Today the museum rotates its works on paper, especially rich in Paris-based artists such as Edouard Manet, Henri de Toulouse-Lautrec, Jules Pascin, Odilon Redon, and Mary Cassatt.

When McNay died in 1950, she left her future museum two works by Picasso. Since then the museum's Picasso holdings have grown to some ninety-five works in various media spanning the artist's long career. *Portrait of Sylvette*, 1954 is part of Picasso's series of the young French woman Sylvette David, who worked at a ceramic studio near him in Vallauris. In 2011 two oil paintings entered the collection including *Reclining Woman on the Beach*.

Not to Miss

Oil on canvas. © 2011 Estate of Pablo Picasso/Artists Rights Society (ARS), New York, Collection of the McNay Art Museum, Jeanne and Irving Mathews Collection

Reclining Woman on the Beach, Pablo Picasso, 1932

Two years before painting this small canvas, Pablo Picasso wrote his mistress: "I see you before me my lovely landscape Marie Therese and do not grow weary of looking at you stretched out on your back on the sand . . . " Just seventeen when she met the forty-five-year-old married artist in Paris, Marie-Therese Walter became one of Picasso's most famous muses. Picasso painted this work at Boisgeloup, part of a series of erotic nudes. His art dealer, Daniel-Henry Kahnweiler, wrote at the time "These pictures look as if they might have been painted by a satyr who has just killed a woman . . . they are very vital, very erotic, but with the eroticism of a giant." Walter would later commit suicide, as did Picasso's second wife, Jacqueline Roque.

Portrait of the Artist with the Idol, Paul Gauguin, circa 1893

This riveting three-quarter canvas is part of a series of Paul Gauguin's enigmatic self-portraits. The mustachioed artist gazes out at viewers with his hand on his chin, while Hina, Polynesian goddess of happiness, looks over his shoulder. The green idol and bright yellow chair back contrast with Gauguin's striped sweater and polka-dot tie. Two periods of self-imposed exile in the South Seas inspired Gauguin's palette, dreamlike scenes, and nontraditional painting style. Before his first trip to Tahiti, Gauguin exchanged self-portraits with Vincent van Gogh. His image includes the words "Les Miserables." Already, Gauguin identified with Victor Hugo's protagonist, Jean Valjean, a nomad trying to escape his past.

Oil on canvas. Collection of the McNay Art Museum, Bequest of Marion Koogler McNay

Oil on canvas. Collection of the McNay Art Museum, Bequest of Marion Koogler McNay

Haymakers Resting, Camille Pissarro, 1891

Camille Pissarro, considered the patriarch of impressionism, is known for his paintings and drawings of the peasants and farm workers of rural France. In this canvas Pissarro applies pointillism to his favorite subjects, using small dots of pure color to create optical illusions of light. Against a yellow field lit by the afternoon sun, three peasant women rest by freshly cut blue green hay. Undeterred by financial hardship, Pissarro stayed true to his vision. "When you put all your soul into a work, all that is noble in you, you cannot fail to find a kindred spirit who understands you," he wrote his son, "one doesn't need legions of them."

Portrait of a Man (Michiel de Wael), Frans Hals, circa 1632–1634, 1931.450, Taft Museum of Art

CHAPTER 9

MEDIEVAL, RENAISSANCE & BAROQUE ART

THE CAUSE OF ART

THE ALLEN MEMORIAL ART MUSEUM
Oberlin, Ohio

"The Allen Memorial Art Museum at Oberlin College has long served as much more than an excellent small public museum. It has been intimately involved with art history and academic programs at this choice Ohio college, and has also served to attract distinguished art historians for several generations . . . "

—Tom L. Freudenheim, the *Wall Street Journal*

A small liberal arts college may seem an unlikely place for an encyclopedic art collection, but Allen Memorial Art Museum is recognized as one of the nation's top academic museums. Located across from Oberlin's main quadrangle, the museum presents works from a wide-ranging fourteen thousand–object

collection. Along with strengths in Japanese prints, German Expressionism, and art of the 1960s and 1970s, the museum is rich in Old Master paintings from Italy, England, and the Netherlands.

Recent renovations to the historic 1917 building allowed curators to present artworks from the

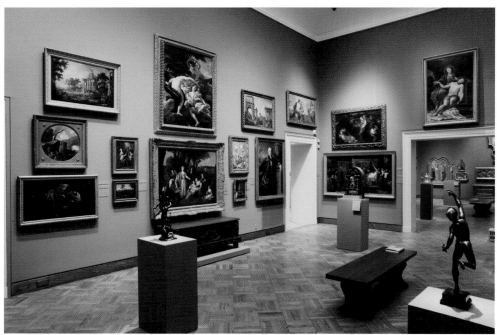

Allen Memorial Art Museum, Oberlin College, Oberlin Ohio

138

R. T. Miller Jr. Fund and gift of the artist in honor of Ellen Johnson, AMAM 1977.39

Ellen Johnson with her 1976 portrait by Alice Neel

permanent collection that haven't been on view for decades. Some two hundred ancient works from the Near East, Egypt, Greece, Rome, Islamic world, and Asia have been installed in the gallery that rings the central sculpture court. Elegant glass-fronted built-ins in the East Gallery house a rotating collection of miniatures and small decorative art objects from Europe and Asia.

The museum is named for Oberlin alumnus and trustee Dr. Dudley Peter Allen, whose widow, Elisabeth Severance Allen, donated funds to build a gallery in his memory. Architect Cass Gilbert (famous for the Woolworth Building, St. Louis Museum of Art, and the Supreme Court Building) loosely modeled the Italian Renaissance–style gallery after Filippo Brunelleschi's Florence orphanage, Ospedale degli Innocenti. Carved in large letters above the entrance

is the phrase: "The Cause of Art Is the Cause of the People" from a speech by British artist William Morris.

In 1977, Oberlin College hired Philadelphia postmodernists Robert Venturi and Denise Scott Brown to add a gallery for modern and contemporary art, as well as a library and print study room. To visually connect their cube-shaped additions to Gilbert's original gallery, the architects designed an exterior checkerboard pattern from pink granite and sandstone. Venturi, who received the Pritzker Prize in 1991, compared museum additions like this one to "drawing a mustache on a Madonna."

Visitors enter the museum through Gilbert's soaring thirty-five-foot-tall sculpture court, an elegant setting for nineteenth-century European and American works. The coffered ceiling is decorated with animals and foliage; upper walls of the clerestory feature

verses by American transcendentalist Christopher Pearse Cranch. To the north is a gallery dedicated to medieval and Renaissance art; to the south is the gallery for European and American art from 1900 to 1950. Rotating exhibitions of works on paper and photographs are presented upstairs.

The Allen's permanent collection is the result of decades of philanthropy and savvy acquisitions, starting at the turn of the twentieth century with Asian ceramics from Cleveland collector Charles F. Olney. In 1912, Detroit railway magnate Charles L. Freer (founder of the Smithsonian's Freer Museum) donated one hundred works, including Chinese and Japanese paintings. Elisabeth Severance Allen bequeathed J. M. W. Turner's *View of Venice*, exhibited at London's Royal Academy in 1841.

The museum's reputation continued to grow in the 1950s under director and art historian Charles Parkhurst, one of the Allied Forces' "monuments men" who searched for art stolen by the Nazis. In 1952, Parkhurst cofounded the Cleveland-based Intermuseum Conservation Association (ICA), the nation's first nonprofit regional art conservation center, a model for other centers. Another art historian who helped burnish Oberlin's image was Dutch Baroque scholar Wolfgang Stechow, who taught at Oberlin for over twenty years. In 1953, Stechow advised Parkhurst to buy Hendrick Ter Brugghen's *Saint Sebastian Tended by Irene*, a masterwork of the collection.

In 1961, as part of its gifts to institutions across the country, the Kress Foundation gave the Allen ten Italian Renaissance paintings, including Pier Franceso Mola's *Mercury Putting Argus to Sleep* and a charming double portrait of siblings by Italian painter Sofonisba Anguissola. Thanks to a recent Kress grant, the museum restored *Cleopatra* by Giovanni Pietro Rizzoli. The Lombard painter—known as Giampietrino—worked in the Milan studio of Leonardo da Vinci. A second version of this work is at the Louvre.

The Allen began collecting contemporary art in the late 1950s, and its holdings represent important American and European artists in a variety of media. Highlights include sculptures by Louise Nevelson, Jean Arp, and Eva Hesse and paintings by Adolph Gottlieb, Richard Diebenkorn, Gerhard Richter, and Richard Serra. *Giant Three-Way Plug*, Claes Oldenburg's first commissioned public work, is located on the lawn between the museum and Hall Auditorium.

Each semester Oberlin students camp out in the courtyard behind the museum for a chance to decorate their dorm rooms with an original piece by Pablo Picasso, Andy Warhol, or Roy Lichtenstein—for five dollars a semester. The art rental program was the brainchild of art professor Ellen Hulda Johnson, who started lending students prints of masterpieces in 1940. Johnson's modern art lectures were informed by her visits to the studios of artists she befriended like Oldenburg, Warhol, and Jasper Johns. She donated much of her art collection to the museum, and originals gradually replaced copies for rent.

Johnson is also responsible for another unique art experience at the Allen. When she died in 1992, she left her Frank Lloyd Wright–designed home to Oberlin College. One of just a few of Wright's sixty affordable Usonian homes open to the public, the redwood and brick L-shaped house is set on three acres near campus. There's a strong visual connection between the interiors and landscape, which Wright also designed. During the 1960s most of the rooms were remodeled and the lot subdivided. Johnson bought the property in 1968 and spent nearly twenty-five years restoring it.

GETTING THERE Address: 87 N. Main St,, Oberlin, OH (on the Oberlin College campus) Phone: (440) 775-8665 Website: oberlin.edu/amam Hours: Tuesday to Saturday 10:00 a.m. to 5:00 p.m., Sunday 1:00 to 5:00 p.m. Tours: Frank Lloyd Wright's Weltzheimer/Johnson House tours April to early December on the first and third Sunday of each month, noon to 5:00 p.m. on the hour, $5 Admission: Free

Not to Miss

St. Sebastian Tended by Irene, Hendrick Ter Brugghen, 1625

Former Louvre director Pierre Rosenberg counts this poignant close-cropped work as one of the best paintings in America. Created four years before Hendrick Ter Brugghen's premature death, the picture depicts St. Irene gently removing an arrow from the side of Sebastian, bleeding from his wounds, his right arm bound to a tree branch. The artist connects the two by giving Irene the same pallid skin tone as Sebastian. After working in Italy for a decade, Ter Brugghen returned to the Netherlands and became a founding member of the Utrecht Caravaggists, a group of Dutch painters strongly influenced by Caravaggio. In addition to theatrical lighting, the successful Ter Brugghen is recognized for his fluid brushwork and harmonious colors.

AMAM 1953.256, R. T. Miller Jr. Fund

AMAM1941.77, R. T. Miller Jr. Fund

Self-Portrait, Michiel Sweerts, circa 1656–1658

With his long wavy black hair, elegant dress, and graceful hand holding a paintbrush dipped in white paint, the Flemish painter looks out at us with a playful gaze. This self-portrait as a young gentleman artist belongs to a long Netherlandish tradition of painters depicting themselves with the tools of their craft. After a period painting in Rome, Michiel Sweerts opened a drawing academy in his native Brussels. A contemporary of Peter Paul Rubens and Anthony Van Dyck, Sweerts painted genre scenes and history paintings in luminous color and lively brushstrokes. A devout Catholic, the artist joined a missionary expedition and died at age forty-six at the Portuguese Jesuit colony in Goa, India. Only about one hundred of Sweerts's paintings survive.

Dovedale by Moonlight, Joseph Wright of Derby, 1784–1785

Known for his candlelit scenes of scientific experiments, the versatile English artist Joseph Wright of Derby also painted portraits and landscapes. This lyrical nocturne is one of his five versions of Dovedale, a centuries-old tourist attraction in the Midlands, northeast of his hometown, Derby. The River Dove, a tributary of the Trent, runs through a picturesque narrow valley of limestone gorges. Using dramatic lighting and a dark-green palette, Wright captures the rocky limestone formation known as Tissington Spires, named for a local village. Delicate foliage and billowing clouds frame a full moon, reflected on the shimmering water. Wright was fascinated with lighting—besides the moon, he illuminated his nocturnes with fires, fireworks, and the eruption of Mount Vesuvius, which he saw during his stay in Italy.

THE JOHN AND MABLE RINGLING MUSEUM OF ART

Sarasota, Florida

"Apart from the superior quality of individual works, the Sarasota museum possesses a treasure to be found in very few other museums: the personality of the founder—for his enjoyment, his enthusiasm are perpetuated within . . ."

—William E. Suida, art historian

Circus impresario John Ringling, one of five Iowa brothers who created the "Greatest Show on Earth" was a voracious art collector. To showcase his possessions, Ringling turned sixty-six acres of alligator-infested swampland along Florida's Gulf Coast into a seaside estate, complete with an elegant art museum and winter residence. Today Ringling's trove of European Old Master paintings forms the heart of the collection.

Ringling's beloved wife Mable died in 1929, and by the time Ringling died seven years later, he was deeply in debt. To avoid creditors Ringling left

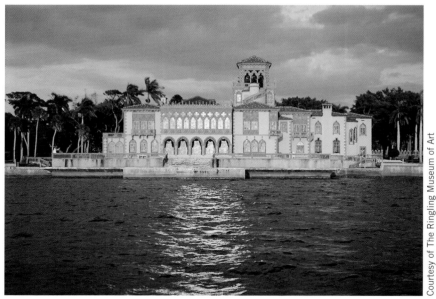

Ca d'Zan mansion

Courtesy of The Ringling Museum of Art

his estate to the people of Florida, stipulating that art bought before his death could not be sold. In 2000, after decades of neglect, Florida transferred Ringling's estate to Florida State University.

A major renovation in 2007 transformed the Ringling into one of the nation's largest academic museums with a permanent collection of ten thousand works. Yann Weymouth based the new twenty-thousand-square-foot wing on architectural plans Ringling had commissioned in the 1920s. The wing houses traveling shows as well as homegrown exhibitions that draw on the strengths of the museum's collection—like Renaissance great Paolo Veronese and Baroque master Peter Paul Rubens.

Forming a U around a sculpture courtyard are the Ringling's twenty-one galleries, each with its own distinctive flavor and story. Early Northern European art is displayed in an intimate period room evoked by gilded paneling, a wood-beamed ceiling, and doorways from the Villa Palmieri in Italy. Two galleries feature interiors that Ringling bought from the Astor Mansion in New York City—a Regency-style library and French rococo salon.

Ringling fell in love with European art and architecture during annual trips to Europe in search of circus acts. He became a regular at auctions and worked with dealers like Joseph Duveen and Julius Bohler. In 1925 Ringling returned from Italy with his first major paintings—Veronese's *The Rest on the Flight into Egypt* and *Madonna of the Dragonfly* by Bernardino Luini, a follower of Leonardo da Vinci.

That same year, Ringling hired New York architect John H. Phillips to design a museum for his growing collection—the southeast's first major museum. Phillips based his plans on a pastiche of buildings he'd seen in Italy, including Florence's Uffizi Gallery. A year later Phillips added a special clerestoried gallery for his boss's latest acquisition—four full-scale canvases by Rubens.

Part of a series commissioned by art patron Isabella Clara Eugenia for her Brussels palace, the works eventually landed in the collection of the Duke of Westminster in London. Acting against prevailing taste and the advice of his art dealer, Ringling paid twenty thousand pounds for the four oils. The purchase turned out to be a savvy investment—Rubens is now widely considered the preeminent artist of the Baroque period.

Outside, the Ringling Museum is no less showy. In Palladio-like fashion, Phillips populated the balustrade of the sculpture courtyard with fifty cast copies of famous Greek, Roman, and Renaissance statues—capped by a campy version of Michelangelo's *David*. Ringling had ordered the sculptures from the Chiurazzi Foundry in Naples for a hotel and art academy that were never completed.

Ever the businessman, Ringling liked to buy art in blocks. In 1928 he paid $125,000 for more than three hundred objects from the Emile Gavet collection. About half of the Parisian art dealer's medieval and Renaissance holdings had adorned Marble House, the Newport, Rhode Island, mansion of Alva Vanderbilt Belmont. The same year, Ringing acquired thirty-three works at the Holford Sale in London, including the highlight of the museum's Spanish holdings—Diego Velazquez's full-length *Portrait of Philip IV*.

Incredibly, in a span of just six years, Ringling amassed 625 Old Master paintings that he triple and quadruple hung in his new gallery. Unlike his predecessors, Gilded Age collectors like Henry Clay Frick and J. P. Morgan who coveted Italian Renaissance art, Ringling focused on the less popular, less costly seventeenth century Baroque. Today about half of the museum's permanent galleries are Baroque with six galleries for Dutch and Flemish art and four galleries for Italian, French, and Spanish works.

Later museum directors and curators added to Ringling's holdings, such as A. Everett Austin Jr.,

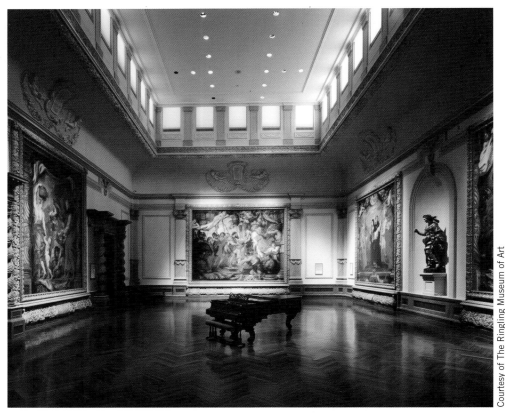

Gallery II, Peter Paul Rubens collection

who acquired Rubens's *Portrait of Archduke Ferdinand* and Nicolas Poussin's *Ecstasy of St. Paul.* In 1950, Austin also installed a gilded eighteenth-century Italian theater on the Ringling grounds. As part of the museum's renovation, the theater was relocated to the visitors pavilion and is a memorable venue for concerts and other events.

A stroll from the museum leads to the Ringling mansion, Ca d'Zan, reopened in 2002 after a six-year renovation. In his will Ringling stipulated that his winter residence be turned into a museum for Venetian art. Eclectic furnishings and antiques fill the ornate interiors—from Venetian glass and seventeenth-century tapestries to French furniture, including the tycoon's mahogany and gilt bronze ormolu bedroom.

The latest addition to the collection is James Turrell's Skyspace *Joseph's Coat.* Embedded in a courtyard, the thirty-eight-foot installation surrounds a twenty-four-by-twenty-four-foot oculus. LED lights wash a rainbow of colors onto the walls and ceiling, creating spectacular contrasts. The most dramatic show occurs at sunrise, sunset, or during a storm, when rain falling over the lip of the oculus is lit in shimmering color.

Since 2009 the Ringling has teamed with the Baryshnikov Arts Center to host a fall arts festival for the visual and performing arts. Attendance by Mikhail Baryshnikov himself creates a ticket frenzy—something John Ringling, of the "Greatest Show on Earth" fame, knew all about.

Not to Miss

Bequest of John Ringling, 1936

The Defenders of the Eucharist, Peter Paul Rubens, 1625–1627

Isabella Clara Eugenia, governor of the Southern Netherlands and daughter of Spain's Philip II, gave her court painter a handful of pearls in partial payment for *Triumph of the Eucharist*. Peter Paul Rubens's religious epic of eleven monumental paintings glorified the Eucharist, the sacrament that caused a major rift between Catholics and Protestants. Here, Isabella Clara Eugenia stars as Saint Clare holding the golden receptacle housing the Eucharist host. The paintings formed the basis for a series of woven tapestries given by the Infanta to Descalzas Reales, the Madrid convent founded by her aunt, where they remain today. Inspired by Rubens's celebrated tapestry cycle of Marie de' Medici at the Louvre, John Ringling bought four of the paintings. In 1980 the museum acquired a fifth in the series.

Bequest of John Ringling, 1936

Still Life with Parrots, Jan Davidsz. de Heem, late 1640s

Spending most of his career in Antwerp, where he became the foremost still-life painter, de Heem combined the opulence of the Flemish Baroque with the precision of his native Holland. By the mid-seventeenth century, Antwerp was one of the world's most important commercial centers, importing delicacies from around the world. In this painterly work that once hung in the Ringling breakfast room, de Heem celebrates that wealth, pulling back a blue curtain to reveal a sumptuous table of exotic objects and foods. The embarrassment of riches looks like it will topple at any moment—a possible allusion to life's fleeting nature. Amid the silver and gold vessels, lobster and pomegranates, an African gray parrot teases a scarlet macaw with a piece of stolen fruit.

Bequest of John Ringling, 1936

Cardinal Albrecht of Brandenburg as Saint Jerome, Lucas Cranach the Elder, 1526

In the early sixteenth century, Lucas Cranach became court painter to the Electors of Saxony and ran a workshop in Wittenberg that employed his sons Lucas II and Hans. Although Cranach was an early convert to Protestantism and illustrated Martin Luther's new Bible, he accepted commissions from Catholic patrons like Cardinal Albrecht, Luther's archenemy. Cranach based this painting on an engraving by his famous contemporary, Albrecht Durer. The cardinal appears as Jerome, the saint who translated the Bible from Hebrew and Greek into the Latin Vulgate. He sits in his study surrounded by books and a menagerie of symbolic animals. Cranach signed this painting with his customary flying dragon.

THE TAFT MUSEUM OF ART
Cincinnati, Ohio

"We are rather amused by a newspaper account of the Great Collections in America. It eliminates Morgan's because so much of it is in Europe and goes on to say the three great ones are Frick's, Widener's and Charles Taft's. No hope for me."

—Isabella Stewart Gardner, in a letter to Bernard Berenson, 1909

Today Gilded Age collectors Isabella Stewart Gardner and Henry Clay Frick are famous for their much loved house museums in Boston and New York City. Less well-known is the Cincinnati mansion turned art museum of their rival, Charles Phelps Taft. The Taft Museum of Art, a National Historic Landmark, houses a highly personal assemblage of Old Master paintings, Limoges enamels, and Chinese porcelain.

In 1927 Charles Taft, publisher of the *Cincinnati Times-Star*, and his wife, Anna Sinton Taft, gave their white mansion, 690 works, and one million dollar

endowment to the city of Cincinnati. Their stately Greek Revival house came with a historical footnote. In 1908 Taft's younger half-brother, William Howard Taft, accepted the Republican presidential nomination on the front steps.

Celebrating its eightieth anniversary in 2012, the Taft Museum of Art has been thoughtfully renovated. From silk window treatments and rich wallpaper to period furnishings and embellished carpeting, each gallery is a snapshot of an interior design style from the century the circa 1820 mansion was a residence. Throughout the period-inspired rooms, Chinese porcelains mix with European paintings and decorative art.

The Tafts began their eclectic collection in 1900 when Anna Taft inherited a fifteen million dollar fortune from her industrialist father, David Sinton. Visits to London's Victoria and Albert Museum and Mentmore, the sumptuous Rothschild country house, helped inform the couple's aesthetic tastes. From Paris, Charles Taft wrote the future president: "I think it would amuse you to see your brother rummaging round in these old antiquaries shops trying to pick up works of art." Over the next twenty-five years, the Tafts bought from noted art dealers Joseph Duveen, Jacques Seligmann, and Charles Fowles.

Tony Walsh, Cincinnati, Ohio. Courtesy of the Taft Museum of Art, Cincinnati, Ohio

Among the Taft's finest possessions is a treasure trove of enamels from Limoges, France, originally part of J. P. Morgan's collection. Because of their fragility, less than three thousand of these brilliant objects have survived; eighty-one reside at the Taft. By the late fifteenth century, Limoges enamelers were using new materials and methods to apply enamel onto copper, achieving brilliant, painterly results. To create iridescent tones, they added gold paint and gold and silver foil under the enamel.

The Taft enamels represent the full range of artistic production by the finest enamelers from the late fifteenth through the early seventeenth centuries. Jewel-like religious objects—goblets, chalices, crosses, and reliquaries—illuminate the medieval treasury. Among the gems is a private devotion *Triptych* by the anonymous artist known as the Monvaerni master. He got his name from part of an inscription on St. Catherine's sword on the triptych's right panel. The nearby Renaissance treasury is filled with more eye candy—including dazzling court portraits and ornamental secular objects like the gilt metal *Casket with the Triumph of Diana* by master enameler Pierre Reymond. Also on display are luxury *maiolica* (tin-glazed earthenware) created in Italy around the same time.

In addition to enamels, the Tafts bought European paintings. Many of the most important are found in the chandeliered Music Room, where the couple married in 1873. The elegant space has been refurbished in a late Federal/early rococo-revival style with early nineteenth-century sofas upholstered in magenta silk with gold rosettes and matching carpeting. Hanging above a pair of eighteenth-century French commodes are Rembrandt's *Portrait of a Man Rising from His Chair* and Frans Hals's three-quarter-length *Portrait of a Man (Michiel de Wael)*, both painted around 1633. Three centuries of landscape painting are represented by a trio of canvases by Meyndert Hobbema, Thomas Gainsborough, and J. M. W. Turner.

Another intimate gallery features small genre scenes, popular with the growing Dutch middle class in the seventeenth century. Displayed alongside scenes of daily life by Gerard ter Borch, Jan Steen, and Pieter de Hooch are blue and white Chinese porcelains—the type Dutch traders introduced to Europe. In the Federal-style eighteenth-century British gallery hang portraits by rivals Thomas Gainsborough and Joshua Reynolds, along with works by Scottish portraitist Henry Raeburn.

Adorning the two parlors are nineteenth-century paintings, notably Turner's *Europa and the Bull*, an unfinished work that represents the artist's late shift toward abstraction. The museum also owns ten Turner watercolors, a medium in which he broke new ground in his use of light. There are also two important portraits by American expats: John Singer Sargent's *Robert Louis Stevenson* and the museum's most modern work, James McNeill Whistler's *At the Piano*, a double portrait of the artist's sister and niece.

The museum also presents French Barbizon School paintings by Jean-François Millet, Jean-Baptiste-Camille Corot, and Charles-François Daubigny from different stages in their careers. Many of these serene, poetic landscapes decorate the neoclassical-style dining room furnished with an early nineteenth-century mahogany table, chairs, and sideboard. Daubigny produced paintings like *A River Scene: The Ferry at Bonnieres* from a floating studio boat—like his famous protégé Claude Monet.

While living in the mansion before her marriage, Anna Sinton Taft had heard rumors about paintings underneath the wallpaper in the foyer. When the house was being readied for the museum's opening, layers of wallpaper were peeled back, revealing a remarkable suite of eight large landscape paintings that continued down the hallway.

Robert S. Duncanson, one of the first African-American artists to gain international acclaim,

received the commission from the home's former owner, the wealthy abolitionist Nicholas Longworth. Ironically the layers of wallpaper that covered the murals for sixty years also helped protect them. They are among Duncanson's 163 surviving works.

GETTING THERE Address: 316 Pike St., Cincinnati, OH Phone: (513) 241-0343 Website: taft museum.org Hours: Wednesday to Sunday 11:00 a.m. to 5:00 p.m. Admission: Adults $8, seniors and students $6, children 18 years and under free; Sunday free

Not to Miss

Portrait of François de Clèves, Duc de Nevers, Leonard Limosin, mid-sixteenth century

Leonard Limosin is considered one of the finest portrait artists in Renaissance France. His virtuosity can be seen in his portrayal of the military commander Duke of Nevers, who rescued the French army at the Battle of Saint-Quentin. The Duke's exquisite ermine-trimmed black velvet jacket and drooping auburn moustache and short beard appear to be painted. Throughout a career spent at the court of Fountainebleau, Limosin created over 130 enamel portraits of monarchs and courtiers, often from drawings by court portraitist Francois Clouet. Limosin used a variety of enamel techniques to achieve his sitters' flesh-toned faces and lifelike hair and clothing.

Enamel on copper, 17 3/4 x 12 inches. Bequest of Charles Phelps and Anna Sinton Taft, Courtesy of the Taft Museum of Art, Cincinnati, Ohio. 1931.305

Edward and William Tomkinson, Thomas Gainsborough, circa 1784

Thomas Gainsborough painted this appealing portrait of eleven-year-old cousins four years before his death at age sixty-one. It's one of a number of the artist's double portraits of children and teenagers that includes his own daughters holding hands and chasing a butterfly. Here, Gainsborough poses the boys in a wooded country setting. Fair-haired Edward gazes at the viewer, while his dark-haired cousin William sits on a grassy embankment, book in one hand and walking stick in the other. The large painting may have contributed to Gainsborough's last falling out with the Royal Academy over the hanging of his work. From 1784 on, he exhibited at his own studio. Gainsborough's passion for landscape painting adds a poetic atmosphere to many of his portraits.

Oil on canvas, 83 3/8 x 59 7/8 inches. Bequest of Charles Phelps and Anna Sinton Taft, Courtesy of the Taft Museum of Art, Cincinnati, Ohio. 1931.412

Oil on canvas, 30 x 23 7/8 inches. Bequest of Charles Phelps and Anna Sinton Taft, Courtesy of the Taft Museum of Art, Cincinnati, Ohio. 1931.414

Mademoiselle Jeanne Gonin, Jean-Auguste-Dominique Ingres, 1821

Although Jean-Auguste-Dominique Ingres considered his neoclassical history paintings and allegories his most important works, he was a highly sought-after portraitist. In contrast to his famous bejeweled sitters, the Taft's frank young sitter wears a conservative black satin dress and gold chain with a clasp to hold her reading glasses. Simple rings worn on the middle fingers of each of her crossed hands were typical of the romantic period. The demure half-length portrait may have been commissioned to celebrate the engagement of Jeanne Gonin and Pyrame Thomeguex. The artist places a simple black ribbon and comb in his subject's brown hair and a blue and white plaid bow at her white lace collar. A native of Montauban, France, Ingres lived in Rome and Florence, where he befriended the Gonin and Thomeguex families.

THE TIMKEN MUSEUM OF ART
San Diego, California

"It is one of the finest small museums I have ever seen . . . Paintings like these are virtually unavailable at any price."
—John Walker, former director, The National Gallery of Art, Washington, DC

❧ Each year millions of people visit San Diego's Balboa Park, home to the San Diego Zoo, Old Globe Theatre, and San Diego Air & Space Museum. With the park's many attractions, it's easy to miss a modest building near the ornate San Diego Museum of Art. The tiny free-admission Timken Museum of Art is among the nation's most intimate art-viewing experiences, quietly housing San Diego's only Rembrandt and a small trove of Old Master paintings.

A bronze cast of Giovanni da Bologna's iconic *Mercury* greets visitors in the museum foyer along with seventeenth-century Gobelin tapestries of queen

Timken Museum of Art, San Diego

Artemisia. Front and back floor-to-ceiling glass walls connect the gallery with the landscapes of Balboa Park. Inside the six intimate, naturally lit galleries, the modern building disappears, drawing our attention to the ornately framed pictures. They hang salon-style—suspended from cords with frame tags identifying the works.

To the right is the gallery for special exhibitions, Italian gallery, and Russian gallery featuring some two dozen icons against rich green crushed velvet wall coverings. To the left are salmon-colored galleries for French, Flemish and Dutch, and American art—a small but fine collection the museum began assembling in the mid-1960s.

The history of this unusual gallery is related to its better-known neighbor. In the 1930s the fledgling San Diego Museum of Art (then called the Fine Arts Gallery) began receiving anonymous gifts of Italian and Spanish paintings by greats like Titian, El Greco, Francisco de Goya, and Francisco de Zurbarán. Benefactors Anne, Irene, and Amy Putnam would arrive at the museum before or after hours in a curtain-shrouded limousine to visit "their" paintings.

The three sisters had moved to San Diego from Vermont in the early 1900s with their elderly parents to join a millionaire uncle, Henry Putnam, patent holder of household items like the safety pin, mop

squeezer, and fruit jar lid. From their father the sisters inherited a small manufacturing and banking fortune. Two years after Irene Putnam's death in 1936, Anne and Amy Putnam received the lion's share of their uncle's estate from their cousin, over five million dollars.

Like Claribel and Etta Cone of Baltimore, the Putnam sisters were well-educated, well-traveled spinsters. But unlike the Cones, who bought directly from artists and lived with their acquisitions, the Putnams focused most of their collecting efforts on Old Masters for San Diego. Their gift of over one hundred paintings turned the San Diego Museum of Art into one of the premier institutions for Old Masters west of the Mississippi.

Before a major purchase the methodical sisters consulted a trusted cadre of art experts. Amy Putnam, who studied Russian at Stanford, decorated the library of the family's three-story house at Fourth and Walnut Streets with hundreds of Russian books and icons, including *Our Lady of Jerusalem* over the fireplace.

In the late 1940s Amy Putnam had a mysterious falling out with the director of the Fine Arts Gallery, Reginald Poland, that led to his resignation and the end of the sisters' donations. The Putnams established a foundation and began lending important paintings to major museums like the Metropolitan Museum of Art, National Gallery of Art, and Art Institute of Chicago.

To keep the Putnam collection in Southern California, local attorney Walter Ames secured funding to build a new museum from the Timken family, early benefactors of the Fine Arts Gallery. Neither Amy nor Anne Putnam lived to see the 1965 opening of the stone, metal, and glass Timken Museum of Art.

Religious works and portraits populate the Italian gallery, including a fourteenth-century panel-painting collection that includes the rare tempura and gold *Madonna and Child* by Niccolo di Buonaccorso created for the central portion of a Siena church altarpiece. In *The Return of the Prodigal Son*, Guercino captures the reunion with his favorite half-length-figure format. From Northern Italy come two memorable early sixteenth-century characters: an androgynous young man in *Portrait of a Youth Holding an Arrow* by Giovanni Antonio Boltraffio and a petulant, luxuriously garbed young woman in Bartolomeo Veneto's *Portrait of a Lady in a Green Dress*.

The Dutch and Flemish gallery is home to many of the museum's masterworks, starting with a rare signed and dated Renaissance painting, *Death of the Virgin*, by Bruges artist Petrus Christus. In *Portrait of a Young Captain*, painted at the height of his career, Antwerp's Baroque master Peter Paul Rubens immortalized his handsome sitter in armor and red sash. Gabriel Metsu takes up the popular Dutch subject of letter writing in *A Girl Receiving a Letter*. Jacob van Ruisdael pictures linen drying on the fields in *View of Haarlem* along with Saint Bavo, the church where he is buried.

Highlights of the French gallery include Francois Clouet's beautifully framed mid-sixteenth-century portrait of dour young Guy XVII, Comte de Laval, in an elegant black and gold jacket. The Timken beat out the National Gallery for Jacques-Louis David's *Portrait of Mr. Cooper Penrose*. Despite the spartan pose, the wealthy Mr. Penrose was eventually expelled from Ireland's Quaker society for his lavish taste. In *Pastoral Landscape* and *View of Volterra*, viewers see influence of Italy on Claude Lorrain and Jean-Baptiste-Camille Corot.

The Timken continues to slowly grow its collection, one masterwork at a time. To mark its fortieth anniversary in 2005, the museum bought Anthony Van Dyck's *Portrait of Mary Villiers, Lady Herbert of Shurland*. Originally part of Charles I's art collection

at St. James Palace, the elegant portrait contrasts the fourteen-year-old's youthfulness with the tragedy of her widowhood. The Timken's fiftieth anniversary coincides with the centenary of Balboa Park's Panama California Exposition—a likely occasion for another gem in San Diego.

GETTING THERE Address: 1500 El Prado, San Diego, CA (in Balboa Park) Phone: (619) 239-5548 Website: timkenmuseum.org Hours: Tuesday to Saturday 10:00 a.m. to 4:30 p.m., Sunday 1:30 to 4:30 p.m. Admission: Free

Not to Miss

The Putnam Collection, Timken Museum of Art, San Diego

Parable of the Sower, Pieter Brueghel the Elder, 1557

This luminous landscape represents Pieter Brueghel's earliest depiction of a parable, a subject he would return to before his premature death at age forty-four. Here Brueghel depicts the parable from the gospel of Matthew. A humble sower in the left foreground scatters seeds in a pasture dwarfed by an Alpine landscape the artist saw when returning to Flanders from Rome. Across the river a small crowd gathers to hear Jesus preaching on the shore. Known as the "new Bosch" in his day, Brueghel is considered the most important figure of sixteenth-century Flemish painting. This canvas is one of just a handful of his paintings in the United States; only about forty survive worldwide. Brueghel started an artistic dynasty—his sons and grandsons became famous in their own right.

The Putnam Collection, Timken Museum of Art, San Diego

Saint Bartholomew, Rembrandt van Rijn, circa 1657

Among his many achievements, Dutch Golden Age master Rembrandt is famous for revolutionizing the portrayal of biblical subjects. After declaring bankruptcy in the latter part of his life, he produced a series of saints and apostles. Among the largest of these is this psychologically riveting portrait of Saint Bartholomew who preached the Gospel in Asia. Rembrandt poses the bearded Saint Bartholomew sitting in shadow on a velvet chair, holding a knife, a symbol of his impending martyrdom. He appears lost in thought as a ray of light from the left illuminates his furrowed brow and half-open mouth. Rendered in broad strokes, his right hand and knife stand out against his roughly painted brown cloak. Former owners of this painting include the British portraitist Joshua Reynolds.

Lovers in a Park, François Boucher, 1758

"I spent half my life at the Hermitage," wrote Madame de Pompadour, mistress of Louis XV, about the rustic hideout she had built at the palace of Versailles. With her fellow courtiers, the early fashionista strolled the hermitages at Versailles and Fontainebleau dressed in luxe versions of peasant clothing. Pompadour's favorite artist, rococo master François Boucher, reflected the new fashion in his decorative pastoral paintings. Here, with dazzling brushwork, Boucher depicts a young barefooted couple and their spaniel stopping to rest in a picturesque garden. While the man weaves flowers into his lover's hair, a milkmaid appears with more flowers. Boucher surrounds his figures with fanciful ruins, putti, and roses, the symbol of love.

The Putnam Collection, Timken Museum of Art, San Diego

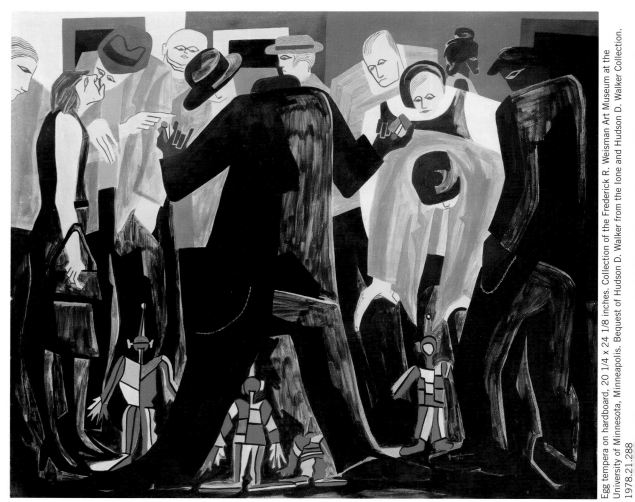

Dancing Doll, Jacob Lawrence, 1947, Weisman Art Museum

CHAPTER 10

MODERN ART

THE KREEGER MUSEUM
Washington, DC

"To turn into that mysterious courtyard . . . is to drive into another world. Part of the city, and yet not part of it at the same time; part of our age, and yet part of a tradition that reaches into antiquity—the Kreeger collection is somehow inseparable from the totality of the Kreeger achievement."

—J. Carter Brown, former director, National Gallery of Art

❧ Even in a museum capital like Washington, DC, David and Carmen Kreeger's highly personal collection of modern art stands out. Presented in their stunning white travertine modernist home on exclusive Foxhall Road, the collection delivers a superb overview of nineteenth- and twentieth-century painting and sculpture. The Kreegers only collected works they both liked. Fortunately for art lovers, the couple's tastes aligned over Pablo Picasso, Claude Monet, Pierre-Auguste Renoir, and Vincent van Gogh. It's the harmonious mix of art, architecture, and nature that makes a visit to the Kreeger Museum so unforgettable.

Color and texture are the unifying elements of the art, which the founder of GEICO and his wife began collecting in the 1950s with nineteenth-century French landscapes by Renoir, Jean-Baptiste-Camille Corot, and Gustave Courbet. Their tastes gradually shifted toward the more abstract and avant-garde, including African sculpture and masks and paintings by Frank Stella, Arshile Gorky, Max Beckmann, and Edward Munch. "Ours is a living collection," said Kreeger, "and therefore constantly shifting, improving, and changing."

To design a showplace for their collection, the Kreegers hired Philip Johnson, creator of the Seagram Building (with Mies van der Rohe) and his own iconic Glass House. The Cleveland-born, Harvard-educated architect had recently finished an elegant glass-walled gallery at Dumbarton Oaks in neighboring Georgetown. For the Kreeger abode, no luxury was spared, including nine hundred tons of Italian travertine marble inside and out.

David and Carmen Kreeger on Sculpture Terrace, 1978

Johnson's travels to Egypt and India also inspired what he called his "contemporary Moorish" design. He worked with a geometric grid of twenty-two-foot cubes, two stories high, many topped with vaulted domes. The biggest challenge facing the architect, an art collector himself, was balancing sunlight and views of the wooded five-acre property with space for 150 paintings and 50 sculptures.

Johnson's solution was to use glass almost exclusively for the home's back walls, creating powerful interplays between art and nature. The architect who liked "seeing only one picture at a time" designed uncluttered gallery space that invites private contemplation of the art.

Surprisingly the immense building stretching over two hundred feet long and one hundred feet deep contained just three bedrooms for the Kreegers (plus another three bedrooms for a servant's wing). Art acquired during construction required Johnson to add three galleries on the lower level, used today to display large abstract paintings. Johnson prevailed over aesthetic decisions—like when he vetoed a diving board for the family swimming pool. The Kreeger children dove off the terrace instead. Carmen Kreeger did insist on a hidden door in the master bedroom so she could reach the kitchen without a hike.

Three decades after its completion, the home opened as a museum. Small guided tours start in the sweeping Great Hall, where prized paintings hang on beige carpeted walls. At the far end of the room by the window is a grand piano used for chamber music recitals. Kreeger, the son of Russian immigrants who ran a small grocery store in New Jersey, helped put himself through Rutgers and Harvard Law School playing the violin in the Adirondacks. He played his Stradivarius alongside virtuoso guests like Isaac Stern and Pablo Casals.

Solid teak doors lead to the show-stealing dining room featuring nine paintings by Monet and spectacular views of the garden and sculpture terrace. The quintessential impressionist, Monet began his career along the rugged Normandy coast and spent his later years painting at his home and garden in Giverny, north of Paris.

The Kreeger's sumptuous Monets span fifteen years, from 1882 to 1897. It's a period that begins three years after Monet's wife Camille died and ends five years after his marriage to Alice Hoschede, the widow of his art patron. Most of the Kreeger's paintings are lyrical, misty studies of light and water, harbingers of the artist's famous water lilies series.

There's nothing subtle about the works of Picasso, widely considered the most important artist of the twentieth century. The Kreeger collection includes eleven Picassos, starting with the early *At the Café de la Rotonde*. Twenty-year-old Picasso exaggerates and distorts the principles of impressionism, cutting off the side of the scene of two women behind a cafe table, eliminating half of one of his subjects and decapitating another.

Around 1907, Picasso and Georges Braque established a new art form—reducing faces, bodies, and still-life subjects into circles, triangles, and cubes. Their art laid the groundwork for other cubists like Juan Gris, Fernand Leger, and Marcel Duchamp. Among Picasso's favorite subjects were his wives and mistresses, whose moods he captured with vibrant color and shapes.

The influence of African masks and sculptures on Picasso and his fellow Cubists is immediately clear in the African art gallery. Contemporary acquisitions include works by artists such as Thomas Downing, James Rosenquist, Milton Avery, Larry Poons, Gene Davis, and Sam Gilliam. Sculptures by Jean Arp, Jacques Lipchitz, Aristide Maillol, Henry Moore, and Isamu Noguchi stand serenely on the terrace. The effect of these works overlooking a forest of trees is breathtaking.

The Great Hall might look different today if David Kreeger hadn't asked Marc Chagall for a preparatory sketch. In 1968 Chagall visited the mansion and proposed a triptych *Love, Art and Music*. The artist, who always referred to himself in the third person, bristled at Kreeger's request, saying, "Chagall does not do sketches." "I figured this thing was going to be in six figures, and I didn't want to be disappointed, so I said no dice," recalled Kreeger. "In retrospect, of course, it was a mistake."

GETTING THERE Address: 2401 Foxhall Rd., NW, Washington, DC Phone: (202) 338-3552 Website: kreegermuseum.org Hours: Friday and Saturday 10:00 a.m. to 4:00 p.m., with optional tours at 10:30 a.m. and 1:30 p.m. on Friday and 10:30 a.m., 12:00 p.m., and 2:00 p.m. on Saturday; Tuesday, Wednesday, and Thursday tours at 10:30 a.m. and 1:30 p.m., reservations required Admission: Adults, $10, seniors and students $7

Not to Miss

Bowl with Zinnias, Vincent van Gogh, 1886

Vincent van Gogh's nearly two-year stay in Paris influenced the remarkable works of the last four years of his life. After arriving from Antwerp, van Gogh traded his muted brown and grays for the vibrant palette of the impressionists and experimented with the color and compositions of Japanese printmakers. Thickly painted red, orange, yellow, and white zinnias appear to burst out of the bowl. The dramatic background and table feature cross-hatched strokes—a technique van Gogh repeated in works like *Gauguin's Chair* and *Sunflowers*.

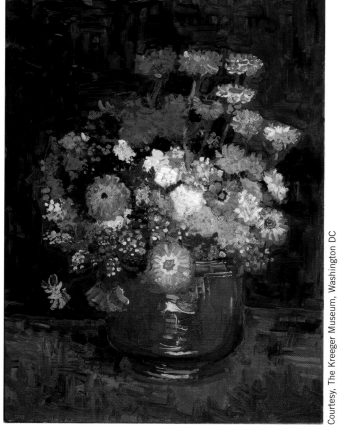

Courtesy, The Kreeger Museum, Washington DC

Springtime at Giverny, Claude Monet, 1886

Throughout his long career, impressionist Claude Monet famously painted his immediate surroundings. From 1883 until his death in 1926, the artist's main source of inspiration was his home in the village of Giverny, about fifty miles north of Paris. In this joyous celebration of spring, Monet captures Giverny's flowering trees with short, thick strokes of pure pigment. In addition to planting flowers and rare botanical varieties, Monet created the water garden depicted in his Japanese bridge and water lilies series.

Houses and Fir Trees, Paul Cézanne, circa 1881

"He was our father," said Pablo Picasso about Paul Cézanne, whose paintings bridged the gap between impressionism and cubism and laid a foundation for early modernism. In the 1870s the young Cézanne was attracted to the new impressionist movement led by Camille Pissarro. A decade later Cézanne moved frequently between Paris and nearby areas and his native Provence, painting still lifes and earth tone landscapes.

MORRIS MUSEUM OF ART
Augusta, Georgia

"Morris visitors are not just surprised, but stunned to find a permanent collection of extraordinary quality and range that delights and enlightens."

—John Baeder, artist

❧ Each spring the world's top golfers descend on Augusta, Georgia, vying for the coveted green jacket at the Masters Golf Tournament. This golf mecca located on the west bank of the Savannah River has also produced performing artists Jessye Norman, James Brown, Laurence Fishburne, and Danny Glover. It's also home to a little-known museum, the Morris Museum of Art, dedicated to the region's rich visual culture.

Situated near the Jessye Norman Amphitheatre along downtown Augusta's tree-lined Riverwalk, the Morris Museum celebrated its twentieth anniversary in 2012. Occupying the first three floors of a brick office building, the museum was established by William S. Morris, III, chairman and CEO of Morris Communications Corporation, parent company of Globe Pequot Press. Morris founded the museum in memory of his parents, William Shivers Morris Jr. and Florence Hill Morris.

The museum's unique Southern focus took shape in 1989 to 1993 with the purchase of 230 paintings and acquisition of another 900 works from the collection of Dr. Robert Powell Coggins. The Marietta, Georgia, physician assembled an early collection of Southern art during the 1970s that he believed represented the "tranquil, slow, relaxed politeness of the true South." Among the artists represented

are Willie M. Chambers, Nell Choate Jones, Elliott Daingerfield, and Thomas Addison Richards.

The museum has continued to build on that foundation, assembling a permanent collection of

Photo by Brent Cline 2011. Courtesy of the Morris Museum of Art, Augusta, Georgia

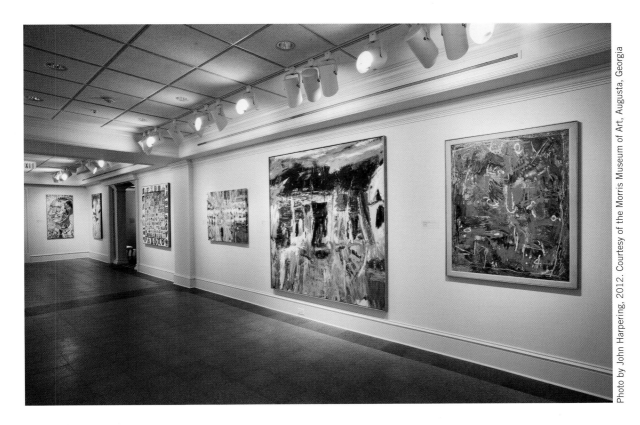

Photo by John Harpering, 2012. Courtesy of the Morris Museum of Art, Augusta, Georgia

nearly five thousand works reflecting the region's diversity with a wide range of artistic styles. Another important acquisition came in 2006—about one thousand objects from the collection of Washington, DC–based art collector Julia J. Norrell, daughter of two congressional representatives from Arkansas. These include works by Beverly Buchanan, Eldridge Bagley, William Clarke, Nancy Witt, William Tolliver, and Stephen Kimball.

The South is defined broadly at the Morris, with sixteen states represented, including Maryland, the District of Columbia, Kentucky, and Texas. A grand staircase leads to the intimate second-floor galleries organized by category—from nineteenth-century portraiture, still-life paintings, and the Civil War to impressionism, modernism, and contemporary art. The portrait gallery is designed to evoke a period salon, furnished with a nineteenth-century piano and secretary.

Throughout the galleries visitors discover paintings by a number of artists not typically associated with the South. Among these are portraits by Samuel F. B. Morse, who spent three years painting Charleston's elite before moving back to New York. Before settling permanently in France, Henry Ossawa Tanner painted *Georgia Landscape* during his time in Atlanta in the late 1880s. The Hudson River School's Martin Johnson Heade produced *Two Magnolia Blossoms in a Glass Vase* during his residence in St. Augustine, Florida.

Within the modern art category fall works from the Charleston Renaissance, an artistic and literary revival between the two World Wars. Charleston native Elizabeth O'Neill Verner, who studied in

Mr. and Mrs. William S. Morris III

Philadelphia, London, and Japan, is known for her South Carolina low-country scenes, like the museum's *Avenue of Oaks at Litchfield Plantation*. Verner's rival, Alfred Hutty, is also represented, as are artists Alice Ravenel Huger Smith, Anna Heyward Taylor, and Ellen Dale Hale.

Other modernists include Georgia artist Lamar Dodd, the influential director of the art department at the University of Georgia. After starting out as an American Scene painter, Dodd made a midcareer shift to abstraction. Also represented are paintings and late sculptures by Louisianan Ida Kohlmeyer. As a teacher at Tulane University, Kohlmeyer was influenced by visiting artist Mark Rothko.

The museum's growing photography collection numbers about six hundred images. Among its strengths are images of life in the South during the Great Depression taken by Farm Security Administration photographers Walker Evans and his friend Ben Shahn, along with Dorothea Lange and Esther Bubley. From the same period come another group of evocative photographs by Eudora Welty, who photographed the rural poor of her native Mississippi before achieving success as a writer. Many

of the South's most important contemporary photographers are also in this collection—including Dave Anderson, John Baeder, William Eggleston, Birney Imes, Greg Kinney, Sally Mann, and Meryl Truett.

Among the most important contemporary artists represented here in photography and other media is William Christenberry. A native of Alabama, Christenberry uses everyday objects to evoke place and the passage of time. In the abstracted *Tenant House II*, blue sky and spring green grass frame the house of a family of sharecroppers, neighbors of the artist's grandparents. The museum also owns a group of Christenberry's Alabama photographs.

Another contemporary Southern artist in the collection is South Carolinian Jonathan Green, best known for capturing the rich traditions of the Gullah, a group of African Americans who settled on the islands and marshlands from Florida to North Carolina. *Daughters of the South* is a good example of the artist's distinctive style and vibrant palette. "The sense of my art is in my culture," said Green, a graduate of the Art Institute of Chicago.

Through commissions the Morris has added a national sensibility to its collection. Robert Rauschenberg's large-scale 1997 *August Allegory* is filled with images of the city—from church steeples and a Confederate monument to a nineteenth-century textile mill and golf references. The following year, Wolf Kahn re-imagined the barn in intense, vibrant hues in *Cotton Barn at Beech Island, South Carolina*.

The work of self-taught artists represents another unique genre in the collection with imagery rich in personal histories. Among the group of largely unknown artists is William O. Golding. Kidnapped dockside as a child by a ship captain and his wife, he spent over four decades at sea "knocking around the world." Golding immortalized the exotic ports and turn-of-the-twentieth-century ships with a remarkable series of drawings.

The museum organizes special exhibitions each year that complement its permanent collection. Recent shows have included the architectural paintings of Augusta-born Edward Rice and portraits by watercolor artist South Carolinian Mary Whyte.

GETTING THERE Address: 1 10th St., Augusta, GA Phone: (706) 724-7501 Website: themorris.org Hours: Tuesday to Saturday 10:00 a.m. to 5:00 p.m.; Sunday noon to 5:00 p.m. Admission: Adults $5, seniors, students, and military $3, children 12 and younger free; Sunday free

Not to Miss

The Morris Museum of Art, Augusta, Georgia

Hoover and the Flood, John Steuart Curry, 1940

In the aftermath of Katrina, John Steuart Curry's monumental painting of the 1927 Mississippi River flood has new resonance. Part of *Life* magazine's series on modern American history, the painting's central figure raises his arms to heaven while a nearby mother and child, in the pose of a Madonna and child, sit by a group of refugees huddled by a relief boat. Amid the suffering is a calm Herbert Hoover, who as secretary of commerce, was in charge of relief efforts. Along with Thomas Hart Benton and Grant Wood, Curry was a leading painter of the regionalist movement that focused on everyday scenes from the Midwest and South.

Sunset Glory, Elliott Daingerfield, circa 1915

Born in Harper's Ferry, Virginia (now West Virginia), and raised in Fayetteville, North Carolina, Elliott Daingerfield spent his early career in New York, where he befriended symbolist painter George Inness. Like his mentor, Daingerfield uses light and color to evoke a sense of mysticism. The symbolic nature of Daingerfield's paintings became even more profound after the death of his wife during childbirth. In this otherworldly painting, Daingerfield reinterprets the rugged landscape of Blowing Rock, North Carolina, where he lived and worked.

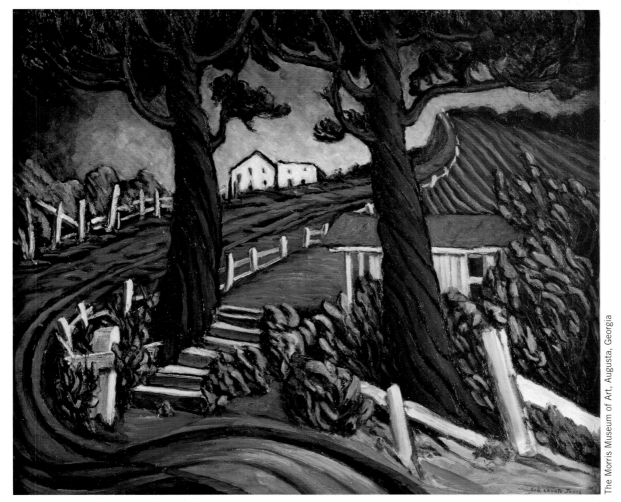

Georgia Red Clay, Nell Choate Jones, 1946

Hawkinsville, Georgia, native Nell Choate Jones moved to Brooklyn, New York, at age four. After starting her artistic career in her forties, Jones found inspiration when she returned home for her sister's burial in 1936. From then on she traveled south frequently, painting the people and lush rural landscape—like this expressionist work with its vivid palette, thick brushstrokes, and exaggerated shapes. "I was born here, I am a Southerner and that's all there is to it," Jones said in an interview with her hometown newspaper. When she died at age 101, her ashes were buried in Georgia clay.

SHELDON MUSEUM OF ART
Lincoln, Nebraska

"The entirety of the Sheldon's components—the marble cladding, columns, arched windows and golden ceiling—make this the most glamorous of [Philip Johnson's] Look for Beauty museums."

—Mary E. Murray, curator of Modern & Contemporary Art,
Munson-Williams-Proctor Arts Institute

In addition to its fifteen-story art deco statehouse, Lincoln, Nebraska, boasts another gem. The elegant Sheldon Museum of Art at the University of Nebraska campus houses an inspired collection of modern art. A series of special exhibitions celebrating the graceful building, abstract art and photography, and cornerstone art collection is planned for the museum's 2013 golden anniversary.

The Sheldon is named for Mary Frances Sheldon and her brother, Adams Bromley Sheldon, who

earmarked funds for a new university gallery. Fresh from designing the Munson-Williams-Proctor Arts Institute in Utica, New York, and the Amon Carter Museum in Fort Worth, Texas, Philip Johnson was hired to build what he called a "temple for art" in Lincoln.

Johnson spared no expense for his classically inspired building, importing white travertine marble from Italy. Two-story glass windows offer views of the dramatic Great Hall, topped with an arched ceiling

© Sheldon Museum of Art, University of Nebraska-Lincoln

The Great Hall

and large gold leaf disks. Two smaller main floor galleries host the museum's annual statewide exhibition and other special shows. Open double staircases form a bridge leading upstairs, where three large north galleries present permanent collection and traveling exhibitions and six intimate south galleries feature works from the permanent collection.

The stellar university art collection was started at the turn of the twentieth century thanks to a community organization, the Nebraska Art Association. Each spring the group organized a show based on recommendations from art faculty. Collectors like Frank and Anna Hall bought paintings by artists like Stuart Davis, Edward Hopper, and Maurice Prendergast, which they later bequeathed to the University. In 1928 the bulk of the couple's estate was placed in a trust for art acquisitions; to date over one million dollars has gone toward masterworks for the Sheldon.

For three decades the Sheldon's artistic force was its director, Norman Geske, who celebrated his ninety-fifth birthday in 2011. Until his retirement in 1983, Geske oversaw the construction of the museum and helped grow the permanent collection with the financial support of Adams Sheldon's widow, Olga.

With nearly 30 percent of its works created by artists born outside the United States, the Sheldon has adopted a "transnational" approach to its collection. Each year curators organize thought-provoking exhibitions using broad, interdisciplinary themes that encourage new dialogues about the collection. Past themes have explored the porous boundaries of American art, women artists, portraiture, landscape, and still life.

American modernists in the Sheldon collection, such as Marsden Hartley and Alfred Maurer, returned to still life after being inspired by European avant-garde artists like Paul Cézanne, Henri Matisse, and Pablo Picasso. Georgia O'Keeffe, who'd never been to Europe, became an icon for the authentic American modernist painter. Her uniquely American subject matter is illustrated by the Sheldon's *New York, Night.*

Another strength here is American scene painting, starting with regionalists Thomas Hart Benton, John Steuart Curry, and Grant Wood. Although their styles differed, the three realist painters celebrated the rural Midwest in direct contrast to the abstraction of the East Coast art establishment. Ironically one of Benton's students was an aspiring painter named Jackson Pollock.

Social realism is represented by artists like Ben Shahn, Diego Rivera, Jacob Lawrence, and Philip Evergood. "Representations will never be replaced by something new because new minds add phrases to it, just as the violin will always remain an instrument because it supplies a need—a special beauty—a quality in music which nothing else can replace," wrote Evergood.

The collection also features work by artists such as Stuart Davis, Milton Avery, and John Marin, who combined representation and abstraction. *Arch Hotel*, one of Davis's Paris street scenes, incorporates the artist's signature words and phrases. The tilting buildings and faceless pedestrians of *Pertaining to Nassau Street, New York* illustrate Marin's genius for watercolor.

Avery's interest in the relationship among shapes, spaces, and color is evident in *Offshore Island*, with its distinct bands of blues, white, and tan representing sky, sea, surf, and sand. Often described as an American Henri Matisse, Avery gained recognition relatively late, having his first solo show around age sixty. The native New Yorker influenced a number of painters, including his friends Mark Rothko and Adolph Gottlieb.

Among the highlights of the Sheldon's African-American Masters collection are Jacob Lawrence's painting *Paper Boats*, Romare Bearden screen prints, and graphics by University of Nebraska alumnus Aaron Douglas. Abstract art is well represented by Rothko, Willem de Kooning, Pollock, Lee Krasner, and Helen Frankenthaler.

GETTING THERE Address: 12th and R Sts., Lincoln, NE (on the University of Nebraska-Lincoln campus) Phone: (402) 472-2461 Website: sheldonartmuseum.org Hours: Tuesday 10:00 a.m. to 8:00 p.m., Wednesday to Saturday 10:00 a.m. to 5:00 p.m., Sunday noon to 5:00 p.m. Tours: Museum and Sculpture Garden tours by appointment, (402) 472-9426 Admission: Free

Not to Miss

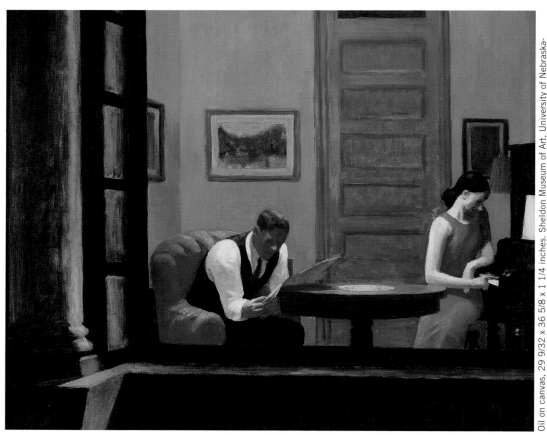

Oil on canvas, 29 9/32 x 36 5/8 x 1 1/4 inches. Sheldon Museum of Art, University of Nebraska-Lincoln, UNL–Anna R. and Frank M. Hall Charitable Trust. Photo © Sheldon Museum of Art

Room in New York, Edward Hopper, 1932

About his friend Edward Hopper, the artist Charles Burchfield wrote, "The element of silence . . . seems to pervade every one of his major works . . . it can almost be deadly as in *Room in New York.*" In this painting Hopper separates the viewer from the room's interior with a window ledge. Inside, a man absorbed in a newspaper ignores a female companion who strikes a piano key. Hopper described this scene as a synthesis of many lighted interiors he'd seen in Greenwich Village, where he lived in the same apartment from 1913 until his death in 1967. Hopper's teachers included William Merritt Chase and Robert Henri. His wife, Josephine Nivison, was his primary female model.

Bravado, Aaron Douglas, 1926

After graduating from the University of Nebraska in 1922, Aaron Douglas became one of the leading visual artists of the Harlem Renaissance, illustrating magazines and literary works by writers like Langston Hughes and Alain Locke. In his graphic art and paintings, Douglas combines cubism, art deco, and African imagery to create a totally unique visual style. This small, striking monochromatic woodcut is one of four from the artist's *Emperor Jones* series, based on Eugene O'Neill's racially charged play. Douglas's murals grace the 135th Street Branch of the New York Public Library and campuses of Bennett College and Fisk University, where he taught art for over twenty-five years. "I refuse to compromise and see blacks as anything less than a proud majestic people," Douglas said.

Transplanted, Niho Kozuru, 2011

Fifty years ago on Philip Johnson's suggestion, the Sheldon acquired Isamu Noguchi's towering two-piece granite and marble *Song of the Bird* for the Great Hall. Today the masterwork has struck up a lively dialogue with the colorful, multi-branched *Transplanted* by Niho Kozuru. Like Noguchi, Kozuru uses segments to create her sculptures; like Johnson, she draws her shapes from classical forms. The base of her work echoes the ovals of Johnson's interior ceiling. "These two modernists, Noguchi and Johnson, both emphasized clarity and essence of form in their work," says Kozuru. "*Transplanted* echoes this modernist vision and looks back at the root of classical forms."

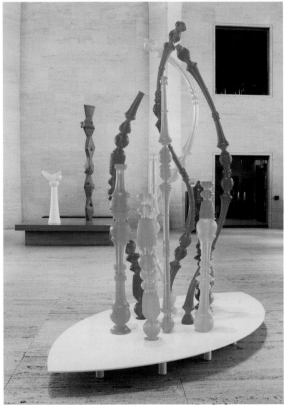

BABY BILBAO

WEISMAN ART MUSEUM
Minneapolis, Minnesota

"You get the idea that your visit will not only be worthwhile, but probably even fun."

—*Star Tribune*

In an age of cookie-cutter museums, Frank Gehry's shimmering stainless steel Weisman Art Museum (WAM) overlooking the Mississippi River at the University of Minnesota is itself a work of art. An addition by Gehry in 2011 is finally allowing the museum's other star to shine—a fine collection of modern art from the first half of the twentieth century.

WAM is named for Minneapolis native and businessman Frederick Weisman, who attended the University of Minnesota for a semester. Toward the

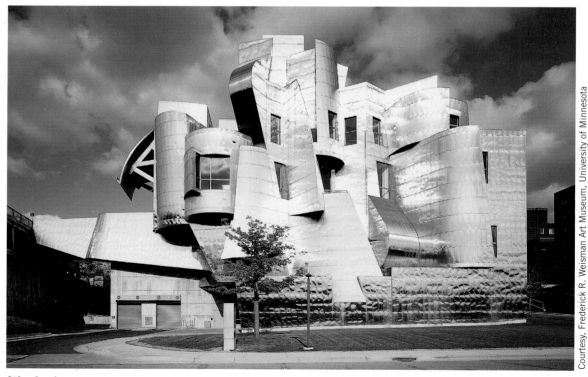

West facade

Courtesy, Frederick R. Weisman Art Museum, University of Minnesota

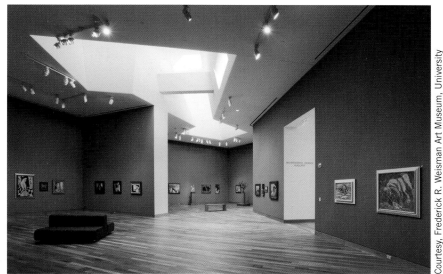

Gallery

end of his life, Weisman decided to leave his contemporary art collection to the public, turning his Holmby Hills, California, home into a museum and establishing campus galleries at Pepperdine University in Malibu and the University of Minnesota.

A fan of Gehry, Weisman commissioned the California architect to design his Toyota headquarters in Bethesda, Maryland. WAM was the first museum Gehry designed from scratch, located on an elevated site facing the river. "The first inspiration came from the Tibetan monasteries that are on hills, where the big frontal elevation is off the side of a cliff," said Gehry. Four years later he used many of the same inventive features and materials for the Guggenheim Museum in Bilbao, Spain, considered among the world's finest contemporary museums.

With WAM's collection approaching twenty thousand works, octogenarian Gehry returned to add much-needed gallery space to the Twin Cities landmark. A walkway topped with a swooping metal canopy leads to the museum entrance. Inside, Roy Lichtenstein's laughing comic book–style redhead in

World's Fair Mural still greets visitors, but now she hangs above a Gehry-designed reception desk made of logs.

In addition to a creative collaboration studio, Gehry created four new third-floor galleries that double the space devoted to art from the permanent collection. Supported by pedestals, the cube-shape galleries pop out of the museum's brick campus-facing side, designed to complement the surrounding buildings. Gehry again turned to geometric skylights to bathe paintings, sculpture, and ceramics with natural light. Richly painted walls and oak floors create a warm, serene backdrop.

The two new American modernism galleries pay tribute to the people who shaped the collection—starting with Hudson Walker, grandson of the founder of the nearby Walker Art Center. In the 1930s, as the museum's first curator and director, Walker helped steer the fledgling gallery toward contemporary American art. In 1936 Walker opened his own gallery in New York City, where he represented artists like Marsden Hartley and Alfred Maurer. At his death in 1976, Walker bequeathed over twelve

hundred works to the university, giving it the largest single collection of Hartley and Maurer paintings.

Another figure who helped form the collection was Walker's successor, museum director Ruth Lawrence. Through her friendship with Alfred Stieglitz, Lawrence acquired many important works for the museum, including its two beloved Georgia O'Keeffe paintings. O'Keeffe was among the cadre of avant-garde American and European artists that Stieglitz promoted in his New York galleries. Other artists he championed include Auguste Rodin, Pablo Picasso, Henri Matisse, Hartley, Arthur Dove, John Marin, and Stanton Macdonald-Wright.

Soon after moving to California, Macdonald-Wright painted WAM's stunning prismatic *Canon Synchromy (Orange)*. Five years earlier in Paris, Macdonald-Wright had cofounded synchronism, an art movement based on the work of French scientist Eugene Chevreul. Considered the first abstract American art, Macdonald-Wright's synchromies were composed according to the same harmonies as musical compositions.

In 1938, while organizing the first US retrospective for Lyonel Feininger, Lawrence acquired *Drobsdorf I*. In Feininger's cubist vision of a German seaside church, building and sky merge through abstracted angles and blended color. A teacher at the influential Bauhaus School in Weimar, Germany after World War I, the New York–born artist spent over half his life in Europe producing paintings, prints, and photographs.

Another celebrated modernist at WAM is African-American painter Jacob Lawrence, known for his observations of urban life. In *Dancing Doll*, Lawrence depicts a lively street scene of a peddler selling colorful marionettes. Just before creating this work, Lawrence achieved national recognition with sixty paintings about the migration of African Americans from the rural South to the industrial North. Lawrence's last public work, the mosaic mural *New York in Transit*, decorates the Times Square subway station.

Twenty years before the Civil Rights movement, Robert Gwathmey, a white artist from Richmond, Virginia, devoted his career to showing the aspirations of African Americans. In *Nobody Around Here Calls Me Citizen*, a tired black man sits next to the number two, symbol of his second-class status. Annual trips to his native Virginia led Gwathmey to write: "Artists have eyes . . . You go home. You see things that are almost forgotten. It's always shocking."

WAM's sculpture collection includes Louise Nevelson's *Silent Music VII* and David Smith's *Star Cage*, created in 1950 at his studio in Bolton Landing, New York. Trained as a painter, the Decatur, Indiana–born artist's innovative welded works are considered the sculptural counterpart to the abstract expressionist paintings of his friends.

WAM's outstanding ceramics collection is showcased in a new sunlit gallery. Over eight hundred pieces of ancient Mimbres pottery came to Minneapolis when University of Minnesota professor Alfred Jenks excavated a southwestern New Mexico village between 1929 and 1931. Ancient Greek pieces reside alongside contemporary works, many donated by former faculty member and ceramic artist Warren MacKenzie.

GETTING THERE Address: 333 East River Rd., Minneapolis, MN (on the campus of the University of Minnesota) Phone: (612) 625-9494 Website: weisman.umn.edu Hours: Tuesday, Thursday, Friday 10:00 a.m. to 5:00 p.m.; Wednesday 10:00 a.m. to 6:00 p.m.; Saturday and Sunday 11:00 a.m. to 5:00 p.m. Admission: Free

Not to Miss

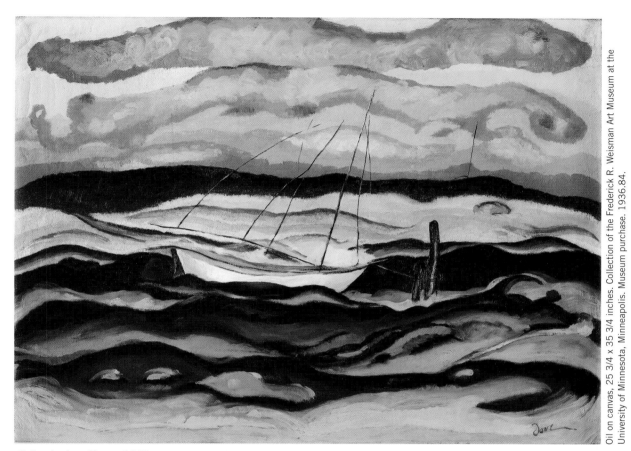

Oil on canvas, 25 3/4 x 35 3/4 inches. Collection of the Frederick R. Weisman Art Museum at the University of Minnesota, Minneapolis. Museum purchase. 1936.84.

Gale, Arthur Dove, 1932

In a letter to Alfred Stieglitz, Arthur Dove described a storm he experienced at sea from his boat: "It is now 3:45 a.m. in the midst of a terrific gale . . . have been trying to memorize this storm all day so that I can paint it. Storm green and storm gray . . ." In this canvas painted when Dove lived at a yacht club on Long Island's north shore, clouds and sea appear as hands, arms, and eyes. Inspired by Paul Cézanne and Pablo Picasso in Paris, Dove went on to develop his signature style to depict nature. In the 1930s Dove took inspiration from Georgia O'Keeffe's "burning watercolors" and took up the medium. At her house in Abiquiu, New Mexico, O'Keeffe hung two Dove paintings. "Dove is the only American painter who is of the earth," she wrote.

Oil on canvas, 32 1/4 x 21 1/2 inches. Collection of the Frederick R. Weisman Art Museum at the University of Minnesota, Minneapolis. Bequest of Hudson D. Walker from the Ione and Hudson D. Walker Collection. 1978.21.234.

Portrait, Marsden Hartley, circa 1914–1915

Part of a series Marsden Hartley created while living in Berlin at the start of World War I, this abstracted painting mixes cubist collage with the coarse brushwork and bright colors of German expressionism. The portrait depicts Hartley's friend, twenty-four-year-old German cavalry officer Karl von Feyburg, who was killed during the early months of the war. Hartley includes heraldic war images and individual references to his friend like his initials and regiment number. A quarter century later, Hartley would immortalize another deceased friend in *Adelard the Drowned, Master of the Phantom,* a member of the family of fishermen he lived with in Nova Scotia. Hartley's German officer paintings inspired ten large silk screen prints by Robert Indiana, *The Hartley Elegies.*

Oil on canvas, 30 x 40 1/8 inches. Collection of the Frederick R. Weisman Art Museum at the University of Minnesota, Minneapolis. Museum purchase. 1937.1.

Oriental Poppies, Georgia O'Keeffe, 1927

Of all Georgia O'Keeffe's themes, her close-up, detailed flowers caused the biggest stir and made her a celebrity. The Wisconsin-born artist produced most of her two hundred giant, brilliantly colored flower paintings between 1918 and 1932 during her courtship and marriage to Alfred Stieglitz. While many critics focused on the flowers' erotic shapes, O'Keeffe explained her interest in her 1939 memoir: " . . . nobody sees a flower—really—it is so small—we haven't time—and to see takes time like to have a friend takes time." Along with O'Keeffe's *Oak Leaves, Pink and Gray*, this brilliantly colored painting of two giant poppies is among WAM's most beloved works.

Buffalo Bill—The Scout, Gertrude Vanderbilt Whitney, 1924, Whitney Gallery of Western Art

NATIVE AMERICAN
& WESTERN ART

MILLICENT ROGERS MUSEUM
Taos, New Mexico

"If anything should happen to me now, ever, just remember all this. I want to be buried in Taos with the wide sky."

—Millicent Rogers, in a letter to her son

Standard Oil heiress and fashion icon Millicent Rogers amassed a stunning art collection in her five short years in Taos, New Mexico. Today her prized possessions are housed in a rambling adobe surrounded by the snowcapped Sangre de Cristo Mountains. Highlights from the eight thousand–object collection are displayed in intimate galleries—from Spanish Colonial and Hispanic art to Native American jewelry, textiles, baskets, and pottery.

Rogers famously traveled with seven dachshunds and a pet monkey draped around her neck. After three divorces and broken romances with Clark Gable, Ian Fleming, and Roald Dahl, Rogers took a much-needed vacation in northern New Mexico in 1947. The area's scenic beauty and rich indigenous cultures proved irresistible, and two years later Rogers bought a ranch in Taos.

Rogers decorated her adobe, Turtlewalk, in an eclectic style, mixing paintings by Pierre-Auguste Renoir and Jean-Baptiste-Camille Corot with Navajo rugs, Pueblo pottery, Native American baskets, and Spanish–New Mexican furniture. Similarly, she mixed couture fashion with Southwest-style clothing: pearls and diamonds with handcrafted turquoise and silver jewelry. By the end of her life in 1953 at age fifty, Rogers had developed a strong spiritual connection to Northern New Mexico.

After Rogers's death, her family established a museum to showcase her collection. In 1968 the museum relocated to a 1930s adobe donated by family friend, Claude Anderson. During an addition of two galleries and a new entrance in the mid-1980s, architect Nathaniel Owens was careful to preserve the original house with its kiva fireplaces and low ceilings adorned with pine vigas and cedar *latillas*. Several sets of initials, including *MR* for "Millicent Rogers," are etched on the original wooden front steps.

Rogers's great love was jewelry, and her presence is felt most keenly in the jewelry gallery filled with her stunning squash blossom necklaces, concha belts, cuffs, and rings. Alongside individual pieces are photographs of Rogers wearing her necklaces and several bracelets on each arm. Rogers bought most of her one thousand-plus pieces directly from Native artists who she met during trips to the Navajo reservation, local fairs, and pueblos. Also on view are Rogers's own bold gold, silver, and copper designs, along with hundreds of the silver buttons she liked to sew onto her velvet blouses.

Although Native artisans shared similar tools and techniques, each tribe developed its own distinctive style—from Navajo stamp and chisel work to Zuni multiple stonework and Hopi overlay style. The museum has continued to add to Rogers's core collection with contemporary pieces by Native and Hispanic

Courtesy of Millicent Rogers Museum

Millicent Rogers

artists like Charles Loloma, Kenneth Begay, Charlie Bird, Gail Bird, Yazzie Johnson, and Larry Martinez. Starting with traditional metalworking techniques, these designers have experimented with color, material, and texture to create distinctive art jewelry.

In the twentieth century a group of highly influential women revived the region's pottery tradition. Among them is acclaimed San Ildefonso potter Maria Martinez. A gallery traces Martinez's long career—from polychrome works to her gleaming "black on black" pieces. From neighboring Santa Clara Pueblo came Margaret Tafoya, who decorated her large, highly polished pots with "bear-paw" imprints and carved designs like water serpents and kiva steps. Acoma Pueblo potter Lucy Martin Lewis revived the ancient Mimbres black-on-white design. Lewis's signature black-on-white and starburst patterns are on display, along with rare Mimbres pottery that inspired her.

The Basket Room is home to stunning works by the Apache, Hopi, and Rio Grande peoples. Of the Southwest tribes, the nomadic Western Apaches are considered the masters of basket weaving. Using willow, cottonwood, or sumac, Apache women created tall open-mouth ollas and shallow bowls that they decorated with complex geometric designs and important iconography.

The museum's Spanish Colonial gallery is anchored by a large European-style loom, the type used to create the colorful Rio Grande wool textiles on display. The traditional mud floor is also authentic and rare—one of just two remaining such floors in Taos. Next door, in the chapel-like Hispanic Religious Room, are examples of the region's liturgical art. Missionary priests from Spain and Mexico traveled to New Mexico with carved saint figures or santos. Local *santeros* began creating their own painted panels known as *retablos* and wood-carved statues or *bultos*.

Rogers sought out the finest Native American textiles, which she used in her home for rugs, wall hangings, and sofa throws. Selections of her prized blankets are rotated in the textile gallery, a visually powerful survey of Navajo blanket making. The rarest blankets—first phase Ute-style from the 1820s to mid-nineteenth century—feature brown, blue, and white bands and stripes. For the next three decades, Navajo weavers added a dozen red rectangles, known as second-phase chief's blankets. Third-phase blankets are distinguished by diamond and half-diamonds decorated with zigzags, crosses, and triangles.

Many of the extraordinary textiles, pottery, and baskets in the collection were created for utilitarian purposes. But by adding designs, generations of artists imbued them with religious and ceremonial importance. The museum recently paid tribute to generations of anonymous Hispanic and Native women weavers, potters, and basket makers with a special exhibit.

During her last years, Rogers traveled to Washington, DC to lobby for citizenship for Native Americans and successfully fought for Indian art to be classified as "historic" to provide protection and status. Per Rogers's wishes, she was buried in a cemetery on the edge of Taos Pueblo "in an Indian blouse, skirt, moccasins and wrapped in a Navajo blanket."

GETTING THERE Address: 1504 Millicent Rogers Rd., Taos, NM Phone: (575) 758-2462 Website: millicentrogers.org Hours: Daily 10:00 a.m. to 5:00 p.m., closed Monday from November to March Admission: Adults $10, seniors $8, students $6, children 6 to 16 $2

Not to Miss

Courtesy of Millicent Rogers Museum

Serpent Pot, Maria Martinez, San Ildefonso Pueblo, 1957

Among the most famous Native American artists of the twentieth century, Maria Martinez was born in the late 1870s and created pottery for over eighty-five years. This beautiful polychrome pot features a serpent motif, a favorite design. Along with her husband, Julian, Martinez created the first black-on-black pottery. These matte designs with highly polished backgrounds and silvery sheens proved so popular with collectors that Martinez taught the technique to others in her pueblo. Many of Martinez's descendants carry on her legacy through their own pottery.

Turquoise Tab Necklace, Leekya Deyuse, Zuni, circa 1945

Millicent Rogers's taste in jewelry ran to the weighty and dramatic, but even she was wowed by this necklace when she saw it at the 1947 Gallup Inter-Tribal Ceremonial. Weighing about four pounds, the spectacular double strand by Leekya Deyuse features a large Cerillos turquoise pendant hung from 294 individually polished turquoise nuggets. Turquoise is important in Zuni religion and mythology, symbolizing wealth and status. The museum also owns examples of the artist's intricately carved bird and animal fetishes.

Courtesy of Millicent Rogers Museum

Courtesy of Millicent Rogers Museum

Germantown Eye Dazzler, Navajo Nation, 1890–1900

Navajo blankets have been highly prized possessions since the early nineteenth century, when they were worn and traded to the Sioux, Cheyenne, and Ute as signs of wealth and prestige. This finely woven "eye dazzler" belonged to Millicent Rogers. It features a serrated diamond design woven in a kaleidoscope of colors, framed by a multicolored stepped border. The use of brightly colored Germantown, Pennsylvania, yarns started in the 1860s, when thousands of Navajo were forcibly relocated to New Mexico's Bosque Redondo. The rich hues and dazzling designs reflect the taste of collectors.

NEW MEXICO MUSEUM OF ART
Santa Fe, New Mexico

"The new museum is a wonder."

—Robert Henri, 1917

❧ Santa Fe, New Mexico, is one of the nation's most artistic cities, home to numerous galleries and museums. An excellent starting point is the New Mexico Museum of Art (NMMA), located off the historic plaza in a classic Pueblo Revival building. The collection highlights the region's unique interplay of three rich cultures and artistic traditions—Native American, Hispanic, and European American.

When the museum opened in 1917 as the Art Gallery of the Museum of New Mexico, it helped launch "Pueblo Revival" or "Santa Fe–style" architecture. I. H. and William M. Rapp were hired to design a replica of their popular New Mexico pavilion for the 1915 Panama-California Exposition. The nearly century-old building features thick adobe walls, hand-carved and painted vigas, and a *latilla* ceiling.

Many of the original artworks remain cornerstones of NMMA's collection. In addition, the museum has continued to assemble some twenty thousand works in a wide range of mediums, focusing on leading artists with ties to the Southwest. Notables include Georgia O'Keeffe, Gustave Baumann, Fritz Scholder, Maria Martinez, Bruce Nauman, and Luis Jimenez.

In 1916 the museum's first director, Edgar L. Hewett, invited artist Robert Henri to visit Santa Fe. The founder of the Ashcan School donated his *Portrait of Dieguito Roybal, San Idelfonso Pueblo* for the gallery opening and invited colleagues John Sloan, Stuart Davis, and George Bellows to Santa Fe. The gallery established an "open-door" policy, allowing artists working in New Mexico to exhibit their art.

The most famous of the many artists who fell in love with New Mexico is O'Keeffe, who first visited Taos in 1929. Some half dozen of O'Keeffe's landscapes are on view in an evocative period-setting gallery upstairs. The Wisconsin-born painter is famous for her depictions of Northern New Mexico's desert and mountain landscapes rendered in brilliant color.

After moving permanently to New Mexico in 1949, O'Keeffe split her time between two properties. She spent summer and fall at Ghost Ranch and winter and spring in nearby Abiquiu, where she restored a Spanish Colonial–era fixer-upper. From her home at Ghost Ranch, O'Keeffe could see the mountain known as the Pedernal. The sacred, flat-topped mesa became a favorite motif, as in the museum's *Red Hills with the Pedernal*. When O'Keeffe died in 1986 at age ninety-eight, her ashes were scattered at Pedernal.

The museum also presents works by members of the Taos Society of Artists, a group of Euro-Americans who began arriving here from the Midwest and East Coast at the turn of the twentieth century. Flamboyant New York socialite Mabel Dodge Luhan reflected the group's romantic attitude

New Mexico Museum of Art Front Entrance, photograph by Blair Clark

when she called Taos "the dawn of the world." Artists like E. Martin Hennings, Ernest Blumenschein, Joseph H. Sharp, and Gustave Baumann helped shaped the popular image of the people and landscapes of the Southwest. In his richly hued prints like *Spring Blossoms* from 1950, Baumann combined the palette, asymmetry, and patterned surfaces of Japanese woodblocks with printing techniques from his native Germany.

At the same time O'Keeffe was experimenting with abstracted landscapes, members of New Mexico's Transcendental Painting Group were taking abstraction even further. Among NMMA's holdings are complex canvases by Raymond Jonson, who taught and painted in Santa Fe for twenty-five years, and Agnes Pelton, one of three women to exhibit at the Armory Show.

The political radicalism of the 1960s inspired a new generation of artists to challenge depictions of Native peoples. Part Luiseño Indian, Fritz Scholder combined Indian subject matter with early experiments in expressionism. In *Snake Dancer*, Scholder transforms a stereotypical Hopi figure with broad brushstrokes and a pop art color palette influenced by his teacher, Wayne Thiebaud.

In his 1976 work *Washington Landscape with Peace Medal Indian*, T. C. Cannon used his flattened pop art style and clashing colors to make a statement about exploitation by the federal government in the nineteenth century. As part of "peace" ceremonies, tribal leaders like the man depicted were invited to Washington, DC and given top hats, medals on ribbons, and canes. When the treaties were broken, all that remained were these empty symbols.

Since 1976, Montana-born Jaune Quick-to-See Smith, member of the Confederated Salish and Kootenai Nation, has lived in Santa Fe. Her political subjects include the museum's work on paper protesting smallpox-infested clothing donated by the government to Indians. Bob Haozous uses Native imagery in his sculptures like *Apache Skull*, made of rusted steel and gun shell casings.

Marcus Amerman, a member of the Choctaw people, works in the traditional Native American art form of beading. Amerman's *Back to the Blanket* is a miniature beaded version of *Cui Bono?*, the museum's large-scale painting by Gerald Cassidy. Emmi Whitehorse is known for abstract works that explore her Navajo culture like the collage *Kin Nah Zin, #223*.

Before you leave, take time to step inside the St. Francis Auditorium, a popular venue for lectures and concerts. The impressive hall features beamed ceilings and a series of otherworldly pastel murals of St. Francis of Assisi, patron saint of Santa Fe. The cycle was designed by Utah artist Donald Beauregard and completed by Kenneth Chapman and Carlos Vierra.

Adding to the serenity of the courtyard is a series of frescoes along with Texas sculptor Jesus Bautista Moroles's *Mountain Fountain*. Water runs down the smooth sides and jagged edges of the striated Dakota granite. Rather than carve granite, Morales "tears" the stone, causing it to split along the natural grain. The nearby sculpture garden features Luis Jimenez's moving *Border Crossing*. In towering fiberglass, the artist depicts his father carrying his mother on his shoulders as they cross the Rio Grande from Mexico to the United States.

GETTING THERE Address: 107 W. Palace Ave., Santa Fe, NM Phone: (505) 476-5041 Website: nmartmuseum.org Hours: Tuesday to Sunday 10:00 a.m. to 5:00 p.m.; Friday 5:00 to 8:00 p.m.; Memorial Day to Labor Day, Monday 10:00 a.m. to 5:00 p.m. Tours: Daily, 10:30 a.m., 2:00 p.m.; art and architecture walking tour April to November Monday 10:00 a.m., June to August Friday 10:00 a.m. Admission: Adults $10, children under 18 free; Friday 5:00 to 8:00 p.m. free

Not to Miss

Oil on canvas, 24 x 20 inches. Collection of the New Mexico Museum of Art. Bequest of Helen Miller Jones, 1989 (1989.259.1), photograph by Blair Clark

Maria (Lucin in Wrap), Robert Henri (1865–1929), circa 1917

"Paint what you feel. Paint what you see. Paint what is real to you," Robert Henri famously said. For several prolific summers, Henri painted what he felt and saw in Santa Fe, working in a studio in the Palace of Governors. Among his New Mexico paintings is this expressive portrait of a young girl in a white wrap set against a dramatic orange and blue background. In an article for the *Craftsman*, Henri wrote: " . . . I only want to find whatever of the *great spirit* there is in the Southwest. If I can hold it on my canvas I am satisfied."

El Santo, Marsden Hartley (1877–1943), 1919

When Marsden Hartley traveled to Taos, New Mexico, in 1918, he was at an artistic impasse, searching for a uniquely American aesthetic. Hartley found it in New Mexico's indigenous Hispanic and Native cultures—including Pueblo Indian dance rituals, singing, pottery making, weaving, and painting. Hartley produced this symbolic still life during his eighteen-month stay, featuring a Hispanic *retablo* of a Catholic saint, a Santa Clara jar, and a striped Navajo blanket. "I am an American discovering America," wrote Hartley.

Oil on canvas, 36 x 32 inches. Collection of the New Mexico Museum of Art. Anonymous gift from a friend of Southwest art, 1919 (523.23P), photograph by Blair Clark

Oil on canvas, 30 1/2 x 16 1/2 inches. Collection of the New Mexico Museum of Art. Gift of the Georgia O'Keeffe Estate, 1987 (1987.312.1) © New Mexico Museum of Art. Photograph by Blair Clark.

Chama River, Ghost Ranch, New Mexico (Blue River), Georgia O'Keeffe (1887–1986), 1937

In a 1942 letter to Arthur Dove, O'Keeffe described her beloved Ghost Ranch in the Jemez Mountains northwest of Santa Fe: "I wish you could see what I see out the window—the earth pink and yellow cliffs to the north-the full pale moon about to go down in an early morning lavender sky . . . pink and purple hills in front and the scrubby fine dull green cedars—and a feeling of much space—It is a very beautiful world." Over some five decades, she would immortalize this world in her works, including this early New Mexico painting, a gift from the artist's estate.

WHITNEY GALLERY OF WESTERN ART
Cody, Wyoming

"But the West of the old times, with its strong characters, its stern battles and its tremendous stretches of loneliness, can never be blotted from my mind."

—William F. "Buffalo Bill" Cody

❧ With its dramatic history and spectacular scenery and wildlife, the American West has long been a source of inspiration for artists. One of the most authentic places to experience this rich tradition is the Whitney Gallery of Western Art in Cody, Wyoming, east gateway to Yellowstone National Park. Part of the Buffalo Bill Historical Center, the Whitney Gallery presents some two hundred years of art—from sublime landscapes and portraits of Native Americans to wildlife paintings and sculpture.

Legendary army scout and pony express rider "Buffalo Bill" Cody fell in love with Wyoming's Bighorn Basin, calling it "the foothills of heaven." At the turn of the twentieth century, he founded the eponymous town of Cody. After Cody's death in 1917, his friends and family commissioned heiress and sculptor Gertrude Vanderbilt Whitney (the future founder of New York's Whitney Museum of American Art) to create a sculpture in his memory.

Along with her bronze equestrian tribute, Vanderbilt Whitney threw in forty acres that became the setting for the Buffalo Bill Historical Center. In 1959 the sculptor's son, Cornelius Vanderbilt Whitney, funded an art museum in his mother's honor. The complex also includes the newly renovated Buffalo Bill Museum, Plains Indian Museum, and Winchester Arms Museum.

Mixing historical and contemporary works, the Whitney Gallery explores themes like the Western experience, Native Americans, heroes and legends, and wildlife. Near the entrance is Alexander Phimister Proctor's re-created studio with small sculptures and a full-scale plaster cast for *Theodore Roosevelt as a Rough Rider.* (Two bronze casts are located in Oregon and North Dakota, where Roosevelt lived after the deaths of his wife and mother.)

Many of the artists who ventured West with exploratory expeditions are represented. The works include Alfred Jacob Miller's intimate ink sketches and watercolors of the Rockies, George Catlin's genre scenes of Native Americans and naturalist John James Audubon's prints.

After the Civil War the natural grandeur of the West became a powerful symbol of national unity. A favorite subject for artists were the geologic wonders of Yellowstone. Among the Whitney's interpretations is *Golden Gateway to the Yellowstone* by Thomas Moran. The British-born artist's canvases are considered key in the effort to make Yellowstone a national park. The collection also features Yellowstone scenes by Albert Bierstadt, Frank Tenney Johnson, and John Henry Twachtman.

The tragic history of Native Americans and their displacement to reservations is another subject

Buffalo Bill Historical Center, Cody, Wyoming, USA; Whitney Gallery of Western Art

Whitney Gallery of Western Art

explored. For his monumental painting *Custer's Last Stand*, Quaker artist Edgar Paxson interviewed survivors of the Battle of Little Bighorn. In James Earle Fraser's moving bronze *End of the Trail*, a dejected warrior and his horse hang their heads, symbols of the fate of Native peoples. Artist Joseph Henry Sharp lived and worked on the Crow Indian Reservation of Montana in the early twentieth century; his studio cabin is located in the museum's garden courtyard.

The collection also features artworks by Native American artists working in a diverse range of styles and mediums. Among these are Allan Houser's alabaster sculpture *Drama on the Plains*, T. C. Cannon's *Buffalo Medicine Keeper*, Jaune Quick-to-See Smith's *Games People Play*, and Francis Yellow's bronze *Tatanka Wan, A Buffalo Bull*. "Our elders teach us that there is a model of the universe inside ourselves . . ." wrote Yellow, a member of the Lakota tribe from South Dakota.

No single artist is more strongly associated with the West than Frederic Remington, who left Yale to pursue a career as an artist. About Remington, President Theodore Roosevelt wrote " . . . he has portrayed a most characteristic and yet vanishing type of American life. The soldier, the cowboy and rancher, the Indian, the horses and the cattle of the plains, will live in his pictures and bronzes, I verily believe, for all time."

From Texas to Montana, Remington collected Native American and frontier objects. Many of his possessions can be seen in a replica of his New Rochelle, New York, studio, complete with a moose head over the brick fireplace. There are paintbrushes and small oils and sketches, beaded moccasins, woven baskets, and spurs and chaps. "I knew the wild riders and the vacant land were about to vanish forever . . . and the more I considered the subject, the bigger the forever loomed," wrote the artist.

Remington never met Charles M. Russell, to whom he continues to be compared. At age sixteen, the Missourian headed west to the Montana Territory, where he worked as a cowhand and sketched and painted. When he was twenty-four, Russell spent the winter living with the Blood Indians in Canada. Soon after, the self-taught artist settled in Great Falls, Montana, filling his log studio with Native American

and cowboy objects. It's here that Russell produced many of his sensitive depictions of Northern Plains Indians. The Whitney Gallery presents Russell's works in a variety of media including pen and ink, watercolor, oil, and bronze.

Wildlife provided another rich subject area for artists. The country's first animalier, Edward Kemeys, studied animals in the wild and imbued his panthers and grizzly bear sculptures with detail and movement. German-born painter and big-game hunter Carl Rungius set his moose, elk, and antelope in rugged natural habitats, settings that became more impressionistic later in his career. There is also a strong collection of works by contemporary sculptor T. D. Kelsey and a half life-size horse by Deborah Butterfield.

Fittingly, toward the back of the Whitney Gallery visitors meet up with Cody, astride his white horse. The small oil was a treasured gift to the adventurer from the French artist Rosa Bonheur, best known for her animal paintings. Bonheur met Cody in Paris where his Wild West Show was performing.

GETTING THERE Address: 720 Sheridan Ave., Cody, WY (part of the Buffalo Bill Historical Center) Phone: (307) 587-4771 Website: bbhc.org/explore/western-art/ Hours: December to February, Thursday to Sunday 10:00 a.m. to 5:00 p.m.; March to April, daily 10:00 a.m. to 5:00 p.m.; May to September 15, daily 8:00 a.m. to 6:00 p.m.; September 16 to October, daily 8:00 a.m. to 5:00 p.m.; November, daily 10:00 a.m. to 5:00 p.m. Admission: Adults $18, seniors $16, students $13, youth $10, children 5 and under free (includes all museums)

Not to Miss

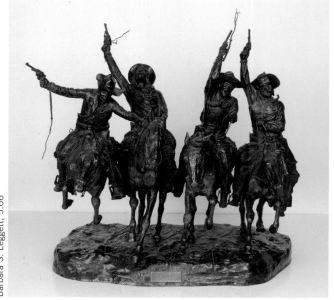

Buffalo Bill Historical Center, Cody, Wyoming, U.S.A., Gift of Barbara S. Leggett, 5.66

Coming Through the Rye, Frederic Remington, circa 1902

In a life cut short at age forty-eight after an emergency appendectomy, New York–born Frederic Remington produced twenty-two bronze works. With their unique patinas, rich surface texture, and fine detail, these bronzes are considered among the best American sculptures ever made. Remington pushed the limits of bronze casting, animating his compositions with movement and energy. Along with his first sculpture, *Bronco Buster, Coming Through the Rye* was one of his most successful. Just over two feet tall, the ambitious work features a group of gun-toting cowboys. Remarkably, the hooves of the two outer horses don't even touch the ground.

Bringing Home the Spoils, Charles M. Russell, 1909

A strong undercurrent in Charles Russell's bronzes and oil and watercolor paintings is a sense of loss for the
pre-reservation American West. In this sunset scene, Russell conveys a sense of pride as the central figure, a
mounted brave, returns home from battle. The spoils in this case are the herd of horses in the background.
Russell also depicted American Indian women in a number of paintings, including *Indian Women Moving Camp.*
The dignified work portrays a group of women on horseback, including a mother carrying a child on her
back. Fifteen years after this painting was made, Native Americans finally got the right to vote.

**Island Lake, Wind River Range,
Wyoming,** Albert Bierstadt, 1861

Albert Bierstadt was already known for his
romantic Hudson River canvases when he
joined a government survey in 1859 from
Fort Laramie, Wyoming, to the Rocky
Mountains. Back in his New York studio,
Bierstadt used his photographs and sketches
to produce idealized paintings of the
Rockies, which he considered comparable
to the European Alps. This canvas depicts
the Wind River Mountain range, where
Bierstadt camped for several weeks. Detailed
trees and rocks in the foreground fade into
the silvery lake and gold-lit mountains.

George Eastman aboard S.S. Gallia, 1890, Frederick Church, albumen print, George
Eastman House

CHAPTER 12

PHOTOGRAPHY

GEORGE EASTMAN HOUSE, INTERNATIONAL MUSEUM OF PHOTOGRAPHY AND FILM
Rochester, New York

"George Eastman House is a diamond. It holds the collective visual memory of our entire nation . . . "

—Graham Nash, musician and photographer

Fittingly, one of the world's leading photography museums is located at the former Rochester, New York, estate of Kodak founder George Eastman. Opened in 1949, the George Eastman House holds a rich photography collection that spans the medium's 175-year history.

It was Eastman's turn-of-the-twentieth-century inventions like the gelatin dry plate and affordable cameras that helped popularize the new medium. One of the millions of people who picked up Eastman's one-dollar Brownie camera was a young boy from San Francisco, Ansel Adams, visiting Yosemite National Park with his family.

Today a breezeway connects Eastman's Colonial Revival mansion to the museum, archive, and conservation lab. Drawing from a vast permanent collection of four hundred thousand photographs by nine thousand artists, curators organize several exhibitions each year—from thematic shows to retrospectives and monographic exhibitions. The whole range of photographic processes and formats is featured with about four hundred photographs on view at any given time.

A permanent gallery off the entrance traces the history of photographic technology. Among the 150 cameras displayed (from a collection of 8,000) are a half a dozen belonging to celebrated artists with the iconic photos they took (in digital facsimile). Joe Rosenthal's Speed Graphic camera is presented alongside his iconic *Raising the Flag on Iwo Jima*, Alfred Stieglitz's Graflex with *The Steerage*, and celebrity photographer Nickolas Muray's three-color Jos-Pe with his portrait of Marilyn Monroe.

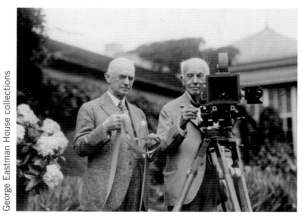

George Eastman House collections

Eastman and Edison at Kodakcolor party 1928

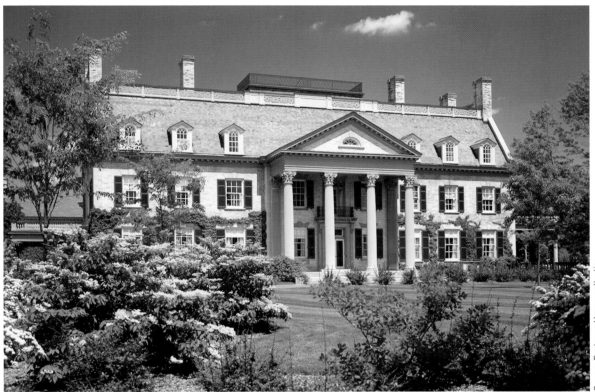

George Eastman House collections

Fifteen years after seventy-eight-year-old George Eastman left his estate to the University of Rochester, his mansion was chartered as a photographic museum. The museum built its historic holdings through acquisitions and gifts of major private collections like those of French portrait photographer Gabriel Cromer, Alden Scott Boyer, and Louis Walton Sipley. Over the next five decades, archives, corporate collections, and artists' portfolios including those of Edward Steichen, Louis Hines, and Roger Mertin entered the collection.

The museum boasts a rich collection of early daguerreotypes created on silver-plated copper. Among these are a rare portrait of a painter by the inventor of the process, Louis Jacques Mandé Daguerre and the twelve hundred–daguerreotype archive of the Boston firm Southworth & Hawes.

There are also examples of Talbotypes, another early process created by English chemist William Henry Fox Talbot, which produced multiple paper prints from a single paper negative.

Another strength is the museum's renowned collection of nineteenth-century American, French, and British photography. Among the treasures are compelling Civil War images including portraits of Abraham Lincoln, General Ulysses S. Grant, Harriet Tubman, and Frederick Douglass and landscapes by Carleton E. Watkins, Eadweard J. Muybridge, and William Henry Jackson that capture the grandeur of the American wilderness.

The George Eastman House's rich twentieth-century collection starts with the Photo-Secessionists, the group founded in 1902 by Alfred Stieglitz whose leading members included Edward Steichen, Anne

Brigman, Gertrude Kasebier, Clarence White, and Paul Strand. Among Stieglitz's famous images are portraits of his wife, painter Georgia O'Keeffe, which defined her public persona for decades. Also well represented are early practitioners of documentary photography like Berenice Abbott, Walker Evans, Margaret Bourke-White, and Dorothea Lange.

The modern collection continues with masters like Brassai, Henri Cartier-Bresson, André Kertesz, Robert Capa, and Lazlo Moholy-Nagy. The museum continues to add to its permanent collection, with a focus on emerging talent. In 2009, Kodak gave the last roll of Kodachrome film to *National Geographic* photographer Steve McCurry. These prints are now part of the collection.

In 1990 a team led by an architectural historian used historic photos to restore Eastman's house, a National Historic Landmark. Between 1905 and 1932, the bachelor used his fifty-room mansion for business and entertaining. Eastman's guest list included notables like Thomas Edison, Mary Pickford, and Admirals Richard Byrd and Kenneth Perry, who carried Kodak cameras on their expeditions. Women guests received orchids from Eastman's greenhouses, presented in white boxes with lavender tissue paper.

Tours of Eastman's house feature the elegant public rooms—like the Wedgwood green library with his books and miniature netsuke collected on a 1920 trip to Japan. Today the enormous dining room safe is left open, lined with Gorham sterling silver, china, and crystal. In Eastman's day, only the head housekeeper knew the combination.

Eastman loved music. He established and supported the Eastman School of Music, a theater, and symphony orchestra. Every morning and evening his private organist played the Aeolian pipe organ in the two-story conservatory. Business associates who arrived for morning meetings had to compete with the strains of the organ. Thanks to local music faculty and students, both the organ and Eastman's Steinway piano are played on Sunday afternoon. In the summer, recitals are held Thursday evening in the garden.

A mahogany staircase leads to an upstairs exhibit chronicling Eastman's rags-to-riches life—from high school dropout and bank teller supporting his widowed mother and two sisters to pioneering inventor and industrialist. Along the way visitors are introduced to Eastman's contemporaries, like Thomas Edison and the Lumière brothers; his groundbreaking inventions; and his passion for hunting that led him to Kenya and Uganda. Four gardens, including the terrace where Eastman introduced the first amateur color motion picture camera, are abloom with original varieties.

GETTING THERE Address: 900 East Ave., Rochester, NY Phone: (585) 271-3361 Website: eastmanhouse.org Hours: Tuesday, Wednesday, Friday, Saturday 10:00 a.m. to 5:00 p.m.; Thursday 10:00 a.m. to 8:00 p.m.; Sunday 1:00 to 5:00 p.m. Tours: Daily exhibition and house tours; to view specific photos and cameras, call for a weekday appointment in the archives. Admission: Adults $12, seniors $10, students $5, children 12 and under free

Not to Miss

Permission of the Estate of Edward Steichen/George Eastman House Collections

The Shadblow Tree, Edward Steichen, 1957, color print

Edward Steichen's crisp, bold style and pioneering color techniques for *Vogue* and *Vanity Fair* revolutionized fashion photography in the 1920s and 1930s. One of the last projects of his long career was a series on a small solitary tree at his Connecticut home that he shot in all seasons and times of day. The result is a narrative on the cycles of nature with hundreds of color prints like this one. "Photography records the gamut of feelings written on the human face, the beauty of the earth and skies that man has inherited, and the wealth and confusion man has created," Steichen wrote. In 1979 the artist's widow, Joanna Steichen, donated his collection to the George Eastman House.

George Eastman House collections

Mrs. Herbert Duckworth, Julia Margaret Cameron, 1867, albumen print

Julia Margaret Cameron's short, prolific career began at age forty-eight when one of her eleven children gave her a camera. Her subjects included women, children, and famous Victorians like Charles Darwin, Alfred Tennyson, and Thomas Carlyle. This striking portrait is one of fifty Cameron took of Julia Jackson, her niece and Virginia Woolf's mother. By purposefully shooting Jackson slightly out of focus with half of her face in shadow, Cameron created an otherworldly image. The inspiration for this masterwork may have been Italian Renaissance portraits along with Cameron's own artistic mission. "My aspirations are to ennoble photography and to secure for it the character and uses of High Art," she wrote.

Migrant Mother, Nipomo, California Dorothea Lange, 1936, gelatin silver print

Like Walker Evans, Dorothea Lange is best remembered for her photographs of the nation's workers and farmers. Among her most powerful images are those recording the human tragedy of the Great Depression, as in this iconic picture of Florence Thompson, a stoic thirty-two-year-old mother with three of her seven children. Lange discovered the family at a Northern California pea pickers camp sitting by a car without tires. Thompson had sold the four tires to buy food. In her composition Lange posed one child sleeping in Thompson's lap while two siblings lean on her, their heads turned away from the camera. Lange's empathetic style has been attributed to an absentee father and childhood polio that left her with a lifelong limp.

George Eastman House collections

THE MONTEREY MUSEUM OF ART
Monterey, California

"They stayed there all summer and found some of their most marvelous inspirations in the atmosphere of the old cypress tree. It was a veritable heaven for them in every way."
—*San Francisco Call*, 1896

With its cypress trees, wind-swept coastline, and dramatic beaches, California's Central Coast has been luring artists for generations, including some of the country's finest photographers. The Monterey Museum of Art (MMA) boasts a choice collection of these images—notably by members of the influential Group f/64 and succeeding generations of photographers that represent the region's rich art history.

MMA's permanent collection forms a foundation for exhibitions presented in the soaring contemporary galleries at La Mirada, a villa tucked away on a wooded knoll overlooking Monterey Bay. Originally a two-room adobe, the property was bought in the 1920s by Hollywood writer Gouverneur Morris, descendant of one of the signers of the US Constitution.

Morris enlarged the home into a sprawling mansion, where he entertained silent-film stars like Charlie Chaplin, Buster Keaton, and Rudolph Valentino. Elizabeth Taylor and Richard Burton stayed here in 1964 while filming *The Sandpiper*. In 1983 La Mirada's last owners deeded the property to the museum. A decade later architect Charles Moore designed a contemporary gallery for special exhibitions. Moore was a fitting choice for the new wing—his master's thesis was on historic adobes of Monterey.

Photography along with early California paintings by artists like Armin Hansen and E. Charlton Fortune are also on view at the museum's sister location on Pacific Street in Old Monterey. The handsome three-story property is directly across from historic Colton Hall, which hosted California's first constitutional convention in the mid-nineteenth century.

The museum's photography collection starts with Carleton Watkins and William Henry Jackson who traveled to northern California in the late nineteenth century to record its scenic wonders. Another influential arrival was French artist Jules Tavernier, who brought the Barbizon tradition of plein air painting to the region.

After the San Francisco earthquake in 1906, many artists fled the city for Carmel and Monterey, where they exhibited at the Hotel Del Monte gallery. At the turn of the twentieth century, Anne Brigman and Johan Hagemeyer brought pictorialism to the Bay Area. Discovered by Alfred Stieglitz and elected to his elite photo-secession group, Brigman posed nude models in evocative settings for her painterly photographs.

MMA owns a fine collection of vintage photographic prints by founding members of Group

Courtesy of the Monterey Museum of Art, photo by Craig Lovell

Monterey Museum of Art—La Mirada

f/64—Ansel Adams, Imogen Cunningham, and Edward Weston. In the 1930s the Bay Area artists named their radical new style after the camera aperture that produces the greatest depth of field. Using large-format cameras and glossy paper, they shot everything in sharp focus, from the immediate foreground to distant background.

From a pine branch to towering mountain ranges, Ansel Adams immortalized the beauty of America's wilderness areas and national parks. Adams combined his emotional response to nature with an intellectual process in which he planned exactly what he wanted the final image to look like. "My approach to photography is based on my belief in the vigor and values of the world of nature," he wrote. ". . . I believe in people and in the simple aspects of human life, and in the relation of man to nature."

Imogen Cunningham started her seventy-five-year career as an assistant in the Seattle studio of documentary photographer Edward S. Curtis and made a name for herself in portraiture. She continued her career in Northern California, where she produced striking images like the museum's *Umbrella Handle with Hand* and *Ampitheater* at Mills College. Cunningham continued to be a role model for younger photographers, working until weeks before her death in 1976 at age ninety-three.

Of all his talented colleagues, Adams most admired the work of his friend Edward Weston. Weston developed a unique style marked by simplicity of form, sharp focus, and sensuous print quality. About Monterey's celebrated cypress tree, Weston wrote: ". . . no one has done them—to my knowledge—as I have, and will. Details, fragments of the trunk, the roots,—dazzling records, technically superb, intensely visioned." When Weston died of Parkinson's in 1958, his ashes were scattered into the Pacific at Point Lobos, where he had taken his last photo a decade earlier.

Group f/64 photographers inspired like-minded artists who form what's known as the Monterey

Peninsula School. The strong connection with nature continues in the work of both Wynn Bullock, a life-long friend of Edward Weston, and Henry Gilpin, who after meeting Adams "came home and threw everything away and started all over again." A former World War II pilot, Gilpin captured a striking ribbon of Coast Highway in his signature image, *Highway 1*. The museum also holds images by local photographer Ryuijie, including *Dunes and Grass* and his platinum prints taken underwater.

The broader photographic tradition is also represented in MMA's collection with artists like Charles Sheeler, Aaron Siskind, Irving Penn, Sally Mann, and Gary Winogrand and Pictures Generation artists Cindy Sherman and Richard Prince. MMA is expanding its twenty-first-century photography holdings with works by artists such as Angela Strassheim who explores seemingly ordinary moments with her carefully staged compositions of family and friends.

GETTING THERE Address: 720 Via Mirada and 559 Pacific St., Monterey, CA Phone: (831) 372-3689 (La Mirada), (831) 372-5477 (Pacific St.) Website: montereyart.org Hours: Wednesday to Saturday 11:00 a.m. to 5:00 p.m., Sunday 1:00 to 4:00 p.m. Admission: Adults $10, students $5

Not to Miss

© Michael Kenna

Cloud Trails, Elkhorn Slough, California, USA, Michael Kenna, 1989

Since moving to San Francisco from England in 1977, Michael Kenna has built a reputation for graceful, often haunting black-and-white landscape photographs. This striking image is part of a series Kenna produced between 1986 and 1991 at Elkhorn Slough near Monterey Bay. In this series Kenna contrasts the natural beauty of the slough with human-made structures that include the highway, power station, and abandoned oyster dock. " . . . Most of my photographs hint at, speak of, certainly invite human presence, even though there is no specific illustration . . . I try to leave space in my photographs so that viewers can participate in the scene and even create their own story."

Sensual Dunes, Death Valley, California, 1984, Rod Dresser

Rod Dresser was born in rural Watsonville, near Monterey. After retiring from the military, a chance meeting with Ansel Adams led to a job in his studio. In the early 1990s, after a stint at commercial photography in San Francisco, Dresser returned to Monterey, where he became known for his shimmering black-and-white photographs of nature, including this signature image of smooth, suggestive dunes at Death Valley. Of his minimalist approach, Dresser said, "When I photograph I distill things down to their essence. I concentrate on what it is in the view-finder that excites me, and I try to eliminate all the distraction."

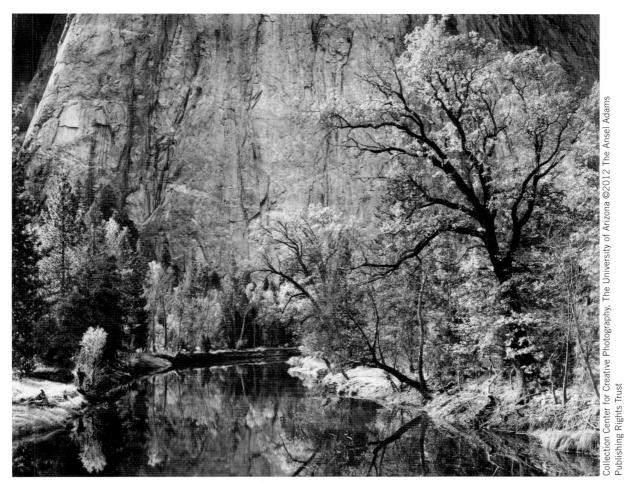

Merced River, Cliffs of Cathedral Rocks, Autumn, Ansel Adams, 1938

With his breathtaking images of the American West, Ansel Adams is widely regarded as one of the greatest landscape photographers. Starting with Adams's first visit at age fourteen, Yosemite National Park became a great source of inspiration, and he immortalized its spectacular scenery in this and many other images. Using large-format cameras, the San Francisco–born photographer achieved unparalleled detail. After World War II Adams became a passionate advocate for environmental causes. In 1983 he visited Yosemite for the last time. Soon after his death in 1984 at age eighty-two, Congress set aside a vast tract of land on Yosemite's south border and named it the Ansel Adams Wilderness.

THE MUSEUM OF CONTEMPORARY PHOTOGRAPHY
Chicago, Illinois

"There are few colleges that have a world class photography museum and collection attached to it. MoCP at Columbia College Chicago is one such institution. Both students and the general public are that much richer because of its presence in Chicago."

—Dawoud Bey

Four blocks from the Art Institute of Chicago is a far lesser-known but wholly unique art destination, Columbia College's Museum of Contemporary Photography (MoCP). Modest only in size, this college museum owns a remarkable collection approaching ten thousand works that celebrate regional, national, and international photography since the Great Depression.

The little-known gallery is tucked away in a former Michigan Avenue photography store. Glass doors open into a serene rectangular gallery with high ceilings that accommodates large-scale works. Each year museum curators organize several thought-provoking shows drawn from the permanent collection and loans from other museums, private collections, and galleries.

Past exhibitions have explored important artistic topics like photography's relationship to painting and sculpture, as well as relevant political issues such as contemporary material culture and the cultural impact of Mexican migration. Retrospectives and monographic shows have showcased artists like John Baldessari, Guy Tillim, and Robert Adams.

To maximize precious space, MoCP has created an open gallery out of its wooden staircase,

projecting videos on the stairwell wall. Continuing upstairs, there's an intimate mezzanine gallery for smaller works. The upper level houses the museum's large-print study room and two storage vaults for the permanent collection. Black-and-white prints and installations are kept at a cool sixty degrees; color photographs are kept chilled in a forty-seven-degree meat locker.

If you're intrigued by a photographer or a particular image, you can visit MoCP's user-friendly online database and arrange to see specific works from the permanent collection. Not only will you be treated to a private screening in the print study room, you can engage in a conversation about the works with a knowledgeable Columbia College photography student or museum staff member. Because photographs need to acclimate to room temperature, two weeks' notice is required.

MoCP's roster includes two of its talented photography teachers. Dawoud Bey is known for his powerful portraits—from his early series of everyday life in Harlem to his expressive pictures of high school students. In her practice, Kelli Connell explores sexuality, gender roles, and the dualities of the self. Using

multiple images of the same model, Connell digitally creates color photographs of imagined situations.

Before teaching at Columbia College, Connell participated in the museum's Midwest Photography Project. Started in 1982 to support emerging talent, the project is a rotating archive of over one thousand photographs by some seventy-five artists living and working in Illinois, Indiana, Iowa, Kansas, Michigan, Minnesota, Missouri, Ohio, and Wisconsin. In 2003, curators chose one such talent, Alec Soth, for his first solo show. The Minnesotan soon emerged as one of the most compelling new voices in photography, acclaimed for his color images in the tradition of road photographers Walker Evans, Robert Frank, and William Eggleston.

MoCP got started in the late 1970s when it began inviting photographers to speak and exhibit their work. In 1980, private collectors like John Mulvaney, David C. Ruttenberg, and Sonia Bloch started donating a core group of photographs. Beginning with Depression-era photographs by artists like Dorothea Lange and Walker Evans, the collection moves into post–World War II abstraction from Chicago's important Illinois Institute of Design, founded by Laszlo Moholy-Nagy.

Shortly before his death in 1946, Moholy-Nagy organized a summit at his institute attended by legendary photographers like Paul Strand, Bernice Abbott, and Roy Stryker. At the time of the summit, Harry Callahan was preparing to teach the first class of students in the new photography program. Fifteen years later Callahan would invite Aaron Siskind to join the faculty.

The long careers of Callahan and Siskind are well represented. From his early pictures of Chicago apartment houses to images of his wife, Eleanor, Callahan's works consistently show his strong sense of design and composition. In his *Pleasures and Terrors of Levitation* series, Siskind captures divers in midleap

over Chicago's Lake Michigan. The museum also owns examples of Siskind's urban architecture and graffiti, as well as a photo from an homage to his friend, abstract expressionist Franz Kline.

MoCP's holdings by Robert Frank include several prints from *The Americans*, which Walker Evans called "the richest and most original set of photographs on America I've ever enjoyed." In the mid-1950s, the Swiss-born photographer won a Guggenheim fellowship to document his travels across the country. In *Political Rally, Chicago*, a musician stands below a draped American flag, his face completely hidden by his tuba. All the viewer can see is the Adlai Stevenson button on his jacket lapel.

Courtesy of the Museum of Contemporary Photography at Columbia College Chicago

Street photography from the 1960s and 1970s is represented by the gritty naturalism of Gary Winogrand, "American social landscape" of Lee Friedlander, and unsettling portraits by Diane Arbus. Also in the collection are Richard Misrach's powerful color images that explore our impact on the landscape, Cindy Sherman's stylized portraits, and Barbara Kruger's layered photographs.

MoCP's recent acquisitions include photographs by artists reinventing traditional subjects like landscapes, still lifes, and portraits. Among these innovators is Daniel Gordon, who builds and photographs life-size three-dimensional collages of images, and Myra Greene, who explores issues of identity and race using nineteenth-century photographic processes.

GETTING THERE Address: 600 S. Michigan Ave., Chicago, IL Phone: (312) 663-5554 Website: mocp.org Hours: Monday to Saturday 10:00 a.m. to 5:00 p.m., Thursday 10:00 a.m. to 8:00 p.m.; closed during Columbia College holidays and between exhibitions Admission: Free

Not to Miss

© Alec Soth

Charles, Vasa, Minnesota, Alec Soth, 2002

Many of Alec Soth's memorable photographs have been taken during solo road trips across the South, Midwest, and Niagara Falls with a wish list of subjects taped to his steering wheel. There's a poignant, timeless quality to Soth's offbeat small town pictures—like this portrait from his *Sleeping by the Mississippi* series. Soth captures his bearded, bespectacled subject standing in green coveralls on the snowy roof of his house, holding a model airplane in each hand. The four-year project also features such diverse images as Charles Lindbergh's boyhood bed, a snowbound houseboat and colorful clothesline, and workers with shovels by the Fort Jefferson Memorial Cross in Kentucky.

Chicago IL, Brian Ulrich, 2003

For over a decade Columbia College alumnus Brian Ulrich has been examining our consumer-dominated culture. From the Mall of America and Las Vegas to the Midwest and New York City, Ulrich's pictures explore the cultural and political implications of consumerism. This photograph of a young Chicago woman clutching a wedding gown on a rack is a good example of his candid portraits. "I wanted to present a kind of mirror in which we see ourselves," said Ulrich. "And that's why the pictures could not be just cynical; they had to be empathetic, not just because I felt that way, but because I wanted the viewers to see themselves in the picture."

A Boy Eating a Foxy Pop, Dawoud Bey, 1988

Dawoud Bey's street photography and expressive portraiture began at age fifteen, when his godmother gave him a range-finder camera that belonged to his godfather. For his first series, *Harlem U.S.A.,* Bey spent five years documenting the details of residents' daily lives. In the 1990s Bey began working with a large Polaroid color camera, posing his subjects for multiple panel diptychs and triptychs that capture their momentary changes in expression and gestures. "My use of color has to do with wanting to make an unabashedly lush and romantic rendering of people who seldom receive that kind of attention," said Bey.

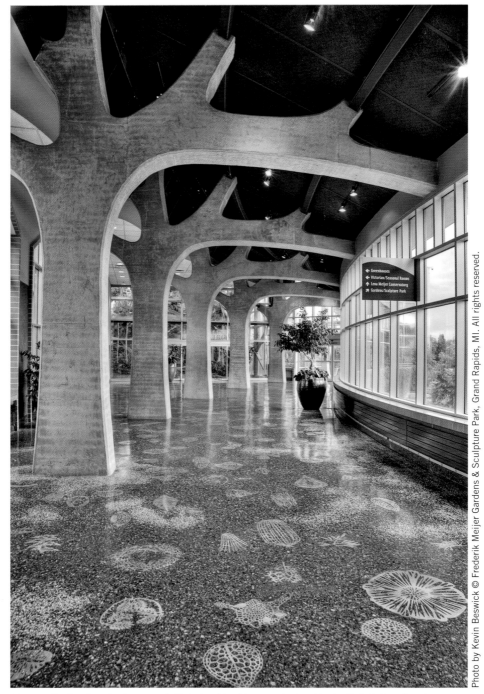

Beneath the Leafy Crown, Michele Oka Doner, 2008, Frederik Meijer Gardens & Sculpture Park

CHAPTER 13

SCULPTURE

NO ORDINARY WALK IN THE PARK

THE SYDNEY AND WALDA BESTHOFF SCULPTURE GARDEN

New Orleans, Louisiana

"The Besthoff Sculpture Garden seamlessly balances the worlds of art and nature in a seductive landscape setting . . . Whether one's taste runs to the classic modern or more cutting-edge, the Sculpture Garden allows the viewer to encounter each of the works in its own bucolic setting."

—Dan Cameron, founder, Prospect New Orleans; chief curator, Orange County Museum of Art

Where else but New Orleans can you enjoy great art from a floating gondola? Since opening in 2003, the Sydney and Walda Besthoff Sculpture Garden, part of the New Orleans Museum of Art (NOMA), has become a local favorite. Set on five lush acres of stately pines and moss-draped oaks in City Park, the Garden is home to an inviting array of modern and contemporary sculpture by noted American and international artists.

City Park is New Orleans's urban playground. At thirteen hundred acres, it's the sixth largest urban park in the country, larger than New York's Central Park. Once a popular spot for sword and pistol duels, the park now houses the New Orleans Museum of Art, New Orleans Botanical Garden, a turn-of-the-twentieth-century carousel, and the Besthoff Sculpture Garden.

Most of the outdoor artworks were a gift to NOMA by native New Orleanians Sydney and Walda Besthoff, who began collecting sculpture in the early 1970s. Sydney Besthoff was chairman and CEO of K & B Incorporated, a family-owned drugstore chain in Louisiana and the Gulf South founded by his grandfather. Rite Aid Corporation bought the company in 1997.

The Besthoffs' interest in sculpture began when they restored *The Mississippi*, Isamu Noguchi's monumental granite fountain in front of K & B's downtown headquarters. To accompany the Noguchi, the couple began to acquire other works, like kinetic sculptures by George Rickey and a Henry Moore. "When we first started collecting, we were not sure of ourselves, so we bought names," said Walda Besthoff.

Sydney and Walda Besthoff

Gondola in Lagoon

Photo © Richard Sexton 2005 and 2011

". . . As time went on, we . . . let our own tastes govern what we were buying."

The Sculpture Garden is adjacent to NOMA, founded over a century ago by Isaac Delgado, a Jamaican immigrant who made a fortune as a sugar broker. Two other entrances face the Botanical Garden and Timken Center. From Big Lake visitors can also rent rowboats and pedal boats or take a gondola ride through the connecting lagoons.

What's unusual about the Besthoff Sculpture Garden is that the sixty-plus sculptures are installed *around* the existing landscape, not vice versa. Architect Lee Ledbetter and landscape architect Brian Sawyer designed the garden's winding walkways so as not to interfere with roots of the centuries-old oaks. In addition to flowering shrubs like camellias and azaleas, oak, cypress, and several varieties of magnolias were planted alongside the mature trees.

Most of the nineteenth- and early twentieth-century art resides in the front section of the Sculpture Garden amid a grove of one-hundred-year-old pines and magnolias. This group of works is anchored by Henry Moore's late *Reclining Mother and Child* along with pieces by Barbara Hepworth, Rene Magritte, and Jacques Lipchitz.

Paths meander to the enlarged lagoon, a popular hangout for pelicans, ducks, and geese. Encircled by purple and yellow Louisiana iris, lilies, and horsetails, the lagoon itself features two sculptures—Kenneth Snelson's *Virlane Tower*, forty-five feet of floating stainless steel tubes, and Arman's *Pablo Casals's Obelisk* covered with dozens of bronze cellos.

Three bridges lead visitors across the lagoon to a more open area dotted with Spanish moss–laden live oaks. The live oaks get their name from their evergreen quality—old leaves drop around the same time

new leaves appear each spring. With their distinctive low spread and sculptural form, the trees create an evocative canopy for many of the Sculpture Garden's larger-scale, contemporary sculptures. These include *Spider*, a giant arachnid by Paris-born Louise Bourgeois and Deborah Butterfield's *Restrained (Horse)*. The towering blue safety pin *Corridor Pin, Blue* is by husband and wife Claes Oldenburg and Coosje van Bruggen, famous for their monumental sculptures of ordinary objects. Between the oak grove and cascading pool is Robert Indiana's iconic *LOVE, Red Blue*. A long interest in literature inspired Indiana's series of works with the word love arranged in stacked capital letters.

Among the garden's dozen or so benches is *Three Figures and Four Benches*. George Segal's trio sits on back-to-back benches, physically close but emotionally distant. Another well-known image is George Rodrigue's iconic blue dog in *We Stand Together* from 2005. That title refers to August 2005, when Hurricane Katrina inflicted devastation on New Orleans, including damage to the Sculpture Garden, which lost forty trees and about a third of its ground cover and bushes. Volunteers and staff worked to save many of the oak trees from salt poisoning and planted new trees and shrubs. Pieces of Kenneth Snelson's *Virlane Tower* were fished out of the lagoon and reassembled. During the garden's seven-month closure in 2009 and early 2010, repairs were made to the entrance pavilions, irrigation system, paths, and lagoon.

Remarkably, *Tree of Necklaces* survived the hurricane. French artist Jean-Michel Othoniel had draped six multicolored Murano glass-bead strands from the branches of one of the garden's oaks. Strands of beads are a familiar sight along New Orleans' Mardi Gras parade route, but the symbolism goes deeper. "When I show necklaces in New Orleans that are the size of a body, because it's New Orleans we think of 'Strange Fruit,'" said Othoniel, referring to Billie Holiday's protest song about lynching. "My works are like time bombs. At first you think they are beautiful, candies; . . . And then, step by step, you enter a story . . ."

The Sculpture Garden continues to grow. One of its newest additions is *Untitled* from 1997 by Bombay-born British artist Anish Kapoor. Like many of Kapoor's works, this stainless steel cube has mirrorlike surfaces that reflect and distort the surrounding oaks, sky, and visitors.

GETTING THERE Address: 1 Dueling Oaks Dr., New Orleans, LA (in City Park) Phone: (504) 658-4100 Website: noma.org Hours: Daily 10:00 a.m. to 4:45 p.m., Friday until 8:45 p.m. Admission: Free

The Sculpture Garden hosts a spring Iris Viewing Festival and a Faberge Egg Hunt, as well as walking tours, concerts, movies, plays, and wellness classes. For a calendar of events, see the museum website.

Not to Miss

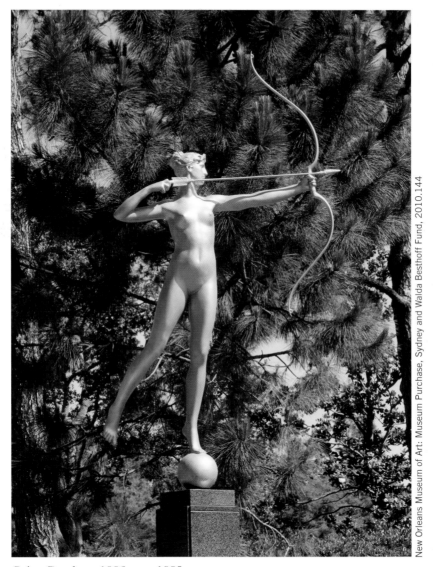

New Orleans Museum of Art: Museum Purchase, Sydney and Walda Besthoff Fund, 2010.144

Diana, Augustus Saint-Gaudens, 1886, cast 1985

When Augustus Saint-Gauden's eighteen-foot Diana proved too weighty to revolve atop the tower of the original Madison Square Garden, he replaced it with a smaller version. The elegant finial inspired many replicas—including this version in hammered and gilt sheet copper. The Dublin-born, French-trained artist portrays the Roman goddess of the hunt in the nude, pulling back her bow and arrow. The cast that topped Madison Square Garden is now at Philadelphia Museum of Art; the Metropolitan Museum of Art owns a gilded eight-foot model.

River Form, Barbara Hepworth, 1965

While her colleague Henry Moore was primarily interested in the figure, Barbara Hepworth worked in a more abstract mode, producing highly organic forms out of stone, wood, and bronze. The prolific artist frequently pierced her sculptures, as in this lyrical bronze, creating interior spaces that allow the passage of light and air. Before the start of World War II, Hepworth moved to St. Ives along the rugged coast of Cornwall, where her studio and garden are now a museum. "I have gained very great inspiration from Cornish land- and sea-scape, the horizontal line of the sea and the quality of light and colour . . ." wrote Hepworth.

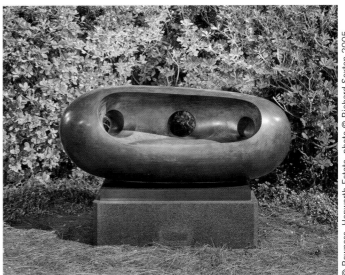

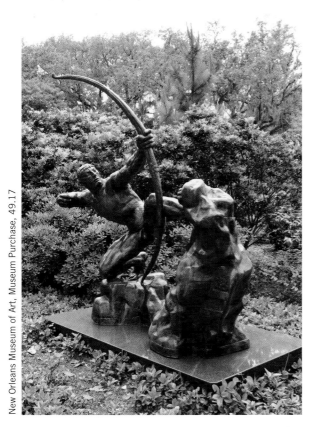

Hercules the Archer, Antoine Bourdelle, 1909, cast 1947

Antoine Bourdelle, a former studio assistant of Auguste Rodin, found a wealth of inspiration in antiquity, as in this powerful bronze of the mythological hero Hercules. With his right knee on the ground and left foot braced against a rock, Hercules aims his large bow and arrow at the man-eating Stymphalian birds of Arcadia, fulfilling one his father Zeus's prescribed labors. "Contain, maintain and master are the rules of construction," Bourdelle told his students, among whom were Aristide Maillol and Alberto Giacometti.

THE CANTOR ARTS CENTER
Palo Alto, California

"You don't outgrow The Gates, *you grow into them."*

—Albert Elsen, Stanford professor of art history and Rodin scholar

Across the sprawling campus affectionately known as "The Farm" and inside its art museum, Stanford University traces the evolution of modern and contemporary sculpture with hundreds of works. Among the many standouts, the museum's crown jewel is one of the world's premier collections by Auguste Rodin, widely considered the father of modern sculpture.

The Cantor Arts Center began as the Leland Stanford Jr. Art Museum, founded by California Governor Leland Stanford and his wife, Jane, in memory of their son, Leland Jr., who died from typhoid just before his sixteenth birthday. In 1906 the museum was badly damaged by the San Francisco earthquake, and in 1989 the Loma Prieta quake forced its closure.

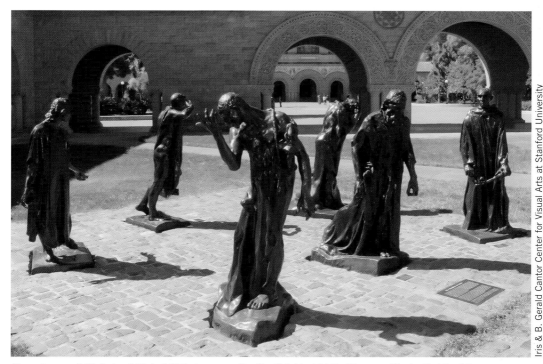

Burghers of Calais, 1884–1895 Auguste Rodin (1840–1917), France, Six individual bronzes

Iris & B. Gerald Cantor Center for Visual Arts at Stanford University

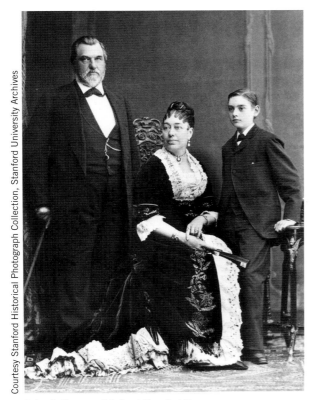

Courtesy Stanford Historical Photograph Collection, Stanford University Archives

Leland, Jane, and Leland Stanford Jr.

A decade later the renovated museum reopened as the Iris & B. Gerald Cantor Center for the Visual Arts, known as the Cantor Arts Center.

The Cantors are to thank for most of Stanford's stellar Rodin collection. In a classic American rags-to-riches story, Bernie Cantor, son of Jewish immigrants from Belarus, went from hawking hot dogs at Yankee Stadium to heading the securities firm Cantor Fitzgerald. Cantor developed a self-described "magnificent obsession" with Rodin's art, describing it as "a source of strength, power and sensuality." By the time Cantor died in 1996, he'd given away some 450 Rodins to dozens of institutions, including Stanford.

The majority of the Rodins, some 170 works, are on view in the ground-floor galleries. These are mostly cast bronzes, but also include wax, plaster, and terra-cotta works. The adjacent Rodin Sculpture Garden is home to another twenty major bronzes. The Sculpture Garden is anchored by *The Gates of Hell* flanked by *Adam* and *Eve*, the way Rodin intended the three works to be seen. Another of Rodin's major commissions, the *Burghers of Calais*, is located nearby at the entrance to the Main Quad.

The Rodin galleries present a survey of the sculptor's career, organized around his greatest hits. His many innovations are on view—heavily textured surfaces, exaggerated proportions, intense emotion, and the partial figure that starts to abstract human anatomy. Rodin famously reused plaster casts of legs, arms, and torsos and never thought his works were finished. Obsessed with the human figure, Rodin took up drawing at age sixty, producing thousands of drawings and influencing artists like Henri Matisse. Examples of his works on paper are rotated in the galleries.

One of Rodin's most recognizable sculptures, *The Thinker*, enjoys center stage in the octagonal rotunda. The approximately one ton, seventy-nine-inch-tall sculpture is the tenth and largest of the one dozen authorized editions. *The Thinker* is surrounded by pairs of related objects, like *Spirit of Eternal Repose* in both bronze and plaster. In the next room a photomural of the plaster version of *The Gates* is the backdrop for other spin-offs, like *The Kiss*, along with Rodin's breakthrough work, *The Age of Bronze*. The last gallery is organized by project, including the *Burghers of Calais* and the monument to writer Honore de Balzac.

Although many of Rodin's major works caused controversy and debate, the prolific sculptor was celebrated during his life. In the decades after his death, the artist's contributions were eclipsed by abstraction and other twentieth-century movements. With nearly a century of perspective, Rodin's impact on

the sculptures of Constantin Brancusi, Jean Arp, and Henry Moore, as well as their offspring like Isamu Noguchi and Magdalena Abakanowicz, is widely recognized.

Rodin directly inspired French-born American sculptor Gaston Lachaise, famous for his overtly sexual sculptures of women. In the 1920s, Lachaise began experimenting with exaggerated partial figures, like the headless, armless bronze *Torso of Elevation*. Italian-born American artist Onorio Ruotolo was called the "Rodin of Little Italy." In *The Doomed* from 1917, the artist uses a defeated prisoner to protest capital punishment.

"I began to do sculpture because of my admiration for Rodin," wrote Japanese-American artist Noguchi. Like many of Rodin's emotionally charged sculptures, Noguchi's *Victim* is a work of profound despair about the tragedy of war. Cast in bronze shortly before the artist's death in 1988, the sculpture is based on a work he created a quarter century earlier. The Los Angeles–born artist trained with Constantin Brancusi, who briefly worked in Rodin's studio.

Contemporary California sculpture is well represented at the Cantor Arts Center, including works by Jeremy Anderson, John Cederquist, and Alvin Light. Ronald Arneson, part of the Bay Area "funk" movement of the 1960s, worked in the figurative tradition. In *Global Death and Destruction*, a globe of the world supports the decapitated head of Daniel Pearl, the *Wall Street Journal* reporter murdered by Islamic extremists in Pakistan. What appears to be a bullet hole morphs into a smoke billowing missile crater. The base of this chilling work includes engravings of a mushroom cloud, skull, and missile, suggesting nuclear war.

More provocative figurative and abstract sculpture, some one hundred works, can be experienced across Stanford's campus. Among the outdoor headliners are Josef Albers, Alexander Calder, Jacques Lipchitz, Joan Miró, and George Segal. Like Rodin, Mark di Suvero often pays homage to celebrated composers and poets. But instead of figurative portraits in bronze, he constructs expressive abstract works like *Miwok* and *The Sieve of Eratosthenes* out of steel.

Stanford's largest work of outdoor art is Andy Goldsworthy's *Stone River*, a 320-foot serpentine sculpture made of sandstone from buildings at Stanford damaged in the 1906 and 1989 earthquakes. A wooded grove by Roble Gym is home to the Papua New Guinea Sculpture Garden, featuring forty works in stone and wood carved by artists from northern New Guinea. A pair of totem poles by Native American carvers guard the entrance to the law school and Dorman Grove. Stanford's art scene continues to grow with the Bing Concert Hall and a new building to house the Anderson Collection of contemporary art.

GETTING THERE Address: Museum Way at Stanford University, Stanford, CA Phone: (650) 723-4177 Website: museum.stanford.edu Hours: Wednesday through Sunday, 11:00 a.m. to 5:00 p.m., Thursday until 8:00 p.m. The Rodin Sculpture Garden is lit at night; outdoor sculptures can be viewed at all hours Rodin Tour: Wednesday 2:00 p.m., Saturday 11:30 a.m., Sunday 3:00 p.m. Outdoor Sculpture Walk: First Sunday of each month at 2:00 p.m., meet at the Main Quad; outdoor sculpture maps are available at the museum's information desk. Admission: Free

Not to Miss

Arcos de Geso Series VIII, Manuel Neri, 1985

Along with Elmer Bischoff, Richard Diebenkorn, and Nathan Oliveira, Manuel Neri was part of the San Francisco Bay figurative movement in the 1950s and 1960s. In the late 1950s, Neri began experimenting with plaster. Two decades later he began casting some of his plasters in bronze, a method practiced by Rodin. Neri continued to transform his original plasters, gouging and severing his figures and obscuring the metal under splashes of paint. This graceful, life-size plaster relief of a female figure in profile is part of an eleven-work series. Using a muted palette, Neri places his figures in a richly surfaced, architectural setting that evokes antiquity.

The Gates of Hell, Auguste Rodin, 1880–circa1900, Posthumous cast authorized by Musée Rodin, 1981

This giant portal measuring over twenty feet tall and thirteen feet wide was Auguste Rodin's first major commission—for the proposed decorative arts museum in Paris. For the dramatic gates, Rodin drew on Dante's *Inferno* and Ghiberti's Baptistery doors in Florence. In the center of the tympanum, *The Thinker* contemplates mankind's fate, while 186 figures writhe in agony on the panels below. The project inspired many major works, including *The Thinker, The Kiss, The Shades, Adam,* and *Eve.* Rodin worked on *The Gates* off and on for some two decades. After the artist's death in 1917, six versions were cast in bronze. The five other casts are found in Paris, Philadelphia, Zurich, Tokyo, and Shizuoka, Japan.

Sage E, Magdalena Abakanowicz, 1990

Like many of Magdalena Abakanowicz's powerful works, *Sage E* deals with issues of alienation and individualism. Growing up in wartime Poland, Abakanowicz experienced the German and Soviet invasions, and her art reflects years of war and life behind the Iron Curtain. Inspired by a group of sculptures made in burlap, this bronze depicts a seated, headless human torso. The form has been simplified with hands on the figure's lap, blending into the knees. A ceramic shell on the roughly textured surface makes the work appear to have been unearthed. Both the rough finish and partial figure were techniques used by Auguste Rodin.

Frederik Meijer Gardens & Sculpture Park
Grand Rapids, Michigan

"That unity of sculpture and nature is just the best it can be."

—Mark di Suvero

Modern and contemporary sculpture has rarely looked better than at the Frederik Meijer Gardens & Sculpture Park in Grand Rapids, Michigan. Within a spectacular landscape that changes with the seasons and even the time of the day, the sculpture park presents a remarkable assembly of works by a roster of internationally acclaimed artists.

The 125 acres at Meijer Gardens & Sculpture Park were a gift from its late namesake and benefactor, Frederik Meijer (pronounced *MY-er*). A humble billionaire on the *Forbes* list of wealthiest Americans, Meijer pioneered the concept of one-stop shopping at his family's retail and grocery chain long before Wal-Mart. Today the privately owned Meijer, Inc. operates some 190 stores in five states.

Since opening in 2002, the sculpture park's holdings have grown to nearly three hundred works, about eighty of which are installed throughout the landscaped grounds. One of the strengths of the collection is UK sculptors—including Henry Moore, Barbara Hepworth, Antony Gormley, Tony Cragg, and Andy Goldsworthy. Women are also well represented by artists like Louise Bourgeois, Louise Nevelson, Kiki Smith, and Beverly Pepper.

Each sculpture enjoys plenty of breathing room. At the same time, new works are carefully sited to create dialogues with neighboring sculptures, often with input from the artists. The environment around each work is also thoughtfully planned—frequently planted with trees, grasses, and wildflowers native to the upper Midwest. Twisty tree-lined trails lead to the artworks, which reveal themselves through the foliage and terrain.

The one chronological area is the manicured Gallery, featuring smaller nineteenth-century works by artists who helped pioneer modern figurative sculpture. Silhouetted against spruce, white pine, and red sugar maples, Auguste Rodin's *Eve* stands with her head nearly buried in the folds of her arm. Nearby is

Fred and Lena Meijer

Aria *by Alexander Liberman and waterfall*

the polished *Torso of Summer* by Aristide Maillol, who Rodin called "the greatest living modern sculptor."

With *Torso of a Knight,* French surrealist Jean Arp created a very different kind of torso in the mid-twentieth century, stripping the human form down to the suggestion of a head and torso, possibly with a knight's pointy helmet and armor. The sculpture stands about three feet tall and is a foot at its widest point, with a dark-brown patina and smooth, contoured surfaces.

Near a Henry Moore and Barbara Hepworth is Joan Miró's *Woman and Bird*. One of the first artists to use found objects in his work, the Spanish surrealist transferred his colorful, abstract painting style into

sculpture and ceramics. In this whimsical cast bronze and painted work, Miró uses a two-foot-tall milking stool for the woman's body. Her head is made from a blue trash can lid with two different-size circles cut out for eyes. A small red object, possibly the bird, sits atop her panlike black hat.

One of the most beautifully sited sculptures is Mark di Suvero's *Scarlatti*, situated on a hillside. Between summer and fall the rich rust-colored Cor-Ten and stainless steel sculpture complements the surrounding trees and blooms of asters, wild indigo, comb flowers, and goldenrods. The sculpture is trademark di Suvero—a transformation of scrap metal and steel cables into a graceful composition. At the

tip of the colossal work, two connected I-beams form an elongated V that rocks in the wind.

Other dramatic installations are found in the northeast part of the park. George Rickey's water sculpture *Four Open Squares Horizontal Gyratory—Tapered* appears to float on the surface of a pond in the glen. The flowering dogwood and water are reflected in the gently moving polished stainless steel squares. Rickey's Russian-born contemporaries Louise Nevelson and Alexander Liberman explore positive and negative space with their nearby works, *Atmosphere and Environment* and *Aria*. Light and air filter through the monumental red *Aria*, in which Liberman explores shapes that suggest musical notes.

Among contemporary artists working in the figurative tradition is Welsh sculptor Laura Ford, whose works like the part-child, part-tree *Espaliered Girl* explore the often macabre world of fairy tales. "I liked the idea of people traipsing around a sculpture park looking for the sculptures and the sculptures pretending they weren't there, sculptures in disguise," said Ford.

The Sculpture Park continues to add two to three works each year. In a large circular lawn surrounded by trees and bushes is one of the newer acquisitions—*Neuron* by Roxy Paine. The colossal branching tree is made of thirty-five hundred stainless steel rods and industrial piping. "I strive for imagery that is between things—nature and industry, science and art, but not quite comfortable in either world," said Paine.

In addition to the outdoor artworks, there are three indoor exhibitions each January, June, and September, as well as three annual horticultural shows. Past exhibits have explored modern masters like Auguste Rodin, Pablo Picasso, and Henry Moore and contemporary artists like George Segal, Anthony Caro, and Deborah Butterfield.

While inside, visitors can spend some time with Michele Oka Doner's green terrazzo and bronze floor sculpture, *Beneath the Leafy Crown*. Inspired by the floor of a Michigan forest, the artist designed and embedded over fifteen hundred bronze botanical elements throughout the first-floor public space. Children are prone to hopscotch from leaf to leaf.

Lena Meijer loves gardens and flowers and her conservatory is a must, especially for orchid lovers. In addition to hundreds of tropical plant species, there are over three thousand orchid plants, including many rare species. Local experts offer workshops and demonstrations and tours on everything from roses and dahlias to orchids and bonsai. Each spring hundreds of butterflies from Asia and Central and South America are released into the conservatory.

GETTING THERE Address: 1000 E. Beltline NE, Grand Rapids, MI Phone: (616) 957-1580 Website: meijergardens.org Hours: Monday, Wednesday, Thursday, Friday, and Saturday, 9:00 a.m. to 5:00 p.m.; Tuesday 9:00 a.m. to 9:00 p.m.; Sunday 11:00 a.m. to 5:00 p.m. Tours: Tram tours run March through December, adults $3, children $1; tickets for the popular outdoor summer concert series go on sale each May. Admission: Adults $12, seniors and students $9, children 5 to 13 $6, children 3 to 4 $4, children 2 and under free

Not to Miss

Male/Female, Jonathan Borofsky, 2001

Jonathan Borofsky is famous for large outdoor public works made with materials like stainless steel, fiberglass, and aluminum. Many of his works deal with dualities, like this striking twenty-three-foot-tall brushed-aluminum sculpture with simplified, intersecting male and female forms. A fifty-foot version stands in front of Baltimore's Penn Station. "Every artist's work is their self-portrait . . . of the inner working and the inner soul and the inner feelings . . ." said Borofsky. ". . . Because I'm an ongoing work myself, my artwork becomes kind of a record, an ongoing portrait of my life."

Cabin Creek, Deborah Butterfield, 1999

Working with a variety of materials, Deborah Butterfield has created a stable of lyrical horses. Her early works, like the Meijer's indoor *Dry Fork Horse*, are made of mud, straw, and clay. More recently Butterfields's horses are made with found objects, wood, welded steel, and bronze. For the weathered *Cabin Creek*, Butterfield arranged twigs, branches, and boards, then carefully disassembled the pieces and cast them in bronze. The bronze elements were reassembled to re-create the original. "The first thing that I saw in my life that I remembered looking important and wonderful was a horse; I was just moved by them in a non-rational, passionate way before I even had words to describe them," said Butterfield.

I, you, she, or he, Jaume Plensa, 2006

Catalan artist Jaume Plensa picked the site for this compelling commission, one of the most popular works at the sculpture park. Like many of Plensa's works, this sculpture explores themes of communication and relationships among individuals. Viewers are pulled into the conversation among a group of three figures, each formed by an open mesh of metallic uppercase letters welded together. The figures sit atop flat limestone boulders. "Sculpture," said Plensa, ". . . is talking about something deep inside ourselves that without sculpture we cannot describe. We are always with one foot in normal life and one foot in the most amazing abstraction. And that is the contradiction that is life."

Capital from Daffodil Terrace, Louis Comfort Tiffany, circa 1915, The Charles Hosmer Morse Museum of American Art

Chapter 14

SINGLE-ARTISTS

THE BRANDYWINE RIVER MUSEUM
Chadds Ford, Pennsylvania

"Among those misty gray hills of Chadds Ford . . . there is that spirit which exactly appeals to the deepest appreciation of my soul."

—N. C. Wyeth, 1907

❦ On the tranquil banks of the Brandywine River in Chadds Ford, not far from Henry Francis du Pont's Winterthur, stands a Civil War–era gristmill turned art museum. Since 1971 the red brick Hoffman's Mill has enjoyed a second life as the Brandywine River Museum featuring the work of three generations of Wyeths, the nation's leading family of artists.

Family patriarch Newell Convers Wyeth came to this rural southeast corner of Pennsylvania from Massachusetts in 1902 to study with illustrator Howard Pyle. It's N. C. Wyeth's work along with that of his son, Andrew Wyeth, and grandson, Jamie Wyeth, that forms the heart of the collection.

A soaring glass wall in the open lobby offers stunning panoramas of the Brandywine River—the same views that have inspired artists for generations. The three-story gristmill has been transformed into rustic, wood-beamed galleries for N. C. Wyeth, American illustration, landscape, still life, genre painting, and changing exhibitions. Two additions in 1984 and 2005 created spacious galleries on the third floor showcasing works by Andrew Wyeth and Jamie Wyeth.

In 1904 N. C. Wyeth traveled west to Arizona, New Mexico, and Colorado, inspiring scenes of the Wild West like *The Hunter* and *In the Crystal Depths*. Frequently on view are Wyeth's well-known pirates and scalawags from classic novels like Robert Louis

Stevenson's *Kidnapped* and *The Last of the Mohicans* by James Fenimore Cooper. Wyeth created the seventeen large oils for Stevenson's *Treasure Island* in under four months, using neighbors and acquaintances as models for Long John Silver, Jim Hawkins, and Billy Bones. He used his two thousand dollars in earnings to buy eighteen acres in Chadds Ford, where he built a home and studio.

Although N. C. Wyeth was one of the country's top illustrators, he aspired to be a fine art painter. In 1920, looking for inspiration, he bought a "storm-beaten homestead" in Port Clyde, Maine, that he christened "Eight Bells" after Winslow Homer's painting. Through the years N. C. Wyeth shared the studio with his daughters Henriette and Carolyn and son Andrew, who split time between the Maine coast and rural Pennsylvania.

N. C. Wyeth's impact on his children was formidable, especially on Andrew, whose frail health kept him home schooled and in daily contact with his father. Andrew Wyeth, who died in 2009 at ninety-one, is considered one of the nation's best realist painters, known for his tightly rendered landscapes and introspective portraits created during a seventy-five-year career.

Andrew Wyeth used watercolor and dry-brush watercolor, a technique that combined drawing and

painting in watercolor. His favorite medium was tempera, a mixture of dry pigment, distilled water, and egg yolk he described as having "a cocoon-like feeling of dry lostness. . ." Visitors can see his meticulous brushwork and subdued palette at work in paintings like *Roasted Chestnuts* and *Night Sleeper*. Frequently the museum's curators display Andrew Wyeth's watercolor and pencil studies alongside his finished paintings, offering a rare look at the artist's process. "I prefer winter and fall, when you feel the bone structure of the landscape—the loneliness of it, the dead feeling of winter," Andrew Wyeth said. "Something waits beneath it, the whole story doesn't show."

Andrew Wyeth's younger son, Jamie Wyeth, has carried on the family tradition, developing his own realist style. Unlike his father's and grandfather's dedication to particular media, Jamie Wyeth has experimented with oil, watercolor, and pen and ink, as well as etching and lithography. He also works in combined mediums of watercolor and gouache and uses pearlescent paint that gives some of his works a luminous quality. On view are Jamie Wyeth's studies for his portrait series of the dancer Rudolf Nureyev, as well as his well-known *Raven* and *Portrait of Pig*.

In its special exhibitions, the museum explores the strengths of its rich collection of over four thousand works, including American illustration by notables like Winslow Homer, Charles Dana Gibson, Maxfield Parrish, and Rockwell Kent.

Guided tours of three nearby properties offer further insights into this gifted family. At the Wyeth house and studio, a National Historic Landmark, light streams through a Palladian window onto an easel holding the artist's last unfinished work, a painting of George Washington. Wyeth's palette and brushes remain untouched; his smock still hangs on a hook, the left arm stiff with dried paint. His props also remain in place—life masks of Lincoln and

N. C. Wyeth's Studio

Brandywine River Museum, Chadds Ford, PA

Beethoven, saddles, snowshoes, moccasins, and a canoe hanging from the ceiling. The scratch marks on the doors are from Wyeth's dogs.

Another National Historic Landmark, neighboring Kuerner Farm inspired some one thousand works by Andrew Wyeth, including many of his best-known images. Starting with his first painting of the farm at age fifteen, Andrew Wyeth drew and painted its people, animals, and landscapes. The farm took on a new poignancy in 1945, when N. C. Wyeth and his grandson were killed when a train hit his stalled car a few hundred yards away. The farm is also where Andrew Wyeth met Helga Testorf, his model for a secret fifteen-year series of nudes that created a national sensation in 1986. The museum recently opened Andrew Wyeth's studio to the public.

GETTING THERE Address: US Route 1, Chadds Ford, PA Phone: (610) 388-2700 Website: brandywinemuseum.org Hours: Daily 9:30 a.m. to 4:30 p.m. Tours: N. C. Wyeth House & Studio, Kuerner Farm, Andrew Wyeth Studio, and Victoria Wyeth Gallery Tours, $5 per person; see website for schedules Admission: Adults, $10, seniors, students, and children $6, children under 6 free, audio tour $3

Not to Miss

All Day He Hung Round the Cove, or Upon the Cliffs, with a Brass Telescope, N. C. Wyeth, 1911

Among N. C. Wyeth's most memorable works are his large painterly oil illustrations for the classic novel *Treasure Island* by Robert Louis Stevenson. The powerful colorful images—like this oil of pirate Billy Bones holding a telescope—helped establish Wyeth as one of the nation's top illustrators. Wyeth based his illustrations on dramatic passages from the novel, rather than characters, and worked without preparatory drawings.

Collection of Brandywine River Museum, Bequest of Gertrude Haskell Britton, 1992 © Brandywine River Museum

Indian Summer, Andrew Wyeth, 1970

This tempera painting is part of Andrew Wyeth's six-work series of Siri Erickson painted at the height of his career. Wyeth met the thirteen-year-old girl in Cushing, Maine, right before the death of his friend and model Christina Olson, who he immortalized in _Christina's World._ For ten summers the artist painted Siri mainly in outdoor settings, along with her family and Finnish neighbors. "To me, these pictures of the young Siri are continuations of the Olsons, and at the same time they are sharp counteractions to the portraits of Christina, which symbolize the deterioration and the dwindling of something. In a way this was not a figure, but a burst of life," Wyeth said in 1977. The artist depicts his subject from the back, standing nude on a blue gray rock gazing into a dark grove of evergreens.

Wolfbane, Jamie Wyeth, 1984

Like his father, Jamie Wyeth can evoke a person without actually picturing him or her in a painting. In this mysterious work, the presence of the artist's wife, Phyllis Mills, is represented by her delicately painted hat, hanging over the back of a chair. Dramatic lighting and a rich dark background lend mystery to her straw hat and high-backed chair. A trailing white scarf wound around a floral sprig suggests the subject's gracefulness. Mills, who was permanently crippled in a car accident, has been the subject of many of Wyeth's paintings, like _And Then into the Deep Gorge, Wicker,_ and _Whale._ Like his grandfather, Jamie Wyeth has illustrated books with watercolors and pen and ink drawings.

A PLACE FOR DREAMS

THE CHARLES HOSMER MORSE
MUSEUM OF AMERICAN ART
Winter Park, Florida

"The most comprehensive and the most interesting collection of Tiffany anywhere."
—Alice Cooney Frelinghuysen, Curator of American
Decorative Arts, Metropolitan Museum of Art

Most people associate Winter Park, Florida, with nearby Orlando and Disney World, but this quiet college town boasts its own attraction. Along with arts and crafts furnishings and American art pottery, the Charles Hosmer Morse Museum of American Art presents one of the world's best collections of works by Louis Comfort Tiffany—from leaded and blown glass to enamels, pottery, and jewelry.

Jeannette Genius McKean and Hugh F. McKean, 1955

In 1942 Jeannette Genius McKean founded the museum that she named after her grandfather, Chicago industrialist and Winter Park retiree Charles Hosmer Morse. To run the fledgling gallery, she hired Rollins College art professor Hugh F. McKean, whom she married several years later. In 1995 the museum moved to its present location, a former bank and office building along Winter Park's charming main street.

An archival gallery introduces visitors to the multifaceted career of Louis Comfort Tiffany that includes painting, interior design, and Broadway stage sets. The son of the famous jewelry firm founder, Tiffany grew up around emeralds, rubies, and other precious gemstones. Among the personal items on display is Tiffany's sketchbook from his travels, when he experienced Islamic mosaic work and medieval stained glass windows. Photographs illustrate Tiffany's early interiors for celebrity clients like Mark Twain and President Chester Arthur.

After stints as a painter and interior designer, Tiffany turned his attention to glassmaking, developing new recipes for opalescent glass with various textures, densities, and colors. With this glass palette Tiffany could effectively "paint" with glass. From the late 1870s to the 1920s, his studios produced

thousands of leaded windows for houses, churches, libraries, theaters, and stores.

In 1893, Tiffany introduced the exquisite blown-glass vases and bowls he called Favrile—from an Old English word for "handmade." His interests in Islamic art and ancient Greek and Roman glass inspired a variety of shapes, colors, and textures, as did motifs from nature, like flowers and leaves. In many cases Tiffany's glass objects feature forms and colors that approach abstraction. As he did with stained glass, Tiffany used the natural properties of the medium to express his vision.

Also around this time, Tiffany began exhibiting his lighting. On view are many famous designs—from the elaborate, sculptural leaded-glass Cobweb and Wisteria shades to a reading lamp made with pressed glass and abalone shell. The design of some of the Tiffany leaded-glass lamps is now credited to Clara Driscoll, head of his studio glass-cutting department.

Of Tiffany's many achievements, Laurelton Hall, his Long Island country estate, is considered his masterpiece. Tiffany's studio draftsman, Robert L. Pryor, drew up plans for the eighty-four-room mansion the artist called "a place for dreams." When it was completed in 1905, Tiffany filled the opulent interiors with hundreds of his own creations, as well as his collections of ancient glass and Japanese and Native American art.

In 1918, Tiffany established a foundation to maintain Laurelton Hall as a museum and to support aspiring artists. Hugh McKean was among the art students living and painting in Tiffany's converted barn and carriage house. After Tiffany's death in 1933, financial reverses caused his foundation to eventually sell the contents of Laurelton Hall and subdivide the property. Sadly, in 1957 a three-day fire gutted the estate.

At the invitation of one of Tiffany's daughters, Jeannette and Hugh McKean traveled to Long Island

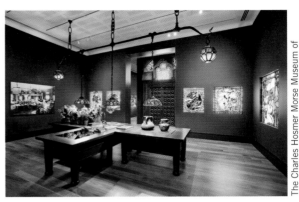

Living Room from Laurelton Hall

to salvage what they could from the ruins. Over the next thirty years, the couple searched for objects that had been auctioned off and sold. In 1978 the McKeans gave the Metropolitan Museum of Art the limestone and ceramic glass loggia from Laurelton Hall.

In 2011 the Morse Museum opened a new wing, reuniting architectural elements and art from Laurelton Hall. In the handsome forest green living room, panels from Tiffany's *Four Seasons* flank carved Indian doors. Five turtleback lamps hang above a replica of the artist's large wood desk. Tiffany started each day with breakfast in the dining room, re-created here with his table and chairs, leaded-glass wisteria suite, and blue and cream rug. The dining room led to Tiffany's Daffodil

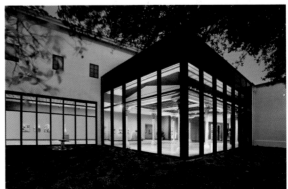

Daffodil Terrace at night

Terrace, painstakingly reassembled by conservators. Bouquets of yellow glass daffodils top eight white marble columns; an iridescent glass pear tree motif adorns the skylight.

In addition to Tiffany's famous leaded and blown glass, visitors are treated to the artist's rarer and lesser-known works in enamel, jewelry, and pottery. In 1899, Tiffany began designing enamels, which he made by applying layers of translucent glass like paste to metal. A separate gallery showcases pottery that Tiffany first exhibited at the Louisiana Purchase Exposition in St. Louis in 1904. For the next decade Tiffany experimented with creamy yellow and mossy green glazes and bronze-covered ceramics to create his nature-inspired vases.

With their thick, complex glazes, Tiffany's ceramics are strikingly different from the American art pottery on display by makers like Rookwood, Fulper, Grueby, and Weller. Also on view are American arts and crafts furnishings from the Winter Park home of the museum's namesake, Charles Hosmer Morse. Among the highlights are his Stickley dining room table and chairs, bedroom set, and rare portiere curtain. A leading proponent of the American arts and crafts movement, Gustav Stickley promoted simple, handcrafted furniture.

GETTING THERE Address: 445 N. Park Ave., Winter Park, FL Phone: (407) 645-5311 Website: morsemuseum.org Hours: Tuesday to Saturday 9:30 a.m. to 4:00 p.m., Sunday 1:00 to 4:00 p.m. Admission: Adults $3 adults, students $1, children under 12 free

Not to Miss

Peacock Necklace, circa 1903–1906

After his father's death, Louis Tiffany became art director at Tiffany & Co., where he sold his enamels, metalware, and art glass. He also applied his aesthetics to jewelry design, creating handcrafted pieces in semiprecious stones and enamels. Tiffany only created a few hundred pieces of jewelry—among the most spectacular is the Morse's peacock necklace, exhibited at the Paris Salon in 1905. The front features a central mosaic of opals and enamel surrounded by amethysts and sapphires. On the back is an enameled design of pink flamingoes. Peacocks, a symbol of immortality, recur in Tiffany's work, as do flamingoes. "One may say that the quality, the artistic quality, of the jewelry which is found among a people goes far to measure that people's level in art . . ." said the designer.

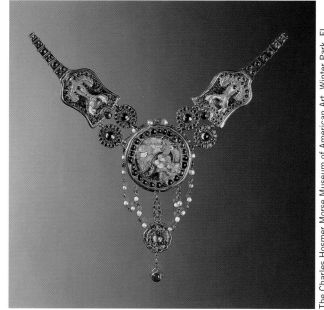

The Charles Hosmer Morse Museum of American Art, Winter Park, FL
© The Charles Hosmer Morse Foundation, Inc.

Winter, from Four Seasons, 1899–1900

Louis Tiffany was at the height of his career when he created a stunning art nouveau window of the four seasons for the 1900 Exposition Universelle in Paris. Eventually Tiffany installed the award-winning panels in a living room alcove at Laurelton Hall, where they survived the fire. Many of Tiffany's glass innovations are illustrated in the winter scene. Although the glow of the fire appears to be painted, it was actually created by backing the panel with several layers of glass, a technique called plating. To achieve the effect of pine needles, Tiffany added a string of green glass into flat molten glass. Chunks of glass the artist called "chipped jewels" added a gemlike sparkle. Tiffany's enamel and gemstone jewel box with the four seasons in miniature is also on view.

Tiffany Chapel, 1893

Inspired by Italian mosaics and French glass, Louis Tiffany created this tour de force for the World's Columbian Exposition in Chicago. The intensely colored leaded-glass windows and reflective glass mosaics put the forty-five-year-old designer on the map and led him to form an ecclesiastical department at his studio. After the exposition Tiffany moved the Byzantine-inspired interior to his studio and then sold it for use in a New York church. After his prized interior was relegated to a basement crypt, Tiffany reacquired it and had it reinstalled at Laurelton Hall. Miraculously the main portion survived the 1957 fire and was salvaged by the McKeans. After three years of conservation, the chapel opened at the museum in 1999. Among the highlights are a chandelier in the shape of a cross, marble and white glass mosaic altar, and dome-shaped baptismal font.

STILL WATERS RUN DEEP

THE CLYFFORD STILL MUSEUM
Denver, Colorado

"You can turn the lights out. The paintings will carry their own fire."

—Clyfford Still

❧ Along with Mark Rothko and Jackson Pollock, Clyfford Still is considered one of the founders of American abstract expressionism. But distrustful of museums and art critics, Still sold only enough paintings to support his family and locked the rest away for decades in a Maryland warehouse. Only a fraction of the artist's work has been accessible in a handful of museums—until now.

In late 2011 the hidden works were finally revealed when the Clyfford Still Museum opened in downtown Denver. Still's widow, Patricia Still, donated 94 percent of everything her husband created—some 825 paintings, 1,575 works on paper, and 3 sculptures. Before the museum opened, 4 of the paintings fetched a record $114 million at auction, a huge boon for the museum's endowment.

Brad Cloepfil of Allied Works Architecture designed the handsome cantilevered building, conveniently located by the Denver Art Museum. From the long lobby, a stairway leads to nine second-floor galleries. Natural light from perforated concrete ceilings washes onto Still's monumental canvases, bringing out the heavily textured surfaces and rich colors. Two outdoor terraces offer visitors a respite along the way. Introductory information, a library, and the artist's archive are located on the ground floor. True to Still's wishes, there is no cafe or auditorium.

The inaugural exhibitions trace Still's sixty-year career—from his early figurative works and surrealist-influenced abstraction to his trademark flame-streaked canvases and lighter late paintings. Also on view in an intimate gallery are a trio of small wood sculptures and works on paper, where the artist worked out his evolving vision. "I never wanted color to be color," Still said. "I never wanted texture to be texture, or images to become shapes. I wanted them all to fuse into a living spirit."

Before entering the galleries, visitors meet Still in a telling three-quarter-length self-portrait. As a result of dramatic foreshortening, the thirty-six-year-old Still looms high above us, staring intensely out from behind wire-rimmed glasses. The self-taught artist portrays himself in a long black coat and tie, with a salt-and-pepper mane and oversize hands.

Born on a North Dakota farm in 1904, Still moved to Spokane, Washington and then Alberta, Canada, where his family homesteaded a wheat ranch. Many of his early figurative pictures feature freight trains and grain elevators, reflecting his fascination with "the awful bigness, the drama of the land, the men and the machines." After graduating from Spokane University, Still completed a master's thesis on Paul Cézanne at Washington State University, where he stayed to teach. Around this time Still turned from

landscape to the human form. On view are examples of his abstracted, distorted farm workers.

In the next galleries, visitors see Still's "aha" moment when he first arrived at abstraction and his large format canvases of the 1940s and 1950s. Although his earth-tone palette and craggy forms evoke geologic formations, Still saw his large-scale works as metaphysical landscapes, metaphors for the limitless human imagination. Unlike many of his colleagues, Still prepared his own pigments. He achieved his caked, tectonic surfaces by applying coarsely ground blacks, browns, and reds with a palette knife and brush. "These are not paintings in the usual sense," Still said of his dramatic abstractions, "they are life and death merging in fearful union . . . they kindle a fire; through them I breathe again, hold a golden cord, find my own revelation."

Before leaving Northern California to teach in Virginia, Still had his first solo show at the San Francisco Museum of Art and met artist Mark Rothko in Berkeley. Two years later Rothko introduced Still to Peggy Guggenheim, who organized a show at her influential gallery, the Art of this Century. "A bolt out of the blue" is how Robert Motherwell described the 1946 exhibition. "Most of us were still working through images . . . Still had none." Like Rothko, Still removed conventional titles from his works in favor of a system of dates, letters, and numbers identifying the order of his paintings. "As before, the pictures are to be without titles of any kind," Still instructed art dealer Betty Parsons in 1949. "I want no allusions to interfere with or assist the spectator."

Along with Motherwell and Jackson Pollock, Still was considered an "action painter"—an artist whose technique emphasized the process of painting. In a 1956 diary entry, Still wrote: "A great free joy surges through me when I work . . . with tense slashes and a few thrusts the beautiful white fields receive their

1940 PH-382 Clyfford Still self-portrait

color and the work is finished in a few minutes." Despite his association with this branch of abstract expressionism, Still refused to acknowledge membership in any artistic movement or school.

After a period of painting and teaching at the California School of Fine Arts, Still returned to New York City in 1951, where he expanded on his themes and introduced new elements like bare canvas and horizontal compositions. One of Still's first New York paintings is part of the collection—a fourteen-foot-wide blue canvas bisected by a slender red "life line"—the kind that often extends through the entire length of his paintings. Until now, this work was shown just once, at the 1963 inaugural exhibition of the Institute of Contemporary Art in Philadelphia.

Around the mid-1950s, Still began severing ties with commercial galleries and restricting how museums could lend and show his paintings. The

Photography by Jeremy Bitterman © Clyfford Still Estate

artist also ended his friendships with fellow abstract expressionists Rothko, Pollock, and Barnett Newman and declined invitations to exhibit in the American Pavilion at the Venice Biennale. In 1961 Still retreated physically, moving to Maryland, where he spent the last two decades of his life.

Clyfford and Patricia Still donated paintings to three institutions: the Albright-Knox Art Gallery in Buffalo, the San Francisco Museum of Modern Art, and the Metropolitan Museum of Art. With the gifts came the restriction that the paintings couldn't travel, be sold, or be shown with works by other artists. Still believed his paintings could only be understood as part of a whole. "My work in its entirety is like a symphony in which each painting has its part," he wrote. Now that symphony is playing in Denver.

GETTING THERE Address: 1250 Bannock St., Denver, CO Phone: (720) 354-4880 Website: clyffordstillmuseum.org Hours: Tuesday to Thursday, Saturday and Sunday 10:00 a.m. to 5:00 p.m., Friday 10:00 a.m. to 8:00 p.m. Tours: Wednesday 1:00 p.m., Saturday 11:00 a.m. Admission: Adults $10, seniors and students $6, youth 6 to 17 $3, children 5 and under free

Not to Miss

1957-J No. 2

Clyfford Still's artistic process included pairs of paintings or replicas—some nearly identical and others varying slightly in size, color, or elements. The first version of this animal hide–like canvas is more dramatic, with red areas pressing in from all sides (Anderson Collection, Stanford University). Denver's version features a splash of yellow at the right, softening the black, white, and red canvas. "Making additional versions is an act I consider necessary when I believe the importance of the idea or breakthrough merits survival on more than one stretch of canvas," Still wrote in 1972. ". . . Although the few replicas I make are usually close to or extensions of the original, each has its special and particular life and is not intended to be just a copy."

1944-N No. 1

Considered Still's first abstract expressionist work, this monumental work was chosen by the artist for his 1979 retrospective at the Metropolitan Museum of Art. For Still, black was a warm, generative color rather than a symbol of death. The large black expanse is interrupted by an irregular red trail and small bursts of yellow, white, and turquoise at the bottom right. Although abstract expressionism is seen as a New York movement, Still produced this and many other abstract expressionist paintings in Virginia and California. In the introduction to Still's 1946 exhibition catalog, Mark Rothko wrote, "It is significant that Still, working out West, and alone, has arrived at pictorial conclusions so allied to those of the small band of Myth Makers . . . his is a completely new facet of this idea, using unprecedented forms and completely personal methods . . ."

PH-1007, 1976

This canvas, painted four years before Clyfford Still's death at age seventy-five, is a good example of how the artist's style loosened dramatically in the 1970s. At the peak of his fame, Still withdrew to a Maryland farm, converting some of the old buildings into a large studio. In contrast to the dense, thickly painted canvases of the late 1940s and 1950s, Still's Maryland canvases have a lighter, more ethereal feel. ". . . In comparative isolation, his work has noticeably changed," observed Katherine Kuh, former curator of modern art at the Art Institute of Chicago. "The recent paintings, vast in scale and totally liberated from any fixed focus, sweep upward with frank exuberance . . . these surging open canvases bear witness to a new optimism, to an escalating power."

THE DALI MUSEUM
St. Petersburg, Florida

"Walls that breathe and pulse imperceptibly . . ."
—Salvador Dali, on his wishes for a museum dedicated to his art

Salvador Dali remains one of the most complex and fascinating artists of the twentieth century. Surprisingly, the most comprehensive collection of his art outside Spain is not found in Paris or New York. Over twenty-one hundred of Dali's works reside in the sunny resort town of St. Petersburg, Florida. At its dramatic new bay front home, the Dali Museum presents all phases of the artist's sixty-year career—from his early experiments with impressionism and transition to surrealism to his later obsession with religion and science.

The collection's improbable path to St. Petersburg began in 1980 when a local lawyer read an article in the *Wall Street Journal*, "U.S. Art World Dillydallies Over Dali." Industrialist A. Reynolds Morse and his wife, Eleanor, were searching for a permanent home for their Dali holdings that had outgrown their Cleveland gallery. The Morses assembled the largest private Dali collection over several decades, visiting the artist frequently at his home in Port Lligat, Spain. "We knew he was a genius," recalled Eleanor Morse, who translated books by and about Dali into English.

At the time, the Midwest couple's enthusiasm for Dali was not shared by the art establishment, which favored abstraction and dismissed the artist for his commercialism and eccentricity. No museum would guarantee to exhibit the Morse collection and keep their bequest intact. St. Petersburg rallied, converting a boat repair warehouse into a museum that opened in 1982, seven years before

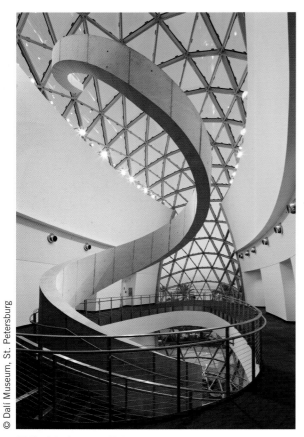
Helical Staircase twilight

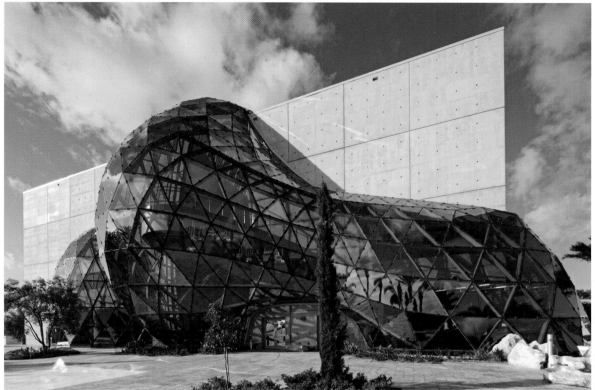

Dali's death. For nearly three decades, the Morse collection resided here, with paintings rotated for lack of space.

Then a funny thing happened. The art world fell in love with Dali—thanks in part to art historical scholarship and two monograph exhibitions that traveled to the Metropolitan Museum of Art in 1995 and Philadelphia Museum of Art in 2004. Suddenly the quiet little museum in St. Petersburg began receiving loan requests from around the world. The value of the art collection that no museum wanted soared to $150 million.

In 2011 the Dali Museum relocated eight blocks north to a Yann Weymouth–designed building with room for all ninety-six paintings and separate galleries for eight masterworks. The centerpiece is a futuristic version of Buckminster Fuller's geodesic dome at Teatro-Museo Dali in Figueres, Spain where Dali is buried. Some nine hundred triangular glass panels form a dome that floods the three-story atrium with light. A helix-shaped staircase, a nod to Dali's fascination with spiral forms, connects the first floor to the third-floor galleries.

In addition to painting, Dali was also a photographer, sculptor, filmmaker, and theater designer. A separate gallery features selections from the museum's extensive holdings of his works on paper, as well as videos and surreal objects. Philippe Halsman's famous black-and-white photographs of Dali—including the fittingly surreal image of the artist suspended in midair with three flying cats, a chair, an easel, and a bucket of water—are also on view. Special exhibitions explore a variety of subjects, including a future show on Picasso and Dali.

The main galleries trace Dali's stylistic evolution and influences—from his iconography to complex symbolism. In the early works gallery, visitors meet the precocious young artist who knew by age twelve that he'd be an artist. There are post-impressionist landscapes of his beloved Catalan region as well as a self-portrait in a large black hat, his bulging right eye fixed on the viewer.

In 1928, art critics compared Dali's *The Basket of Bread* to still-life paintings by Caravaggio and Francisco de Zurbarán. He set his hyperlit wicker bread basket and white cloth dramatically against a dark table and background. "Bread has always been one of the oldest fetishistic and obsessive subjects in my work, the one to which I have remained the most faithful," Dali later wrote. Expelled from Madrid's prestigious Academia de San Fernando for refusing to take his final exams, Dali turned to cubist and avant-garde styles of his fellow Catalan artists Pablo Picasso and Joan Miró.

Another grouping presents examples of Dali's surrealist art from the 1930s, considered by many his finest work. In 1934 Dali married Gala, the Russian-born former wife of poet Paul Eluard, who became his muse and manager. The couple rented a fisherman's cabin in the tiny village of Port Lligat (meaning "tied in harbor" in Catalan), which they bought and expanded. That year, Dali painted the small *Ghost of Vermeer at Delft*, set in the lane above their house. "I am home only here; elsewhere I am camping out,"

he wrote of the Catalan region, which he viewed as the most beautiful place in the world and depicted throughout his career. Port Lligat would remain his prime residence until Gala's death in 1982.

Also on view are Dali's Freudian-inspired "hand painted dream photos" and canvases filled with his own symbols—like ants and grasshoppers, rhinoceros horns and fried eggs. The Morse's first acquisition, *Daddy Longlegs of the Evening—Hope!* marks Dali's transition from surrealist dream photos toward his later classic period. The couple paid $1,250 for the ominous prewar painting and another $1,700 for the frame, selected by Dali. When World War II broke out that year, the pro-Franco artist left Spain for the United States.

The last installations focus on Dali's fascination with atomic power and modern science after his return to Spain in 1949. He called his new combination of mystical and scientific iconography "nuclear mysticism." During this period Dali became a devout Catholic and drew inspiration for religious-themed paintings from Old Masters and nineteenth-century academic painters.

In his 1963 "screen dot" *Portrait of My Dead Brother*, Dali explores the tragic loss of his older brother and namesake who died as a toddler. At age five Dali's parents took him to Salvador's grave, telling him he was his brother's reincarnation. Of his brother Dali said, "[We] resembled each other like two drops of water, but we had different reflections . . ."

GETTING THERE Address: One Dali Blvd., St. Petersburg, FL Phone: (707) 823-3767 Website: thedali.org Hours: Monday to Wednesday, Friday and Saturday 10:00 a.m. to 5:30 p.m.; Thursday 10:00 a.m. to 8:00 p.m.; Sunday noon to 5:30 p.m. Tours: Daily on the half hour Admission: Adults $21, seniors $19, students $15, children 6 to 12 years $7, children 5 years and under free

Not to Miss

Weaning of Furniture-Nutrition, 1934

In this small seven-by-nine-inch panel, Salvador Dali depicts Llucia, his beloved childhood nurse in a dual image as his nurse and an old woman mending a fishing net on the beach in Port Lligat. Dali associated his night table and baby bottle with his nurse, seeing the physical objects as part of her being. Here, Dali weans the baby bottle and table physically from Llucia's body, creating a rectangular hole requiring a wooden crutch to hold her up. The balance of the composition features fishing boats, terraced hills, and an orange and blue sunset. The painting's previous owner, Jocelyn Walker (Mrs. Charles Potter), saved the work from the Nazis by hiding it in her coat when she fled the Channel Islands.

The Disintegration of the Persistence of Memory, 1952–1954

In this work, Salvador Dali reinterprets his most-celebrated surrealist painting, *The Persistence of Memory.* The 1931 canvas of melting clocks Dali called the "camembert of time" is now flooded, with Cadaqués hovering above the water. Watch hands float above their dials and cone-shaped objects are suspended in parallel formation. Dali replaces the original orange stopwatch with the glowing eye of a floating fish. "After 20 years of total immobility . . ." Dali wrote, "the soft watches disintegrate dynamically while the highly colored chromosomes of the fish's eye constitute the hereditary approach of my pre-natal atavisms."

The Discovery of America by Christopher Columbus, 1958–1959

Some historians claimed Christopher Columbus hailed from Catalonia, making the explorer's discovery especially meaningful to Salvador Dali. In this fourteen-foot-tall work, Dali depicts an idealized Columbus in classical robes, bringing Christianity to the New World. His wife, Gala, poses as the Blessed Virgin on the large banner in Columbus's right hand. Dali used himself as a model for the head of Christ and paints himself into the background as a monk kneeling behind a crucifix. Dali makes references to fellow Spaniard Diego Velasquez, borrowing spears from the artist's *The Surrender of Breda* onto which he paints the image of a crucified Christ.

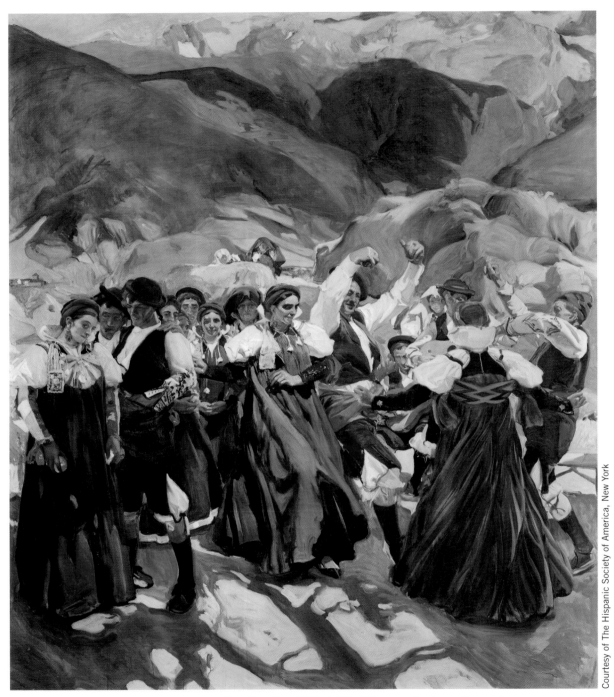

Vision of Spain, Aragon, Joaquín Sorolla y Bastida, 1911–1919, Hispanic Society of America

CHAPTER 15

SPANISH & LATIN AMERICAN ART

THE ART MUSEUM OF THE AMERICAS
Washington, DC

"For many, many years, the Art Museum of the Americas has sheltered and promoted creative people in Latin America and the Caribbean. The result has been the emergence of great artists who today are internationally renowned . . ."

—Eduardo Mac Entyre, Argentine artist

For most Americans, Latin American art is synonymous with Frida Kahlo and the "three great ones"—muralists Diego Rivera, Jose Clemente Orozco, and David Alfaro Siqueiros. The Art Museum of the Americas (AMA) introduces visitors to a much wider cadre of talent, whose visions represent a rich art history.

Despite its incredible location six blocks from the White House, the AMA is easy to miss. Part of the Organization of American States (OAS), the museum occupies a gracious two-story Spanish colonial-style villa, the former home of its secretaries general. The museum's sculpture garden has become a popular local lunch spot, an oasis in the middle of the nation's capital.

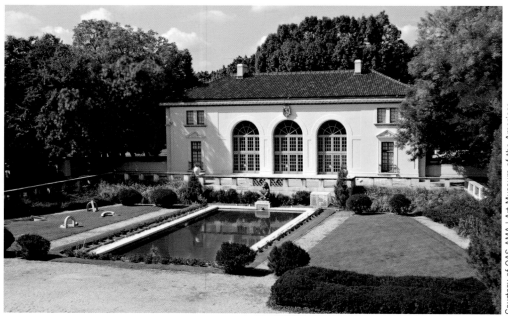

Courtesy of OAS AMA | Art Museum of the Americas

Aztec Garden

Inside, visitors are treated to a personal one-on-one art experience. Exhibitions of sophisticated, global art from OAS member nations are presented in five intimate galleries. Although the art is cutting-edge, the focus on emerging talent is part of a tradition that goes back to the 1950s and 1960s, when the museum helped boost the careers of artists like Jesus Rafael Soto, Alejandro Otero, and Carlos Cruz-Diaz.

Every year and a half to two years, the AMA also presents works from its extensive permanent collection, especially strong in South American abstraction, "primitive" Caribbean art, and photography. From a modest 250 works at its 1976 opening, the museum's holdings have grown to nearly 2,000 in various media, including painting, sculpture, installations, prints, drawings, and photographs. Touchstone works from the permanent collection are on view at the nearby OAS General Secretariat building.

The person largely responsible for the permanent collection is Cuban lawyer and art critic Jose Gomez-Sicre. Determined to gain respect for Latin American artists, Gomez-Sicre presented over two hundred exhibitions in his thirty-four-year tenure at the OAS. For many of the artists he promoted, Washington, DC was their first exposure outside their own countries. To Gomez-Sicre, they were part of "... a true international movement . . . though still belittled today by the great commercial art centres . . ."

The AMA collection features important works by mid-century avant-garde artists like Guatemalan Carlos Merida, Mexican Rufino Tamayo, and Chilean Roberto Matta, whose highly personal symbolic abstract forms greatly influenced early abstract expressionists.

Caribbean artists, especially the Cuban generation of the 1920s, are well represented. Pablo Picasso introduced the young Cuban artist Wilfredo Lam to Henri Matisse and Joan Miró and encouraged his interest in African masks and totemic carvings.

Loggia

Courtesy of OAS AMA | Art Museum of the Americas

Lam's works evoke imagery of his Afro-Cuban religion, Santeria. Like Lam, Cuban artist Amelia Pelaez studied in Paris and traveled throughout Europe. Her bright, exuberant abstracted canvases feature colors separated by strong black lines, reminiscent of Georges Braque and Matisse.

Latin America had a profound impact on French-American architect Paul Philippe Cret, who submitted the winning design for the House of the Americas (the OAS main historic building) and its adjacent secretaries general villa, today's art museum. For the villa, Cret combined classical architecture he'd studied at Paris's Ecole des Beaux-Arts with Latin American traditions from his travels to Mexico and South America.

The museum's white walls, iron grilles, and red-tiled roof reflect colonial traditions; its blue-tiled loggia celebrates Aztec and Mayan motifs. The pre-Columbian theme continues outside in the Aztec Garden, where flower prince Xochipilli presides over a reflecting pool. To appease their powerful god of fertility and good harvests, the Aztecs held a seasonal rite in his honor.

Joining Xochipilli in the garden are a group of contemporary sculptures. Puerto Rican artist Pablo Rubio's towering stainless steel *Vejigante II* depicts the popular masked character that represents a trickster

in religious festivities. In *Presence on the Path*, Beatriz Blanco's female figure seems to walk away from a cut-out space in a tall rectangular steel plate. Greeting visitors by the museum's entrance is *El Maiz*, a shaped and folded yellow steel cornstalk, a gift from Colombian artist Edgar Negret.

Over a century ago at the dedication of the main building, President William H. Taft planted a peace tree in the enclosed patio (it's still thriving). In his speech, the president praised the "perfect" architecture and thanked Andrew Carnegie for his largesse and Secretary of State Elihu Root, who ". . . went in with enthusiasm to persuade Mr. Carnegie that this was the method of promoting peace, and at the same time to erect here a beautiful monument to art." That monument is well worth a visit.

GETTING THERE Address: 201 18th St., NW; the General Secretariat Building is at 1889 F St., NW, Washington DC Phone: (202) 458 3362 Website: museum.oas.org Hours: AMA, Tuesday to Sunday 10:00 a.m. to 5:00 p.m.; OAS General Secretariat Building, Monday to Friday 9:00 a.m. to 5:30 p.m. Tours: By appointment, Tuesday to Friday, 10:00 a.m. to 4:00 p.m. Admission: Free

Not to Miss

Collection OAS AMA | Art Museum of the Americas

La Niña, John Castles, 2000

Using basic geometric forms like triangles, squares, and trapezoids, contemporary Colombian sculptor John Castles creates bold, abstract compositions like this large metal and steelwork of Christopher Columbus's ship, *La Niña*. To Castles, *La Niña* represents both the golden age of exploration as well as nostalgia for his childhood. "The project . . . resembles the traditional, folded paper boat, a universal toy," he explained. Following in the footsteps of fellow Colombian Edgar Negret, Castle's initial style focused on natural phenomenon like gravity and equilibrium and evolved to feature curves and lines.

Untitled, Manabu Mabe, 1980

The AMA has a rich collection of works by postwar Japanese-Brazilian artists like Tomie Ohtake, Kazuo Wakabayashi, and Manabu Mabe. This large Mabe mural graces the eighth floor of the General Secretariat building, a gift from Brazil. The eldest of seven sons in a family that emigrated in 1934, Mabe practiced painting and calligraphy when he wasn't working at a coffee plantation. The artist would later combine that elegant calligraphic tradition with bold Brazilian color to create his signature abstract canvases like this. The year before Mabe created this mural, over 150 of his works were lost when a cargo plane from Tokyo to Rio de Janeiro went missing.

Paracas Landscape, Fernando de Szyszlo, 1981

Known for his lyrical imagery and abstract expressionist style, Peruvian Fernando de Szyszlo often alludes to sacred places of pre-Columbian cultures. With sweeping apparitions flashing against an earth-tone background, this twenty-four-foot-long triptych is a fine example, commissioned for the lobby of the General Secretariat building. According to the artist, the work tries to convey the mystery of the barren peninsula in southern Peru, home to the ancient Paracas. This people wrapped the mummified corpses of their dead in embroidered cloaks, considered among the finest examples of pre-Columbian art. The artist worked as an advisor for the OAS from 1957 to 1960.

THE HISPANIC SOCIETY OF AMERICA
New York, New York

"Such a revelation."

—Queen Sofia of Spain, 1998

❧ Finding the Hispanic Society of America isn't easy. Although its terrace occupies nearly a city block in upper Manhattan, the building is literally hiding in plain sight behind a gate. But the effort is rewarded almost immediately when visitors meet Francisco de Goya's *Duchess of Alba* resting on an easel in the middle of the main court.

Archer Milton Huntington, circa 1900

The famous portrait has resided here since 1908, when Archer Milton Huntington bought the work to celebrate the opening of his "Spanish Museum," the Hispanic Society of America. The Duchess is among the many unexpected treasures at this little-known, world-class museum. For over thirty years, Huntington quietly amassed an arcane collection of objects that includes rare books and manuscripts, ceramics and decorative arts, and paintings and sculpture.

Gothic and Renaissance tomb sculptures occupy a hushed space at the east end of the museum. From a ruined monastery near Leon come the well-dressed effigies of Suero de Quinones and his second wife, Elvira de Zuniga, the earliest Spanish works of Pompeo Leoni. With his talented, temperamental father Leone, Pompeo sculpted for Spain's royals. Here he depicts de Quinones holding a sword, likely the one an excitable fifteenth-century ancestor used against anyone unlucky enough to cross his bridge.

The stairwell is itself a gallery, decorated with colorful, glazed *cuerda seca* ceiling tiles from the sixteenth- to eighteenth–centuries. More Spanish and Hispanic ceramics are found to the left of the upper foyer, including stunning Islamic examples (over two dozen pieces, including an exquisite tenth-century ivory box, are on long-term loan to the Metropolitan Museum's Islamic galleries). There are also stunning

examples of decorative ceramics, glass, and porcelain from factories at Alcora, La Granja, and Buen Retiro.

Huntington's collection of paintings hangs chronologically in the upstairs gallery. The concentration of seventeenth-century Madrid masterworks are ". . . surpassed only by the Hermitage and equaled but by few other museums outside of Spain," writes art historian Jonathan Brown. Unlike the Hermitage, you're likely to have these remarkable paintings all to yourself.

We first meet *Duke of Alba*, a dramatic three-quarter-length portrait of the nobleman in full armor and red sash by Flemish painter Anthonis Mor. Though Mor's stay in Spain was brief, he established a formula for official court portraiture. The portrait was a wedding gift from Archer Huntington's father, railroad baron Collis Potter Huntington. Thanks to a large inheritance from his father, Archer Huntington began acquiring Spanish Old Masters. After a shaky start, he struck gold with pictures like the *Duchess of Alba* and El Greco's *Pieta* and *The Holy Family*.

Archer Huntington's mother, Arabella, remarried her late-husband's nephew, Henry Huntington, and filled their San Marino, California, mansion with English art (today's Huntington Library and Gardens). For her son's fledgling museum, Arabella paid $650,000 for Velazquez's full-length portrait of the powerful *Gaspar de Guzman, Count-Duke of Olivares.*

Archer Huntington inherited his mother's passion for collecting, but he developed his own unique passion for the arts and culture of Spain. At age twelve Archer Huntington became fascinated with rare Iberian coins and medals. A few years later he took up Spanish and later taught himself Arabic so he could produce a better translation of the epic poem *El Cid*. During an extended trip to Spain in 1892, Huntington saw Velazquez's paintings for the first time at the Prado. "Stunning, amazing, a discovery, and cannot be talked about," he wrote in his diary.

Huntington turned down an offer to manage his father's shipyards to start a museum. "The museum

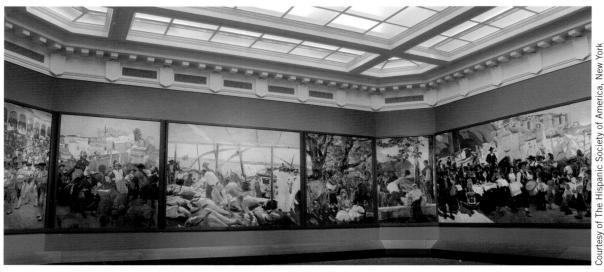

The Bancaja Gallery with Sorolla's Vision of Spain

. . . must condense the soul of Spain into meanings, through works of the hand and spirit," he wrote his mother. Huntington hired his cousin, architect Charles Pratt Huntington, to design a Beaux Arts cultural center at Audubon Terrace, the former farm of naturalist John James Audubon. To attract other cultural institutions, Huntington offered land and subsidized construction. Of the original five organizations, only the Hispanic Society and the American Academy of Arts and Letters remain.

In addition to Spanish Old Masters, Huntington collected contemporary artists. His favorite was Valencian artist Joaquín Sorolla y Bastida, for whom he hosted an exhibition. In 1911 Huntington commissioned *Vision of Spain,* an epic series of murals celebrating the country's provinces. In 2010, after a tour through Spain that included the Prado, the colorful murals were reinstalled at the Hispanic Society. Larger-than-life dancers, bullfighters, fishermen, and sheepherders fill this visual tour de force. Another joyful Sorolla is found upstairs—a portrait of Louis

Comfort Tiffany sitting at an easel in his garden surrounded by flowers and his dog, Funny.

In 1923 Huntington married sculptor Anna Hyatt with whom he shared a birthday and a passion for art. She helped decorate the Beaux-Arts plaza with bronzes of El Cid and limestone reliefs of Don Quixote and Boabdil, Granada's last Moorish king. The same year Huntington married Hyatt, he dispatched photographers to document life in Spain and Latin America. Among them was Nebraskan Ruth Anderson, who took over fourteen thousand pictures in Spain between 1923 and 1930.

Anderson's evocative images can be enjoyed by appointment in the library, a place where time seems to have stood still. Among the holdings are medieval charters, royal letters, sailing charts, illuminated bibles, and books of hours. There are 15,000 rare books (pre-1701) and 250 incunabula (pre-1500). Among Archer Huntington's treasures are a first edition of *Don Quixote,* a fifteenth-century illuminated Hebrew Bible, and a seventeenth-century globe.

Not to Miss

Oil on canvas, 51.5 x 41 cm. Courtesy of The Hispanic Society of America, New York

Portrait of a Little Girl, Diego Rodriguez de Silva y Velazquez (1599–1660), circa 1638–1644

Edouard Manet called Diego Rodriguez de Silva y Velazquez "the painter of painters" and in this intimate, naturalistic portrait it's clear why. A young girl of eight or nine gazes at us with beautiful black eyes, her dark hair lit by highlights, her dress only lightly sketched. The sitter may be Velazquez's granddaughter, one of six children of his daughter Francisca and Juan Bautista Martinez del Mazo, his assistant. Velazquez married the 16-year-old daughter of his own teacher, Francisco Pacheco. In 1909, Archer Huntington bought the engaging portrait with his mother for $100,000.

Oil on canvas, 210.2 x 149.2 cm. Courtesy of The Hispanic Society of America, New York

Duchess of Alba, Francisco de Goya y Lucientes (1746–1828), 1797

This portrait is among those Francisco de Goya painted of the thirteenth Duchess of Alba during his year-long stay at her Andalusia estate. Goya sets the glamorous widow against a dreamy landscape and blue sky. She wears a traditional maja costume—black veil, black taffeta skirt, and yellow jacket trimmed with gold lace cuffs. With an elegant ringed hand, the duchess points to an inscription in the sand next to her slipper, SOLO GOYA ("only Goya"). Inscribed on her two rings are ALBA and GOYA. Discovered in Goya's studio after his death in 1828, the portrait fueled rumors of a romance between artist and sitter.

Tin-glazed earthenware with cobalt and luster. Height: 43 cm, Diameter of mouth: 35.5 cm. Courtesy of The Hispanic Society of America, New York

Vase Neck, Malaga kingdom of Granada, late fourteenth or early fifteenth century

Archer Huntington found this graceful vase fragment from Southern Spain in Paris. Fifteen medallions are set against a cobalt blue background with gold borders and gold Arabic lettering. Above the medallions, thin vertical ridges painted in gold luster divide the neck into eleven sections. The inscription GOOD HEALTH is repeated five times on a circular band. Cobalt and luster ceramics were produced on the southern coast of al-Andalus from about 1300 to 1425. The luster technique, as well as cobalt painting and tin oxide, originated in Iraq. Recipes were closely guarded secrets.

PRADO ON THE PRAIRIE

THE MEADOWS MUSEUM
Dallas, Texas

". . . a museum with a long and serious engagement with the art and culture of the Iberian world."

—Earl A. Powell III, director, National Gallery of Art

While other Texas oilmen collected Remington and Russell, Algur Hurtle Meadows amassed a collection of Spanish art considered among the finest outside of Spain. The unlikely home for his prized collection is the campus of Southern Methodist University (SMU) in Dallas, Texas. King Juan Carlos and Queen Sofia of Spain were on hand in 2001 when the Meadows Museum inaugurated its new red brick building, roomy enough to present most of its 125 paintings and sculptures.

Outside, the tone is strikingly contemporary with Santiago Calatrava's kinetic *Wave*, 120 moving bronze coated steel bars, and Jaume Plensa's *Sho*, a thirteen-foot-tall openwork mesh sculpture depicting the head of a young girl. Inside, the museum's first floor is largely devoted to special exhibitions—from Gothic tapestries and illuminated manuscripts to contemporary sculpture and photography. Upstairs, rich galleries set a dramatic stage for works that starts with medieval, Renaissance, and counter-reformation Spain and continue with golden age portraiture, Spanish impressionist landscapes, and modern abstraction.

This small museum gem is the serendipitous result of its founder's search for oil. In the 1950s Al Meadows spent one to three months a year in Madrid, while his company, General American Oil, searched for oil in the Iberian Peninsula. To pass the time the businessman frequently visited the Prado. That's where he discovered another precious natural resource—Spanish paintings.

To create a "small Prado in Texas," Meadows began buying art from dealers in Madrid. The savvy businessman who boasted that he'd never made a really bad deal couldn't say the same about the art world. When his eponymous museum opened at SMU in 1965, some two thirds of the paintings turned out to be misattributions or copies, including three paintings by El Greco. With help from a team of art experts, Meadows rebuilt the collection with important paintings by Diego Velazquez, Bartolomé Esteban Murillo, Jusepe de Ribera, Francisco de Zurbarán, and Francisco de Goya.

Meadows also fell victim to a French forgery ring. As he did with Spanish art, Meadows started over, carefully vetting acquisitions of impressionists as well as works by Joan Miró and Jackson Pollock. "I don't hold anything against anybody," said the courtly tycoon. "Life is too short to carry grudges around."

Today visitors can experience Meadows's favorite religious paintings—the majority of which were commissioned to inspire faith in Spain's churches. A fine example is *The Mystic Marriage of Saint Catherine of Siena*, a late work by Zurbarán. In a luminous

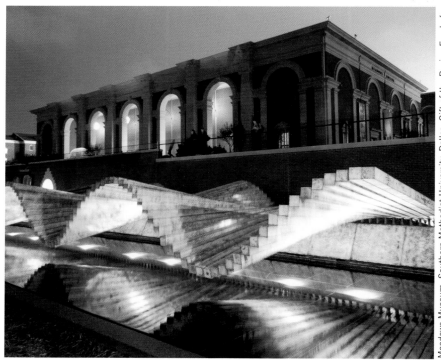

Meadows Museum, Southern Methodist University, Dallas. Gift of the Rosine Fund of the Communities Foundation of Texas through the generous vision of Mary Anne and Richard Cree. MM.02.01. Photograph by Jake Dean © 2011

The Meadows Museum and Santiago Calatrava's Wave, 2002. *Perpetual motion sculpture: steel bronze, nylon.*

triangle, Jesus places a ring on the finger of the young saint while the Virgin looks on. After plague ravaged Seville, Murillo's idealized style caught hold. In *The Immaculate Conception* in the Meadows's stairwell, putti tumble adoringly at the feet of the elegant Virgin. The collection also includes *Saint Paul the Hermit* by Ribera and his studio, one of many of the artist's depictions of elderly ascetics. Although he signed his work "espanol," Ribera spent most of his career in Naples. "I judge Spain to be a loving mother to foreigners and a very cruel stepmother to her own sons," he said.

One of the collection's strengths is portraiture— including Flemish court artist Anthonis Mor's *Portrait of Alessandro Farnese*, the teenage nephew of Philip II. Near Diego Velazquez's young Philip IV is a later portrait of Philip's niece and second wife, Queen

Mariana, painted around the same time as his masterpiece *Las Meninas*. With a light touch, Velazquez captures the young queen beneath the rouge and enormous wig made of wool hair and pearls. After Philip IV's death, Mariana became Queen Regent to their son Charles II and appointed Juan Carreño de Miranda court painter. In *Portrait of King Charles II*, Carreño sympathetically depicts the sickly teen, the last Spanish Hapsburg.

Another Spanish master, Francisco de Goya, is well represented with four oil paintings and complete first-edition sets of the artist's four great print series: *La Tauromaquia*, *Los Disparates*, *Los Caprichos*, and *Los Desatres de la Guerra*. Goya's designs for Madrid's Royal Tapestry Factory led to portrait commissions and court appointments. But after an illness left him deaf and weak, Goya began exploring new

subjects—social injustice and war. Inspired by a scene he'd witnessed in his hometown of Zaragoza, Goya created the small but powerful *Yard with Madmen*. Insanity and cruelty are played out as two naked men fight while being beaten by a guard.

Goya lost his day job as Ferdinand VII's court painter to Vicente Lopez, whose rich palette and realistic style are on view in a trio of Meadows portraits, including a full-length painting of American exporter and art collector Richard Worsam Meade. Lopez became the first director of the Prado, which today houses his best-known work, a portrait of his friendly rival Goya at age eighty.

Spanish painting between Goya and Pablo Picasso is underrepresented in American art museums. The Meadows has a fine collection of paintings by unfamiliar talents like Antonio Maria Esquivel, Jenaro Perez Villaamil, and Dario de Regoyos. In 1906, impressionist Joaquin Sorolla joined landscape painter Aueliano de Beruete in Toledo. Among the results is Sorolla's poetic *Blind Man of Toledo*, which depicts an elderly man and iconic Bridge of Alcantara.

The twentieth-century gallery features a small but notable collection. In Miro's *Queen Louise of Prussia*, a small faceless figure of a queen stands with her hands on her hips, her long neck stretched above a red collar. Miró's queen wears a triangular brown skirt outlined in green like the farthingales worn by Spain's queens. Nearby are Picasso's collage-like *Still Life in a Landscape*, Juan Gris's finely controlled *Cubist Landscape*, and Diego Rivera's early cubist portrait of Russian writer Ilya Ehrenburg.

Meadows, who died after a car accident in 1978, would have relished his museum's recent partnership with the Prado Museum. The last of three masterpieces to travel from Madrid to Dallas is Velazquez's full-length version of Philip IV.

Museum entrance, photograph courtesy of Meadows Museum, Southern Methodist University, Dallas, photography by Michael Bodycomb

GETTING THERE Address: 5900 Bishop Blvd., Dallas, TX (on the campus of SMU) Phone: (214) 768-2516 Website: meadowsmuseumdallas.org Hours: Tuesday to Saturday 10:00 a.m. to 5:00 p.m., Thursday until 9:00 p.m., Sunday 1:00 to 5:00 p.m. Tours: Sunday 2:00 p.m., permanent collection; Thursday 6:30 p.m., special exhibitions Admission: Adults $10, seniors $8, students $4, children under 12 free; Thursday after 5:00 p.m. free

Not to Miss

Oil on canvas, 87 3/4 x 142 inches. Meadows Museum, Southern Methodist University, Dallas. Algur H. Meadows Collection, MM.67.27

Jacob Laying Peeled Rods before the Flocks of Laban, Bartolomé Murillo, circa 1665

Bartolomé Murillo is best known for his radiant images of the Immaculate Conception. As this large painting demonstrates, he was also a gifted landscapist. Part of a five-work cycle about the life of the biblical patriarch Jacob, Murillo uses a palette of aquamarine, celadon, pale pink, and blue to create the lush scene (other works in the cycle reside at the Hermitage, Cleveland Museum of Art, and National Gallery of Ireland). The series wowed British playwright Richard Cumberland who wrote in 1787, ". . . I am inclined to think I should take those canvases before any I have seen, one miracle of art alone excepted, the Venus of Titiano."

Saint Francis Kneeling in Meditation, El Greco, circa 1605–1610

The Meadows acquired this painting in 1999 after a thirty-year quest for an El Greco. Throughout his long career, the Crete-born artist often depicted Saint Francis in prayer, helping popularize the saint as an artistic subject. The Meadows's version dates from the artist's late, most mystical phase. Kneeling before a rocky grotto, Saint Francis contemplates death in the form of a crucifix leaning against a skull. Although King Philip II was not a fan, El Greco found a loyal following with churchmen in his adopted city of Toledo. With his loose, overlapping brushwork and elongated figures, El Greco created a new, spiritually intense experience for the viewer.

Portrait of King Philip IV, Diego Velazquez, circa 1623–1624

Diego Velazquez painted this bust-length royal portrait not long after teenage Philip IV's accession to the throne. Historians believe this work may have helped Velazquez secure his royal appointment at the Spanish court. In contrast to the elaborate style of his father, the teenage Philip IV wears his trademark somber black jacket and simple starched white collar. About Velazquez's likenesses of King Philip, Pablo Picasso said, "We can not conceive of Philip IV in any other way than the one Velazquez painted . . . "

New Mexico Museum of Art Gallery

INDEX

ABOUT THE AUTHOR

For her debut book, *A Love for the Beautiful: Discovering America's Hidden Art Museums,* art and travel writer Susan Jaques crisscrossed the country in search of extraordinary museums. With a background in journalism and training in art, Susan's special passion is for unique art experiences that are off the beaten path.

Susan holds a Bachelor of Arts in history from Stanford University and an MBA from UCLA's Graduate School of Management. She lives in Los Angeles where she's a gallery docent at the J. Paul Getty Museum.

Visit her website at susanjaques.com.

Photo by Clara Jaques